Canon® EOS Rebel XS/1000D Digital Field Guide

Charlotte K. Lowrie

Canon® EOS Rebel XS/1000D Digital Field Guide

Published by
Wiley Publishing, Inc.
10475 Crosspoint Boulevard
Indianapolis, IN 46256

Copyright © 2009 by Wiley Publishing, Inc., Indianapolis, Indiana

Published simultaneously in Canada

ISBN: 978-0-470-40950-3

Manufactured in the United States of America

10987654321

No part of this publication may be reproduced, stored in a retrieval system or transmitted in any form or by any means, electronic, mechanical, photocopying, recording, scanning or otherwise, except as permitted under Sections 107 or 108 of the 1976 United States Copyright Act, without either the prior written permission of the Publisher, or authorization through payment of the appropriate per-copy fee to the Copyright Clearance Center, 222 Rosewood Drive, Danvers, MA 01923, (978) 750-8400, fax (978) 646-8600. Requests to the Publisher for permission should be addressed to the Legal Department, Wiley Publishing, Inc., 10475 Crosspoint Blvd., Indianapolis, IN 46256, (317) 572-3447, fax (317) 572-4355, or online at http://www.wiley.com/go/permissions.

LIMIT OF LIABILITY/DISCLAIMER OF WARRANTY: THE PUBLISHER AND THE AUTHOR MAKE NO REPRESENTATIONS OR WARRANTIES WITH RESPECT TO THE ACCURACY OR COMPLETENESS OF THE CONTENTS OF THIS WORK AND SPECIFICALLY DISCLAIM ALL WARRANTIES, INCLUD-ING WITHOUT LIMITATION WARRANTIES OF FITNESS FOR A PARTICULAR PURPOSE. NO WAR-RANTY MAY BE CREATED OR EXTENDED BY SALES OR PROMOTIONAL MATERIALS. THE ADVICE AND STRATEGIES CONTAINED HEREIN MAY NOT BE SUITABLE FOR EVERY SITUATION. THIS WORK IS SOLD WITH THE UNDERSTANDING THAT THE PUBLISHER IS NOT ENGAGED IN RENDERING LEGAL, ACCOUNTING, OR OTHER PROFESSIONAL SERVICES. IF PROFESSIONAL ASSISTANCE IS REQUIRED. THE SERVICES OF A COMPETENT PROFESSIONAL PERSON SHOULD BE SOUGHT. NEITHER THE PUBLISHER NOR THE AUTHOR SHALL BE LIABLE FOR DAMAGES ARISING HEREFROM. THE FACT THAT AN ORGANIZATION OR WEB SITE IS REFERRED TO IN THIS WORK AS A CITATION AND/OR A POTENTIAL SOURCE OF FURTHER INFORMATION DOES NOT MEAN THAT THE AUTHOR OR THE PUBLISHER ENDORSES THE INFORMATION THE ORGA-NIZATION OF WEB SITE MAY PROVIDE OR RECOMMENDATIONS IT MAY MAKE. FURTHER, READERS SHOULD BE AWARE THAT INTERNET WEB SITES LISTED IN THIS WORK MAY HAVE CHANGED OR DISAPPEARED BETWEEN WHEN THIS WORK WAS WRITTEN AND WHEN IT IS READ.

For general information on our other products and services or to obtain technical support, please contact our Customer Care Department within the U.S. at (800) 762-2974, outside the U.S. at (317) 572-3993 or fax (317) 572-4002.

Wiley also publishes its books in a variety of electronic formats. Some content that appears in print may not be available in electronic books.

Library of Congress Control Number: 2008939320

Trademarks: Wiley and the Wiley Publishing logo are trademarks or registered trademarks of John Wiley & Sons, Inc. and/or its affiliates. Canon is a registered trademark of Canon, Inc. All other trademarks are the property of their respective owners. Wiley Publishing, Inc. is not associated with any product or vendor mentioned in this book.

About the Author

Charlotte K. Lowrie is a professional editorial, portrait, and stock photographer and an award-winning writer based in the Seattle, Washington area. Her writing and photography have appeared in a variety of newsstand magazines and on various Web sites. She is the author of 10 books including the best-seller *Canon EOS Digital Rebel XSi Digital Field Guide*, the *Canon EOS Digital Rebel XTi Digital Field Guide*, the *Canon EOS 40D Digital Field Guide*, the *Canon EOS 5D Digital Field Guide*, and she is co-author of *Exposure and Lighting for Digital Photographers Only*. Charlotte also teaches two photography classes at BetterPhoto.com every month. Her images have appeared on the Canon Digital Learning Center, and she is a featured photographer on www.takegreatpictures.com.

Charlotte's images have been published in a variety of books, magazine articles, commercial products, and advertisements. She shoots stock, editorial assignment, and portrait images for a variety of clients. You can see more of her images on wordsandphotos.org

Credits

Acquisitions Editor Laura Sinise

Project Editor Laura Town

Copy Editor Marylouise Wiack

Editorial Manager Robyn B. Siesky

Senior Marketing Manager Sandy Smith

Vice President & Group Executive Publisher Richard Swadley

Vice President & Publisher Barry Pruett

Business Manager Amy Knies **Project Coordinator** Erin Smith

Graphics and Production SpecialistsAndrea Hornberger
Jennifer Mayberry
Christin Swinford

ProofreadingJoni Heredia

Indexing Potomac Indexing, LLC I dedicate this book to my six grandchildren, some of whom are coming into their own as young photographers. I also thank God for His inspiration in this amazing journey in photography.

Acknowledgments

y thanks to Bryan Lowrie and Sandy Rippel who kindly contributed images for this book.

Contents at a Glance

Acknowledgmentsvii ntroductionxvii Getting the Most from This Bookxviii
Part I: Using the EOS Rebel XS/1000D
Part II: Creating Great Photographs with the EOS Rebel XS/1000D
Part III: Creative Accessories and More137Chapter 8: Exploring Canon Lenses139Chapter 9: In the Field with the EOS Rebel XS/1000D159Appendix A: Downloading Images and Updating Firmware219Appendix B: Exploring RAW Capture225Glossary235
Index

Contents

Acknowledgments	vii
Introduction	xvii
Getting the Most from This Book	xviii

Part I: Using the EOS Rebel XS/1000D 1

Chapter 1: Exploring and Setting Up the EOS Rebel XS/1000D 3

Anatomy of the EOS Rebel	
XS/1000D	
Front camera controls	
Top camera controls	
Rear camera controls	6
Camera terminals	9
The LCD	9
Viewfinder display	9
Lens controls	10
Setting Up the EOS Rebel XS/1000	D11
Formatting an SD/SDHC card	12
Setting the date and time	13
Choosing the file format and	
quality	14
JPEG format	15
RAW format	16
Changing file numbering	17

Chapter 2: Using the EOS Rebel XS/1000D 19

Choosing a Shooting Mode	20
How shooting modes relate	
to exposure	20
Basic Zone shooting modes	21
Full Auto mode	22
Portrait mode	つて

Landscape mode	24	Erasing Images	53
Close-up mode	25	Protecting Images	54
Sports mode	25	Using the EOS Integrated Cleaning	
Night Portrait mode	26	System	54
Flash-off mode	27	Automatic sensor cleaning	55
Creative Zone Shooting Modes	28	Obtaining Dust Delete Data	55
P mode	28	Applying Dust Delete Data	56
Tv mode	29		
Av mode	31	Part II: Creating Great	
M mode	32		
A-DEP mode	33	Photographs with the	
Selecting a Metering Mode	34	EOS Rebel XS/1000D	57
Evaluative metering	35		
Partial metering	36	Chapter 3: Using White	
Center-weighted Average	30	Balance and Picture Styles 5	59
metering	37	THE RESERVE AND ADDRESS OF THE PERSON OF THE	
Modifying Exposure	37		L
Auto Lighting Optimization	37		
Exposure Compensation	38		add .
Auto Exposure Bracketing	39	1/2/10	
Auto Exposure Lock	40		
Evaluating Exposure	42		
Brightness histogram	42		
RGB histograms	43		
Setting the ISO Sensitivity	44		
Selecting AF Modes and Getting		About Color Spaces	59
Sharp Focus	46	Choosing a Color Space	61
Selecting an Autofocus point	49	Choosing White Balance Options	62
Choosing a Drive Mode	50	Approaches to using various	
Single-shot mode	50	white balance options	64
Continuous mode	50	Set a custom white balance	66
Self-timer modes	51	Use White Balance Bracketing	67
Viewing and Playing Back Images	52	Set White Balance Shift	68
Single-image playback	52	Choosing and Customizing a	
Index Display	52	Picture Style	70
Auto play	53	Registering a User Defined Picture Style	75
Using the Display (Disp.)		Using the Picture Style Editor	76
button	53	Osing the ricture Style Editor	70

Chapter 4: Using Live View 79

About Live View	79
Live View Features and Functions	80
Live View focusing	80
Exposure simulation and	
metering	81
Using a flash	81
Setting Up for Live View	81
Setting Live View Custom	
Functions	82
C.Fn-7	82
C.Fn-5	83
Live View function settings	83

Shooting in Live View	84
Focusing with Quick or Live	
mode	84
Quick mode focusing	84
Live mode focusing	85
Manual focusing	86
Using Live View with	
tethered shooting	87

Chapter 5: Customizing the EOS Rebel XS/1000D 91

Setting Custom Functions	91
Custom Function groupings	92
Custom Functions specifics	92
C.Fn Group I: Exposure	92
C.Fn Group II: Image	94
C.Fn Group III: Autofocus/	
Drive	96
C.Fn Group IV: Operation/	
Others	97
Setting Custom Functions	100
Customizing My Menu	101
Changing the Screen Color	103

Chapter 6: The Fundamentals of Exposure and Light 105

The Four Elements of Exposure	105
Light	106
Sensitivity: The role of ISO	107
Intensity: The role of the	
aperture	109
Wide aperture	109
Narrow aperture	110
Choosing an aperture	110
What is depth of field?	
Time: The role of shutter	
speed	
Equivalent Exposures	
Putting It All Together	
Let There Be Light	115
Understanding color	
temperature	115
The colors of light	116
Sunrise	116
Midday	116

Sunset	116
Diffused light	116
Electronic flash	
Tungsten light	
Fluorescent and other	
light	118
Metering light	118
Additional characteristics	
of light	120
Hard light	120
Soft light	122
Directional light	122

Chapter 7: Using Flash 125

Exploring Flash Technology	125
Using the Onboard Flash	127
Using the flash's	
autofocus-assist beam	
without the flash	129
Red-eye reduction	130
Modifying Flash Exposure	131
Flash Exposure Lock	131
Flash Exposure	
Compensation	
Using Flash Control Options	134
Using One or More Accessory	
Speedlites	136

Part III: Creative Accessories and More 137

Chapter 8: Exploring Canon Lenses 139

Understanding the Focal Length	
Multiplication Factor	139
Lens Choices	141
Wide angle	142
Normal	142
Telephoto	142
Macro	142
Zoom versus Prime Lenses	143
About zoom lenses	143
Zoom lens advantages	143
Zoom lens disadvantages	144
About prime lenses	144
Prime lens advantages	145
Prime lens disadvantages	145
Canon Lens Terminology	145
Using Wide-Angle Lenses	148
Using Telephoto Lenses	149

Using Normal Lenses	151
Using Macro Lenses	151
Using Tilt-and-Shift Lenses	153
Using Image-Stabilized Lenses	153
Exploring Lens Accessories	156
Lens extenders	156
Extension tubes and	
close-up lenses	157

Chapter 9: In the Field with the EOS Rebel XS/1000D 159

proaches to Composition	159
Subdividing the photographic	
frame	160
Balance and symmetry	160
Tone and color	162
Lines and direction	163
Fill the frame	165
Check the background	165
Frame the subject	165
Control the focus and depth	
of field	165
Defining space and	
perspective	167

Action and Sports Photography	167
Action and Sports Photography	
Inspiration	169
Taking action and sports	
photographs	169
Action and sports	
photography tips	
Animal and Wildlife Photography	172
Inspiration	
Taking animal and wildlife	
nhotographe	175
Animal and wildlife	
Architectural and Interior	
Architectural and Interior	
Photography	177
Inspiration	179
Taking architectural and interior photographs	
interior photographs	180
Architectural and interior	
photography tips	182
Child Photography	183
	184
Inspiration	
Taking child photographs	185
Child photography tips	186
Macro Photography	187
Inspiration	188
	189
Taking macro photographs	
Macro photography tips	191
Nature and Landscape	
Photography	192
Inspiration	193
Taking nature and landscape	
photographs	194
Nature and landscape	100
photography tips	196
Night and Low-Light Photography	196
Inspiration	198
Taking night and low-light	
photographs	199
Night and low-light photography tips	
nhotography tips	201
Protography tips	
Portrait Photography	201
Lens choices	201
Backgrounds and props	202
Lighting	202
Accessory flash	202
Posing	203
E/OLST I B I S	SPAVATED

Rapport	203
Direction	203
Inspiration	203
Taking portrait photographs	204
Portrait photography tips	206
Still-Life Photography	207
Inspiration	208
Taking still-life photographs	209
Still-life photography tips	210
Stock Photography	211
Inspiration	212
Taking stock photographs	212
Stock photography tips	214
Travel Photography	214
Inspiration	216
Taking travel photographs	216
Travel photography tips	218

Appendix A: Downloading Images and Updating Firmware 219

Downloading with a USB Cable 219
Downloading with a Card Reader 221
Updating the XS/1000D Firmware 222

Appendix B: Exploring RAW Capture 225

Learning about RAW Capture 225
Canon's RAW Conversion Program 228
Sample RAW Image Conversion 228
Creating an Efficient Workflow 232

Glossary 235

Index 241

Introduction

Thank you for buying this *Canon EOS XS/1000DXS/1000D Digital Field Guide*. I hope that the book will help you begin your journey into the wonderful world of photography. Or, if you're a seasoned Rebel photographer, I hope this book becomes a valuable resource for a journey you've already begun. With the introduction of the XS/1000DXS/1000D, Canon packed a bevy of technology in this affordable, digital SLR that is responsive, reliable, and produces outstanding images. This book is designed to help you master using the camera and get the best images from it. From my experience with the XS/1000D, I can say that this camera is a capable and fun tool that will enable you to capture countless memorable images.

The XS/1000DXS/1000D features the best of Canon's latest technology that gives this camera very good response and performance, and a suite of powerful features that give you more control during shooting. The camera is small and lightweight and is designed for ease of use regardless of your experience level. The XS/1000D features Live View shooting for new creative opportunities, good customizability, in-camera Canon EX SpeedLite control, large-text, intuitive, full-feature menus, a personalized menu, a big, bright, wide-angle view LCD, and automatic image-sensor cleaning.

The XS/1000DXS/1000D is the latest in Canon's new generation of cameras that open the door to greater creative expression for photographers. This book is designed to help you explore the XS/1000DXS/1000D to experience its full potential.

This book includes a mix of how-to-use-the-camera information together with in-field examples of specific photographic subjects. Regardless of your favorite subjects for shooting, remember that all of life is a photographic stage. In his book *The Mind's Eye: Writings on Photography and Photographers*, Henri Cartier-Bresson said, "There is subject in all that takes place in the world, as well as in our personal universe. We cannot negate subject. It is everywhere. So we must be lucid toward what is going on in the world, and honest about what we feel...In photography, the smallest thing can be a great subject. The little human detail can become a leitmotiv. We see and show the world around us, but it is an event itself which provokes the organic rhythm of forms."

I hope that this book is a rewarding resource for you, not only in learning to use the EOS XS/1000DXS/1000D, but also in exploring a universe of subjects and distilling the essence of each image with freshness and personal creative vision. And as you use this book, remember that it is you, the photographer, who makes the picture. It's your creative vision that drives the images you'll make. And having a camera like the EOS XS/1000DXS/1000D gives you a big step up in realizing your vision.

Getting the Most from This Book

Chances are that you've already been shooting with the XS/1000D perhaps in automatic modes. If you've wondered what all the different controls are and how to use them, then spend some time in the first half of the book. Here you'll learn your way around the camera and learn what each control does in various camera modes. The first half of the book also concentrates on the effect of using different controls and settings during shooting. It is essential to know the camera controls well, and to set up functions so that they best suit your routine shooting preferences. The XS/1000DXS/1000D is customizable, giving you ample opportunity to set up the camera so that it works well for you. Further, Canon provided a full complement of features that give you control over exposure, color, and drive modes. Knowing the extent of these features will go a long way toward making your photography efficient and successful.

One of the features you'll learn about is Canon's Picture Styles, which determine the color, contrast, and sharpness of images you make with the XS/1000D. Chapter 3 explains why you need to carefully evaluate Picture Styles and how to modify them. The more you know about Picture Styles, the better your chances of getting the best color and contrast—both from the camera and subsequently from the prints you make. If you're a fan of Live View shooting, then Chapter 4 details the ins and outs of shooting in Live View mode on the XS/1000D. The XS/1000DXS/1000D also offers many opportunities to customize the functions and use of the camera. As you'll see in Chapter 4, the customizations translate into time saving both during shooting and later as you process your XS/1000DXS/1000D images.

In Chapter 6, those who are new to photography can get an overview on the basics of photographic exposure including an introduction to ISO, aperture, shutter speed, and the types and characteristics of light, and how these elements work together to create a good exposure.

You'll also find discussions of Canon SpeedLites and lenses and in Chapters 7 and 8. In Chapter 7, you'll learn about both the onboard flash as well as using one and more accessory SpeedLites. Chapter 8 introduces the range of lenses that Canon offers as well as providing example images taken using some of the lenses. These chapters are designed as a quick reference, not an exhaustive compendium of lens test results and flash shooting techniques — both of which are book-length topics on their own. The next part of the book concentrates on the photographic areas where the EOS XS/1000DXS/1000D is a stand-out performer. Each section offers discussions about each photographic area; field notes on using the XS/1000DXS/1000D; lenses, flash, and accessories, and shooting tips and experiences.

Granted, you may not be interested in shooting every subject detailed in Chapter 9, but you can still gain insight into the camera operation and performance in a variety of shooting situations – and many shooting scenarios are common to all type of photographic subjects. This part of the book is designed to discuss camera performance and capability in various venues and to provide suggestions and comments to make your shooting more efficient

and successful. As with any area of photography, there are as many options, preferences, and opinions as there are photographers. The information provided in this part of the book reflects one photographer's experience — use it as a springboard for your work with the XS/1000DXS/1000D.

In Appendix A, you learn about getting and installing periodic firmware updates for the XS/1000DXS/1000D that are provided by Canon. These updates are important in resolving any known bugs with the camera as well as updating menu functions.

Digital images aren't finished, of course, until they are edited, and, in the case of RAW capture, until they are converted to TIFF or JEPG format. Canon provides a suite of programs that allow you to view and edit XS/1000DXS/1000D images. In addition, if you are interested in getting started with RAW capture, Appendix B provides the basics for shooting and converting RAW images using Canon's Digital Photo Professional program.

I hope that during your journey through this book, you will be inspired and challenged to use the XS/1000DXS/1000D to capture stunning, personal-best images. Regardless, I am confident that you will find that the EOS XS/1000DXS/1000D is an exceptional camera and one that is uniquely capable in helping you achieve your photographic vision.

The editor, the staff at Wiley, and I hope that you enjoy reading and using this book as much as we enjoyed creating it for you.

Using the EOS Rebel XS/1000D

P A R

In This Part

Chapter 1
Exploring and Setting
Up the EOS Rebel
XS/1000D

Chapter 2Using the EOS Rebel XS/1000D

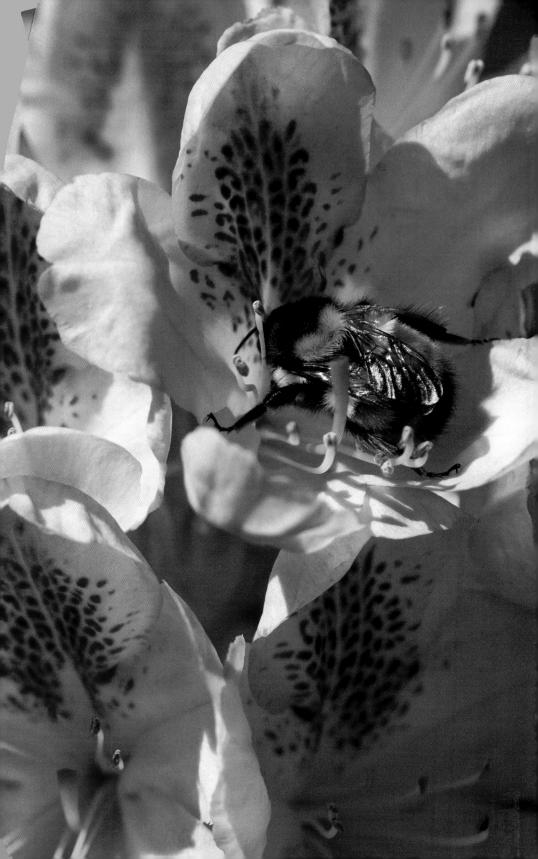

Exploring and Setting Up the EOS Rebel XS/1000D

ne of the first steps in photography is learning the camera so thoroughly that you can operate it with no hesitation and without hunting for controls. By knowing the camera and lens controls well, you can make adjustments instinctively and confidently so that you don't miss getting the shots you want.

The simple design of the EOS Rebel XS/1000D makes mastering it both easy and fun; yet despite the simplicity, the camera offers full-function features for exceptional creative control. Internally, Canon's 210.1-megapixel CMOS (complementary metal-oxide semiconductor) sensor and the DIGIC III Image Processor deliver dependably vivid, crisp images, especially at the highest image-quality settings.

Anatomy of the EOS Rebel XS/1000D

Many of the Rebel XS/1000D's controls are within a finger's reach for quick adjustment as you're shooting. Less frequently used functions are accessible only through the menus. The following sections help you to explore and master the XS/1000D controls.

CHAPTER

In This Chapter

Anatomy of the EOS Rebel XS/1000D

Setting up the EOS Rebel XS/1000D

Front camera controls

The front of the camera has controls and connections that you'll use often, including the Lens Release button, lens mount index marks, the Flash Pop-up button, and the Depth of Field Preview button.

The front camera controls, from the left to right side, include the following:

- Shutter button. Pressing this button halfway down sets focus and initiates metering and exposure calculation, and pressing it completely fires the shutter to make an exposure.
- Red-eye reduction/Self-timer lamp. This red lamp flashes to count down the seconds to shutter release when the camera is set to one of the Self-timer modes.
- markers. Use these markers on the lens mount to line up the lens when you mount it on the camera. Use the red EF lens mount index for all EF lenses that have a red marker on the lens, and the white EF-S lens mount index for EF-S lenses that have a white marker on the lens. The lens that comes with the XS/1000D is an EF-S lens designed specifically for the smaller image sensor size of the Rebel. But Canon's EF lenses also work perfectly on the XS/1000D.
- Built-in flash and Flash Pop-up button. The flash provides illumination either as the main light source or as a fill flash. In Basic Zone modes such as Full Auto, Portrait, Landscape, and so on, the flash fires automatically. In Creative Zone modes such as P, Tv, Av, and so on, pressing the Flash Pop-up button raises the flash for use.

- Depth of Field Preview button.
 - Press this button to stop down, or adjust, the lens diaphragm - the opening at the back of the lens to the current aperture to preview the depth of field in the viewfinder. The larger the area of darkness in the viewfinder, the more extensive the depth of field will be. At the lens's maximum aperture, the Depth of Field Preview button cannot be depressed because the diaphragm is fully open. The aperture cannot be changed as long as the Depth of Field Preview button is depressed. You can also preview depth of field when using the Live View function.
- Lens Release button. Press and hold this button to disengage the lens from the lens mount by turning the lens to remove it.

Top camera controls

Controls on the top of the camera enable you to use the thumb and index finger on your right hand to control common adjustments quickly. Here is a look at the top camera controls.

- Mode dial. This dial enables you to switch among shooting modes by lining up the mode you want with the white mark beside the dial.
- ♦ ISO Speed button. Press this button to set the ISO setting, which determines the sensor's sensitivity to light in Creative Zone modes such as P (Program AE [Auto Exposure]), Tv (Shutter-priority Time value), Av (Aperture-priority Aperture value), and M (Manual). You can select Auto where the camera automatically sets the ISO from 100 to 800, or you can set it

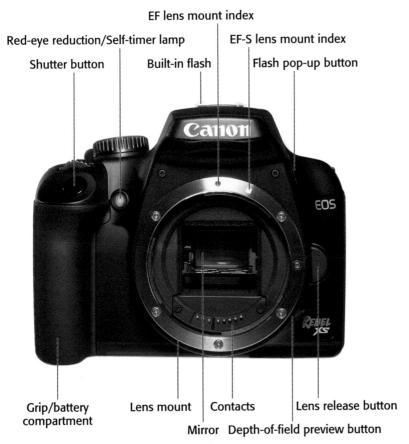

1.1 EOS XS/1000D front camera controls

from 100 to 1600. In Basic Zone modes such as Full Auto, Portrait, and Landscape, the camera automatically sets the ISO between 100 and 800. Before you can display the ISO settings screen, the LCD shooting information display must be on. If the display is off, press the Display button to turn it on.

Main dial. This dial selects a variety of settings and options. Turn the Main dial to manually select an AF (autofocus) point after pressing the AF Point Selection/Magnify button; to set the aperture in Av mode; to set the shutter speed in Tv and Manual modes; and to shift the exposure program in P mode. Additionally, you can turn the Main dial to scroll among Menu tabs.

Shutter button. Pressing the Shutter button halfway sets the point of sharpest focus at the selected AF point in manual AF point selection mode, and it simultaneously sets the exposure based on the ISO and the amount of light in the scene. Pressing the Shutter button completely makes the exposure. In any mode except Direct Printing, you can also halfpress the Shutter button to dismiss camera menus and image playback.

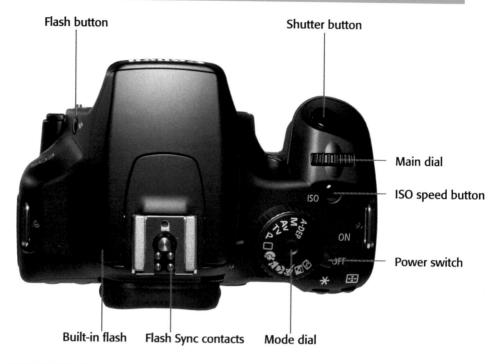

1.2 EOS XS/1000D top camera controls

Rear camera controls

The rear camera controls are handy for making quick adjustments while you're shooting. In particular, you'll likely use the WB (White Balance), Menu, Playback, and AF Point Selection/Magnify (Autofocus) buttons often.

Your ability to use some of the rear camera controls depends on the shooting mode you're using. In automatic modes such as Portrait, Landscape, and Sports, pressing the Av, WB, and Drive Mode Selection buttons has no effect because the camera sets these functions automatically. But in the Creative Zone modes such as P, Tv, Av, M, and A-DEP, these buttons function as described next.

If you press the WB (White Balance), AF (Autofocus), or other buttons on the camera and nothing happens, check the Mode dial first to see if you're using an automatic mode such as Full Auto, Portrait, Landscape, and so on. If you want to use these buttons to make changes, then switch to P, Tv, Av, M, or A-DEP mode.

- Menu button. Press the Menu button to display camera menus. To move among Menu tabs, turn the Main dial or press the left or right cross keys on the back of the camera.
- Disp. (Display) button. Press this button to turn the LCD display on or off. If you're using the camera menus, you can press this button to display the current camera settings. Then press the button again to return to the menu. If you are in single-image playback, then pressing this button cycles through the

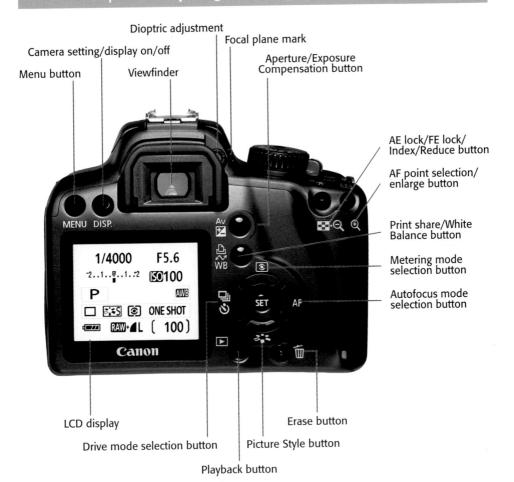

1.3 EOS XS/1000D rear camera controls

various playback display modes to show shooting information and one or more histograms with an image preview. You can also use this button when you're printing directly from the SD/SDHC card to change the image between horizontal and vertical orientations.

The LCD display is on by default when you turn the camera on. But you can set Custom Function (C.Fn) 11 to change the power status when you turn on the camera.

See Chapter 5 for details on using Custom Functions.

- Av button. Press and hold this button and turn the Main dial to set Exposure Compensation in P, Tv, Av, and A-DEP. In Manual mode, press and hold this button and turn the Main dial to set the aperture.
- Print Share/WB (White Balance)
 button. Pressing the Print Share/
 WB button enables you to transfer all or selected images from the SD/
 SDHC card to your computer. Press

this button when you want to print images on the SD/SDHC card directly to a compatible printer. When you're shooting, pressing the button enables you to set a white balance to match the type of light in the scene for accurate, natural-looking colors.

- ◆ Playback button. Pressing this button displays the last captured image on the LCD. The default single-image Playback display includes a ribbon of shooting information at the top. During image playback, you can also press the Index/Reduce button on the top-right back of the camera to display a grid of images that you can scroll through using the Main dial. You can also press the AF Point Selection/Magnify button one or more times to return to single-image display.
- Erase button. Press this button to delete the currently displayed image during image playback.

Within the circle at the back right of the Rebel XS/1000D are four buttons, collectively referred to as cross keys. The cross key functions change depending on whether you're playing back images, navigating camera menus, or changing exposure settings.

For example, when you play back images, the left and right cross keys move backward and forward through the images stored on the SD/SDHC card; and when you're navigating through menu options, the cross keys move among the options.

• Drive mode selection. Press the left cross key to set the drive mode to shoot in the following ways: one picture at a time; continuously at 3 frames per second (fps) up to the card capacity for JPEGs; five RAW frames; or four RAW +Large/Fine JPEG frames per burst. You can also use this button to select one of the Self-timer/remote control modes. During image playback, press this button to move to a previous image.

- ◆ Picture Style. Press the down cross key to display the Picture Style screen where you can choose a style or "look" that varies the image contrast, color rendition, saturation, and sharpness. You can choose Standard (S), Portrait (P), Landscape (L), Neutral (N), Faithful (F), or Monochrome (M) Picture styles and can customize up to three User Defined Picture Styles denoted as 1, 2, and 3.
- ♠ AF (Autofocus) mode. Press the right cross key (labeled as AF) to choose among three autofocus modes: One-shot for still subjects, AI Focus for subjects that may start to move or move unpredictably such as kids and wildlife, or AI Servo, which tracks focus of moving subjects. During image playback, press this button to move to a next image.
- Metering mode selection. Press the up cross key to choose a metering mode that determines how much of the scene the camera uses to meter subject brightness. The default Evaluative metering mode takes into account the entire scene as shown in the viewfinder and is accurate for most scenes, including backlit subjects. Partial metering weights the metering at the center of the viewfinder, and Centerweighted average weights metering throughout the scene but gives more weight to the center.

- Set button. Press this button to confirm changes you make on the camera menus, and to display submenus. You can also customize this button using Custom Function (C. Fn) 10 for use while you're shooting. At the top-right corner of the Rebel XS/1000D are two buttons that you'll use often to select AF points manually and to check focus as you enlarge images during playback.
- AE Lock/FE Lock/Index/Reduce button. Press this button to do the following: set Auto Exposure (AE) Lock or Flash Exposure Lock (FEL) when the built-in flash is raised; display multiple images as an index during image playback; or reduce the size of an enlarged image during image playback.
- ◆ AF Point Selection/Magnify button. Press this button to activate the AF points in the viewfinder so you can select an AF point manually or select automatic AF point selection. Press and hold the button and turn the Main dial to select one AF point or all AF points. During image playback, you can press this button to enlarge the displayed image to check focus.

Camera terminals

On the side of the XS/1000D is a set of terminals under a cover and embossed with icons that identify the terminals. They include the following:

 Video Out terminal. The Video Out terminal enables you to connect the camera to a television set using the video cable supplied in the camera box.

- Remote Control terminal. Use the Remote Control terminal to connect the optional Remote Switch RS-60E3 cable to the camera.
- Digital terminal. The Digital terminal/USB 2.0, together with a USB cable provided in the box, can be used to connect the camera to a computer to download images, to shoot with the camera connected to the computer, or to connect to a compatible printer to print images from the SD/SDHC card.

The LCD

With the XS/1000D, the 2.5-inch LCD not only displays captured images, camera settings, and menus, but it also provides a continuous view of the scene during Live View shooting.

Viewfinder display

The XS/1000D has a Pentamirror viewfinder with a precision-matte focusing screen. The viewfinder displays approximately 95 percent of the scene that the sensor captures. In addition, the viewfinder displays the seven AF points, as well as information at the bottom that displays the shutter speed and aperture settings, the Exposure Level indicator, exposure and flash exposure compensation settings, a focus confirmation light, and other settings, depending on the functions in use.

Seven AF points are etched into the focusing screen. When you manually select AF points by pressing the AF Point Selection/Magnify button, the AF points are highlighted as you rotate the Main dial. If the camera automatically selects an AF point, the selected point displays in red in the viewfinder when you press the Shutter button halfway down.

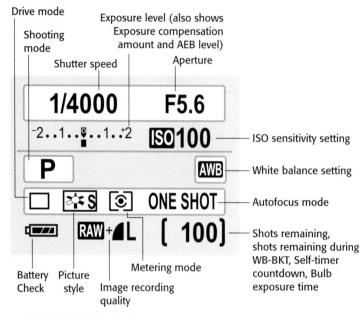

1.4 XS/1000D LCD display

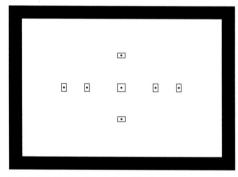

1.5 XS/1000D AF point display

To ensure that the viewfinder image and focusing screen elements are adjusted for your vision, you can adjust the diopter setting from -3 to +1 dpt. To set the dioptric adjustment, focus the lens by pressing the Shutter button halfway, and then turning the diopter switch — located to the right of the viewfinder eyecup — until the image in the viewfinder is sharp. If you wear eyeglasses during shooting, be sure to wear them as you set the dioptric adjustment.

Lens controls

All Canon lenses provide both automatic and manual focusing functionality through the AF/MF (Autofocus/Manual Focus) switch on the side of the lens. If you choose MF, the XS/1000D provides focus assist, shown in the viewfinder, to confirm sharp focus. When sharp focus is achieved, the Focus confirmation light in the viewfinder burns steadily and the camera emits a focus confirmation beep if the beep is turned on.

Depending on the lens, additional controls may include the following:

- Focusing distance range selection switch. This switch determines and limits the range that the lens uses when seeking focus to speed up autofocusing. The focusing-distance range options vary by lens.
- Image stabilizer switch. This switch turns Optical Image Stabilization on or off. Optical

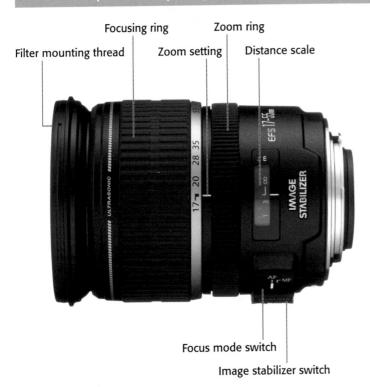

1.6 Lens controls

Image Stabilization (IS) corrects vibrations at any angle when hand-holding the camera and lens. IS lenses typically allow sharp hand-held images of two or more f-stops over the lens's maximum aperture.

- Stabilizer mode switch. Offered on some telephoto lenses, this switch has two modes: one mode for standard shooting and one mode for vibration correction when panning at right angles to the camera's panning movement.
- Focusing ring and zoom ring. The lens focusing ring can be used at any time, regardless of focusing mode. On zoom lenses, the zoom ring zooms the lens in or out to the focal lengths marked on the ring.

Distance scale and infinity compensation mark. This shows the lens's minimum focusing distance to infinity. The infinity compensation mark compensates for the shifting of the infinity focus point resulting from changes in temperature. You can set the distance scale slightly past the infinity mark to compensate.

Setting Up the EOS Rebel XS/1000D

Setting up the Rebel EOS XS/1000D is the first step in using the camera. Although this chapter offers important pointers on setting up your camera, ultimately the best way to

get great pictures from the Rebel XS/1000D is to use the camera settings, and then carefully evaluate the images. Unlike paying for film, the pictures that you take with the Rebel XS/1000D are at no additional charge, so to speak. This gives you the freedom to explore by taking many pictures at different camera settings until you get pictures with a combination of color, saturation, and contrast that creates great prints.

You may have already completed some of the setup tasks. If you have, then you can skim through the chapter and look for tips that you may have missed in your initial setup.

Formatting an SD/SDHC card

The Rebel XS/1000D accepts SD and SDHC (Secure Digital High Capacity) media cards. You can also use media cards with capacities of up to 4GB at this writing.

Not all media cards are created equal, and the type and speed of media card that you use affects the Rebel XS/1000D's response times. These include the ability to write images to the media card and to continue shooting quickly, the speed at which images display on the LCD, and how quickly you can zoom images on the LCD.

The type of file format that you choose also affects the speed of certain tasks. For example, when writing images to the media card, JPEG image files write to the card faster than RAW or RAW+Large JPEG files. JPEG and RAW file formats are discussed in detail later in this chapter.

Tip For performance results of various media cards, visit Rob Galbraith's Web site at www.robgalbraith.com.

As you take pictures, the LCD shooting-information display shows the approximate number of images that remain on the media card in the lower-right corner of the display. The number is approximate because each image varies slightly, depending on the ISO setting, the file format and resolution, the Picture Style chosen on the camera, and the image itself (different images compress differently).

You insert the card into the card slot on the camera, with the front of the card facing the back of the camera. When you buy a new card, always format it in the camera and

If You Need to Start Over

If you're new to digital SLR cameras, you may avoid changing camera settings for fear that it will "mess up" the camera or the pictures you're getting, or that you'll forget how to reset the camera if you don't like the changes you've made. Canon provides a reset option, which means that you can revert to the original camera settings to have a fresh start at any time.

To reset the camera to the default settings, just press the Menu button, press the right cross key to select the Set-up 3 (yellow) menu, and then press the down cross key to select Clear settings. Press the Set button. On the Clear settings screen, press the up or down cross key to select Clear all camera settings, and then press the Set button. Press the right cross key to select OK, and then press the Set button.

never on your computer. However, be sure that you off-load all images to the computer before you format the card because formatting erases images. Formatting a media card in the camera also sets the data structure on the card for the Rebel XS/1000D.

To format a card in the camera, be sure that you've downloaded all images to your computer first. Then follow these steps:

- Press the Menu button, and then turn the Main dial to select the Set-up 1 (yellow) menu.
- Press the down cross key to select Format, and then press the Set button. The Format screen appears, asking you to confirm that you want to format the card and lose all images on the card.
- Press the right cross key to select OK.
- 4. Press the Set button. The camera formats the card, and then displays the Set-up 1 (yellow) menu. Lightly press the Shutter button to return to shooting.

It is generally a good idea to format media cards every few weeks. If you've used a media card in another camera, be sure to format it in the XS/1000D to ensure that proper data structure is set, and to clean up the card.

Note

It is possible to take pictures when no memory card is in the camera, which is useful when you're capturing Dust Delete Data. Otherwise, this option can cause you to lose images when you mistakenly think that an SD/SDHC card is in the camera. You can turn off the option to shoot without a card. Just press the Menu button, turn the Main dial to select the Shooting 1 (red) menu, and then press the

down cross key to select Shoot w/o card. Press the Set button, press the down cross key to select Off, and press the Set button again.

Setting the date and time

Setting the date and time on the Rebel XS/1000D ensures that the data that travels with each image file has the correct date and time stamp. This data is stored with the image as metadata. Metadata is a collection of all of the information about an image, including the filename, date created, size, resolution, color mode, camera make and model, exposure time, ISO, f-stop, shutter speed, lens data, and white balance setting. EXIF, used interchangeably with the term metadata, is a particular form of metadata.

It is very helpful to have the date and time information for the image when you want to organize your image collection. In fact, the XS/1000D's Direct Image Transfer function stores images in dated folders when you download them to your computer's hard drive.

To set the date and time on your XS/1000D, follow these steps:

- Press the Menu button, and then turn the Main dial to select the Set-up 2 (yellow) menu tab.
- Press the down cross key to select Date/Time, and then press the Set button. The Date/Time screen appears.
- Press the Set button. The month field is activated.
- Press the up or down cross keys to change the Month field, and then press the Set button.

- Press the right cross key to move to the Day field.
- Repeat Steps 3 to 5 to change the remaining fields.
- 7. When all options are set, press the Set button. The Set-up 2 menu appears. Lightly press the Shutter button to return to shooting.

Note

You may want to reset the date and time to adjust for daylight savings time and when you change time zones during traveling.

Choosing the file format and quality

The file format and quality level that you use to take your pictures is one of the most important decisions that you will make. These settings determine not only the number of images that you can store on the media card, but also the sizes at which you can later enlarge and print images from the

Rebel XS/1000D. Table 1.1 explains the options that you can choose from.

With the high-quality images that the XS/1000D delivers, you can make beautiful enlargements from them. Even if you don't foresee printing images any larger than 4×5 inches, you may get a once-in-a-lifetime shot and want to print it as large as possible. For this reason, and to take advantage of the XS/1000D's fine image detail and high resolution, it pays to shoot at the highest quality setting for all of your shooting.

The JPEG quality options on the XS/1000D are shown with two icons that indicate the compression level of the files and the recording size. A solid quarter-circle icon indicates a low compression level. A jagged quarter-circle icon indicates a higher compression level. High compression levels reduce the file size more than low compression levels so that you can store more images on the SD/SDHC card. File formats and compression are discussed next.

	Table	1.1		
Rebel XS/1000D File Quality and Size				
Image Quality	Approximate File Sizes in Megabytes (MB)	Image Size in Pixels (approximate number of images stored on a 2GB SD/SDHC card)		
L (Large) JPEG (Solid quar- ter-circle icon)	3.8MB	3888 × 2592 (394)		
L (Large) JPEG (Jagged quarter-circle icon)	2.0MB	3888 × 2592 (781)		
M (Medium) JPEG (Solid quarter-circle icon)	2.3MB	2816 × 1880 (682)		
M (Medium) JPEG (Jagged quarter-circle icon)	1.2MB	2186 × 1880 (999)		
S (Small) JPEG (Solid quar- ter-circle icon)	1.3MB	1936 × 1288 (999)		

Image Q	uality	Approximate File Sizes in Megabytes (MB)	Image Size in Pixels (approximate number of images stored on a 2GB SD/SDHC card)	
S (Small) JPEG (Jagged quarter-circle icon)		0.7MB	1936 × 1288 (999)	
RAW		9.8MB	3888 × 2592 (122)	
RAW +	L (Large) (Solid quarter-circle icon)	9.8MB	3888×2592 for each image (180)	

JPEG format

JPEG, which stands for Joint Photographic Experts Group, is a popular image file format that enjoys not only smaller file sizes than the RAW format, but also offers the advantage of being able to display your images straight from the camera on any computer, on the Web, and in e-mail messages. To achieve the small file size, JPEG discards some data from the image during compression — usually data that you would not easily see anyway. This characteristic gains JPEG its lossy moniker because it "loses" image data during compression. There are different levels of JPEG compression. High compression levels discard more image data than low ratios. The higher the compression level, the smaller the file and the more images that you can put on the media card.

Tip If you edit JPEG images in an editing program, image data continues to be discarded each time you save the file. Over time, the loss of data can become visible, so I recommend downloading JPEG files to the computer, and then saving them as TIFF (Tagged Image File Format) before you begin editing them. TIFF is a lossless file format that

does not discard image data.

As the compression ratio increases, more of the original image data is discarded, and the image quality degrades. Compression also introduces defects, referred to as artifacts, that can create a blocky, jagged look, blurring, and diminished color fidelity in the image. At low compression ratios, artifacts are minimal, but as the ratio increases, they become more noticeable and objectionable.

Avoid Losing Images

When the camera's red access light — located on the back of the camera — is blinking, it means that the camera is recording or erasing image data. When the access light is blinking, do not open the SD/SDHC card slot cover, do not attempt to remove the SD/SDHC card, and do not remove the camera battery. Any of these actions can result in a loss of images and damage to the media card and camera. There is an audible warning to let you know that images are being written to the card, but make it a habit to watch for the access light anyway and don't open the media card slot cover or turn off the camera.

You'll see the effects of high compression ratios when you enlarge the image to 100 percent in an image-editing program on the computer.

To get the highest-quality images, use the lowest compression and the highest quality settings. If space on the card is tight, then use the next lower setting. If you use lower quality settings and high compression, the image quality diminishes accordingly. Also, when you shoot JPEG images, the camera's internal software processes, or edits, the images before storing them on the media card. This image pre-processing can be an advantage, especially if you routinely print images directly from the SD/SDHC card. And because the XS/1000D offers a variety of Picture Styles that change the way that image contrast, saturation, sharpness, and color are rendered, you can get very nice prints with no editing on the computer.

Picture Styles are detailed in Chapter 3.

RAW format

RAW files store image data directly from the camera's sensor to the media card with a minimum of in-camera processing. Unlike JPEG images, which you can view in any image-editing program, you must view and convert RAW files using the Canon's Digital Photo Professional program or other programs such as Adobe Bridge and Adobe Camera Raw. As a result, shooting in RAW format is a great option provided that you enjoy working with images on the computer. If, however, you prefer to print images directly from the camera, RAW is likely not a good option for you.

If you enjoy processing images, then RAW files offer the ultimate flexibility and control over the image, because you can change key camera settings after you take the pic-

ture. For example, if you didn't set the correct white balance or exposure, you can change it in a RAW conversion program on the computer. You can also adjust the brightness, contrast, and saturation after you take the picture. In short, you have precise control over how the image is rendered. The only camera settings that the XS/1000D applies to RAW files are aperture, ISO, and shutter speed. Other settings such as White Balance, Picture Style, and so on are "noted," but not applied to the file. As a result, you can control how image data is rendered during image conversion. The RAW conversion process takes only a few additional minutes, and then you can save the image in a lossless file format such as TIFF, and work with the image as you would with any other image from the camera.

RAW files are denoted with a .CR2 filename extension. After converting the RAW data, you save the image in a standard file format such as TIFF, and work with it as you do with other image files.

On the XS/1000D, you can choose to shoot either RAW images or RAW+JPEG, which records the RAW file and a Large JPEG image. The RAW+JPEG option is handy when you want the advantages of having the flexibility that you get with a RAW file, and you also want a JPEG image to quickly post on a Web site or to send in e-mail.

Because RAW is a lossless format (no loss of image data), image quality is not degraded by compression. However, RAW files are larger than JPEG files, and you can store fewer RAW images on the media card than JPEG images.

With this overview of the differences between image quality settings and file format, you're in a better position to choose the setting that best suits your needs.

The image-quality settings depend on the shooting mode you choose. In Basic Zone shooting modes such as Portrait, Landscape, and so on, the camera automatically sets the file format to JPEG, but you can set the image quality and compression level. In Basic Zone modes, you do not have the option to select the RAW format.

In Creative Zone modes — P, Tv, Av, M, and A-DEP — you can select any of the JPEG options as well as RAW or RAW+JPEG.

To set the image quality in both Basic and Creative Zone modes, follow these steps:

- Turn the Mode dial to a Basic Zone mode. Basic Zone modes are indicated by icons such as a person's head for Portrait mode, mountains for Landscape mode, and so on.
- Press the Menu button, and then turn the Main dial to select the Shooting 1 (red) menu.
- Press the down cross key to select Quality if it isn't already selected.
- 4. Press the Set button. The Quality screen appears with the currently selected quality setting displayed, along with the image dimensions in pixels.
- 5. Press the down cross key to select the size and quality that you want. In Basic Zone modes, you can choose only JPEG options at different levels of compression. A solid quarter-circle icon indicates a low compression level. A jagged quarter-circle icon indicates a higher compression level. In Creative Zone modes such as P, Tv, Av, M, and A-DEP, you can select RAW+JPEG or RAW.

- 6. Press the Set button.
- Turn the Mode dial to a Creative Zone mode.
- Repeat Steps 2 to 6 to set the quality for Creative Zone modes.

Changing file numbering

With the Rebel XS/1000D, you can set the camera to number images using one of three options: Continuous, Auto reset, and Manual reset. These options allow you to number your images sequentially, to restart numbering each time you change the media card, or to choose to manually reset numbering. Here is how the options work.

Continuous. This is the default option for file numbering on the XS/1000D, where the camera stores the last, highest image number internally to continue a sequential numbering system. Images are numbered sequentially with a unique, four-digit number from 0001 to 9999. The camera automatically creates a folder on the SD/SDHC card named 101. It stores images in the folder until you shoot image number 9999. At that point, the camera creates a new folder named 102, and the next image that you shoot restarts with the number 0001.

Continuous numbering works great until you insert an SD/SDHC card that has images on it. When you take another picture, the new image file number continues from the highest numbered image that's stored on the card if it is higher than the highest image number stored in the camera's memory. In other words, the camera uses the highest number whether that high number is stored in internal memory or on

the card. If you want to continue continuous numbering, insert only formatted/empty SD/SDHC cards into the camera. The advantage of continuous numbering is that files have unique filenames up to image number 9999, and this makes managing and organizing images on the computer easier because you don't have to worry about having images with the same filename on your computer up to image number 9999.

- Auto reset. With this option, file numbering restarts at 0001 each time you insert a different SD/ SDHC card. If the SD/SDHC card has images stored on it, then numbering continues from the highest image number stored on the card. So if you want the images to always begin at 0001 on each SD/ SDHC card, then be sure to insert freshly formatted SD/SDHC cards each time you replace a card. If you like to organize images by media card, this is a useful option. However, if you use this option, be aware that multiple images that you store on the computer will have the same number or filename. Be sure to create separate folders on the computer and follow scrupulous folder organization to avoid filename conflicts and potential overwriting of images that have the same filename.
- Manual reset. With this option, the camera creates a new folder on the SD/SDHC card, and images are saved to the new folder starting at 0001. After Manual reset, file num-

bering returns to Continuous or Auto reset, based on what you used previously. The Manual reset option is handy if you want the camera to create separate folders for images that you take over a span of several days.

On the XS/1000D, up to 999 folders can be created with up to 9,999 images stored in each folder. If you reach these capacities, a message appears telling you to change the SD/SDHC card even if there is room remaining on the card. Until you change the SD/SDHC card, the camera will not let you take another picture. If you run into this problem, there is nothing wrong with the camera; you just need to replace the current SD/SDHC card, regardless of the space remaining on it.

To change the file-numbering method on the XS/1000D, follow these steps:

- Press the Menu button, and then turn the Main dial to select the Set-up 1 (yellow) menu.
- Press the up or down cross key to select File numbering, and then press the Set button. Three file numbering options, Continuous, Auto reset, and Manual reset, appear with the current setting highlighted.
- 3. Press the down cross key to select the file-numbering option you want, and then press the Set button. The option you choose remains in effect until you change it, with the exception of Manual reset, as noted previously.

Using the EOS Rebel XS/1000D

f you're new to digital single lens reflex (SLR) cameras, then you've likely been shooting with the EOS Rebel XS/1000D using the automated modes, which are like the modes on a point-and-shoot digital camera. The automated modes are a great way to get a feel for not only using the camera, but also for the image characteristics and quality that the camera delivers.

On the Rebel XS/1000D, the automatic modes are referred to as Basic Zone modes. In these modes, all of the exposure elements are set automatically so that you can concentrate on capturing the moment. These modes enable you to use the XS/1000D as you would use a point-and-shoot camera, but with the ability to change lenses. Each mode is designed for specific scenes or subjects. For example, if you're shooting fast action, the XS/1000D's Sports mode automatically sets the camera to shoot in rapid-fire sequence, and it tracks the subject movement to maintain subject focus.

If you're an experienced photographer, or if you're anxious to move beyond the automated modes and get more creative control over images, then the Creative Zone modes are the best choice. They give you creative control by enabling you to have partial or full control over some or all of the exposure settings. For example, in Aperture-Priority AE (Av) mode, you can set the aperture, or f-stop, that you want, and the camera automatically sets the appropriate shutter speed. In addition, you can control the focus point, the white balance, the drive mode, and much more.

Because you can choose among different shooting modes, you may find that you enjoy using the automated Sports mode, but for other shots, you may prefer using Aperture-priority (Av)

In This Chapter

Choosing a shooting mode

Selecting a metering mode

Modifying exposure

Evaluating exposure

Setting the ISO sensitivity

Selecting AF modes and getting sharp focus

Choosing a drive mode

Viewing and playing back images

Erasing images

Protecting images

Using the EOS Integrated Cleaning System mode. With the XS/1000D, you can switch between automatic and semi-automatic modes and be assured of getting great shots, regardless of the mode you use.

This chapter explains each of the shooting modes on the Rebel XS/1000D to help you get the most out of them.

Choosing a Shooting Mode

Choosing a shooting mode is the first decision you make when shooting with the Rebel. When you choose a shooting mode, the mode determines how and what kinds of exposure settings are set by the camera and by you. In addition, these modes determine whether you or the camera sets all or part of the exposure settings, as well as other controls, including the autofocus (AF), white balance, shooting speed, and metering mode. Some shooting modes are fully automatic so that all of the exposure settings are set for you. Other shooting modes are semi-automatic, giving you control over key exposure settings. And Manual (M) mode gives you control over all of the exposure and other camera settings.

The XS/1000D Mode dial is divided into two sections: the Basic Zone and the Creative Zone. The Basic Zone section of the Mode dial groups seven automatic shooting modes that are identified by icons, such as a person's head to designate Portrait mode, a running person to designate Sports mode, and so on. The exception is Full Auto mode, which is designated by a green rectangle.

The opposite half of the Mode dial groups five semi-automatic and manual modes. These Creative Zone modes are designated

2.1 Rebel XS/1000D Mode dial

by letter abbreviations such as P for Program, AE (Auto Exposure), Tv for Shutter-priority, Av for Aperture-priority, M for Manual, and A-DEP for Automatic Depth of Field. These modes give

you either partial or full control over the camera settings. As a result, you can control depth of field, how subject motion appears in the image, white balance, AF point selection, and more. Creative Zone modes range from semi-automatic and manual modes to a semi-automatic but "shiftable" Program mode.

How shooting modes relate to exposure

With the Rebel XS/1000D, you can choose to control none, all, or part of the exposure settings, and you do that by choosing a shooting mode. If you're new to photographic exposure, the brief discussion here will help you understand the descriptions of the shooting modes later in this chapter.

To make a good exposure, the camera requires that the ISO (International Organization for Standardization), aperture (or f-stop), and shutter speed be set correctly based on the amount of light in the scene or from the flash. When the ISO, f-stop, and shutter speed are set correctly, you get a well-exposed picture. Here is a brief overview of these elements.

If you are new to photography, be sure to read Chapter 6, which gives much more detail about each of the following exposure elements. ◆ ISO. The ISO setting determines how sensitive the image sensor is to light. A high ISO such as 400 or higher means that the sensor is sensitive to light and less light is needed to make the exposure. A low ISO such as 100 or 200 means that the sensor is less sensitive to light and needs more light to make the exposure.

Note

On digital cameras, high ISO sensitivity settings amplify the output of the sensor so that less light is needed. However, the amplification also increases digital noise, which produces a grainy appearance and unwanted color flecks, particularly in the shadow areas of an image. High ambient temperatures and high ISO settings increase the incidence of digital noise.

- Aperture. The aperture determines how much the lens diaphragm expands or contracts to let more or less light into the camera. The diameter of the lens diaphragm opening is determined by the aperture, or f-stop, you select. Aperture is the main factor that controls depth of field, or how much of the scene is in acceptably sharp focus from front to back from the plane of sharp focus. Each change in aperture, or "f-stop," doubles or halves the exposure.
- Shutter speed. The shutter speed determines how long the shutter remains open to let light into the sensor. Shutter speeds are expressed as fractions of a second, such a 1/60, 1/125, 1/250 second, and so on. Shutter speed is most commonly associated with the ability to control how motion is shown in an image and the ability to

handhold the camera in low-light scenes. As with aperture, each shutter speed change either doubles or halves the exposure.

All of the exposure elements work together. If one changes, then the others change proportionally. Many different combinations of f-stop and shutter speed produce an "equivalent" exposure — in other words, they provide the same amount of light into the camera to make the exposure. For example, given the same ISO setting, f/11 at 1/15 second is equivalent to f/4 at 1/125 second. However, while the exposure is the same, the rendering of the image is very different between the two exposures.

The following sections summarize the shooting modes on the Rebel XS/1000D. As you read about them, keep the exposure summary here in mind because it will help you understand what you can control or expect with each mode.

Basic Zone shooting modes

The Basic Zone shooting modes are grouped together on one half of the Mode dial and are denoted by pictorial icons and a green rectangle. The pictorial icons depict commonly photographed scenes or subjects. For example, the mountain icon denotes Landscape mode, which gives exposure settings that provide acceptable sharpness from back to front in the image. To do this, the XS/1000D sets a narrow aperture (large f-stop number) based on the light, to provide an extensive depth of field. Each of the other settings makes similar adjustments to give you a predictable and classic photographic result.

When you choose a Basic Zone mode, the camera automatically sets all of the exposure settings, including ISO, aperture, and shutter speed, as well as the focus mode and AF points, drive mode, white balance, and other settings. With the exception of Full Auto mode (denoted by the green rectangle), the only control you have is to specify the type of scene that you're shooting, by setting the Mode dial and the choice of lens or zoom setting that you use.

Basic Zone modes are often a good choice for making quick shots. For example, when you select Portrait mode, the Rebel sets a wide aperture (f-stop) to blur the background. Or, if you are shooting a football game and you want the motion of the players to be crisp and without blur, then choose Sports mode, which sets as fast a shutter speed as possible given the light in the scene. In short, Basic Zone modes are programmed to render the subject that its mode name represents in predictable ways.

In addition to setting the exposure elements, the Rebel XS/1000D automatically sets other aspects of the image.

In all Basic Zone modes, the camera also automatically sets the following:

- JPEG recording format, although you can select the quality level
- The white balance, which changes depending on the shooting mode you select
- Evaluative metering, which assesses the overall scene to determine the amount of light in the scene and to calculate the correct exposure settings.
- The sRGB (standard Red, Green, Blue) color space

 Auto Lighting Optimizer, an XS/1000D feature that automatically corrects underexposed (dark) and low-contrast images

In addition, the camera also selects the following:

- * AF mode and AF point or points
- Drive mode
- Picture Style
- Use of the built-in flash

In Basic Zone shooting modes, you cannot change the camera settings.

Full Auto mode

In Full Auto mode, the Rebel XS/1000D automatically selects all of the exposure and camera settings, and you can only set the JPEG quality level and whether or not to use Red-eye reduction. This can be a good mode to use for quick snapshots. However, keep in mind that the camera defaults to using the built-in flash in lower light, although you may not want or need to use the flash, and it sets the ISO from 100 to 800. At ISO 800, the chance of introducing digital noise increases. Also remember that in all modes, the lens that you choose enhances your creative control.

Digital noise is detailed later in this chapter.

When you choose Full Auto mode, the camera is set to AI Focus AF mode, which is one of the three different autofocus modes on the Rebel. In this autofocus mode, if you focus on a stationary subject and if the subject begins moving, then the camera automatically switches to AI Servo AF mode to track the subject's movement and maintain focus.

2.2 This image was taken in Full Auto mode. Here the XS/1000D sets a wide aperture to blur the background foliage. Exposure: ISO 100, f/5.6, 1/200 second.

Note

Autofocus modes are detailed later in this chapter.

The camera also automatically selects the AF point or points. It may choose one or multiple AF points. The AF points are typically set on whatever in the scene is closest to the lens and/or that have the most readable contrast in the scene. The camera displays the selected AF points in red in the viewfinder so that you can see where the camera will set the point of sharpest focus.

Tip

If the camera doesn't set the point of sharpest focus where you want, you can try to force it to choose a more appropriate AF point by moving the camera position slightly one or more times. If you want to control where the point of sharpest focus is set in the image, then it is better to switch to a Creative Zone mode and set the AF point manually.

In Full Auto mode, the camera automatically sets the following:

- Standard Picture Style
- Single-shot (one-image-at-a-time) drive mode with the option to set the 10-second Self-timer
- Automatic flash, but you can choose to turn on Red-eye reduction

Picture Styles are detailed in Chapter 3.

Portrait mode

To create a classic portrait look, Portrait mode sets a wide aperture (small f-stop number), providing a shallow depth of field to blur background details so they don't distract from the subject. The Rebel also switches to Portrait Picture Style, which is designed to enhance the skin tones. Obviously, Portrait mode is great for people portraits, but it's also a great mode for taking pet portraits, indoor and outdoor still-life shots, and nature shots such as flowers that

you photograph from a moderate distance. However, if you use Portrait mode for nature shots, the Portrait Picture Style may render the color less vivid than if you use other modes that use other Picture Styles.

In Portrait mode, the camera automatically sets the following:

- Portrait Picture Style
- One-shot autofocus mode with automatic AF point selection
- Continuous drive mode so that you can shoot Large JPEG images at 3 fps in a burst sequence with the option to set the 10-second Selftimer

2.3 This image was taken in Portrait mode, and it shows how the XS/1000D sets a wide aperture to blur the background and fires the flash automatically. Exposure: ISO 400, f/4, 1/60 second.

 Automatic flash, but you can turn on Red-eye reduction

Tip To enhance the effect that Portrait mode provides of blurring the background, you can use a telephoto lens or move the subject farther from the background.

In Portrait mode, the camera automatically selects the AF point or points. When the camera chooses the AF point, it looks for points in the scene where lines are well defined, for the object that is closest to the lens, and for points of strong contrast. The eyes of a subject in a portrait should always be the point of sharpest focus, but the eyes may not fit the camera's criteria for setting focus. As a result, the camera often focuses on the subject's nose, mouth, or clothing. You can see which AF points the camera chooses when you half-press the Shutter button. If it isn't focusing on the eyes, then shift your shooting position slightly to try to force it to focus on the eyes. If you can't force the camera to refocus on the eyes, then you can switch to Av mode, set a wide aperture such as f/5.6, and then manually select the AF point that is over the subject's eves.

Landscape mode

Landscape mode is designed to give acceptably sharp focus throughout as much of the frame as possible. To do this, the Rebel XS/1000D sets a narrow aperture (large f-stop number) that provides extensive depth of field. It also chooses the fastest shutter speed possible given the amount of light in the scene. In addition, the Rebel may increase the ISO up to 800.

Because the camera maintains as narrow an aperture as possible, the shutter speed will be slow in low-light making it difficult to get sharp images when you're handholding the camera. As the light fades, watch the

2.4 This image was taken in Landscape mode, where the XS/1000D sets a narrow aperture to provide extensive depth of field. Exposure: ISO 400, f/14, 1/400 second.

viewfinder or LCD to monitor the shutter speed. If the shutter speed is 1/30 second or slower, or if you're using a telephoto lens, then steady the camera on a solid surface or use a tripod. As it does in all Basic Zone modes, the camera uses Evaluative metering to measure the light in the scene to determine the exposure settings.

In Landscape mode, the camera automatically sets the following:

- Landscape Picture Style
- One-shot autofocus mode and automatic AF point selection
- Single-shot drive mode with the option to set the 10-second Selftimer
- The flash never fires

Close-up mode

In Close-up mode, the Rebel XS/1000D allows a close focusing distance, and it sets a wide aperture to provide a shallow depth of field that blurs background details. It also sets as fast a shutter speed as possible given the light. This mode produces much the same type of rendering as Portrait mode, but it uses the Standard Picture Style. You can further enhance the close-up effect by using a macro lens. If you're using a zoom lens, zoom to the telephoto end of the lens.

Tip All lenses have a minimum focusing distance that varies by lens. To ensure sharpness, never focus closer than the minimum focusing distance of the lens. The easy way to tell if you're not too close is to listen for the beep from the camera that confirms sharp focus.

In Close-up mode, the camera automatically sets the following:

- Standard Picture Style
- One-shot autofocus mode with automatic AF point selection
- Single-shot drive mode with the option to set the 10-second Selftimer
- Automatic flash with the option to turn on Red-eye reduction

Sports mode

In Sports mode, the Rebel XS/1000D sets a fast shutter speed to freeze the motion of a moving subject. This mode is good for capturing athletes in mid-air, a player sliding toward a base, or the antics of pets and children.

In this mode, when you focus by half-pressing the Shutter button, the camera automatically tracks focus on the moving subject and locks the focus at the moment you fully press the Shutter button. And if you continue to hold the Shutter button down,

2.5 This image was taken in Close-up mode, where the camera also sets a wide aperture, automatically chooses the autofocus point, and fires the flash, which acts as fill light in this shot. Exposure: ISO 200, f/5.6, 1/500 second.

the camera maintains focus for continuous shooting. In Sports mode, the camera automatically sets the following:

- Standard Picture Style
- Al Servo AF autofocus mode with automatic AF point selection
- Continuous drive mode.
 Continuous drive mode enables you to shoot Large JPEG images at 3 fps up to the capacity of the SD/SDHC card. You also have the option to use the 10-second Self-timer.
- Flash-off mode

Night Portrait mode

In Night Portrait mode, the Rebel XS/1000D adds a slow synch flash to the exposure to correctly expose both the person and the background. Because this mode uses a longer exposure, it's important that the subject

2.6 This image was taken in Sports mode, in which the camera sets as fast a shutter speed as possible to freeze subject motion. Exposure: ISO 100, f/5, 1/500 second.

remain still during the entire exposure to avoid blur. Be sure to use a tripod or set the camera on a solid surface to take night portraits.

You should use this mode when people are in the picture, rather than for general night shots, because the camera blurs the background similar to the way it does in Portrait mode. For night scenes without people, use Landscape mode or a Creative Zone mode and a tripod.

In Night Portrait mode, the camera automatically sets the following:

- Standard Picture Style
- One-shot autofocus mode with automatic AF point selection
- Single-shot drive mode with the option to set the 10-second Selftimer
- Automatic flash with the ability to turn on Red-eye reduction

Flash-off mode

In Flash-off mode, the camera automatically sets the following:

- Standard Picture Style
- Al Focus AF autofocus mode with automatic AF point selection. This means that the camera uses Oneshot AF designed for still subjects, but it automatically switches to the focus tracking mode AI Servo AF if the subject begins to move. The camera automatically selects the AF point.
- Single-shot drive mode with the option to set the 10-second Selftimer
- No flash, obviously

You can easily change to any of the Basic Zone modes: turn the Mode dial so that one of the Basic Zone modes lines up with the white mark on the camera. Then press the Shutter button halfway down to focus, and press it completely to make the picture.

2.7 This image was taken in Flash-off mode because in other automatic modes, the flash would likely have fired. Exposure: ISO 100, f/4.5, 1/50 second.

How Is Program Mode Different from Full Auto Mode?

While the names of these two modes seem similar, they vary greatly in the amount of control that they allow you. In Full Auto mode, the camera sets the exposure and all other camera settings, such as the AF mode and AF points, the white balance, Picture Style, and more, and you cannot change any of the settings. However, in Program (P) mode, you can temporarily change the camera's suggested shutter speed and aperture settings. Equally important, P mode allows you much more control over camera functions. In P mode you can set the following functions, none of which you can set in Full Auto mode:

- Shooting settings. AF mode and AF point selection, Drive mode, Metering mode, Program shift, Exposure Compensation, Auto Exposure Bracketing, AE Lock, Depth-of-field preview, Clear all camera settings, Custom Functions and Clear all Custom Functions, and Sensor cleaning.
- Built-in flash settings. Flash on/off, Flash-Exposure Lock, and Flash Exposure Compensation.
- Image settings. RAW, RAW+Large JPEG selection, ISO, White balance, Custom white balance, White balance correction, White balance bracketing, Color space, and Picture Style.

Creative Zone Shooting Modes

Creative Zone shooting modes, grouped on the opposite side of the Mode dial from automatic modes, offer semi-automatic or manual control over some or all exposure, shooting, and image settings. Creative Zone modes include two automated modes, P (Program AE) and A-DEP (Automatic Depth of Field). These modes could arguably be classified as Basic Zone modes, but they offer you control over some shooting, and all image and flash settings that are not offered in the automatic Basic Zone modes. The three traditional Creative Zone modes — Tv (Shutter-priority AE), Av (Aperture-priority AE), and M (Manual exposure) — put full or partial creative control of the exposure in your hands.

P mode

Program AE, shown as P on the Mode dial, is a fully automatic but "shiftable" mode. Shiftable means that you can change programmed exposure by changing or shifting the shutter speed or aperture. When you shift one exposure element, such as the aperture, the camera automatically adjusts other settings to maintain the same or equivalent exposure.

For example, if you turn the Mode dial to P, the camera may initially suggest an exposure at f/2.8 at 1/30 second. But if you turn the Main dial one click to the left, you can "shift" the program to f/3.2 at 1/20 second to get a slightly more extensive depth of field but also a slower shutter speed. Turning the Main dial to the right results in a shift to f/4.0 at 1/15 second, and so on.

Unlike other Creative Zone modes, the change in exposure that you make in P mode is maintained for only one shot, after which the XS/1000D reverts to the camera's suggested ideal exposure.

P mode is handy when you want to quickly change the depth of field and shutter speed for a single shot and make a minimum of camera adjustments. For example, the camera's suggested exposure may set the aperture at f/8, but you may want to soften the background using a wide aperture such as f/4. You can turn the Main dial to shift the programmed exposure settings to a wider aperture. The camera then automatically adjusts the shutter speed to maintain the

2.8 This image was taken in P mode, where I changed the camera's suggested aperture of f/4 to f/5.6 to get slightly more extensive depth of field. Exposure: ISO 100, f/5.6, 1/60 second.

same overall exposure. However, if you're using the flash, you can't shift the program in P mode.

Tip

If you see 30 and the maximum lens aperture or 4000 and the minimum lens aperture blinking in the viewfinder, this indicates an underexposure and overexposure, respectively. In these instances, you can increase or decrease the ISO, accordingly.

To switch to P mode, follow these steps:

- Turn the Mode dial to line up P with the white mark on the camera. The XS/1000D displays its ideal suggested exposure settings in the viewfinder.
- 2. To shift the program, or change the exposure, press the Shutter button halfway, and then turn the Main dial until the aperture or shutter speed that you want displays in the viewfinder. You cannot shift the program if you're using the flash. If you wait too long to take the image, the exposure shifts back to the camera's suggested exposure.

Tv mode

Shutter-priority AE mode, shown as Tv on the Mode dial, is the semi-automatic mode that enables you to set the shutter speed while the camera automatically sets the aperture. Among other things, controlling the shutter speed allows you to freeze subject motion or show it as a blur. Setting a fast shutter speed freezes subject motion, while setting a slow shutter speed shows motion blur. You can also use this mode to ensure that the shutter speed is within handholding limits. For example, if you're shooting an indoor or low-light event, and you don't want the shutter speed to go

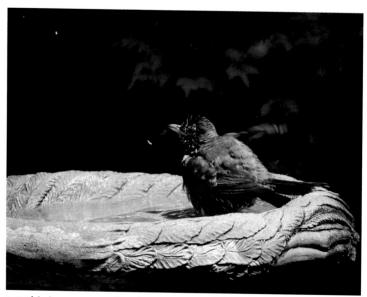

2.9 This image was taken in Tv mode using a moderately slow shutter speed to show the motion of the bird moving its wing in the bath but freeze the motion of the water splashes. Exposure: ISO 200, f/5.6, 1/25 second.

slower than, say, 1/30 second, Tv mode enables you to set and maintain that shutter speed.

Note

How fast a shutter speed is necessary to avoid camera shake? If you're not using an Image Stabilization (IS) lens, or a monopod or tripod, then the general rule is that you can handhold the camera and get a sharp image at the reciprocal of the focal length: 1/[focal length]. So if you're using a non-IS zoom lens zoomed to 200mm, then 1/200 second is the slowest shutter speed at which you can handhold the lens and not get blur from camera shake. For details on IS lenses, see Chapter 8.

In Tv mode, you can select the AF mode, AF point selection, metering and drive modes, Picture Style, and whether to use the built-in or an accessory flash. The shutter speeds that you can choose from depend on the

light in the scene. In low-light scenes without a flash, you may not be able to get a fast enough shutter speed to freeze the action. Shutter speeds on the XS/1000D are 1/4000 to 30 seconds, and Bulb. Shutter speed increments can be changed from the default 1/3-stop to 1/2-stop increments using C.Fn-1. Flash sync speed is 1/200 second or slower. Or you can set the flash sync speed to be fixed at 1/200 second using C.Fn-2. To change to Tv mode, follow these steps:

- Turn the Mode dial to line up Tv with the white mark on the camera.
- 2. Turn the Main dial to the shutter speed that you want. As you set the shutter speed, the camera sets the aperture automatically. At the default settings, shutter speed values display in the viewfinder and LCD in 1/3-stop increments; for example, 125 indicates 1/125 second, and "0"6" indicates 0.6 seconds.

If the f-stop blinks, it means that a suitable aperture is not available at that shutter speed and under the prevailing light conditions. You can switch to a higher ISO or a slower shutter speed.

Av mode

Aperture-priority AE mode is shown on the camera Mode dial as Av. Av mode is a semi-automatic mode that enables you to control the aperture. In this mode, you change the aperture by turning the Main dial, and then the camera automatically calculates and sets the appropriate shutter speed.

Additionally, you may want to use Av mode to set and maintain the aperture at the "sweet spot" of the lens that you're using. The sweet spot is the aperture at which the lens provides the best detail, contrast, and sharpness, and it varies by lens. Or in low-light scenes, you may want to use Av mode because you know that you'll need to shoot consistently at the largest aperture.

In Av mode, you have control over the AF mode, AF point, drive and metering modes, white balance, Picture Style, and use of the built-in or an accessory flash.

Tip

You can preview the depth of field for an image by pressing the Depth of Field Preview button on the front of the camera.

When you press the button, the lens diaphragm closes to the aperture that you've set so that you can see the range of acceptable focus.

If you choose this mode, check the shutter speed in the viewfinder; if it is 1/30 second or slower, be sure to use a tripod or use the handholding rule provided earlier in the Tv section. Aperture value increments can be changed from the default 1/3-stop to 1/2-stop increments using C.Fn-1.

For details on setting Custom Functions, see Chapter 5.

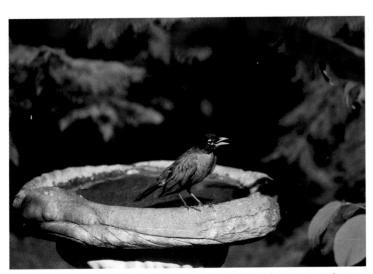

2.10 This image was taken in Av mode, using a wide aperture that provides a shallow depth of field. Exposure: ISO 100, f/5.6, 1/125 second.

To change to Av mode, follow these steps:

- Turn the Mode dial to line up Av with the white mark on the camera.
- 2. Turn the Main dial to the aperture that you want. The camera automatically sets the shutter speed. At the default settings, aperture values display in the viewfinder and LCD in 1/3-stop increments, such as 5.6, 6.3, 7.1, and so on. The higher the f-number, the smaller the aperture, and the more extensive the depth of field. The smaller the f-number, the larger the aperture, and the shallower the depth of field.

M mode

As the name implies, Manual mode, indicated by an M on the Mode dial, allows you to set both the aperture and the shutter

speed, based on the camera's light-meter reading and the current ISO setting. M mode is helpful in difficult lighting situations when you want to override the camera's suggested ideal exposure, and in situations where you want consistent exposures across a series of photos, such as for a panoramic series. M mode is also used for fireworks and other low-light and night scenes where you know in advance the exposure that you want to use.

Note

Because it takes more time to set all of the exposure settings yourself in M mode, many people prefer to routinely use semiautomatic modes such as Av and Tv.

In M mode, you also have control over the AF mode, AF point, drive and metering modes, white balance, Picture Style, and use of the built-in or an accessory flash.

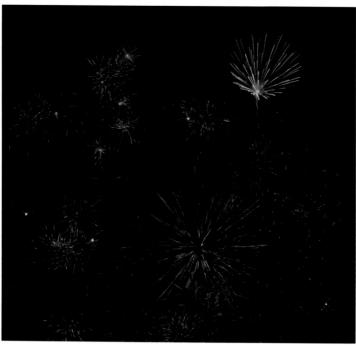

2.11 These images were taken in M mode with the camera mounted on a tripod and composited in Adobe Photoshop. Exposure: ISO 100, f/11, 1/8 second.

When you use M mode, you also use the Exposure Level Indicator that is shown in the viewfinder and on the LCD display. The indicator shows the best exposure for the scene based on the light metering taken at the currently selected AF point. When the tick mark is at "0" on the indicator scale, the exposure is correct at the active AF point. If you focus on something dark, then the exposure is different from the exposure when you focus on a light area.

So in M mode, choose the area of the scene or subject that is critical for good focus. For example, in a portrait, focus on the subject's skin to take the meter reading, and then set those exposure settings on the Rebel. Then, after you've set the exposure settings, you can focus on the portrait subject's eyes and make the picture. You can also modify the exposure from the camera's ideal exposure that's shown when the tick mark is at the center of the Exposure Level Indicator by adjusting either the shutter speed or the underexpose. aperture to overor Overexposure from the ideal exposure is shown when the tick mark is to the right of the center mark, and vice versa.

To use Manual mode, follow these steps:

- Turn the Mode dial to line up M with the white mark on the camera.
- 2. Press the Shutter button halfway down. The exposure level index in the viewfinder and on the LCD has a tick mark that indicates how far the current exposure is from the camera's ideal or suggested exposure. Watch the exposure level index as you complete Step 3.
- Turn the Main dial to the shutter speed that you want, and then press and hold the Aperture/ Exposure Compensation (Av)

button on the back of the camera as you turn the Main dial to set the aperture. If you want to use the camera's ideal exposure, then adjust the shutter speed or aperture until the tick mark is at the center of the exposure level index. You can also set the exposure above (to overexpose) or below (to underexpose) the ideal exposure. If the amount of under- or overexposure is +/- 2 Exposure Values (EV), the exposure level indicator bar blinks to show the amount of plus or minus EV in the viewfinder and on the LCD panel. You then adjust either the aperture or shutter speed until the exposure level that you want is displayed.

A-DEP mode

A-DEP, or Automatic Depth of Field, mode automatically calculates the optimum depth of field between near and far subjects. A-DEP mode uses the camera's seven AF points to detect near and far subject distances, and then calculates the aperture needed to keep the subjects in sharp focus. While the automatic depth-of-field calculation is handy, getting the maximum depth of field often means that the camera sets a narrow aperture, and this often translates to a slow shutter speed. If the shutter speed is slow, be sure to use a tripod, monopod, and/or IS lens to avoid getting a blurry picture, or increase the ISO sensitivity setting.

In A-DEP mode, you cannot control the aperture, shutter speed, AF points, and focus distance, so use a wide-angle lens or move farther away from the subject. You can use the built-in flash in this mode, but the maximum depth of field is sacrificed so that A-DEP mode performs more like P mode.

To change to A-DEP mode, follow these steps:

2.12 This image was taken in A-DEP mode with the camera mounted on a tripod. The AF points that the camera selected were not precisely over the flowers, and, as a result, the focus is just short of being tack-sharp. Exposure: ISO 100, f/32, 1/8 second.

- Turn the Mode dial to line up A-DEP with the white mark on the camera.
- 2. Focus on the subject; in the viewfinder, verify that the AF points
 displayed in red cover the subject, and then take the picture. If
 the correct AF points aren't
 selected, shift the camera position
 slightly and refocus. If the aperture
 blinks, it means the camera can't
 get the maximum depth of field.
 Move back or switch to a wideangle lens or zoom setting.

Selecting a Metering Mode

To make a good exposure, the camera has to know the amount of light that illuminates the subject or scene. To determine this, the camera's light meter measures the amount of light in the scene, and, based on the ISO, calculates the aperture and shutter-speed combinations that will make a proper exposure. The camera can measure light from the entire viewfinder or only part of the viewfinder. And the camera can give more "weight" to the light measured at the center of the viewfinder. On the XS/1000D, metering modes determine how much of the scene the camera uses to measure light in the scene.

Most cameras, including the XS/1000D, use a reflective light meter that measures light reflected from the subject back to the camera. In addition, the meter is calibrated to assume that all scenes have an "average" distribution of light, medium, and dark tones so that the "average" of all tones in the scene is medium, or 18 percent, gray. And, in "average" scenes, the camera's meter produces a properly exposed image.

However, not all scenes contain average tonality; for example, a snow scene is predominantly white, while a scene with a large expanse of water is predominantly dark. Nonetheless, the meter still assumes that the scene has an average tonality, and it averages the tones to medium gray. In a snow scene, the result is gray snow. Conversely, in a scene with a large expanse of dark water, the result is gray water.

In other scenes, the subject may be positioned against a very dark or very light background. In these cases, averaging the tones produces a less than optimal exposure. Instead of metering the entire scene, you may want the camera to read the light falling only on the subject and to disregard the brighter or darker background. That's where metering modes and modifying exposure come into play. In Creative Zone modes, you can change the metering mode depending on the scene.

Note

In the fully automatic Basic Zone modes, such as Full Auto, Portrait, Landscape, and so on, you cannot change the metering modes. The Rebel XS/1000D chooses Evaluative metering in all Basic Zone modes.

The XS/1000D offers three metering modes that are differentiated by how much of view-finder area the camera uses to meter scene light.

It is important to know that metering is tied to the AF point that you or the camera selects. When you press the Shutter button halfway down to focus, the camera simultaneously meters the light primarily at that the selected AF point to calculate the exposure. The AF point may or may not be the point of critical metering. If it isn't, then be sure to read the topics on modifying exposure later in this chapter, which explain how to compensate exposure or decouple metering from the AF point.

Evaluative metering

Evaluative metering is the default metering mode on the Rebel XS/1000D, and it analyzes light from 35 zones throughout the entire viewfinder and links it to the autofocus system. The meter analyzes the point of focus and automatically applies compensation if the surrounding areas are much lighter or darker than the point of focus. To determine exposure, the camera analyzes subject position, brightness, background, front- and backlighting, and camera orientation.

Evaluative metering produces excellent exposures in average scenes that include a distribution of light, medium, and dark tones. However, in scenes where there is a large expanse of predominantly light or dark areas,

2.13 This image was taken using Evaluative metering. Subsequent images show the same subject in different metering modes. Exposure: ISO 100, f/5.6, 1/500 second.

the metering averages the tones to middle gray, thereby rendering snow scenes and large expanses of dark water as gray. In these situations, it's good to use Exposure compensation to increase or decrease exposure by one to two stops for scenes with predominantly light or dark tones, respectively.

Note

Evaluative metering mode is the default for all Basic Zone modes.

To select Evaluative metering mode, set the camera to P, Tv, Av, M, or A-DEP mode, press the Metering mode (top cross) key on the back of the camera, and then press the up or down cross key to select the icon showing a solid dot within a circle within a rectangle.

Note

If pictures are slightly underexposed, the camera automatically corrects them using Auto Lighting Optimizer. This optimization is applied to all images taken in Basic Zone modes, and to JPEG images taken in Creative Zone modes except M mode. Optimization is handy if you print directly from the media card. But if you prefer to see the original exposure, you can turn off the optimization by disabling C.Fn-5. See Chapter 5 for details on Custom Functions.

Partial metering

Partial metering meters the scene from the center 10 percent of the viewfinder. Partial metering is handy in backlit or side-lit scenes where you want to ensure that the main subject is properly exposed. For example, if you take a portrait of a person who is backlit, you can use Partial metering mode to ensure that the person's face is properly exposed. This metering mode is also useful if the background is much darker than the subject.

2.14 This image was taken using Partial metering. Exposure: ISO 100, f/5.6, 1/160 second.

Note

The XS/1000D's exposure meter is sensitive to stray light that can enter through the viewfinder. If you're using the self-timer or you don't have your eye pressed against the viewfinder, then stray light entering the viewfinder can result in underexposed images. Be sure to use the viewfinder eyepiece cover that is attached to the camera strap, or cover the viewfinder with your hand.

To select Partial metering mode, press the Metering Mode (top cross key) button on the back of the camera, and then press the down or up cross key to select the icon showing an empty circle within a rectangle.

Center-weighted Average metering

Center-weighted Average metering gives more weight to the area of the scene within the center of the viewfinder to calculate exposure. Then the camera averages the reading for the entire scene. This metering mode assumes that the main subject is in the center of the frame, so be aware that it may not produce the best exposure for off-center subjects.

To select Center-weighted Average metering mode, press the Metering mode (top cross) key on the back of the camera, and then press the down or up cross keys to select the icon showing an empty rectangle.

2.15 This image was taken using Centerweighted Average metering. Exposure: ISO 100, f/5.6, 1/160 second.

Modifying Exposure

For average scenes, using the camera's suggested exposure produces excellent images. However, many scenes are not average, and that's when the Rebel XS/1000D's exposure modification options, including Auto Lighting Optimization, Exposure Compensation, Auto Exposure Bracketing (AEB), and Auto Exposure (AE) Lock, come in handy. These options are detailed in the following sections.

Auto Lighting Optimization

Auto Lighting Optimization is a built-in image-correction feature that automatically boosts contrast, brightens highlights in flat lighting, and adjusts image brightness when flash output is too low.

Auto Lighting Optimization is not a setting that you can adjust manually, and it is used when you shoot in all Basic Zone modes such as Portrait, Landscape, Sports mode, and so on. It is also used when you shoot JPEG images in Creative Zone modes including P, Tv, Av, and A-DEP. It is not used in M mode or when you shoot RAW or RAW+JPEG format images.

While automatic brightening may be handy, it also tends to reveal any digital noise in the image. Digital noise creates a grainy look and appears as multicolored flecks, particularly in the shadow areas of the image. Also, by using Auto Lighting Optimization, the effect of exposure modification may not be evident. For example, if you set negative Exposure Compensation (detailed later in this section), then Auto Lighting Optimization brightens the image. The same happens for other exposure modifications such as AEB and AE Lock. If you prefer to see the effect of

exposure modifications, then you can turn off Auto Lighting Optimization, but only for Creative Zone shooting modes.

To turn off Auto Lighting Optimization for Creative Zone shooting modes only, follow these steps:

- Set the Mode dial to P, Tv, Av, M, or A-DEP.
- Press the Menu button, and turn the Main dial until the Set-up 3 (yellow) menu is displayed.
- Press the up or down cross key to highlight Custom Functions (C. Fn), and then press the Set button. The Custom Functions screen appears.
- 4. Press the right or left cross key until the number "5" is displayed in the box at the top right of the screen, and then press the Set button. The Custom Function option control is activated and the option that is currently in effect is highlighted.
- 5. Press the down cross key to highlight 1: Disable, and then press the Set button. This turns off Auto Lighting Optimization in Creative Zone shooting modes. Lightly press the Shutter button to return to shooting.

Auto Lighting Optimization remains turned off until you reset it.

Exposure Compensation

Exposure Compensation enables you to purposely and continuously increase or decrease the standard exposure by a specific amount up to plus or minus two f-stops in 1/3-stop increments or in 1/2-stop increments using C.Fn-1. Scenarios for using Exposure Compensation vary widely, but a

common use is to override the camera's suggested ideal exposure in scenes that have large areas of white or dark tones. In these types of scenes, the camera's onboard meter averages light or dark scenes to 18 percent gray to render large expanses of whites as gray and large expanses of black as gray. To avoid this, you can use Exposure Compensation. For a snow scene, a +1 to +2 stop of Exposure Compensation renders snow as white instead of dull middle gray. A scene with predominantly dark tones might require -1 to -2 stops of Exposure Compensation to get true dark renderings.

Here are some things that you should know about Exposure Compensation:

- Exposure Compensation works in all Creative Zone modes except in Manual mode and during Bulb exposures. In Tv mode, setting Exposure Compensation changes the aperture by the specified amount of compensation. In Av mode, it changes the shutter speed. In P mode, compensation changes both the shutter speed and aperture by the exposure amount you set.
- The amount of Exposure Compensation you set remains in effect until you reset it. This applies whether you turn the camera off and back on, change the SD/SDHC card, or change the battery.
- You can combine exposure compensation with AutoExposure Bracketing.
- The XS/1000D is initially set to make exposure adjustments in 1/3stop increments. This fine level of change gives precise control. However, if you want larger exposure changes, you can use 1/2-stop settings by setting C.Fn-1 to Option 1: 1/2-stop.

Custom Function (C.Fn) details are provided in Chapter 5.

You can set Exposure Compensation by following these steps:

- Set the shooting mode to P, Tv, Av, or A-DEP, and then press the Shutter button halfway down to initiate a meter reading on the subject. You cannot set Exposure Compensation in M mode.
- 2. Watch the Exposure Index in the viewfinder or on the LCD, and then press and hold the Aperture/Exposure Compensation button (the button marked Av) on the back of the camera. Then turn the Main dial to the right to lighten the exposure or to the left to darken the exposure.

Auto Exposure Bracketing

When you set Auto Exposure Bracketing (AEB), you take three pictures at three different exposures: one picture at the standard exposure set by the camera, one picture at an increased (lighter) exposure, and another picture at a decreased (darker) exposure. AEB is a way to ensure that at least one exposure in a series of three images is acceptable. For example, if the scene includes bright highlights, the darkest of the three exposures may retain more detail in the highlights than the standard or lighter exposures. Conversely, in a scene with expanses of dark areas or deep shadows, the lighter exposure may provide a better rendering of the scene with more extensive shadow details.

When you set AEB, the camera bracketing increments are set by 1/3 f-stop increment

exposure changes. If you want a greater exposure difference, you can set C.Fn-1 to Option 1: 1/2-stop. With either setting, you can bracket images up to plus or minus two stops. While bracketing isn't necessary in all scenes, it's a good technique to use in scenes that are difficult to set up or that can't be reproduced. It is also useful in scenes with contrasty lighting such as a landscape with a dark foreground and a much lighter sky.

Here are some things to know about AEB:

- You can't use AEB with the built-in or an accessory flash or when the shutter is set to Bulb. If you set AEB, and then pop up the built-in flash or pop it up while you're making one of the three bracketed images, the AEB settings are immediately cancelled.
- AEB is available in P, Tv, Av, and A-DEP modes, but not in Manual mode.
- The order of bracketed exposures begins with the standard exposure followed by decreased (darker) and increased (lighter) exposures.
- You can use AEB in combination with Exposure Compensation. If you combine AEB with Exposure Compensation, the shots are taken based on the compensation amount.
- If Auto Lighting Optimizer is turned on in Creative Zone modes, the effects of AEB may not be evident in the darker image because the camera automatically lightens dark images. You can turn off Auto Lighting Optimizer by setting C.Fn-5 to Option 1: Disable.

Here's how AEB works in the different drive modes:

- In Continuous and Self-timer modes, pressing the Shutter button once automatically takes three bracketed exposures. In the 10-second and 2-second Self-timer drive modes, the three bracketed shots are taken in succession after the timer interval has elapsed. In Self-timer continuous mode, you get six total shots at the default 2 continuous shots in this mode.
- In Single-shot drive mode, you have to press the Shutter button three separate times to get the three bracketed exposures.
- If C.Fn-8 is set for Mirror Lockup, and you're using AEB and Continuous drive mode, only one of the bracketed shots is taken at a time. You press the Shutter button once to lock up the mirror and another time to make the exposure. The exposure level indicator in the viewfinder flashes after each exposure until all three bracketed images have been made. The exposure index also shows which of the exposures is currently being made, for example, the decreased exposure.
- AEB settings are temporary. If you change lenses, pop up the built-in flash or mount an accessory flash, or turn off the camera, the AEB settings are cancelled. You can set AEB by following these steps:
 - Press the Menu button, and then turn the Main dial to select the Shooting 2 (red) menu.
 - 2. Press the up or down cross key to select AEB.

- Press the Set button. The AEB bracketing scale is activated.
- 4. Press the right cross key to select the bracketing amount. Markers that show increased and decreased exposure settings are displayed on the bracketing scale. You can set bracketing up to plus or minus two stops. The default exposure increment is 1/3 stop.
- Press the Set button. Lightly press the Shutter button to return to shooting.
- 6. If you're in One-shot drive mode, half-press the Shutter button to focus, and then press it completely to make the shot, and then press the Shutter button two more times to take all three bracketed shots. In Continuous or Self-timer mode, the three shots are taken by pressing the Shutter button once.

Auto Exposure Lock

With the Rebel XS/1000D, both the exposure and the focus are set at the selected AF point. However, there are times when you don't want to set the exposure at the same point where you set the focus. For example, if a person that you're photographing is lit by a spotlight, the brightest light may fall on the subject's forehead. In this situation, you want to set the exposure for the forehead highlight to ensure that the detail in this area is retained, but then you also want to focus on the person's eyes. To do this, you have to de-couple the exposure metering from the AF point, and Auto Exposure (AE) Lock enables you to do this.

By pressing and holding the AE Lock button, the camera sets and retains the exposure.

2.16 For this image, I used AE Lock and locked the exposure on the highlights of the water ripples. Exposure: ISO 100, f/2.8, 1/80 second.

and then you can move the camera and focus on a different area of the scene. This is one of the most useful features on the XS/1000D for preventing blowout of detail in the highlights, and for ensuring good exposure for critical areas of the image.

If you shoot JPEG capture, then AE Lock is the best way to ensure that the brightest highlights retain detail. If you shoot RAW capture, there is slightly more latitude because you can recover varying amounts of highlight detail during image conversion.

Table 2.1 shows how AE Lock works with each metering mode and AF point.

You can set AE Lock by following these steps:

 Select the AF point that you want to use. For example, if you're making a portrait, select the AF point that is over the subject's eye that is nearest the lens.

- Point the selected AF point at the part of the scene where you want to set the exposure, and then press the Shutter button halfway down. The exposure is displayed in the viewfinder.
- 3. Continue to hold the Shutter button halfway down as you press the AE Lock button. The AE Lock button is the left button of the two buttons on the top-right back of the camera and has an asterisk icon above it. When you press this button, an asterisk icon appears in the viewfinder to indicate that AE Lock is activated. You can now release the Shutter button.
- 4. Move the camera to recompose the shot, half-press the Shutter button to focus on the subject, and then make the picture. As long as you see the asterisk in the viewfinder, you can take additional pictures using the locked exposure. After a few seconds, AE Lock shuts off automatically.

Table 2.1
AE Lock Behavior with Metering Mode and AF Point Selection

Metering Mode	AF Point Selection				
	Manual AF Point Selection	Automatic AF Point Selection	Lens switch is set to MF		
Evaluative	Exposure is locked at the selected AF point	Exposure is locked at the AF point that achieves focus	Exposure is locked at the center AF point		
Partial	Exposure is locked at the center AF point				
Center- Weighted Average					

Evaluating Exposure

Following each exposure, you can best evaluate the exposure by looking at the histogram. If you're new to digital photography, the concept of a histogram may also be new. A histogram is a bar graph that shows either the grayscale brightness values in the image — from black (level 0) to white (level 255) — or the Red, Green, Blue (RGB) brightness levels, along the bottom of the graph. The vertical axis displays the number of pixels at each location. The XS/1000D offers two types of histograms: a Brightness (or luminance) histogram, and RGB (Red, Green, and Blue color channel) histograms.

The histograms are the most useful tools for ensuring that highlights are not blown, or lacking detail, and that shadows are not blocked up, or transitioning too quickly to solid black without detail. Here is an overview of each type of histogram.

Brightness histogram

A Brightness histogram shows grayscale brightness values in the image along the

horizontal axis of the graph. The values range from black (level 0 on the left of the graph) to white (level 255 on the right of the graph). This histogram shows you the exposure bias and the overall tonal distribution in the image.

If the histogram has pixels crowded against the far right side of the graph, then the image is overexposed with a subsequent loss of detail in the highlights. This means that some highlight values are blown out, or totally white with no image detail. If the histogram has pixels crowded against the far left side of the graph, it indicates blocked shadows, with pixels at 0, or completely black with no detail.

In average scenes, good exposure is shown on the histogram with highlight pixels just touching the right side of the histogram. Underexposure, shown by a gap between the pixels and the right side of the histogram, increases the chances of getting digital noise in the image. Overexposure, shown by pixels crowded against the right side of the histogram, means that highlights are blown out.

Not every scene is average, and depending on the lighting and other factors, some scenes cause a weighting of tonal values more to one or the other side of the graph. For example, in scenes that have predominantly light tones, the pixels are weighted toward the right side of the histogram, and vice versa.

For a wedding, outdoor shooting, and nature shooting, the brightness histogram can be most useful for evaluating critical highlight exposure.

RGB histograms

An RGB histogram shows the distribution of brightness levels for each of the three color channels — Red, Green, and Blue — that combine to create color in the image. With the RGB histogram, each color channel is shown as a separate graph so that you can evaluate the color channel's saturation, gradation, and color bias.

The horizontal axis shows how many pixels exist for each color brightness level, while the vertical axis shows how many pixels exist at that level. More pixels to the left indicate that the color is darker and more prominent, while more pixels to the right indicate that the color is brighter and less dense. If pixels are spiked on the left or right side, then color information is either lacking or oversaturated with no detail, respectively. If you're shooting a scene where color reproduction is critical, the RGB histogram is likely the most useful.

On the Rebel XS/1000D, the RGB histograms are displayed along with a Brightness histogram so that you can evaluate both the color per channel and the brightness distribution.

2.17 The histogram inset in this picture shows the pixels crowded against the right side of the histogram, indicating that areas of the image are overexposed in the highlights. Highlight overexposure is evident in the clouds behind the climbing platform, with no detail remaining in these areas. Exposure: ISO 100, f/8, 1/200 second.

The histogram is a very accurate tool to use in evaluating JPEG captures. If, however, you shoot RAW capture, the histogram is based on the JPEG conversion of the image. So if you shoot RAW, remember that the histogram is showing a less robust version of the image than you'll get during RAW image conversion.

To display the histogram during image playback, follow these steps:

 Press the Playback button on the back of the camera. The most recent image appears on the LCD

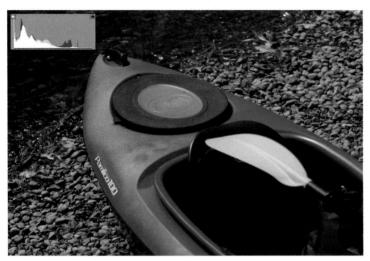

2.18 In the histogram inset in this picture, shadow pixels are crowded to the left side of the histogram, reflecting the dark area of the canoe seat where shadow areas are blocked up — containing little or no detail. Exposure: ISO 100, f/4.5, 1/1250 second.

- with a ribbon of basic shooting information at the top of the preview image.
- Press the Display (Disp.) button on the top-left back of the camera once to display the file capture type and current number of images on the SD card.
- 3. Press the Display button again to display the Brightness histogram with more extensive shooting and file information. This display also has a highlight alert that flashes to show areas of the image that are overexposed (or areas that have no detail in the highlights).
- Press the Display button again to display the RGB histograms along with the Brightness histogram, in addition to more limited shooting information.

To set the type of histogram that is displayed during image playback, follow these steps:

- 1. Press the Menu button, and turn the Main dial to select the Playback (blue) menu.
- Press the up or down cross key to select Histogram, and then press the Set button. The camera displays the Brightness and RGB options.
- 3. Press the down or up cross key to select the type of histogram you want, and then press the Set button. The option you choose remains in effect until you change it.

Setting the ISO Sensitivity

Setting the ISO determines the sensitivity of the image sensor to light. At low settings such as ISO 100, the sensor needs comparatively more light to make an exposure than at a high ISO setting such as 800.

Differences in Exposing JPEG and RAW Images

When you shoot JPEG images, it's important to expose for the highlights because you want to retain image detail in the bright highlights. If this detail isn't captured during shooting, it is gone forever. To ensure that images retain detail in the brightest highlights, you can use one of the exposure techniques described in this chapter, such as AE Lock or Exposure Compensation.

Conversely, for RAW capture, you have more exposure latitude because some highlights can be recovered during RAW image conversion in Canon's Digital Photo Professional or other RAW conversion programs. It's important to know that fully half of the total image data is contained in the first f-stop in RAW capture. This fact alone underscores the importance of capturing the first f-stop of image data by not underexposing the image. In everyday shooting, this means biasing the exposure slightly toward the right side of the histogram, resulting in a histogram in which highlight pixels just touch, but are not crowded against, the right edge of the histogram.

With this type of exposure, the image preview on the LCD may look a bit light, but in a RAW conversion program, you can bring the exposure back slightly. So for RAW exposure, expose with a slight bias toward the right side of the histogram to ensure that you capture the full first f-stop of image data.

However, as the sensitivity setting increases on a digital camera (a higher ISO number), the output of the sensor is also amplified. So while you have the option of increasing the ISO sensitivity at any point in shooting, the tradeoff in increased amplification or the accumulation of an excessive charge on the pixels represents an increase in digital noise. And the result of digital noise, depending on the appearance and severity, is an overall loss of resolution and image quality.

In practice, the most compelling benchmark in evaluating digital noise is the quality of the image at the final print size. If the digital noise is visible and objectionable in an 8×10 -inch or 11×14 -inch print when viewed at a standard viewing distance of a foot or more, then the digital noise degraded the quality to an unacceptable level. It is worthwhile to test the camera by using all of the ISO settings, processing and printing enlargements at the size at which you typi-

cally print, and then evaluating how far and fast you want to take the XS/1000D's ISO settings.

The XS/1000D offers two useful Custom Functions that help counteract noise: C.Fn-3 Long-exposure noise reduction and C.Fn-4 High ISO speed noise reduction.

Cross-Reference

See Chapter 5 for details on each of these Custom Functions and how to set them.

Note

The ISO sensitivity setting affects the effective range of the builtin flash, and the range depends on the lens that you're using. In general, the higher the ISO speed, the greater the effective flash range.

There really is no substitute for knowing how far and fast to push the ISO settings on the XS/1000D unless you test it by making images at each of the ISO settings and com-

paring the images on the computer. To compare the results, view the images at 100-percent enlargement in an image-editing program, and then compare the shadow areas. If you see grain and colorful pixels where the tones should be continuous and of the same color, then you're seeing digital noise. Having low levels of digital noise won't spoil prints from the image, but high levels of digital noise can be objectionable in prints of 8×10 inches and larger. While you can use a digital noise-reduction program to make the noise less objectionable, you still need to know what to expect by doing your own tests with the XS/1000D.

To change the ISO sensitivity setting on the XS/1000D, follow these steps:

- 1. Set the camera to P, Tv, Av, M, or A-DEP, and then press the ISO button on the top of the camera. The ISO speed screen appears in the viewfinder and on the LCD. If the ISO screen doesn't also appear on the LCD, it's because the shooting information display on the LCD was not active when you began. Press the Display button to display the shooting information on the LCD, and then press the ISO button.
- 2. Turn the Main dial to the ISO setting you want. ISO options include Auto (the camera automatically selects an ISO between 100 and 800) and individual settings from 100 to 1600. The ISO option you select remains in effect until you change it again. The current ISO sensitivity setting is displayed in the viewfinder and on the LCD.

Selecting AF Modes and Getting Sharp Focus

In addition to good exposure, the success of a picture also depends on getting tack-sharp focus for both still and action subjects. The XS/1000D offers three AF modes for different types of subjects, and seven AF points that are etched in the viewfinder.

Note

Technically, getting tack-sharp focus depends on three factors: the resolving power of the lens (its ability to render fine details sharply), the resolution of the image sensor, and, if you print the image, the resolution of the printer.

Autofocus speed figures into the final image sharpness as well, especially for fleeting moments such as a capturing a ball coming off the bat or a covey of birds taking flight. Autofocus speed depends on factors including the speed of the lens-focusing motor, the speed of the AF sensor in the camera, and how easy or difficult it is for the camera to focus on the subject.

For most shooting situations, the Rebel XS/1000D's wide-area AI (artificial intelligence) AF system — a system that is tied closely to the camera's drive modes — is fast and reliable. The camera automatically chooses one of three focusing modes:

One-shot AF. This mode is designed for still subjects. In Basic Zone modes, the camera chooses One-shot AF mode in Portrait, Landscape, Close-up, and Flash-off modes, and the camera selects the AF point(s) automatically. In Creative Zone modes, including P, Tv, Av, and M mode, you can select this AF mode. You can then either select the AF point yourself, or have the camera select it automatically.

- AI Focus AF. This mode is designed for still subjects that may begin to move. In this mode, the camera uses One-shot AF but automatically switches to AI Servo AF if it detects subject movement. This mode is good for photographing wildlife, music concerts, events, and children at play. In Basic Zone modes, the camera automatically uses this AF mode in Full Auto and Flash-off shooting modes. In P, Tv, Av, and M modes, you can select this AF mode manually.
- AI Servo AF. This mode tracks focus on moving subjects and locks focus and exposure at the moment you take the picture. In this mode, the shutter fires even if sharp focus hasn't had time to be finalized. If the AF point is automatically selected by the camera, it uses the center AF point and tracks the subject as it moves across all seven AF points. If you manually select the AF point when shooting in P, Tv, Av, or M modes, then the camera uses the selected AF point to track the subject. This is also referred to as

predictive focus because if a subject is moving toward or away from the camera at a constant rate, then the camera "predicts" the subject distance to calculate focus. In Basic Zone modes, the camera automatically uses AI Servo AF mode in Sports shooting mode. In P, Tv, Av, and M modes, you can select this AF mode manually.

To change AF modes in Creative Zone modes, ensure that the lens is set to AF (autofocus), and then follow these steps:

- Set the camera to P, Tv, Av, M, or A-DEP shooting mode.
- 2. Press the AF (right cross key) button on the back of the camera. The AF mode screen appears.
- 3. Press the right or left cross key to change the AF mode, and then press the Set button. In A-DEP shooting mode, you can only select One-shot AF mode. The mode you choose remains in effect for shooting in Creative Zone modes until you change it. As you've learned by now, almost every function of the camera relates to other functions, and the same is true for AF modes. Table 2.2 shows which mode is selected in each drive and exposure mode.

Improving Autofocus Accuracy and Performance

Autofocus speed depends on factors including the size and design of the lens, the speed of the lens-focusing motor, the speed of the AF sensor in the camera, the amount of light in the scene, and the level of subject contrast. Given these variables, it's helpful to know how to get the speediest and sharpest focusing. Here are some tips for improving overall autofocus performance.

◆ Light. In low-light scenes, the autofocus performance depends in part on the lens speed and design. In general, the faster the lens, or the larger the maximum aperture of the lens, such as f/2.8, the faster the autofocus performance.

Continued

Provided that there is enough light for the lens to focus without using the AF-assist beam, lenses with a rear-focus optical design, such as the EF 85mm f/1.8 USM, will focus faster than lenses that move their entire optical system, such as the EF 85mm f/1.2L II USM. But regardless of the lens, the lower the light, the longer it takes for the system to focus.

Low-contrast subjects and subjects in low light slow down focusing speed and can cause autofocus failure. In low light, consider using the built-in flash or an accessory EX Speedlite's AF-assist beam as a focusing aid. By default, the Rebel XS/1000D is set to use the AF-assist beam for focusing. This is controlled by the Custom Function, C.Fn-6.

- ◆ Focal length. The longer the lens, the longer the time to focus. This is true because the range of defocus is greater on telephoto lenses than on normal or wide-angle lenses. You can improve the focus time by manually setting the lens in the general focusing range, and then using autofocus to set the sharp focus.
- AF point selection. Manually selecting a single AF point provides faster autofocus performance than using automatic AF point selection because the camera doesn't have to determine and select the AF point or points to use first.
- Subject contrast. Focusing on low-contrast subjects is slower than on highcontrast subjects. If the camera can't focus, shift the camera position to an area of the subject that has higher contrast, such as a higher-contrast edge.
- EF Extenders. Using an EF Extender reduces the speed of the lens-focusing drive.

Table 2.2							
Autofocus and Drive Modes							
Drive	Focus Mode						
Mode	One-shot AF	AI Focus AF	Al Servo AF				
Single-shot shooting	In One-shot AF mode, the camera must con- firm accurate focus before you can take the picture. If you're using Evaluative metering, exposure is also locked at the selected AF point.	If the subject moves, the AF mode automatically switches from Oneshot AF to AI Servo AF to track and focus on the moving subject.	The camera focuses on the subject and main- tains focus during sub- ject movement. The exposure is set at the moment the image is captured.				
Continuous shooting	Same as One-shot AF mode during continuous shooting.		Same as for One-shot shooting, with AF continuing during continuous shooting.				

Selecting an Autofocus point

Selecting an Autofocus (AF) point determines the point in the image that will have the sharpest focus. When you're shooting in P, Tv, Av, and M modes, you can manually choose one of the seven AF points shown in the viewfinder. Or you can have the XS/1000D automatically choose the AF point for you. In Basic Zone modes and in A-DEP mode, the camera automatically selects the AF point or points.

Note

As mentioned previously, the AF point that you or the camera selects is also the point at which the camera meters the light in the scene and determines its ideal exposure.

If you opt to have the camera automatically choose the AF points, be aware of how it determines what to focus on in the scene. In general, the Rebel XS/1000D focuses on whatever is nearest the lens or has the most readable contrast. This may or may not be

the area that should have the point of sharpest focus. Because sharp focus is critical to the success of any image, you can switch to a Creative Zone mode and manually select a single AF point.

You can manually select the AF point by following these steps:

- Set the Mode dial to P, Tv, Av, or M mode. In A-DEP mode, the camera automatically sets the AF point or points.
- Press the AF Point Selection button on the back upper-right corner of the camera. The AF Point Selection button has an icon below it that shows a plus sign inside a magnifying glass. The currently selected AF point lights in red in the viewfinder.
- 3. As you look in the viewfinder, turn the Main dial until the AF point that you want to use is highlighted. The LCD also displays the AF points as long as the LCD shooting information display was

Does Focus-lock and Recompose Work?

Some suggest that you can use the standard point-and-shoot technique of focus-lock and recompose with the XS/1000D. This is the technique where you lock focus on the subject, and then move the camera to recompose the image. In my experience, however, the focus shifts slightly during the recompose step, regardless of which AF point is selected. As a result, focus is not tack-sharp.

Some Canon documents concede that at distances within 15 feet of the camera and when shooting with large apertures, the focus-lock-and-recompose technique increases the chances of back-focusing. Back-focusing is when the camera focuses behind where you set the AF point. Either way, the downside of not using the focus-lock-and-recompose technique is that you're restricted to composing images using the seven AF points in the viewfinder. The placement of the seven AF points isn't the most flexible arrangement for composing images. But manually selecting one AF point, locking focus, and then not moving the camera is the best way that I know to ensure tack-sharp focus in One-shot AF mode.

turned on when you began these steps. You can also use the cross keys to select an AF point. If you select the option where all of the AF points are lit in red in the view-finder, then the camera automatically selects the AF point or points for focusing. If you want to control the point of sharpest focus in the image, then do not choose this option. Rather, choose an option where only one AF point is highlighted. To quickly move to the center AF point, press the Set button once.

4. Move the camera so that the AF point you selected is over the point in the scene that should have sharp focus, press the Shutter button halfway down to focus on the subject, and then press it fully to make the picture.

You can verify image sharpness by pressing the Playback button, and then pressing and holding the AF Point Selection/Magnify button on the back of the camera. If you need to scroll the magnified image to the point of sharpest focus, you press the cross keys to move around the image.

Choosing a Drive Mode

A drive mode determines how many shots the camera takes at a time, or, in Self-timer mode, it sets the camera to fire the shutter automatically after a 10- or 2-second delay. The Rebel XS/1000D offers drive modes for different shooting situations: Single-shot, Continuous, and three Self-timer modes. If you're shooting in Continuous drive mode, then you can capture images at 3.0 frames

per second (fps) speed up to the capacity of the SD/SDHC card.

In Basic Zone modes, the camera automatically chooses the drive mode. You can select the drive mode in all Creative Zone modes.

Single-shot mode

As the name implies, Single-shot means that the XS/1000D takes one picture each time you press the Shutter button. In this mode, you can shoot 3.0 fps, depending on shutter speed.

Continuous mode

Continuous drive mode enables continuous shooting of 3.0 fps, or, if you press and hold the Shutter button, you can continue shooting JPEG images at 3.0 fps to the capacity of the SD/SDHC card, or approximately 514 JPEG Large images with a 2GB SD/SDHC card at ISO 100. If you're shooting RAW images, you can get approximately 5 images at a rate of approximately 1.5 shots per second. If you're shooting RAW+JPEG Large images, you can get approximately four images at a rate of 1.5 shots per second. All estimates depend on the type and speed of the SD/SDHC card and image recording quality.

When the buffer is full from a continuous shooting burst, you can't shoot until some of the images are offloaded to the SD/SDHC card. Thanks to Canon's smart-buffering capability, you don't have to wait for the buffer to empty all of the images to the media card before you can continue shooting. After a continuous burst sequence, the camera begins offloading pictures from the buffer to the card. As offloading progresses, the camera indicates in the viewfinder when there is enough buffer space to continue shooting.

When the buffer is full, a "busy" message appears in the viewfinder, but if you keep the Shutter button pressed, the number of pictures that you can take is updated in the viewfinder. This is where it is useful to have a fast SD/SDHC card, which speeds up image offloading from the buffer.

Note

If the AF mode is set to AI Servo AF, the XS/1000D focuses continually during continuous shooting. However, in One-shot AF mode, the camera only focuses once during the burst.

Self-timer modes

In Self-timer modes, the camera delays making the picture for 10 or 2 seconds after the Shutter button is fully depressed. In addition, you can use 10-second delay plus Continuous shooting. For Self-timer shots, be sure to use the eyepiece cover included with the camera to prevent stray light from entering through the viewfinder.

Tip

Using the 10- or 2-second Selftimer modes is a great way to avoid camera shake from pressing the Shutter button during long shutter-speed shots.

Here is a summary of the Self-timer modes:

◆ 10-second self-timer. In this mode, the camera waits 10 seconds before the shutter is fired, giving you time to get into the picture. On the Drive mode screen, this mode is depicted as a stopwatch with the numeral 10 beside it. This mode is useful when you want to be in the picture with others because it gives you time to move into the group. It can be combined with Mirror Lock-up (C.Fn-8).

- ◆ 2-second self-timer. In this mode, the camera waits for 2 seconds before firing the shutter. This is a good choice when you're photographing documents, art, nature close-ups, and low-light scenes. On the Drive mode screen, this mode is depicted as a stopwatch with the numeral 2 beside it.
- ◆ 10-second self-timer plus continuous shots. In this mode, you can choose to have the camera take two to ten sequential shots, each with a 10-second delay.

In 10-second Self-timer mode, the Self-timer lamp on the front of the camera blinks, a beep is emitted slowly for 8 seconds, and then the speed of the beep and the lamp blinking increase for the final 2 seconds before the shutter releases. In 2-second Self-timer mode, the Self-timer lamp lights continuously with a fast beep being sounded. The camera displays the count-down to firing on the LCD panel if the LCD display is turned on. To change the drive mode, follow these steps:

- Press the Drive Mode button (the left cross key) on the back of the camera. The Drive mode screen appears.
- 2. Press the right or left cross key to select the mode you want. Each Self-timer mode is denoted by a descriptive icon: a single rectangle indicates Single-shot drive mode, tiled rectangles indicate Continuous mode, and a stop watch with or without a numeral or the letter "C" denotes the Self-timer modes. The mode you select remains in effect until you change it.

Viewing and Playing Back Images

On the Rebel XS/1000D, you can not only view images after you take them, but you can also do the following: magnify images to verify that the focus is sharp; display and page through multiple images that you have stored on the SD/SDHC card; display an image with a brightness or RGB histograms and a brightness histogram; display images as a slide show; and display the image along with its exposure settings. The following sections describe viewing options and suggestions for using each option.

Single-image playback

Single-image playback is the default playback mode, and it briefly displays the image on the LCD after you take the picture. Canon sets the initial display time to 2 seconds, hardly enough time to move the camera from your eye and to see the image preview. The display time is intentionally set to 2 seconds to maximize battery life, but a longer display time of 4 seconds is more useful. You can also choose to set the Hold option to display the image until you dismiss it by lightly pressing the Shutter button.

To turn on image review, press the Playback button on the back of the camera. If you have multiple pictures on the SD/SDHC card, you can use the left and right cross keys to move forward and back through the images.

If you want to change the length of time that images display on the LCD, follow these steps:

- 1. Press the Menu button.
- Turn the Main dial to select the Shooting 1 (red) menu, and then press the down cross key to select Review time.
- **3. Press the Set button.** The Review time options appear.
- 4. Press the down cross key to select Off, 2, 4, 8, or Hold. The numbers indicate the number of seconds that the image displays. Off disables image display, while Hold displays the image until you dismiss it by pressing the Shutter button.
- Press the Set button. Lightly press the Shutter button to return to shooting.

Index Display

The Index Display shows an index of images stored on the SD/SDHC card in a 2×2 or 3×3 grid. This display is handy when you need to ensure that you have a picture of everyone at a party or event, or to quickly select a particular image on a card that is full of images.

To turn on the Index Display, follow these steps:

- Press the Playback button on the back of the camera.
- 2. Press the AE/FE Lock button on the back right side of the camera. This button has an asterisk displayed above it. The LCD displays the last four images stored on the SD/SDHC card. If you don't have four images on the card, it displays as many images as are stored on the card. Press the button again to display a 3 × 3 index of images.

- Press the cross keys to move among the images. The selected image has a blue border.
- 4. Press the Magnify button up to 15 times to magnify the image. A rectangular cursor appears in this view. You can move around the image using the cross keys to view different areas of the magnified image.
- Press the Shutter button to cancel the display.

Auto play

When you want to sit back and enjoy all of the pictures on the SD/SDHC card, the Auto play option plays a slide show of images on the card, displaying each one for 3 seconds. Use this option when you want to share pictures with the people that you're photographing, or to verify that you've taken all of the shots that you intended to take during a shooting session.

You can turn on Auto play by following these steps:

- Press the Menu button, and then turn the Main dial to select the Playback (blue) menu.
- Press the down cross key to select Auto play.
- 3. Press the Set button. Images are displayed in the display mode that you last used. For example, if you displayed images with the Brightness histogram, they are displayed in this mode during Auto play. Images display sequentially and in a continuous loop until you press the Shutter button to stop the slide show. You can pause the automatic display by pressing the Set button. A Pause icon appears in

the upper-left area of the image preview. Press the Set button again to resume Auto play.

Using the Display (Disp.) button

You can use the Display button to sequence through different displays in Playback mode. In Single-image playback mode, press the Display button once to display basic shooting information overlaid on the image preview. Press it again to display shooting information, a small image preview, and the Brightness histogram. Press it again to display abbreviated shooting information, an image preview, and both the RGB and Brightness histograms. Press it once more to return to an image display with the top ribbon of shooting information. You can use the cross keys to move forward and back through pictures in this display.

You can specify whether the LCD display is retained either as on or off when you turn off the camera by setting C.Fn-11.

Tip During playback, you can press the up cross key to display a jump bar that enables you to move forward and back among images by 10 or 100 images at a time, or by date. To choose the jump method, press the up or down cross key to select the increment you want. Then you can turn the Main dial to browse through images. To return to single-image browsing, press the left or right cross key.

Erasing Images

Erasing images is useful only when you know without a doubt that you don't want the image that you're deleting. From experience, however, I know that some images that appear to be mediocre on the LCD can very often be salvaged with some judicious image-editing on the computer. For that reason, you should erase images with caution.

If you want to delete an image, follow these steps:

- Press the Playback button on the back of the camera, and then press the left and right cross keys to select the picture that you want to delete.
- Press the Erase button, and then press the right cross key to select Erase.
- Press the Set button to erase the image. When the access lamp stops blinking, lightly press the Shutter button to continue shooting.

Protecting Images

On the other end of the spectrum from erasing images is the ability to ensure that images that you want to keep are not accidentally deleted. When you have that perfect or once-in-a-lifetime shot, you can protect it to ensure that it is not erased.

Setting protection means that no one can erase the image when they use the Erase or Erase All options.

Even protected images are erased if you or someone else formats the SD/SDHC card.

You can protect an image by following these steps:

 Press the Menu button, and then turn the Main dial to select the Playback (blue) menu.

- 2. Press the up or down cross key to select Protect images, and then press the Set button. The last image taken is displayed on the LCD with a protection icon in the upper-left corner. If this isn't the image you want to protect, press the left or right cross key to display the image you want to protect.
- Press the Set button to protect the displayed image. A protection icon denoted by a key appears in the display above the thumbnail display.
- 4. Press the left or right cross key to scroll to other images that you want to protect, and then press the Set button to add protection to the images. If you want to remove protection, scroll to a protected image, and then press the Set button. Protection is removed and is indicated by the protection icon being removed.

Using the EOS Integrated Cleaning System

Each time you change the lens on the camera, dust can filter into the lens chamber and eventually settle on the low-pass filter in front of the image sensor. Dust spots on the image sensor inevitably appear as dark spots on your images. With the Rebel XS/1000D, a two-step automated cleaning system addresses both small, light particles and sticky particles that adhere to the filter in front of the image sensor.

The first step is automatic cleaning that uses ultrasonic vibrations to shake off dust from the first low-pass filter in front of the image sensor. Dust is captured by sticky material

that surrounds the low-pass filter. Each time you turn the camera on and off, the self-cleaning unit operates for 1 second. You can suspend automatic cleaning by pressing the Shutter button.

The second step of the camera's Integrated Cleaning System addresses larger, sticky particles that can't be shaken off by vibration. This step, called Dust Delete Data, identifies the size and position of large dust particles from a picture that you take of a white piece of paper. The camera then appends the dust data to all upcoming JPEG and RAW images. To delete the dust, you use Canon's Digital Photo Professional Copy Stamp tool and apply the Dust Delete Data. Dust Delete Data can be updated at any time, and you can stop the camera from appending the data to images if you want.

Automatic sensor cleaning

Automatic sensor cleaning can be initiated and turned off at any time. To reduce the risk of overheating the cleaning element, self-cleaning can't be operated more than five consecutive times in a 10-second period.

To manually initiate sensor cleaning, follow these steps:

- Press the Menu button, and then turn the Main dial to select the Set-up 2 (yellow) menu.
- Press the down cross key to select Sensor cleaning, and then press the Set button. The Sensor cleaning screen appears.
- Press the up or down cross key to select the option you want.

- Auto cleaning. This option turns off the default sensor cleaning when the power switch is turned on and off.
 Select it and then press the Set button. On the Auto cleaning screen, press the right cross key to select Disable, and then press the Set button.
- Clean now. This open cleans the sensor when it is selected.
 Select it and press the Set button to select OK on the Clean now screen.
- Clean manually. If the camera is in a Creative Zone mode, you can select this option. Before choosing this option, ensure that the battery has a full charge. Press the Set button. The reflex mirror flips up and the shutter opens to allow you to use appropriate cleaning tools to clean the sensor. When you finish, turn the power off.

Obtaining Dust Delete Data

For larger, sticky dust particles, you can determine the size and location of dust by taking a picture of a white piece of paper. Although you take a picture of the paper, no image is recorded to the SD/SDHC card. From the picture, the XS/1000D maps the coordinates of dust particles that are stuck to the low-pass filter and creates a tiny data file that is appended to future images. To erase the dust, use Canon's Digital Photo Professional, an editing program that is included on the Canon EOS Digital Solution Disk that comes with the Rebel XS/1000D.

Appending dust data does not increase the image file size, and it does not affect the continuous shooting speed or maximum burst rate of the XS/1000D.

Before you begin, ensure that you do the following:

- Have a clean piece of white paper that will fill the viewfinder if you position it approximately one foot from the lens. Ensure that the paper is evenly lit by any light source.
- Zoom the lens to 50mm or longer. On a zoom lens, the focal-length settings are displayed on the lens ring. Turn the lens ring to a focal length of 50 or higher.
- Set the lens to manual focus by turning the switch on the side of the lens to MF.
- With the camera facing forward, set the focus to infinity by turning the lens-focusing ring all the way to the left.

To obtain Dust Delete Data, follow these steps:

- 1. Press the Menu button, and then select the Shooting 2 (red) tab.
- Press the down cross key to select Dust Delete Data, and then press the Set button. The Dust Delete Data screen appears.
- 3. Press the left cross key to select OK, and then press the Set button. The camera initiates the automatic sensor self-cleaning. A message appears with the last date that data was obtained.
- Press the right cross key to select OK, and then press the Set button.
- With the camera approximately one foot from the white paper and the paper filling the viewfinder, press the Shutter button completely to take a picture of

- **the paper.** The XS/1000D captures the Dust Delete Data and displays a message confirming the capture.
- Select OK by pressing the Set button. The Shooting menu appears. Lightly press the Shutter button to return to shooting.

Applying Dust Delete Data

After you've acquired Dust Delete Data, you can use Canon's Digital Photo Professional program to apply the data to images. Be sure that you have installed Digital Photo Professional from the Canon EOS Digital Solution Disk that comes with the camera. You can apply Dust Delete Data to either JPEG or RAW images.

To apply Dust Delete Data in Digital Photo Professional, follow these steps:

- Start Digital Photo Professional, and then navigate to the folder that contains images with Dust Delete Data appended.
- Select an image, and then click in the Edit image window in the toolbar. The image-editing window appears.
- On the menu, click Tools, and then click Start Stamp tool. A new window appears with the image and a tool palette on the right side.
- 4. Click Apply Dust Delete Data. A progress pane appears, and then a confirmation message tells you that the data has been applied.
- Click OK. You can repeat these steps to apply the Dust Delete Data to the remaining images in the folder.

Creating Great Photographs with the EOS Rebel XS/1000D

PART

In This Part

Chapter 3Using White Balance and Picture Styles

Chapter 4Using Live View

Chapter 5Customizing the EOS
Rebel XS/1000D

Chapter 6The Fundamentals of Exposure and Light

Chapter 7 Using Flash

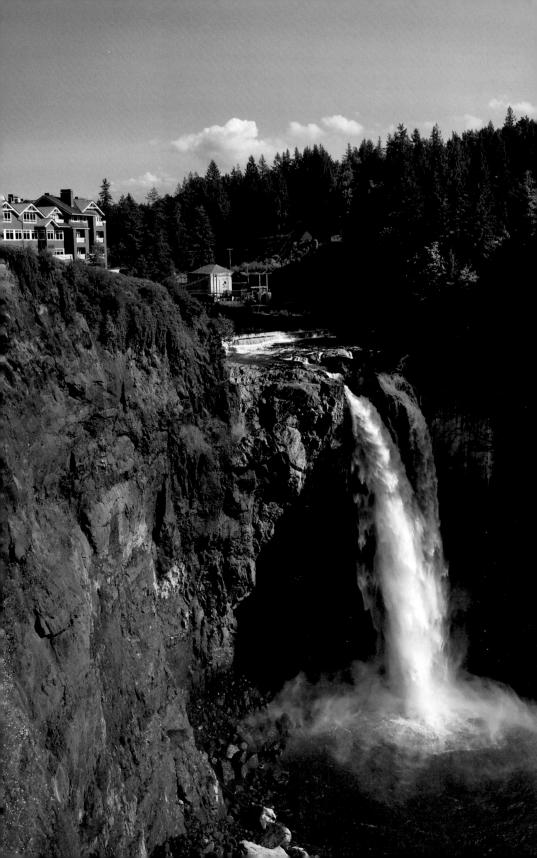

Using White Balance and Picture Styles

ne of the big advantages of digital photography is the ability to get accurate color both in the camera and in prints. Color control begins in the camera when you select a white balance that matches the light in the scene that you're shooting. You can also choose a color space that supports one of two ranges of colors. And finally, you can choose among six Picture Styles that determine the default tonal curve, sharpness, color rendering, and saturation of images. The Picture Styles replicate the look of traditional film or render color in different ways in the camera if you're shooting JPEG capture, and either in the camera or after capture if you're shooting RAW capture.

In this chapter, you learn how to make the most of each color option, as well as learning some useful techniques for ensuring accurate color.

About Color Spaces

You may have seen the color space options on the camera menu and wondered what they are. A color space defines the range of colors that can be reproduced and the way that a device such as a digital camera, monitor, or printer reproduces color. The XS/1000D offers two color space options — Adobe RGB and sRGB. The Adobe RGB (Red, Green, Blue) color space is richer in that it supports a wider gamut, or range, of colors than the sRGB (standard RGB) color space option. And in digital photography, the more data captured, or, in this case, the more colors the camera captures, the richer and

Using the Picture Style

Editor

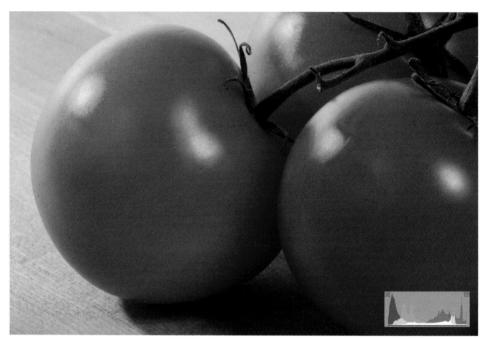

3.1 This RAW image was converted in Adobe Camera Raw and edited in Photoshop. The inset histogram shows the unprocessed RAW image in the sRGB color space. The spikes on the left and right indicate potential clipping or discarding of pixels in the shadows and highlights respectively.

more robust the file. It follows that the richer the file, the more image data you have to work with, whether you're capturing JPEG or RAW images.

Note

The same principle — getting the most that the XS/1000D image sensor offers — also holds true in regard to image bit depth.

The following histograms show the difference between a large and small color space in terms of image data. Spikes on the left and right of the histogram indicate colors that will be clipped, or discarded, from the image.

Cross-Reference

For details on evaluating histograms, see Chapter 2.

Much more image data is retained by using the wider Adobe RGB color space. Richer files can withstand editing, which is by nature destructive, much better than smaller files with less color data and a lower bit depth.

Also, Adobe RGB is the color space of choice for printing on both inkjet and commercial printers, although some commercial printing services use sRGB. However, for images destined for online use in e-mail or Web display, sRGB provides the best online color. While this may sound like a conflict in choosing color spaces, for most photographers it translates into using Adobe RGB for capture in the camera, and for editing and printing. Then, when an image is needed for the Web or e-mail, you can make a copy of the image and convert it to sRGB in an image-editing program such as Photoshop or Photoshop Elements.

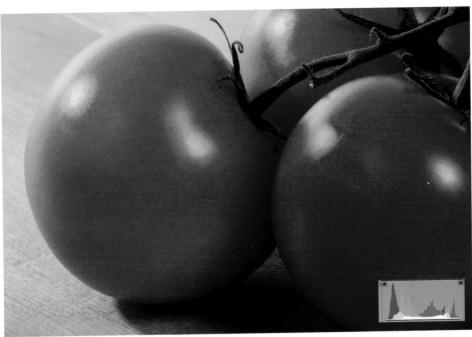

3.2 The inset histogram here is from the same unprocessed RAW image but in the Adobe RGB color space. Notice that the highlights and shadows no longer clip. The difference between this and the histogram in Figure 3.1 shows how much more color data is retained in the wider color space that Adobe RGB offers.

Choosing a Color Space

On the XS/1000D, you can select a color space for shooting in the Creative Zone shooting modes, which are P (Program AE), Tv (Shutter-priority AE), Av (Aperture-priority AE), M (Manual exposure), and A-DEP (Automatic Depth of Field). The options are Adobe RGB or sRGB. The color space you choose applies to both JPEG and RAW files shot in Creative Zone modes. In all Basic Zone modes, the camera automatically selects sRGB and JPEG capture.

If you choose Adobe RGB for Creative Zone modes, image filenames are appended with _MG_.

To set the color space on the XS/1000D for Creative Zone modes, follow these steps:

- Set the Mode dial to P, Tv, Av, M, or A-DEP.
- Press the Menu button, and then turn the Main dial to select the Shooting 2 (red) menu.
- Press the up or down cross key to highlight Color space, and then press the Set button. The camera displays two color space options.

4. Press the up or down cross key to highlight the color space you want, either sRGB or Adobe RGB, and then press the Set button.

The color space remains in effect until you change it or switch to a Basic Zone mode. In Basic Zone modes, the camera automatically sets sRGB, and you don't have the option to change it.

Using white balance settings can help you spend less time color-correcting images on the computer and more time shooting. On the XS/1000D, you can choose one of the seven preset white balance options or set a custom white balance.

Tip If you shoot RAW images, you can set or adjust the white balance in the RAW conversion program after the image is captured

Table 3.1 provides the white balance options and the approximate color temperature as measured in Kelvin.

Choosing White Balance Options

White balance settings tell the camera what type of light is in the scene so that the camera can render colors accurately in images.

Table 3.1

XS/1000D White Balance Temperature Ranges

White Balance Option	Approximate Range in Kelvin (K)	XS/1000D Setting and Approximate Corresponding Color Temperature (K)
Auto (AWB)	N/A	3000 to 7000
Daylight	5000 to 6500	5200
Shade	7000 to 10,000	7000
Cloudy, twilight	6000 to 8000	6000
Tungsten	2500 to 3500	3200
White fluorescent	4000 to 4300	4000
Flash	4500 to 6000	4900
Custom	N/A	2000 to 10,000

3.3 The images in this series were captured in daylight using the Daylight White Balance setting using a modified Neutral Picture Style. With the Daylight White Balance setting, the colors are accurate and natural. Exposure: ISO 100, f/11, 1/400 second. The exposure is the same for the next series of images.

3.4 This image was captured using the Tungsten White Balance setting using a modified Neutral Picture Style. The image has a noticeable blue tint because the white balance setting did not match the light temperature in the scene.

3.5 This image was taken using the Shade White Balance setting.

3.6 This image was taken using the cloudy White Balance setting.

3.7 This image was taken using the Fluorescent White Balance setting.

More about White Balance

Unlike a mechanical camera, the human eye automatically adjusts to the changing colors (temperatures) of light. For example, we see a white shirt as being white in tungsten, fluorescent, or daylight; in other words, regardless of the type of light in which we view a white object, it appears to be white. Digital image sensors are not as adaptable as the human eye, however, and they cannot distinguish white in different types of light unless they are told what the light temperature is. And that's what a white balance setting does—it tells the camera what the light temperature is in the scene so that the camera can accurately represent the colors in the scene in the image.

Light temperature is measured on the Kelvin scale and is expressed as Kelvin (K). Once the camera knows the light temperature, it can render white as white. On the XS/1000D, a preset white balance option covers a range of light temperatures, so rendering white is more approximate than specific; on the other hand, setting a custom white balance, or setting a specific light temperature, is more specific and typically renders more neutral (or accurate) color.

3.8 This image was taken using the Flash White Balance setting.

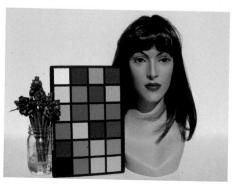

3.9 This image was taken using the Automatic White Balance (AEB) setting.

Approaches to using various white balance options

Because the XS/1000D offers two basic approaches to setting white balance, you may find that you use different approaches in different shooting scenarios. Following are examples for thinking about how you would use the different approaches. Note that color rendition is also affected by Picture Styles (detailed later in this chapter), and I mention them here so that you'll be aware of the interaction with white balance settings.

Using preset white balance settings. For outdoor shooting, especially during clearly defined lighting situations such as bright daylight, an overcast sky, or shooting indoors in fluorescent light, the preset white balance settings perform nicely with the possible exception of tungsten, which tends toward an excessively yellow/orange rendering. In general, the preset white

balance settings have good color and hue accuracy and good saturation. However, as you shoot, watch the image histograms for oversaturation in any of the color channels, particularly when using the Standard or Landscape Picture Styles. You may want to change the parameters of the Picture Style or use another Picture Style.

Setting a custom white balance. Setting a custom white balance is an option that produces very accurate color because the white balance is set precisely for the light in the scene. To use this option, you photograph a white or gray card and select the image in the camera; then the camera imports the color data and uses it to set the

color temperature for images. This approach is effective when you're shooting a series of shots in scenes where the light doesn't change. But if the light changes, you have to repeat the process to set a new custom white balance or switch to a preset white balance. Certainly for JPEG capture, this is an accurate technique that I highly recommend. For RAW capture, this and other techniques work well.

Note

Gray cards are specifically designed to render accurate color by providing a neutral, white-balance reference point that's used either in the camera to set a custom white balance, or later during image editing to color-balance images.

Getting Accurate Color with RAW Images

If you are shooting RAW capture, a great way to ensure accurate color is to photograph a white or gray card that is in the same light as the subject, and then use the card as a point of reference when processing RAW images on the computer.

For example, if you're taking a portrait, ask the subject to hold the gray card under or beside his or her face for the first shot, and then continue shooting without the card in the scene. When you begin converting the RAW images on the computer, open the picture that you took with the card. Click the card with the white balance tool to correct the color, and then click Done to save the corrected white balance settings. If you're using a RAW conversion program such as Adobe Camera Raw or Canon's Digital Photo Professional, you can copy the white balance settings from the image you just color-balanced, select all of the images shot under the same light, and then paste the white balance settings to them. In a few seconds, you can color-balance 10, 20, 50, or more images.

There are a number of white and gray card products you can use, such as the WhiBal cards from RawWorkflow.com (www.rawworkflow.com/products/whibal) or ExpoDisc from expoimaging (www.expodisc.com/index.php), to get a neutral reference point. There are also small reflectors that do double duty by having one side in 18 percent gray and the other side in white or silver. The least expensive option, and one that works nicely, is a plain, white unlined index card.

Tip

Whatever your approach to white balance options, the time you spend using and understanding them and how they can enhance your images is time that you'll save color-correcting images on the computer.

To change to a preset white balance option such as Daylight, Tungsten, Shade, and so on, follow these steps:

- Set the Mode dial to P, Av, Tv, M, or A-DEP. In the automatic Basic Zone modes, such as Full Auto, Portrait, and so on, the XS/1000D automatically sets the white balance, and you cannot change it.
- Press the WB button on the back of the camera. The White balance screen appears.
- 3. Press the left or right cross key to select a white balance setting. The white balance settings are shown with text and icons that represent different types of light. The white balance option you set remains in effect until you change it.

Set a custom white balance

Scenes in which there is a mix of lighting, such as tungsten and daylight, can make getting accurate or visually pleasing image color a challenge. Two options work well to get neutral color quickly in mixed lighting scenes. If you're shooting RAW capture, one option is to shoot a gray or white card as described in the earlier sidebar. The second option is to set a custom white balance. Setting a custom white balance balances colors for the specific light or combination of light types in the scene. A custom white balance is relatively easy to set, and it's an excellent way to ensure accurate color.

Because I shoot RAW capture, I alternate between setting a custom white balance and shooting a white card so that I can colorbalance groups of images dur-RAW conversion. techniques work in the same general way, but they differ on when you set the white balance. With a custom white balance. you set it as you're shooting; with the gray- or white-card technique, you set it during RAW image conversion. Both techniques involve roughly the same amount of time and effort.

Another advantage to custom white balance is that it works whether you're shooting JPEG or RAW capture in a Creative Zone mode. Just remember that if light changes, you need to set a new custom white balance to get accurate color.

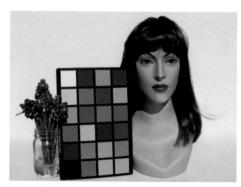

3.10 This image was captured using a custom white balance, and it shows excellent accuracy of colors throughout the different elements in the image. Setting a custom white balance takes a bit more time, but the results are worth the extra effort. Exposure: ISO 100, f/11, 1/400 second.

To set a custom white balance, follow these steps:

- 1. Set the camera to P, Av, Tv, M, or A-DEP, and ensure that the Picture Style is not set to Monochrome. To check the Picture Style, press the Picture Style button (the down cross key) on the back of the camera. The Picture Style screen is displayed. If the M (Monochrome) Picture Style is highlighted, press the left or right cross key to select another style except for 1, 2, or 3, and then press the Set button.
- 2. In the light that is used for the subject, position a piece of unlined white paper so that it fills the center of the viewfinder, and take a picture. If the camera cannot focus, switch the lens to MF (manual focus) and focus on the paper. Also ensure that the exposure is neither underexposed nor overexposed such as by having Exposure Compensation set. For this picture, you can have the camera set to any of the preset white balance settings.
- Press the Menu button, and then press the left cross key to select the Shooting 2 (red) menu.
- 4. Press the up or down cross key to highlight Custom WB, and then press the Set button. The camera displays the last image captured (the white piece of paper) with a Custom white balance icon in the upper left of the display. If the image of the white paper is not displayed, press the left cross key until it is.
- Press the Set button. The XS/1000D displays a confirmation screen asking if you want to use

- the white balance data from this image for the custom white balance.
- Press the right cross key to highlight OK, and then press the Set button. A screen appears, reminding you to set the white balance to Custom.
- 7. Press the WB button on the back of the camera, and then press the right cross key to select Custom White Balance. The Custom White Balance setting is denoted by text and an icon with two triangles on their sides with a black square between them.
- 8. Press the Set button. You can begin shooting now and get custom color in the images as long as the light doesn't change. The custom white balance remains in effect until you change it by setting another white balance. When you finish shooting in the light for which you set the custom white balance and move to a different area or subject, remember to reset the white balance option.

Use White Balance Bracketing

Because of the wide range of indoor tungsten, fluorescent, and other types of lights that are available, the preset white balance options may or may not be spot-on accurate for the type of light in the scene. And even if the preset white balance options are accurate, you may prefer a rendering with a bit more of a magenta/green or blue/amber bias in the overall image color. With the XS/1000D, you can use White Balance Auto Bracketing to get a set of three images, each a slightly different color bias up to plus or minus three levels in one-step increments. White Balance Auto Bracketing is handy when you don't know which color bias will give the most pleasing color, or when you don't have time to set a manual white balance correction (detailed next in this section). The white balance bracketed sequence gives you three images from which to choose the most visually pleasing color. If you're shooting JPEG capture in Creative Zone shooting modes and use the Standard, Portrait, or Landscape Picture Styles, white balance bracketing can be a good choice to reduce the amount of color-correction time you spend on the computer.

Note

White Balance Auto Bracketing reduces the maximum burst rate of the Rebel XS/1000D by one-third because three images are taken for the bracketed sequence. Bracketing also slows the process of writing images to the SD (Secure Digital) card.

To set White Balance Auto Bracketing, follow these steps:

- Press the Menu button, and then press a cross key until the Shooting 2 (red) menu is selected.
- Press the up or down cross key to highlight WB SHIFT/BKT, and then press the Set button. The WB Correction/WB Bracketing screen appears.
- 3. Turn the Main dial clockwise to set Blue/Amber bias, or counterclockwise to set a Magenta/Green bias. As you turn the Main dial, three squares appear and the distance between them increases as you continue to turn the dial. The distance between the squares sets the amount of bias. On the right side of the screen, the camera indicates the bracketing direction

- and level under BKT. You can set up to plus or minus three levels of bias
- Press the Set button. The Shooting
 (red) menu appears.
- Lightly press the Shutter button to dismiss the menu.
- 6. If you're in One-shot drive mode, press the Shutter button three times to capture the three bracketed images, or if you're in Continuous drive mode, press and hold the Shutter button to capture the three bracketed images. As you shoot, the White balance icon on the LCD and in the viewfinder flashes until all three bracketed images are made. With a blue/ amber bias, the standard white balance is captured first, and then the bluer and more amber bias shots are captured. If magenta/green bias is set, then the image-capture sequence is the standard, followed by more magenta bias, and then more green bias.

Note

You can combine White Balance Bracketing with Auto Exposure Bracketing. If you do this, a total of nine images are taken for each shot.

White Balance Bracketing continues until it is cleared or the camera is turned off.

Set White Balance Shift

White Balance Correction is similar to White Balance Auto Bracketing, but with White Balance Shift, you manually set the color bias of images to a single bias. White Balance Shift is similar to using a color-correction filter for a specific light source. With White Balance Shift, you can bias the color toward blue (B), amber (A), magenta (M), or green (G) in plus or minus nine levels measured as mireds, or

densities. Each level of color correction that you set is equivalent to five mireds of a color-temperature conversion filter. When you set a color shift or bias, it is used for all images until you change the setting.

Note

On the Rebel XS/1000D, color compensation is measured in mireds, a measure of the density of a color-temperature conversion filter, which is similar to densities of color-correction filters used in film photography that range from 0.025 to 0.5. Shifting one level of blue/amber correction is equivalent to five mireds of a color-temperature conversion filter.

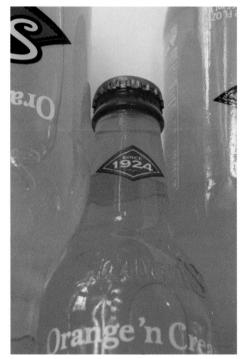

3.11 This image was taken in tungsten light with a custom white balance. The colors are neutral but lack warmth. Exposure for this and figure 3.12: ISO 100, f/11, 1/6 second.

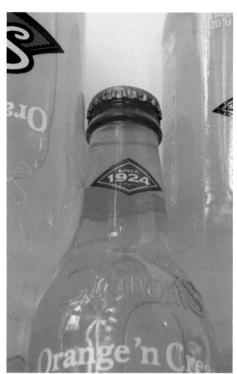

3.12 This image was taken in tungsten light with a custom white balance and with a White Balance Shift of Amber 6/Magenta 5 to warm up the orange soda and gold cap colors. The shift is intentionally exaggerated here for the printed book.

To set White Balance Correction, follow these steps:

- Press the Menu button, and then turn the Main dial to select the Shooting 2 (red) menu.
- Press the up or down cross key to highlight WB SHIFT/BKT, and then press the Set button. The WB Correction/WB Bracketing screen appears.
- Press a cross key to set the color bias and amount that you want toward blue, amber, magenta, or green. On the right of the screen,

How Color Temperature Is Determined

Unlike air temperature, which is measured in degrees Fahrenheit (or Celsius), light temperature is based on the spectrum of colors that is radiated when a black body radiator is heated. Visualize heating an iron bar. As the bar is heated, it glows red. As the heat intensifies, the metal color changes to yellow, and with even more heat, it glows blue-white. In this spectrum of light, color moves from red to blue as the temperature increases.

This concept can be confusing because "red hot" is often thought of as being significantly warmer than blue. But in the world of color temperature, blue is, in fact, a much higher temperature than red. That also means that the color temperature at noon on a clear day is higher (bluer) than the color temperature of a fiery red sunset. And the reason that you should care about this is because it affects the color accuracy of your images. So as you use color temperatures, keep this general principle in mind: The higher the color temperature is, the cooler (or bluer) the light; the lower the color temperature is, the warmer (or yellower/redder) the light.

the SHIFT panel shows the bias and correction amount. For example, A2, G1 shows a two-level amber correction with a one-level green correction. If you change your mind and want to start again, press the Disp. button on the back of the camera.

4. Press the Set button. The color shift you set remains in effect until you change it. To turn off White Balance Correction, repeat Steps 1 and 2, and in Step 3, press the Disp. button to return the setting to zero.

Choosing and Customizing a Picture Style

On the XS/1000D, Picture Styles determine how the camera delivers tonal curves, color rendering, color saturation, and sharpness in the final image. The XS/1000D applies a Picture Style for every image that you shoot, and that style is the foundation for how images are rendered.

The XS/1000D offers six Picture Styles, which are detailed in Table 3.2. The Standard Picture Style is the default style for Creative Zone shooting modes and for some Basic Zone modes. All Picture Styles have specific settings for sharpness, contrast, color saturation, and color tone. Individual styles with different settings can mimic the look of films such as Fuji Velvia, for rendering landscape and nature shots with vivid color saturation, or Kodak Portra, for rendering portraits with warm, soft skin tones and subdued color saturation. You can also modify Picture Style settings to suit your preferences, and you can create up to three User Defined Styles that are based on one of Canon's Picture Styles.

Figures 3.13 to 3.19 show how Picture Styles change image renderings. They can help you evaluate how each Picture Style affects a range of colors. The images in this next sequence were shot using custom white balance.

3.13 This image was made using the Standard Picture Style. Exposure for this series of images: ISO 100, f/5.6, 1/1000 sec. using -0.67 Exposure Compensation.

3.16 Neutral Picture Style. Color is neutral with a lower overall contrast than the Standard Picture Style; however, it provides very pleasing color.

3.14 Portrait Picture Style. The color saturation and sharpness are much more subdued, but this leaves latitude for RAW conversion adjustments and editing in Photoshop.

3.17 Faithful Picture Style. This style is colorimetrically adjusted to 5500K with low color saturation.

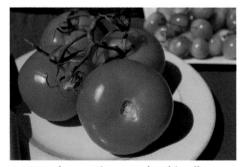

3.15 Landscape Picture Style. This offers a modified tonal curve and saturated colors, particularly greens and blues.

Besides forming the basis of image rendering, Picture Styles are designed to produce classic looks that need little or no post-processing so that you can print JPEG images directly from the SD/SDHC card with prints that look sharp and colorful. If you shoot RAW capture, you can't print directly from the SD/SDHC card, but you can apply Picture Styles either in the camera or during conversion using Canon's Digital Photo Professional conversion program. You can also use the new Picture Style Editor to modify and save changes to Picture Styles for captured

3.18 Monochrome Picture Style and no filter effect. This option offers snappy contrast and a nice overall tonal range.

images. The Picture Style Editor is included on Canon's EOS Digital Solution Disk that comes with the camera.

Regardless of whether you use direct printing, test Picture Styles, and then choose the ones that provide the best prints for both your JPEG and RAW capture image capture when you shoot in P, Tv, Av, M, or A-DEP shooting modes.

Choosing and customizing Picture Styles is how you get the kind of color results out of the camera that you need, whether you prefer the higher contrast and saturation look of the Standard style, or the more neutral saturation and color rendition of the Neutral and Faithful styles. Following are parameter

adjustments that you can modify for each Picture Style in Creative Zone modes.

- ♦ Sharpness: 0 to 7. Level zero applies no sharpening and renders a soft look. Using a high range of sharpening can introduce sharpening halos, particularly if you also sharpen after editing and sizing the image in an image-editing program. If you print images directly from the SD/SDHC card, a moderate amount of sharpening, such as level 3 or 4, produces sharp images.
- Contrast. The important thing to know about contrast is that the changes you make affect the image's tonal curve. A negative adjustment produces a flatter look, but it helps to avoid clipping, or discarding bright highlight tones or dark shadow tones. A positive setting increases the contrast and can clip tones.
- ◆ Saturation. This setting affects the strength or intensity of the color with a negative setting producing low saturation and vice versa. The key to using this setting is to find the point at which individual color channels do not clip. A +1 or +2 setting is adequate for snappy JPEG images destined for direct printing.
- Color Tone. Negative adjustments to color tone settings produce redder skin tones while positive settings produce yellower skin tones.

With the Monochrome Picture Style, only the sharpness and contrast parameters are adjustable, but you can add toning effects, as detailed in Table 3.2. Default settings are listed in order of sharpness, contrast, saturation, and color tone.

Table 3.2
EOS XS/1000D Picture Styles

Picture Style	Description	Sharpness	Color Saturation	Default Settings
Standard	Vivid, sharp, crisp images that are suitable for direct printing from the SD/SDHC card	Slightly high	High	3,0,0,0
Portrait	Enhanced skin tones, soft texture rendering, low sharpness	Slightly low	Slightly high	2,0,0,0
Landscape	Vivid blues and greens, high sharpness	High	High satura- tion for greens and blues	4,0,0,0
Neutral	Allows latitude for image editing and has low saturation and contrast	None	Low	0,0,0,0
Faithful	True rendition of colors with no increase in specific colors. No sharpness applied.	None	Low	0,0,0,0
Monochrome	Black-and-white or toned images with slightly high sharpness	Slightly high	Yellow, orange, red, and green fil- ter effects available. Toning effects: Sepia, Blue, Purple, and Green.	3,0, N/A, N/A

It seems logical that a zero setting for one Picture Style would directly correspond to the same setting in another style. For example, a zero Contrast setting on Standard would correspond to a zero setting on the Portrait Style. But that's not necessarily true, and the differences in the tonal curve are sometimes enough to result in clipping. You can evaluate the effect of the tonal curve on RAW images in the histogram shown in Canon's Digital Photo Professional program.

You can choose a Picture Style by following these steps:

- 1. Press the Picture Style button on the back of the camera. The Picture Style screen appears with the current Picture Style highlighted. The screen also shows the default setting for the style to the left.
- 2. Press the up or down cross key to highlight the Picture Style you want, and then press the Set button.

After using, evaluating, and printing with different Picture Styles, you may want to change the default parameters to get the rendition that you want. Additionally, you can create up to three Picture Styles that are based on an existing style.

After much experimentation, I settled on a modified Neutral Picture Style that provides pleasing results for my work. Here are the settings I used when I modified the Neutral Picture Style settings.

- Sharpness. +3
- Contrast. +1
- Saturation, +1
- **Color tone.** 0

These settings provide excellent skin tones provided that the image isn't underexposed and the lighting isn't flat. You can try this variation and modify it to suit your preferences for image rendering.

To modify a Picture Style, follow these steps:

 Press the Menu button, and then turn the Main dial to select the Shooting 2 (red) menu.

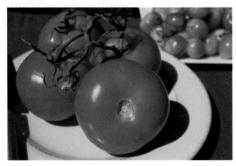

3.19 This image uses my modified settings, which are based on the Neutral Picture Style.

- 2. Press the up or down cross key to highlight Picture Style, and then press the Set button. The Picture Style screen appears with a list of the preset Picture Styles.
- 3. Press the up or down cross key to highlight the Picture Style you want to modify, and then press the Disp. button. The Detail set. screen appears for the selected Picture Style.
- 4. Press the Set button to change the Sharpness parameter that is selected by default. The Sharpness control is activated.
- 5. Press the left or right cross key to change the parameter, and then press the Set button. For all the parameter adjustments, negative settings decrease sharpness, contrast, and saturation, and positive settings increase sharpness, contrast, and saturation. Negative color tone settings provide reddish skin tones, and positive settings provide yellowish skin tones.
- Press the down cross key to move to the Contrast parameter, and then press the Set button. The camera activates the control.
- Press the left or right cross key to adjust the parameter, and then press the Set button.
- Repeat Steps 6 and 7 to change additional parameters.
- 9. Press the Menu button. The Picture Style screen appears where you can modify other Picture Styles. The Picture Style changes remain in effect until you change them. Press the Set button to return to the Shooting 2 (red) menu, or lightly press the Shutter button to dismiss the menu.

Using Monochrome Filter and Toning Effects

While you can customize the Monochrome Picture Style, only the Sharpness and Contrast parameters can be changed. However, you have the additional option of applying a variety of filter and/or toning effects.

- Monochrome Filter effects. Filter effects mimic the same types of color filters that photographers use when shooting black-and-white film. The Yellow filter makes skies look natural with clear white clouds. The Orange filter darkens the sky and adds brilliance to sunsets. The Red filter further darkens a blue sky, and makes fall leaves look bright and crisp. The Green filter makes tree leaves look crisp and bright and renders skin tones realistically.
- Monochrome Toning effects. You can choose to apply a creative toning effect when shooting with the Monochrome Picture Style. The Toning effect options are None, S: Sepia, B: Blue, P: Purple, and G: Green.

Registering a User Defined Picture Style

With an understanding of the settings that you can change with Picture Styles, you can create a Picture Style to suit your preferences. Each style that you create is based on one of Canon's existing styles, which you can choose as a base style.

And because you can create three User Defined Picture Styles, there is latitude to set up styles for different types of shooting situations. For example, you might want to create your own Picture Style for everyday photography that is less contrasty than the Standard Picture Style. While you could modify the existing Standard style, you may want to use it when you know that you're going to print images directly from the SD/SDHC card, and use the User Defined Picture Style for images you want to edit on the computer before printing.

To create and register a User Defined Picture Style, follow these steps:

- Press the Menu button, and then turn the Main dial to select the Shooting 2 (red) menu.
- 2. Press the down cross key to select Picture Style, and then press the Set button. The Picture Style screen appears.
- 3. Press the down cross key to scroll down and highlight User Def. 1, and then press the Display button. The Detail set. User Def. 1 screen appears with the base Picture Style, Standard displayed.
- **4. Press the Set button.** The Picture Style control is activated so that you can choose a different base Picture Style if you want.
- Press the up or down cross key to select a base Picture Style, and then press the Set button.
- 6. Press the down cross key to highlight the Sharpness parameter, and then press the Set button. The camera activates the parameter's control.

- Press the left or right cross key to set the parameter and then press the Set button.
- 8. Repeat Steps 6 and 7 to change the remaining settings. The remaining parameters are Contrast, Saturation, and Color tone.
- 9. Press the Menu button to register the style. The Picture Style selection screen appears. The base Picture Style is displayed to the right of User Def. 1. If the base Picture Style parameters were changed, then the Picture Style on the right of the screen is displayed in blue. This Picture Style remains in effect until you change it.
- Press the Set button. Repeat these steps to set up User Def. 2 and 3 styles.

Using the Picture Style Editor

Modifying preset Picture Styles and registering a User Defined Picture Style are two approaches to getting Picture Styles that render images to your liking. But these approaches are experimental: You set the style, capture the image, and then check the results on the camera and on the computer until you get the results you want.

A more precise and efficient approach to getting Picture Styles that you want is to use the Picture Style Editor program that is included on the EOS Digital Solution Disk. Using a RAW image you've already captured, you can apply a Picture Style and make changes to the style while watching the effect of the changes as you work on the computer. Then you save the changes as a

Picture Style file (PF2), and use the EOS Utility to register the file in the camera and apply it to images.

The Picture Style Editor looks simple, but it offers powerful and exact control over the style: for example, you can apply color specifications and minute adjustments to hue, saturation, luminosity, and gamma (tonal curve) characteristics. Up to 100 color points can be selected in the color specifications, and three color display modes — HSL (Hue, Saturation, Luminosity), Lab, and RGB — are available. You can also set the color work space display, such as Adobe RGB. A histogram display shows the distribution of luminance and color in the sample image, and the display can be switched to luminance, RGB, or R, G, and B. If you are familiar with Canon's Digital Photo Professional program, then the color tones will be familiar because the Picture Style Editor uses the same algorithms for image processing. You can set up to ten points anywhere on the tone curve and watch the effect of the change to the sample image in the main window.

In addition, you can compare before and after adjustments in split windows with magnification from 12.5 to 200 percent. Because the goal of working with the Picture Style Editor is to create a Picture Style file that you can register in the camera, the adjustments that you make to the sample RAW image are not applied to the image. Rather, the adjustments are saved as a file with a .PF2 extension. However, you can apply the style in Digital Photo Professional after saving the settings as a PF2 file.

While the full details of using the Picture Style Editor are beyond the scope of this book, I encourage you to read the Picture Style Editor descriptions on the Canon Web site at web.canon.jp/imaging/picturestyle/editor/index.html.

Be sure you've installed the EOS Digital Solution Disk programs before you begin. To start the Picture Style Editor, follow these steps:

- 1. Choose Start ⇔ All
 Programs ⇔ Canon
 Utilities ⇔ Picture Style Editor. On
 the Mac, choose
 Applications ⇔ Canon
 Utilities ⇔ Picture Style
 Editor ⇔ Picture Style
 Editor ⇔ Picture Style Editor.app. The
 Picture Style Editor main window
 appears.
- 2. Drag a RAW image (labeled with a .CR2 extension) onto the main window. You can also choose File ⇒ Open image, and navigate to a folder that contains RAW images, double-click a RAW file, and then click Open. When the file opens, the Picture Style Editor displays the Tool palette.
- Click the arrow next to Base
 Picture Style if you want to select
 a Picture Style other than
 Standard.
- 4. At the bottom of the main window, click one of the split screen icons to show the original image and the image with the changes you make side by side. You can choose to split the screen horizontally or vertically. Or if you want to switch back to a single image display, click the far-left icon at the bottom of the window.
- 5. Click Advanced in the Tool palette to display the parameters for Sharpness, Contrast, Color saturation, and Color tone. These are the same settings that you can change on the camera. However, with the

- Picture Style Editor, you can watch the effect of the changes as you apply them to the RAW image.
- Make the changes you want, and then click OK.
- 7. Adjust the color, tonal range, and curve using the palette tools. If you are familiar with image-editing programs, or with Digital Photo Professional, most of the tools will be familiar. Additionally, you can go to the Canon Web site at web. canon.jp/imaging/picturestyle/editor/functions.html for a detailed description of the functions.

When you modify the style to your liking, you can save it and register it to use in the XS/1000D. However, when you save the PF2 file, I recommend saving two versions of it. During the process of saving the file, you can choose the Disable subsequent editing option, which prevents disclosing the adjustments that have been made in the Picture Style Editor as well as captions and copyright information. This is the option to turn on when you save a style for use in the XS/1000D and in the Digital Photo Professional program. But by turning on that option, the style file can no longer be used in the Picture Style Editor.

For that reason, you'll likely want to save a second copy of the PF2 file without turning on the Disable subsequent editing option in the Save Picture Style File dialog box. That way, if you later decide to modify the style, you can use the Picture Style Editor to make adjustments to this copy of the PF2 file.

Before you begin, ensure that you've installed the EOS Digital Solution Disk programs on your computer.

To save a custom Picture Style, follow these steps:

- Click the Save Picture Style File icon at the top far right of the Picture Style Editor tool palette. The Save Picture Style File dialog box appears.
- Navigate to the folder where you want to save the file.
- 3. To save a file to use in the XS/1000D, click the Disable subsequent editing option at the bottom of the dialog box. To save a file that you can edit again in the Picture Style Editor, do not select this option.
- 4. Type a name for the file in the Save As box, and then click Save. The file is saved in the location you specified with a .PF2 file extension.

To install the custom Picture Style on the XS/1000D, follow these steps. Before you begin, be sure that you have the USB cable that came with the camera available.

- Connect the camera to the computer using the USB cable supplied in the XS/1000D box.
- 2. Choose Start ⇔ All
 Programs ⇔ Canon Utilities ⇔ EOS
 Utility. On the Mac, choose
 Applications ⇔ Canon
 Utilities ⇔ EOS Utility ⇔ EOS Utility.
 app. The EOS Utility screen
 appears.
- Click Camera settings/Remote shooting under the Connect Camera tab in the EOS Utility. The capture window appears.
- Click the camera icon in the red tool bar, and then click Picture Style. The Picture Style window appears.

- Click Detail set at the bottom of the Picture Style list. The Picture Style settings screen appears.
- 6. Click the arrow next to Picture Style, and then click User Defined 1, 2, or 3 from the drop-down menu that appears. If a Picture Style file was previously registered to this option, the new style overwrites the previous style. When you select User Defined, additional options appear.
- **7. Click Open.** The Open dialog box appears.
- 8. Navigate to the folder where you saved the Picture Style file that you modified in the Picture Style Editor, and click Open. The Picture Style settings dialog box appears with the User Defined Picture Style displaying the modified style you opened. If necessary, you can make further adjustments to the file before applying it.
- 9. Click Apply. The modified style is registered in XS/1000D. It's a good idea to verify that the style was copied by pressing the Picture Style button on the back of the XS/1000D, and then selecting the User Defined Style you registered to see if the settings are as you adjusted them.

In addition to creating your own styles, you can download additional Picture Styles from the Canon Web site at web.canon.jp/imaging/picturestyle/index.html. You can download these files, and then register them in the XS/1000D using the steps provided on the Canon Web site.

Using Live View

he Live View feature on the EOS Rebel XS/1000D offers a familiar shooting technique for people who are upgrading from a point-and-shoot digital camera. On a digital SLR, Live View shooting offers some advantages: it offers flexibility in framing images, particularly when you are crouching down to examine the shot through the viewfinder, which requires unnatural body contortions; it offers a large LCD view that can be magnified up to 10x to ensure tack-sharp automatic or manual focus; and it can be used with the camera connected to a computer with control of the camera offered on the computer using the EOS Utility program.

Unlike on a point-and-shoot camera, the Live View shooting function is useful in specific, rather than in all shooting situations including macro and still-life work, when shooting tethered, or where the camera is connected by a cable to a computer. In short, it is most useful in controlled and close-up shooting scenarios.

About Live View

The concept of the camera being able to hold the shutter open to provide a real-time view of the scene and yet pause long enough to focus is impressive in terms of technology for digital SLR cameras. And even more impressive is the quality of the live view that the XS/1000D provides, which is smooth and detailed.

Although Live View shooting has an admittedly high "coolness" factor, it comes with cautionary notes. With continual use of Live View shooting, the sensor heats up quickly, and the battery life diminishes markedly. So if you're making the transition from a point-and-shoot camera to the XS/1000D, it pays to use Live View shooting only for specific shooting scenarios, and otherwise to compose images using the view-finder.

More specifically, here is what you can expect with Live View shooting:

- ♦ Battery life and flash use affect the number of shots you can get using Live View. With a fully charged LP-E5 battery, you can expect 200 shots without flash use and approximately 190 shots with 50-percent flash use in 73-degree temperatures. In freezing temperatures, you can expect 190 shots without flash use and 180 shots with 50-percent flash use per charge. With a fully charged battery, you'll get approximately 30 minutes of continuous Live View shooting before the battery is exhausted.
- Avoid digital noise and color problems in images. Both high temperatures and ISO speeds, as well as long exposures, can cause digital noise or irregular color in images taken using Live View. And because continuous Live View shooting can cause high internal camera temperatures and degrade image quality, you should stop using Live View when you're not shooting.
- Don't use extension tubes or tiltand-shift lenses when shooting in Live View. Using either in Live View can cause incorrect exposures.
- You cannot use the option Remote Switch RS-60E3 when shooting in Live View.

Live View Features and Functions

Before you shoot in Live View mode, it's important to understand some of the functions that change, particularly the three

focusing methods and metering in Live View shooting. This section gives you an overview of shooting, and the next section provides step-by-step instructions for setting up the XS/1000D for Live View shooting.

Live View focusing

With Live View shooting, you have three focusing options: Quick mode, which uses the camera's seven-point autofocus system; Live mode, which is a contrast-based autofocus system that reads the sharpness of subjects directly from the image sensor; or manual focusing. Of the three focusing options, manual focusing with the image magnified provides the most precise focusing.

By necessity, the camera's reflex mirror must remain locked up to provide the live view of the scene. When you use Quick mode to focus, Live View is momentarily interrupted so that the mirror can drop to establish focus. During that time, you cannot make the picture, but you can make the picture after focus is achieved and Live View resumes. In Quick mode, you can choose any of the AF points in the viewfinder for focusing before you begin shooting in Live View.

The second autofocusing mode, Live mode, uses contrast detection based on data from the image sensor. Focusing with this method is slower than with Quick mode, and the camera may have difficulty focusing, but the live view of the scene is not interrupted as it is with Quick mode.

The third focusing option is manual focusing that provides sharp focus, particularly if you are working with a magnified view of the image on the LCD. This method takes a sharp eye and it helps to magnify the view before making the shot.

For details on focusing and drive modes, see Chapter 2.

Exposure simulation and metering

As you move the camera in Live View, the Rebel XS/1000D updates the LCD to show the scene as it simultaneously meters the changing scene light. To show you whether the LCD view is close to what the final picture will be, the XS/1000D superimposes an Exp.SIM icon on the LCD display. If the icon blinks, it means that the image simulation is not displayed at the suitable brightness level because of very low or bright ambient light. Also, if Custom Function, C.Fn-5, is enabled, which it is by default on the XS/1000D, then Auto Lighting Optimizer automatically corunderexposed and low-contrast images. As a result, images may appear brighter than they would without using Auto Lighting Optimizer.

Note

Auto Lighting Optimizer also corrects image brightness if you have set exposure modifications such as negative Exposure Compensation. To see the effect of exposure modifications, disable C.Fn-5, Auto Lighting Optimizer, by choosing Option 1: Disable. Custom Functions are detailed in Chapter 5.

As you move the camera around a scene, or as the light changes, the exposure must be updated accordingly. You can choose the amount of time that the exposure is retained, and the options are from 4 seconds to 30 minutes. A longer time speeds up Live View shooting overall, and this option works well when the scene light is controlled or constant.

You can also use the Depth of Field Preview button on the front of the camera. And if you are tethered to the computer (the camera is connected to the computer using the supplied USB cable), the EOS Utility Remote Live View window also enables you to preview the depth of field using the program's controls.

By setting the Live View function settings on the Set-up 2 (yellow) menu, you can choose to display a handy 3×3 grid on the LCD to help align vertical and horizontal lines in the image.

Using a flash

You can also use the built-in flash or an accessory EX-series Speedlite with Live View shooting. When the built-in flash or an accessory EX-series Speedlite is used, the shooting sequence after fully pressing the Shutter button is for the reflex mirror to drop to allow the camera to gather the preflash data, and then the mirror to move up out of the optical path for the actual exposure. As a result, you hear two quick shutter clicks, but only one image is taken. Here are some things you should know about using Live View shooting with a flash unit.

- With an EX-series Speedlite, FE (flash exposure) Lock, modeling flash, and test firing cannot be used, and the Speedlite's Custom Functions cannot be set on the flash unit.
- Non-Canon flash units will not fire.

Setting Up for Live View

Before you begin using Live View shooting, decide on the focusing method that you want to use and whether you want to turn off Auto Lighting Optimizer, which automatically adjusts underexposed and low-contrast

images. The next step is to set the options on the camera menu to activate Live View shooting and set your preferences for focusing and metering.

It's also a good idea to spend a few minutes setting up Custom Functions, especially if you want to use autofocusing instead of focusing manually.

Setting Live View Custom Functions

While Chapter 5 details setting Custom Functions (C.Fn), there are two functions you should set before you begin using Live View shooting. For the sake of convenience, they are included here.

C.Fn-7

AF during Live View shooting determines whether you use the camera's built-in autofocus system during Live View shooting. The function is set to Disable by default. To use the camera's autofocus system, you must turn on either Quick mode or Live mode, both of which are explained in the next section of this chapter.

Tip If you choose not to use either of the autofocus methods, you can focus in Live View manually, a technique that is detailed later in this section.

To set this Custom Function so that you can use the XS/1000D's autofocus system during Live View shooting, follow these steps:

- Set the Mode dial to P, Tv, Av, M, or A-DEP.
- Press the Menu button, and then press the right cross key until the Set-up 3 (yellow) menu is displayed.

- Press the up or down cross key to highlight Custom Functions (C. Fn), and then press the Set button. The Custom Functions screen appears.
- 4. Press the right or left cross key until the Custom Function number "7" is displayed in the box at the top right of the screen, and then press the Set button. The Custom Function option control is activated and the option that is currently in effect is highlighted. Here is an explanation of each option.
 - 0: Disable. If you want to use manual focus, this is the option to choose. But if you want to use the XS/1000D's autofocus system, do not choose this option because it isn't possible to use the XS/1000D's onboard autofocus system in either Quick or Live modes.
 - 1: Quick mode. Using this option, you focus as you normally do in non-Live View shooting using the onboard autofocus system and with the focusing switch on the lens set to AF. When you focus, the reflex mirror flips down to establish focus, and that temporarily suspends Live View on the LCD. With this option, you can manually select any of the AF points in the viewfinder before you begin shooting in Live View.
 - 2: Live mode. Using this option, focusing is established using the image sensor. You can autofocus while the Live View image is displayed on the LCD, but focusing is slower and may be more difficult than with Option 1: Quick mode.

5. Press the up or down cross key to highlight the option you want, and then press the Set button. The option you choose remains in effect until you change it. Lightly press the Shutter button to return to shooting.

C.Fn-5

Auto Lighting Optimizer is an automatic exposure adjustment that corrects overly dark or underexposed images and boosts the contrast in low-contrast scenes such as in hazy or overcast light. While this may be a good option if you print directly from the SD/SDHC card, it "corrects" the effects of Bracketing Auto Exposure using Exposure Compensation so that you don't see the changes. For example, if you've set negative Exposure Compensation for shooting in Live View mode, the image will be automatically brightened by Auto Lighting Optimizer, negating the effect of Exposure Compensation.

If you want to disable Auto Lighting Optimizer for Live View shooting, follow these steps:

- Follow steps 1 to 4 in the previous step-by-step task, and then go to Step 2 below.
- 2. Press the right or left cross key until the Custom Function number "5" is displayed in the box at the top right of the screen, and then press the Set button. The Custom Function option control is activated and the option that is currently in effect is highlighted.
- 3. Press the down cross key to select 1: Disable, and then press the Set button. The option you choose remains in effect for pictures you make in Creative Zone modes such as P, Tv, Av, and so on,

until you change it. Lightly press the Shutter button to return to shooting.

Live View function settings

The second Live View pre-shooting task is to enable Live View shooting and set your preferences, including whether to display a grid on the LCD and how long the XS/1000D retains the current exposure settings.

To set up the Rebel for Live View shooting and to set your preferences, follow these steps:

- 1. Set the Mode dial to P, Tv, Av, M, or A-DEP.
- Press the Menu button, and then press the right cross key until the Set-up 2 (yellow) menu is displayed.
- 3. Press the up or down cross key to highlight Live View function settings, and then press the Set button. The Live View function settings screen appears with the Live View shoot option selected.
- 4. With the Live View shoot option highlighted, press the Set button. The camera activates the Live View shoot options.
- Press the down cross key to highlight Enable, and then press the Set button. The Live View function settings screen is displayed.
- 6. Press the down cross key to select Grid display, and then press the Set button. The Grid display options appear. Turning on the grid option displays a 3 × 3 grid on the LCD that helps you square up horizontal and vertical lines during Live View shooting.

- 7. Press the down cross key to highlight On, and then press the Set button. The default setting is Off. If you do not want the grid displayed, leave the setting to Off, and then press the Set button without making any changes. The Live View function settings screen is displayed.
- 8. Press the down cross key to highlight Metering timer, and then press the Set button. The Metering timer options, from 4 seconds to 30 minutes, appear.
- 9. Press the down or up cross key to highlight the timer option you want, and then press the Set button. Longer times speed up shooting, but if the light changes, you want the camera to meter for the light change, so balance the metering time based on the lighting changes versus performance of Live View.
- Lightly press the Shutter button to dismiss the menu.

You can press the Set button to begin shooting in Live View now, but you may want to read through the next sections before you begin.

Shooting in Live View

If you've completed the tasks up to now, you're ready to begin shooting in Live View. Live View is well suited for macro or still-life shooting. With this type of shooting, you most likely want to use either manual focusing or Quick mode autofocusing with manual tweaking. During focusing, you can enlarge the view up to 10x to ensure tack-sharp focus.

Another good option is to use Remote Live View with the camera connected, or tethered, to a computer. With the Remote Live View option, you connect the camera to the computer using the supplied USB cable and then control the camera on the computer. You can view the scene on the computer monitor in real time.

Either way, just a few minutes of watching the real-time view convinces you that a tripod is necessary for Live View shooting. With any focal length approaching telephoto, Live View provides a real-time gauge of just how steady or unsteady your hands are.

Focusing with Quick or Live mode

When you're shooting in Live View, you have choices on how to focus. You can choose Quick mode, Live mode, or manual focusing, as described earlier in this chapter. Shooting with each option is detailed below.

Quick mode focusing

Quick mode focusing uses the XS/1000D's seven-AF-point autofocus system and is useful for capturing action or shooting in low light. With this option, you press the AE Lock button on the back-right side of the camera to focus instead of half-pressing the Shutter button. And because this system uses the camera's autofocus system to measure subject contrast, when you press the AE Lock button down, the camera flips the mirror down briefly to focus on the subject. When focus is achieved, you press the Shutter button completely to make the picture, and then Live View resumes.

Before you begin, verify that the focusing switch on the side of the lens is set to AF (autofocus) and that you've set C.Fn-7 to Option 1: Quick mode.

To focus in Quick mode, follow these steps:

- Set the Mode dial to P, Tv, Av, M, or A-DEP, and then set the ISO, aperture, and/or shutter speed. Your settings depend on the shooting mode you chose. You can also use AEB, choose a Picture Style, and set the white balance for Live View shooting.
- Before you press the Set button to begin Live View shooting, press the Disp. button if the shooting information is not already displayed on the LCD. If the shooting information is displayed, skip this step.
- Press the AF Point Selection/ Magnify button on the top right of the back of the camera. The AF point selection screen appears on the LCD.

Note

If you have the camera set to A-DEP mode, skip Step 3. In A-DEP mode, the camera automatically selects the AF points, and you cannot change them.

- 4. Press a cross key to select the AF point that you want to use. You can also turn the Main dial to select the AF point.
- 5. Press the Set button to begin Live View shooting mode. The LCD displays the scene in real time. The selected AF point and a larger focusing frame are superimposed on the LCD Live View scene. You can move the focusing frame by pressing the cross keys. You may want to magnify the image by pressing the AF Point Selection/ Magnify button on the top-right back of the camera.

- 6. Position the camera so that the AF point is over the part of the subject that you want in sharp focus, and then hold down the AE Lock button. The AE Lock button is on the back-right side of the camera, and it has an asterisk above it. The reflex mirror flips down momentarily to establish focus and a beep confirms the focus. As long as you hold down the AE Lock button, you cannot press the Shutter button to make the picture.
- Release the AE Lock button to resume the Live View, and without moving the camera, press the Shutter button completely to make the picture.

Live mode focusing

Alternately, you can use Live mode focusing. In this mode, the mirror stays up and the shutter stays open so that Live View is not interrupted. In this mode, the camera detects contrast directly from the image sensor. You can move the focusing frame around approximately 80 percent of the screen by pressing and holding the cross keys to move the frame. You can also zoom in to 5x or 10x to verify the focus. If you use this mode, don't point the camera at a bright light source during Live View.

Verify that the lens focusing switch is set to AF, and that you've set C.Fn-7 to Option 2: Live mode. Then, to focus in Live View using Live mode, follow these steps:

 Set the Mode dial to P, Tv, Av, M, or A-DEP, and then set the ISO, aperture, and/or shutter speed. Your settings depend on the shooting mode you chose. You can also use AEB, choose a Picture Style, and set the white balance for Live View shooting.

- Press the Set button to begin Live View shooting. The scene is displayed in real time on the LCD along with the white focusing rectangle.
- 3. Position the camera so that the AF point is over the part of the subject that you want in sharpest focus, and then press the AE Lock button on the top-right back of the camera. The AE Lock button has an asterisk above it. You can also press the AF Point Selection/ Magnify button on the top far-right corner of the camera to magnify the view. The first press of the button enlarges the view to 5x, and a second press enlarges the view to 10x. The magnifications are shown on the LCD as X5 and X10. When focus is achieved, the AF point rectangle turns green and the beeper sounds. If focus isn't achieved, the AF point rectangle turns orange. Note also that in this mode, it may take slightly longer for the camera to achieve focus than you're accustomed to. When sharp focus is achieved, the Exp.SIM icon is displayed in white, confirming that the exposure is being accurately reflected in the view
- Release the AE Lock button, and then press the Shutter button completely to make the picture.
- 5. Press the Set button to return to standard (non-Live View) shooting mode. If you do not perform this step, the camera automatically closes the shutter when the camera Auto Power Off (Set-up 1 menu) delay elapses.

Manual focusing

Manual focusing, coupled with a magnified view in Live View shooting, provides the most precise focusing, especially if the XS/1000D is mounted on a tripod. Without a tripod, movement from handholding the camera makes sharp focus iffy at best.

To shoot in Live View using manual focus, follow these steps, but first ensure that C. Fn-7 is set to Option 0: Disable.

- Set the Mode dial to P, Tv, Av, M, or A-DEP, and then set the ISO, aperture, and/or shutter speed.
 Your settings will depend on the shooting mode you chose. You can also use AEB, choose a Picture Style, and set the white balance, and use AE Lock in Live View shooting. AE Lock is applied to the full-view exposure.
- Set the focusing switch on the side of the lens to MF (Manual Focus).
- **3. Press the Set button.** Live View is displayed on the LCD.
- 4. Compose the image as you want by moving the camera. You can press the Depth of Field Preview button on the front of the camera to gauge the depth of field. In A-DEP mode, the camera does not automatically select the AF points and calculate the optimal depth of field, so it responds in much the same way as if you were shooting in P (Program AE) mode.
- Press any of the cross keys to move the focusing frame, or to quickly select the center AF point, press the Erase (trash can) button on the back of the camera.

- 6. Press the AF Point Selection/ Magnify button on the top farright corner of the camera to magnify the view. The first press of the button enlarges the view to 5x, and a second press enlarges the view to 10x. These magnifications are shown on the LCD as X5 and X10.
- 7. Turn the lens focusing ring to focus. Once focus is achieved, you can press the AE Lock/Reduce button to return to full view.
- 8. Press the Shutter button completely to make the picture. The shutter fires to make the picture, the image playback is displayed, and then the Live View resumes.

Using Live View with tethered shooting

One of the best uses for Live View is shooting still-life subjects such as products, food, stock shots, and so on with the camera connected to a computer. You can set up with the XS/1000D connected to a computer using the USB cable supplied with the camera.

Before you begin, ensure that you have installed the EOS Digital Solution Disk on the computer to which you are connecting the camera.

To shoot in Live View with the XS/1000D tethered to the computer, follow these steps:

 Turn off the camera, and attach the USB cord to the Digital terminal located under the terminal covers on the side of the camera. Be sure that the icon on the cable connector faces the front side of the camera.

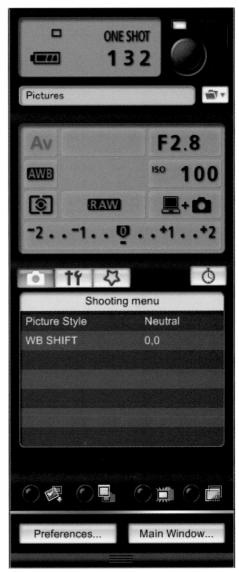

4.1 The EOS Utility Remote Shooting control panel

- Connect the other end of the USB cable to a USB terminal on the computer.
- Turn on the power switch on the camera and set the Mode dial to P, Tv, Av, or M. If this is the first

time you've connected the camera to the computer, the computer installs the device driver software and identifies the camera. If you're using Windows Vista, the AutoPlay dialog box appears. Click Downloads images from EOS camera using EOS Utility. The EOS Utility – EOS XS/1000D dialog box appears. If a camera model selection screen appears, select the EOS XS/1000D.

4. Click Camera settings/Remote shooting in the EOS Utility window on the PC, or double-click Applications/Canon Utilities/EOS Utility/EOS Utility.app on the Mac. The XS/1000D control panel appears. You can use the panel to control exposure settings, set the white balance, set the Picture Style, and set White-Balance Shift. To set exposure, double-click the aperture, ISO, and so on, and use the controls to adjust the settings.

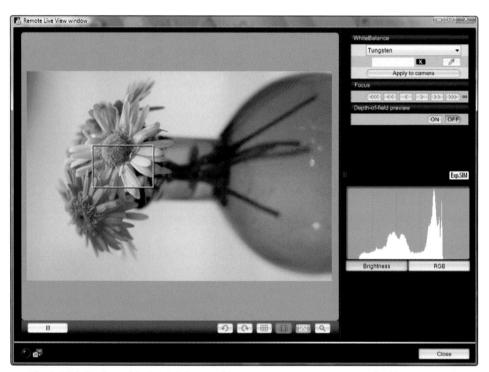

4.2 The initial display with the Brightness histogram. You can rotate vertical images to the correct orientation.

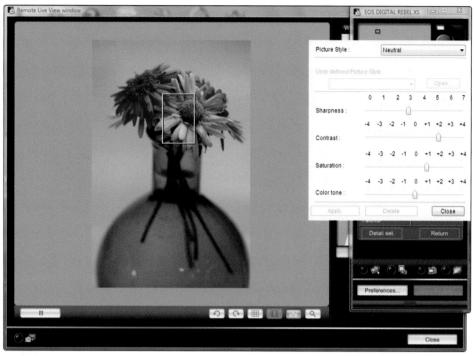

- 4.3 You can also set the Picture Style and the Picture Style parameters, displayed here, just as you would on the camera.
 - 5. Click the Remote Live View
 Shooting button (the third from
 the left button at the bottom
 right of the Remote Shooting control panel). The Remote Live View
 window appears. In this window,
 you can set the white point by
 clicking a white area or neutral gray
 area in the scene, use the controls
 to set the Exposure Compensation,
 preview the depth of field by clicking the On button, and switch
 between the Brightness and RGB
- histograms, and you can monitor the histogram as the camera moves or as lighting changes.
- 6. When the exposure and composition is set, you can magnify the view, and then focus using either Quick or Live mode focusing techniques detailed earlier in this chapter, or you can focus manually, depending on your setting for C.Fn-7.

90 Part II + Creating Great Photographs with the EOS Rebel XS/1000D

4.4 The Final image taken in Live View shooting using Quick mode autofocusing. Exposure: ISO 100,f/2.8, 1/15 second, using an EF 100mm f/2.8 Macro USM lens.

- Press the Shutter button at the top right of the EOS Utility control panel to make the picture. The Digital Photo Professional main window opens with the image selected.
- 8. When you finish, turn off the camera, and then disconnect the USB cable from the camera.

Customizing the EOS Rebel XS/1000D

he EOS Rebel XS/1000D offers excellent options for customizing the operation of controls and shooting functionality for everyday shooting and for shooting specific scenes and subjects.

The XS/1000D offers two helpful features for customizing the use and operation of the camera:

- Custom Functions. Twelve Custom Functions allow you to control functions ranging from whether digital noise reduction is applied for long-exposure and high-ISO images to the way the camera controls operate.
- My Menu. This is a feature where you can place six of your most often used menu items in priority order on a single menu for fast access.
- LCD Screen Colors. Whether it's a matter of increasing the readability of the LCD shooting information display, or just adding a bit of color and pizzazz to it, you have four options for personalizing the look of the display.

These customization features, used separately and in combination, provide a great way to spend less time tweaking camera settings and more time shooting.

Setting Custom Functions

If you're new to digital SLRs, then setting Custom Functions may not be at the top of your priority list in learning the camera. But from personal experience, I can say that the time you

In This Chapter

Setting Custom Functions

Customizing My Menu

Changing the screen color

spend reviewing and setting Custom Functions pays excellent dividends in your enjoyment of the camera and in getting the most from the Rebel XS/1000D. Custom Functions enable you to customize camera controls and operations to suit your shooting style; and, as a result, they can save you significant time.

The XS/1000D offers 12 Custom Functions ranging from exposure customizations to the functions of various buttons. Before you begin, there are a couple of points to keep in mind regarding Custom Functions:

- They can be set only in Creative Zone modes such as P, Tv, Av, M, and A-DEP.
- When you change a Custom Function, the change remains in effect until you reset it.
- If you go too far or get confused while setting Custom Functions, you can quickly reset all Custom Functions back to their defaults using the Clear settings option on the Set-up 3 (yellow) menu.

Some Custom Functions are useful for specific shooting specialties or scenes, while others are more broadly useful for everyday shooting. For example, the Mirror Lockup Custom Function is useful in specific scenarios such as when you're shooting macro and long exposures and when you're using a super-telephoto lens. On the other hand, the Custom Function that enables the Set button to be used during shooting is an example of a function that is broadly useful for everyday shooting.

Be sure to remember how you have set the Custom Functions because some options change the behavior of the camera controls.

Custom Function groupings

Canon organized the 12 Custom Functions into four main groups denoted with Roman numerals, all of which you can access from the Set-up 3 (yellow) camera menu.

Table 5.1 delineates the groupings and the Custom Functions within each group.

Custom Functions specifics

In this section, I explain each of the Custom Functions and the options that you can set. As you read about each Custom Function, consider how you could use it to simplify or customize the camera to suit your preferences. You don't have to set each Custom Function, and it is likely you may find only a few that are useful to you in the beginning. But as you continue shooting, you'll likely grow to appreciate the power that they offer.

Keep in mind that the functions are easy to find, so that you can go back and reset them if you don't like the changes that you've made. I think that you will be pleasantly surprised at how much more you'll enjoy the XS/1000D after you customize it for your personal shooting needs and style.

C.Fn Group I: Exposure

In this group, the two Custom Functions enable you to determine the amount of fine control you have over exposure and over flash exposure synchronization speeds when you're shooting in Aperture-priority (Av) mode.

Table 5.1 Custom Functions

C.Fn Number	Function Name
Group I	: Exposure
1	Exposure-level increments
2	Flash synchronization speed in Av mode
Group I	I: Image
3	Long-exposure noise reduction
4	High ISO speed noise reduction
5	Auto Lighting Optimizer
Group I	II: Autofocus/Drive
6	AF-assist beam firing
7	AF during Live View shooting
8	Mirror Lockup
Group I	V: Operation/Others
9	Shutter button/AE Lock button
10	Set button when shooting
11	LCD display when power On
12	Add original decision data

C.Fn-1 Exposure-level increments

The options available for this function enable you to set the exposure increment to use for shutter speed, aperture, exposure compensation, and Auto Exposure Bracketing (AEB). This function on film cameras allowed adjustment to match the film's latitude that differed for negative and transparency film types. The function is retained in the XS/1000D and your choice depends on how fine a control level you want. The exposure increment you choose is displayed in the viewfinder and on the LCD as double marks at the bottom of the exposure-level indicator. Here are the C.Fn-1 options with a description of each one:

 0: 1/3-stop. This is the Rebel XS/1000D's default and recommended option for everyday shooting because it offers the finest level

- of exposure control. Using this option, the camera displays shutter speeds in finer increments such as 1/60, 1/80, 1/100, 1/125 second, and so on. It also offers apertures such as f/4, f/4.5, f/5, f/5.6, f/6.3, f/7.1, and so on.
- ♦ 1: 1/2-stop. This is a coarser exposure control setting. Using this option, the XS/1000D displays shutter speeds in increments such as 1/60, 1/90, 1/125, 1/180 second, and so on. It also offers apertures as f/4, f/4.5, f/5.6, f/6.7, f/8, f/9.5, and so on. You may want to set this option when you want to quickly make larger changes in exposure settings.

C.Fn-2 Flash synchronization speed in Av (Aperture-priority AE) mode

This function enables you to either have the flash sync speed set automatically up to 1/200 second or to set it to a fixed 1/200 second in Av mode. Here are the options and a description of each one:

- 0: Auto. When you're shooting in Av mode, choosing this option means that the XS/1000D will choose a shutter speed of 1/200 second, the flash sync speed, or slower. Slower flash sync speeds allow the scene to be illuminated by both the flash and the ambient light in the scene. However, you must watch the shutter speed because at slow shutter speeds. any subject or camera movement appears as a blur. As long as the shutter speed is reasonably fast, this option is preferable because the combination of ambient light and flash creates a much more natural-looking image than when the scene is illuminated primarily by flash light.
- ↑ 1: 1/200 second (fixed). With this option, the flash sync speed is always set to 1/200 second and the flash provides the main illumination with less ambient light being included in the exposure. While this option prevents blur from subject or camera movement that you may get using option 0: Auto, you'll likely get flash shadows and a dark background that are characteristic of flash images with this option.

C.Fn Group II: Image

The Image Custom Function group concentrates primarily on avoiding and reducing digital noise (a grainy and mottled

appearance in the image), allowing you greater latitude in avoiding blown highlights, or highlights that are completely white with no detail, and improving the appearance of dark and low-contrast images.

For details on digital noise, see Chapter 6.

C.Fn-3 Long-exposure noise reduction

With this function, you can turn noise reduction on or off, or set it to automatic for long exposures. If you turn on noise reduction, the reduction process takes the same amount of time as the original exposure. In other words, if the original image exposure is 1 second, then noise reduction takes an additional 1 second. This means that you cannot take another picture until the noise reduction process finishes, and, of course, this greatly reduces the maximum shooting rate in Continuous drive mode. I keep the XS/1000D set to Option 1 to automatically perform noise reduction if it is detected in long exposures. Here are the options and a description of each one:

- 0: Off. This is the default setting where no noise reduction is performed on long exposures. This maximizes fine detail in the image, but it also increases the chances of noise in images of 1 second and longer. With this option, there is no reduction in the maximum burst rate in Continuous drive mode.
- ♠ 1: Auto. The camera automatically applies noise reduction on 1-second and longer exposures if it finds noise present. If the Rebel XS/1000D detects noise that is typically found in long exposures, then it takes a second picture at the same exposure time as the original image, and it uses the second image, called a "dark frame," to subtract noise from the first image.

- Although technically two images are taken, only one image the original exposure is stored on the Secure Digital (SD/SDHC) card.
- 2: On. The XS/1000D automatically performs noise reduction, whether or not it detects noise, on all exposures of 1 second and longer. This option slows shooting down considerably because the XS/1000D always makes the dark frame to subtract noise from the original image, and the dark frame is exposed at the same amount of time as the first image. Weigh the option you choose based on the shooting situation. If you need to shoot without delay, then Option 0 or 1 is preferable. But if you want to avoid applying noise reduction during image editing, then Option 2 is the ticket.

Note

If you're using Live View and you have Option 2 set, then no image displays on the LCD during the time that the camera performs the dark-frame noise-reduction exposure.

C.Fn-4 High ISO speed noise reduction

This option applies more aggressive noise reduction to shadow areas, particularly when you're shooting at high ISO speed settings. (The camera applies some noise reduction to all images.) If you turn this option on, noise in low ISO images is further reduced. Because Canon has a good noise reduction algorithm, this setting maintains fine detail in images and reduces color noise in the shadows. Note also that the options tend to be all or nothing. If you turn on High ISO speed noise reduction, it's applied at all ISO speed settings. Here are the options and a description of each one. Also, if you choose Option 1: On, then you cannot use Continuous drive mode for shooting.

- 0: Off. No noise reduction is applied to high ISO images.
- ◆ 1: On. The XS/1000D applies noise reduction to all images, particularly high ISO images. At low ISO speed, this option is useful for further reducing noise present in shadow areas of the image.

Note

If you have C.Fn-4 set to On, you cannot use White Balance Bracketing.

C.Fn-5 Auto Lighting Optimizer

This function is an automatic exposure adjustment that is designed to correct overly dark, or underexposed, images and to boost the contrast in low-contrast scenes such as those in hazy or overcast light. However, just as in an image-editing program, when you brighten underexposed images, any digital noise that is present is revealed. The same effect may result from using Auto Lighting Optimizer. While you can turn off this function for shooting in Creative Zone modes, you cannot turn it off for images shot in Basic Zone shooting modes such as Full Auto, Portrait, Landscape, and so on. Also, if you're shooting in P, Tv, Av, or A-DEP modes, automatic lightening is not applied to RAW or RAW+Large JPEG images. In addition, the function is not applied if you're shooting in Manual shooting mode.

Because Auto Lighting Optimizer is on by default, if you use AEB to shoot three images — one at standard exposure, one with more exposure, and one with less exposure — you may not see much or any difference between the standard and decreased exposure images because it is automatically optimized for brightness. If you want to see the effects of AEB, then set the option to 1: Disable. In addition, if you shoot in Live View mode with Auto Lighting Optimizer enabled, and if you set negative

Exposure Compensation, then images may appear brighter than they would without Auto Lighting Optimizer.

So should you turn off Auto Lighting Optimizer? The answer is that it depends. If you print images directly from the SD/SDHC card and you do not routinely edit your images on the computer, then you may find that the optimization provides better prints. However, if you routinely edit images on the computer, then disabling this function allows you to control brightening and contrast adjustments to your personal tastes while controlling the appearance of digital noise in the shadow areas. In addition, disabling this function gives you a true representation of images shot with Auto Exposure Lock, Auto Exposure Bracketing, and Exposure Compensation, plus you can use White Balance Bracketing. Because I edit images on the computer and prefer to control brightening myself, I turn off Auto Lighting Optimizer. Here are the options and a description of each one:

- O: Enable. Applies automatic lightening and contrast adjustment to all images in all shooting modes, except images shot in Manual (M) mode and when shooting RAW and RAW+JPEG images. Enable is the Rebel XS/1000D's default setting.
- 1: Disable. Turns off Auto Lighting Optimizer when shooting JPEG images in P, Tv, Av, and A-DEP shooting modes.

C.Fn Group III: Autofocus/Drive

This group of functions concentrates on autofocus speed and use during Live View shooting, and on enabling Mirror Lockup to prevent blur from the action of the reflex mirror in macro and long exposures.

C.Fn-6 AF-assist beam firing

This function allows you to control whether the Rebel XS/1000D's built-in or an accessory EX Speedlite's autofocus-assist light is used to help the camera's autofocus system establish focus. The AF-assist beam speeds up and ensures sharp focus in low-light or low-contrast scenes where you want to use the flash. Here are the options and a description of each one:

- O: Enable. This option allows the AF-assist beam from either the built-in flash or a Canon Speedlite mounted on the camera to help the camera focus. The Enable option is the default setting for the Rebel XS/1000D.
- ◆ 1: Disable. If you choose this option, neither the built-in flash nor the Speedlite AF-assist beam emits to help establish focus. While this option is useful in shooting situations where the AF-assist light may be annoying or intrusive, it may be difficult to establish accurate focus in low-light scenes.
- 2: Only external flash emits. If you choose this option, the AF-assist beam emits only when a Canon Speedlite is mounted on the camera's hot shoe. The Speedlite's AF-assist beam is more powerful than the beam of the built-in flash, and that makes this option good for low-light and low-contrast subjects that are farther away from the camera. However, be aware that if you have set the Custom Function on the Speedlite so that the AF-assist beam does not fire, then the Speedlite's Custom Function option overrides the camera's Custom Function option.

C.Fn-7 AF during Live View shooting

This function enables you to use autofocus by choosing Option 1 or 2 when you use Live View shooting. Here are the options and a description of each one:

Details on using focusing options in Live View shooting are provided in Chapter 4.

- 0: Disable. With this default option set, autofocus using the Rebel XS/1000D's onboard autofocus system is not possible in either Quick or Live mode. But you can use manual focus for Live View shooting.
- ↑ 1: Quick mode. Using this option, you focus using the onboard autofocus system and with the focusing switch on the lens set to AF (autofocus). However, when you focus, the reflex mirror flips down to establish focus, which temporarily suspends Live View on the LCD. The camera must be set to One-shot AF mode as well. With this option, you can manually select any of the AF points in the viewfinder before you begin Live View shooting.
- ◆ 2: Live mode. Using this option, focusing is established using the image sensor. You can autofocus while the Live View image is displayed on the LCD, but focusing is slower and may be more difficult than with Option 1: Quick mode.
 - For fast and accurate focusing in Live View shooting, I recommend using Option 1.

C.Fn-8 Mirror Lockup

Option 1 for this function prevents blur that can be caused in close-up and super-telephoto shots by the camera's reflex mirror flipping up at the beginning of an exposure. While the effect of motion from the mirror is

negligible during normal shooting, it can cause slight blur in the extreme magnification levels for macro shooting and when using super-telephoto lenses. If you turn on Mirror Lockup, the first time that you press the Shutter button, it flips up the reflex mirror. You then have to press the Shutter button again to make the exposure. Also be sure to use a tripod in conjunction with Mirror Lockup. You cannot use C.Fn-8 with Live View shooting. Here are the options and a description of each one:

- 0: Disable. This is the default setting where the reflex mirror does not lock up before making an exposure.
- ◆ 1: Enable. Choosing this option locks up the reflex mirror when you first press the Shutter button. With the second press of the Shutter button, the exposure is made and the reflex mirror drops back down. You can also use the Self-timer mode to avoid vibration from pressing the Shutter button with your finger.

Tip If you often use Mirror Lockup, you can add this Custom Function to My Menu for easy access. Customizing My Menu is detailed later in this chapter. Also, if you use Mirror Lockup with bright subjects such as snow, bright sand, the sun, and so on, be sure to take the picture right away to prevent the camera curtains from being scorched by the bright light.

C.Fn Group IV: Operation/Others

This group of Custom Functions enables you to change the functionality of camera buttons for ease of use to suit your shooting preferences, to control the LCD display, and to add data that verifies that the images are original and unchanged.

C.Fn-9 Shutter button/AE Lock button

This function changes the role of the Shutter button and the AE Lock button (the button located at the top-right back of the camera with an asterisk above it) in starting and stopping autofocus and exposure metering. To understand this function, it's important to know that the Rebel XS/1000D links the light metering, which determines the exposure for the image, to the selected AF point. So when you press the Shutter button halfway, the XS/1000D simultaneously meters the amount of light in the scene, calculates an ideal exposure based on the amount of light, and sets the point of sharpest focus. All of these tasks are linked to the selected AF point.

However, there are many times when you want to set the exposure somewhere other than where you want to focus. For example, if you're shooting a portrait, you may want to meter the light (on which the exposure will be calculated) on a highlight area on the subject's face. The facial highlight isn't, however, where you want to set the focus; rather, you want to focus on the subject's eyes. To meter on one area and focus on another area, you have to decouple the meter reading from the AF point, and you do that by using AE Lock.

Continuing the previous example, to use AE Lock, you would point the camera so that the selected AF point is over the highlight on the subject's skin, and then press and hold the AE Lock button. Then you would move the camera to recompose the scene, press the Shutter button to focus on the subject's eye, and then press it completely to make the picture. In that way, you decouple the XS/1000D's metering and autofocus functions so that you meter on one point but focus on a different point.

With that background, you can better understand the effects of this Custom Function. The options enable you to switch or change the functionality of the Shutter button and the AE Lock button, or to disable AE Lock entirely when you're using continuous focusing through AI Servo AF mode. Note that C.Fn-9 does not work when you're shooting in Live View.

Here are the options and a description of each one:

- 0: AF/AE lock. This is the default setting where you set the focus using the Shutter button, and you can optionally set and lock the exposure by pressing and holding the AE Lock button.
- ◆ 1: AE lock/AF. Choosing this option switches the function of the Shutter button and the AE Lock button. Pressing and holding the Shutter button halfway sets and locks the exposure, while pressing the AE Lock button sets the focus. Then you press the Shutter button completely to make the picture.
- ◆ 2: AF/AF lock, no AE lock. If you're shooting in AI Servo AF mode where the camera automatically tracks the motion of a moving subject, this function enables you to press the AE Lock button whenever an object moves in front of the subject so that focus on the subject isn't thrown off. For sports, action, and wildlife shooting, this option is useful in ensuring sharp subject focus. The downside, of course, is that you do not have the ability to use AE Lock.
- 3: AE/AF, no AE lock. This option extends Option 2 by allowing you to suspend AI Servo AF focus tracking by pressing the AE Lock button.

For example, if you are photographing a player on the football field who starts and stops moving erratically, you can press the AE Lock button to start and stop autofocus tracking to follow the player's movement. In AI Servo AF mode, the exposure and focusing are set when you press the Shutter button.

C.Fn-10 Set button when shooting

This Custom Function enables you to take advantage of using the Set button when the camera is ready to shoot rather than only when you're using camera menus. The Set button continues to function normally when you're accessing camera menus.

If you have Live View shooting enabled, however, pressing the Set button initiates Live View display on the LCD monitor, regardless of the options you've chosen for this Custom Function. Here are the options and a description of each one:

- 0: LCD monitor On/Off. With this option, pressing the Set button toggles the LCD monitor display on or off, replicating the functionality of the Disp. button on the back of the camera.
- 1: Change quality. With this option, you can press the Set button as you shoot to display the Image-recording quality menu to make changes. This is handy if you frequently switch among different JPEG quality options or switch between JPEG and RAW capture.
- 2: Flash exposure compensation.
 With this option, you can press the
 Set button to quickly display the
 Flash exposure comp. (compensation) screen so that you can
 increase or decrease flash output.

- 3: Menu display. With this option, pressing the Set button displays the last camera menu that you accessed with the last menu item highlighted.
- 4: Disabled. The Set button has no functionality during shooting.

C.Fn-11 LCD display when power On

Turning on this function saves a bit of battery power by choosing whether or not the shooting information is displayed on the LCD when you turn on the Rebel XS/1000D. Sounds simple enough, but Option 1 isn't quite as straightforward as it seems. Here are the options and a description of each one:

- O: Display. This is the default setting where the XS/1000D displays shooting information on the LCD when you turn on the camera. To turn off the display, you must press the Disp. button on the back of the camera.
- 1: Retain power Off status. With this option, the shooting information is not displayed on the LCD when you turn on the camera only if you pressed the Disp. button to turn off the LCD display the last time you used the camera. To display shooting information, press the Disp. button. Now, you might assume that setting this option, and turning off the display before shutting down the camera would be sufficient, but such is not the case. If you had the shooting information displayed on the LCD the last time the camera was turned off, the shooting information is displayed when you power up the camera. So to keep the display from turning on, you have to remember to turn off the display by

pressing the Disp. button before powering down the camera every time you use the camera.

It's tempting to choose Option 1 simply to save battery power. But if you keep the display off, then you have to manually turn on the display by pressing the Disp. button before you can display the ISO settings screen or set exposure compensation by pressing the ISO and Aperture/Exposure Compensation buttons on the camera.

For the sake of convenience and to avoid having to press the Disp. button before using the ISO and Av buttons, I recommend using Option 0: Display.

C.Fn-12 Add original decision data

When this option is turned on, data is appended to verify that the image is original and hasn't been changed. This is useful when images are part of legal or court proceedings. The optional Original Data Security Kit OSK-E3 is required. Here are the options and a description of each one:

- 0: Off.
- 1: On. With this option and when used with the Original Data Security Kit OSK-E3, data is automatically appended to the image to verify that it is original. When you display shooting information for the image, a distinctive locked icon appears.

Setting Custom Functions

Depending on your shooting preferences and needs, you may immediately recognize functions and options that would make your shooting faster or more efficient. You may also find that combinations of functions are useful for specific shooting situations. Whether used separately or together, Custom Functions can significantly enhance your use of the XS/1000D.

To set a Custom Function, follow these steps:

- Set the Mode dial to P, Tv, Av, M, or A-DEP.
- Press the Menu button, and then press the right cross key until the Set-up 3 (yellow) menu is displayed.
- If necessary, press the up or down cross key to highlight Custom Functions (C.Fn), and then press the Set button. The most recently accessed Custom Function screen appears.
- 4. Press the right or left cross key to move through the Custom
 Function numbers that are displayed in the box at the top right of the screen, and when you get to the number you want, press the Set button. The Custom
 Function option control is activated and the option that is currently in effect is highlighted.
- 5. Press the up or down cross key to highlight the option you want, and then press the Set button. You can refer to the previous descriptions in this section of the chapter to select the function option that you want. Repeat Steps 3 to 4 to select other Custom Functions and options. Lightly press the Shutter button to return to shooting.

If you want to reset one of the Custom Functions, repeat these steps to change it.

If you want to restore all Custom Function options to the camera's default settings, follow these steps:

- Set the camera Mode dial to P, Tv, Av, M, or A-DEP.
- Press the Menu button, and then press the right cross key until the Set-up 3 (yellow) menu is displayed.
- Press the down or up cross key to highlight Clear Settings, and then press the Set button. The Clear Settings screen appears.
- 4. Press the up or down cross key to highlight Clear all Custom Func. (C.Fn), and then press the Set button. The Clear all Custom Func. (C.Fn) screen appears.
- 5. Press the right cross key to highlight OK, and then press the Set button. All Custom Functions are cleared and the camera returns to the Clear Settings screen. Lightly press the Shutter button to return to shooting.

Customizing My Menu

Given the number of menus and menu options on the XS/1000D, and given that in an average day of shooting you may use two or three menus consistently, customizing the My Menu option makes good sense as a timesaving step. My Menu lets you select and register six of your most frequently changed menu items and Custom Functions for easy access.

Plus, you can add and delete items to My Menu easily and quickly, and you can change the order of items by sorting the items you register. You can also set the XS/1000D to display My Menu first when you press the Menu button.

My Menu is available only when you're shooting in P, Av, Tv, M, or A-DEP shooting modes.

Before you begin registering items to My Menu, look through the camera menus and Custom Functions carefully and choose your six most frequently changed items.

To register camera Menu items and Custom Functions to My Menu, follow these steps:

- Set the camera to P, Av, Tv, M, or A-DEP.
- Press the Menu button, and then press the right cross key until My Menu (green) is displayed.
- Press the up or down cross key to highlight My Menu settings, and then press the Set button. The My Menu settings screen appears.
- 4. Press the up or down cross key to highlight Register, and then press the Set button. The My Menu registered item screen appears. This screen contains a scrolling list of the camera's menu items and Custom Functions.
- 5. Press the down cross key to scroll through and highlight the menu items and Custom Functions that you want to register, and then press the Set button. As you press the down cross key to scroll, a scroll bar on the right of the screen shows your relative progress through the list. When you select an item and press the Set button, a confirmation screen appears.
- 6. Press the right cross key to highlight OK, and then press the Set

- **button.** The My Menu registered item screen reappears.
- Repeat Steps 5 and 6 until you've selected and registered six menu items.
- When you finish registering menu items, press the Menu button.
 The My Menu settings screen appears.
- Press the down cross key to highlight Sort, and then press the Set button. The Sort My Menu screen appears.
- 10. Press the up or down cross key to select the item that you want to move, and then press the Set button. The sort control for the selected item is activated.
- Press the up cross key to move the item up in the list, or press the down cross key to move it down in the list, and then press the Set button.
- 12. Repeat Steps 10 and 11 to move other menu items in the order that you want. Lightly press the Shutter button to return to shooting.

Note

The My Menu settings item always appears at the bottom of the My Menu list. Selecting it gives you access to the My Menu settings screen where you can Register, Sort, Delete, Delete all items, and disable the display of My Menu.

You can delete either one or all items from My Menu. And you can choose to have My Menu displayed first every time you press the Menu button. To delete one or more items from My Menu, follow these steps:

 Set the camera to P, Av, Tv, M, or A-DEP.

- Press the Menu button, and then press the right cross key until My Menu (green) is displayed.
- Press the down cross key to highlight My Menu settings, and then press the Set button. The My Menu settings screen appears.
- 4. Press the down cross key to highlight Delete in order to delete a single item, or highlight Delete all items in order to delete all registered items, and then press the Set button. The Delete My Menu or the Delete all My Menu items screen appears depending on the option you chose.
- 5. If you chose to delete a single menu item, press the down cross key to highlight the menu item you want to delete, and then press the Set button. The Delete My Menu confirmation screen appears.
- Press the right cross key to select OK, and then press the Set button. Lightly press the Shutter button to return to shooting.

If you want the My Menu tab to be the first menu displayed when you press the Menu button, follow these steps:

- Set the camera to P, Av, Tv, M, or A-DEP.
- Press the Menu button, and then press the right cross key until My Menu (green) is displayed.
- Press down cross key to highlight My Menu settings, and then press the Set button. The My Menu settings screen appears.
- 4. Press the down cross key to highlight Display from My Menu, and

- then press the Set button. Two options appear.
- 5. Press the down cross key to select Enable, and then press the Set button. Lightly press the Shutter button to return to shooting.

Changing the Screen Color

Another customization option on the Rebel XS/1000D is choosing the screen color you want for the LCD shooting information display. You can choose from four options:

- White text on a black background, which is the default setting
- Black text on a white background
- ♦ White text on a blue background
- Black text on a tan background

To set the screen color, follow these steps:

- In any camera mode, press the Menu button, and then turn the Main dial to select the Setup 1 (yellow) menu.
- Press the down cross key to highlight Screen Color, and then press the Set button. The Screen color screen appears.
- Press a cross key to select the color scheme that you want, and then press the Set button. The option you choose remains in effect until you change it.

The XS/1000D offers you a high level of customizability. While the full complement of choices may initially seem overwhelming, I recommend taking each one in turn and building on it to set more custom settings until you get the camera set up for your shooting style.

The Fundamentals of Exposure and Light

f you're new to photography, this chapter on the elements of exposure and the characteristics of light can help you build a foundation from which you can expand your skills and make the most of the creative options offered on the EOS Rebel XS/1000D. And if you're returning to photography after some time away from shooting, the information in this chapter provides a refresher on exposure and light.

The Four Elements of Exposure

As you learned in Chapter 2, the EOS Rebel XS/1000D offers shooting modes that allow you to control all or part of the exposure settings. As you read about exposure elements in this chapter, think about why you'd choose one or another of the Creative Zone shooting modes to control specific aspects of the image. With that in mind, we'll move into the elements of exposure.

Exposure is a precise combination of four elements — light, light sensitivity, light intensity, and time — all of which are interrelated. If one element changes, then the other elements must change proportionally. And each element depends on the others to create a successful exposure.

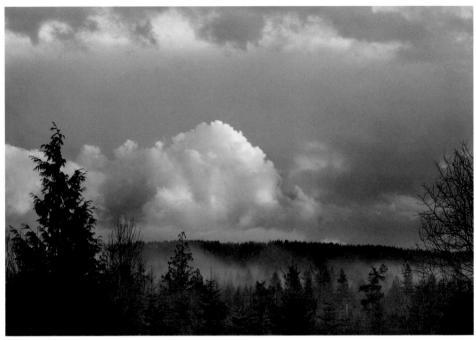

6.1 The Rebel XS/1000D offers excellent creative control and responsiveness. Exposure: ISO 100, f/8, 1/100 second.

Following is a summary of four elements of exposure that are discussed in more detail in this chapter:

- Light. The starting point of exposure is the amount of light that's available in the scene to make a picture. The range of creative control that you have with the Rebel XS/1000D is directly related to the amount of light the camera has to work with. For every image, the Rebel XS/1000D measures, or "meters," the amount of light in the scene and bases exposure calculations on that meter reading.
- Sensitivity. Sensitivity refers to the amount of light that the camera's image sensor needs to make an exposure or to the sensor's sensitivity to light.

- Intensity. Intensity refers to the strength or amount of light that reaches the image sensor. Intensity is controlled by the aperture, or f-stop. The aperture you choose controls the lens diaphragm, an adjustable opening that expands or contracts to allow more or less light through the lens and into the image sensor.
- Time. Time refers to the length of time that light is allowed to reach the sensor. Time is controlled by setting the shutter speed, which determines how long the shutter stays open.

Light

All exposure is based on the amount of light available to make the picture. To calculate

exposure for every image, the camera first measures the amount of light in the scene. This process is referred to as metering light.

The XS/1000D, like all digital SLR (Single Lens Reflex) cameras, uses a reflective light meter that measures the light that is reflected from the subject back to the camera. Regardless of the shooting mode you've chosen, the camera uses its light meter reading to calculate the "ideal" exposure. On the XS/1000D, the light meter reading is taken at the autofocus (AF) point that you or the camera select.

The Rebel XS/1000D couples the autofocus and metering at the selected AF point. Chapter 2 details using Auto Exposure (AE) Lock, a technique that decouples metering from autofocus so that you can meter one area of the scene but set the point of sharpest focus on another area of the scene. Chapter 2 also provides details on choosing and using different shooting modes.

The exposure is set automatically in the automatic Basic Zone modes such as Portrait, Landscape, Sports, and so on. In the semi-automatic modes of Av and Tv, you can set two of the exposure elements — either the ISO (International Organization for Standardization) and the aperture in Av mode, or the ISO and the shutter speed in Tv mode. In M (Manual) mode, you set the ISO, aperture, and shutter speed by watching the exposure level indicator shown in the viewfinder.

In all cases, the camera's exposure options are directly related to the amount of light in the scene. Because the XS/1000D offers a wide range of shutter speeds and ISO settings, and because you can switch to a faster

lens, you have good creative control even in less-than-optimal light.

As you read this chapter, think about when you'd use the XS/1000D's different metering modes to provide the best subject exposure based on the lighting. As a refresher, Evaluative metering mode meters light throughout the viewfinder based on the selected AF point; Partial mode meters a much smaller area at the center of the viewfinder; and Center-weighted Average mode gives more weight to light metered at the center of the frame.

Sensitivity: The role of ISO

The ISO setting determines how sensitive the image sensor is to light. The higher the ISO number, the less light that's needed to make a picture. The lower the ISO number, the more light that's needed to make a picture. In everyday shooting, photographers use high ISO numbers or settings such as ISO 800 to 1600 to get faster shutter speeds so that they can handhold the camera and get a sharp image in low-light scenes. Conversely, in bright to moderately bright light, low settings from ISO 100 to 400 work well because there is enough light in the scene to ensure a fast enough shutter speed to handhold the camera and still get a sharply focused image.

Each ISO setting is twice as sensitive to light as the previous setting. For example, ISO 800 is twice as sensitive to light as ISO 400. As a result, the sensor needs half as much light to make an exposure at ISO 800 as it does at ISO 400.

On the XS/1000D, the ISO sequence encompasses Auto (ISO 100 to 800, which is set automatically by the camera), and ISO 100,

200, 400, 800, and 1600. In the automated Basic Zone modes, the XS/1000D automatically sets the ISO from 100 to 800, depending on the light.

In addition to setting the relative light sensitivity of the sensor, ISO also factors into the overall image quality in several areas, including sharpness, color saturation, contrast, and digital noise or lack thereof. Digital noise appears in images as a grainy appearance and as multicolored flecks in shadow areas.

On a digital camera, increasing the ISO setting amplifies both the signal and the noise in the image, much like hiss or static in an audio system that becomes more audible as the volume increases. Noise in digital images is roughly analogous to grain in high-ISO film. However, in digital photography, noise is comprised of luminance and chroma noise. In digital images, luminance noise resembles film grain. Chroma noise appears as mottled color variations and as colorful pixels in the shadow areas of the image.

The important thing to know is that digital noise degrades overall image quality by overpowering fine detail in foliage and fabrics, reducing sharpness and color saturation, and giving the image a mottled look. Digital noise increases with high ISO settings, long exposures, and underexposure, as well as high ambient temperatures, such as from leaving the camera in a hot car or in the hot sun. This occurs because the hotter the sensor gets, the more digital noise appears.

Many photography students in my classes set the ISO to 400, 800, or even 1600 and never change it. Unless you need a higher ISO setting due to low light, it's always preferable to set the XS/1000D to the lowest ISO setting that will provide an acceptable shutter speed for your needs. This helps to ensure that you'll get the best image quality from the XS/1000D.

See Chapter 5 for details on setting Custom Functions.

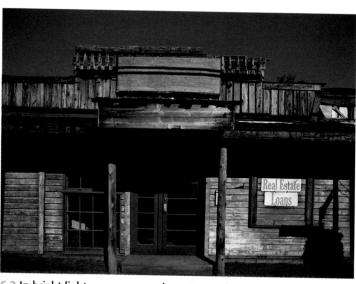

6.2 In bright light, you can set a low ISO, such as 100, and get fast shutter speeds. Exposure: ISO 100, f/5.6, 1/250 second.

Checking for Digital Noise

If you choose a high ISO setting, be sure to check for digital noise by zooming the image to 100 percent in an image-editing program. Look for flecks of color in the shadow and midtone areas that don't match the other pixels and for areas that resemble the appearance of film grain.

If you detect objectionable levels of digital noise, you can use noise reduction programs such as Noise Ninja (www.picturecode.com), Neat Image (www.neatimage.com), or NIK Dfine (www.niksoftware.com) to reduce it. Typically, noise reduction softens fine detail in the image, but these programs minimize the softening. If you shoot RAW images, programs including Canon's Digital Photo Professional and Adobe Camera Raw offer noise reduction that you can apply during RAW conversion.

The tolerance for digital noise is subjective and varies by photographer. It's important to shoot images at each of the ISO settings and examine the images for noise. This type of testing helps you know what to expect in terms of digital noise at each ISO setting. Then you can determine how high an ISO you want to use on an average shooting day.

For long exposures, you can also enable a Custom Function (C.Fn-3: Long exposure noise reduction) to reduce digital noise in exposures of 1 second or longer. This option doubles the exposure time duration, but the noise is virtually imperceptible. In addition, you can set C.Fn-4: High ISO speed noise reduction to either Option 1: Auto or Option 2: On to help counteract noise from high ISO sensitivity settings.

Intensity: The role of the aperture

The lens aperture (the size of the lens diaphragm opening) determines the intensity of light that strikes the image sensor. Aperture is indicated as f-stop numbers, such as f/2.8, f/4.0, f/5.6, f/8, and so on. With each increase or decrease of the aperture by one full f-stop, the exposure doubles or halves respectively. For example, f/8 doubles the light that f/5.6 provides, while f/5.6 provides half as much light as f/4.0.

Note

The apertures that you can choose depend on the lens that you're using. For example, the Canon EF-S 18-55mm f/4.5-5.6 lens has a maximum aperture of f/4.5 at 18mm and f/5.6 at 55mm and a minimum aperture

of f/22, while the EF 100-300mm f/4.5-5.6 USM lens has a maximum aperture of f/4.5 at 100mm and f/5.6 at 300mm and a minimum aperture of f/32-38 at the same respective zoom settings.

Wide aperture

Smaller f-stop numbers, such as f/2.8, set the lens diaphragm to a large opening that lets more light reach the sensor. A large lens opening is referred to as a wide aperture. Based on the ISO and in moderate light, a wide aperture (a large diaphragm opening) such as f/5.6 delivers sufficient light to the sensor so that the amount of time that the shutter has to stay open to make the exposure decreases, thus allowing a faster shutter speed.

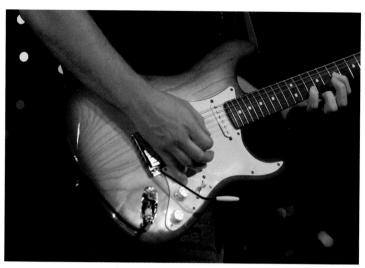

6.3 In this image, an aperture of f/2.8 blurred the background, bringing focus to the guitarist's hand. Exposure: ISO 400, f/2.8, 1/80 second.

Narrow aperture

Larger f-stop numbers, such as f/16, set the lens diaphragm to a small opening that lets less light reach the sensor. A small lens opening is referred to as a narrow aperture. Based on the ISO and in moderate light, a small diaphragm opening such as f/11 delivers less light to the sensor, and so the amount of time that the shutter has to stay open increases, allowing a comparatively slow shutter speed.

Note

Aperture also plays a starring role in the depth of field of images. Depth of field is detailed in this chapter.

Choosing an aperture

In everyday shooting, photographers most often select an aperture based on how they want background detail to be rendered in the image — either with distinct detail or with indistinct or blurred detail. This is called controlling the depth of field, discussed later in the chapter. But the choice of aperture involves other factors as well. For example,

6.4 For this image, a narrow aperture of f/10 provided good sharpness throughout the frame. Exposure: ISO 100, f/10, 1/320 second.

if you want to avoid blur from camera shake in lower light, you can choose a wide aperture (small f-number such as f/4 or f/5.6) so that you get the faster shutter speeds. Or if you want selective focus, where only a small part of the image is in sharp focus, then you'd also choose a wide aperture.

On the Rebel XS/1000D, you can control the aperture by choosing Av or M mode. In Av mode, you set the aperture, and the camera automatically sets the correct shutter speed based on the ISO that you set. In M mode, you set both the aperture and the shutter speed based on the reading from the camera's light meter. The light meter reading is indicated by the Exposure Level Index displayed in the viewfinder. This index is a scale that indicates overexposure, underexposure, and correct exposure based on the current aperture, shutter speed, and ISO. When the exposure, measured at the selected AF point, is correct, the tick mark on the scale is at the center, or the "0" point. If the tick mark is to the left or right of the zero point, the image will be underexposed or overexposed respectively.

Tip

You can use P mode to make one-time changes to the aperture that the camera initially sets. Unlike Av mode, where the aperture you choose remains in effect until you change it, in P mode, changing the aperture is temporary. After you take the picture, the camera reverts to its suggested aperture and shutter speed.

You can learn about exposure modes in Chapter 2.

What is depth of field?

Depth of field is the zone of acceptably sharp focus in front of and behind a subject. In simple terms, depth of field determines if the foreground and background are rendered as a soft blur or with distinct detail. Depth of field generally extends one-third in front of the point of sharp focus and two-thirds behind it.

Aperture is the main factor that controls depth of field, although camera-to-subject distance and the focal length of the lens you're using affect it as well. Depth of field is as much a practical matter — based on the light that's available in the scene to make the picture — as it is a creative choice to enhance the rendering of background and foreground elements in the image.

Shallow depth of field

Images where the background is a soft blur and the subject is in sharp focus have a shallow depth of field. As a creative tool, shallow depth of field is typically preferred for portraits, some still-life images, and food photography. As a practical tool, choosing a wide aperture that creates a shallow depth of field is necessary when shooting in low light. In general terms, to get a shallow depth of field, choose a wide aperture such as f/2.8, f/4, or f/5.6. The subject will be sharp, and the background will be soft and nondistracting.

Extensive depth of field

Pictures with acceptably sharp focus in front of and behind the point of sharpest focus in the image are described as having extensive depth of field. Extensive depth of field is preferred for images of large groups of people, landscapes, architecture, and interiors. To get extensive depth of field, choose a narrow aperture, such as f/8, f/11, f/16, or smaller.

Given the same ISO, choosing a narrow aperture such as f/16 requires a longer shutter speed to ensure that enough light reaches the sensor for a correct exposure. Conversely, given the same ISO, choosing a wide aperture requires a shorter shutter speed.

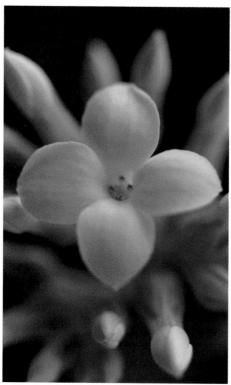

6.5 In this image, a wide aperture of f/5.6 plus a close camera-to-subject shooting distance provided a very shallow depth of field. Exposure: ISO 400, f/2.8, 1/250 second.

While aperture is the most important factor that affects the range of acceptably sharp focus in a picture, two additional factors also affect depth of field:

- Camera-to-subject distance. At any aperture, the farther you are from a subject, the greater the depth of field is and vice versa.
- Focal length. Focal length, or angle of view, is how much of a scene the lens "sees." From the same shooting position, a wide-angle lens produces more extensive depth of field than a telephoto lens.

For more information on focal length, see Lens Choices in Chapter 8.

Throughout this section, I've talked about wide and narrow apertures in general terms. More specifically, wide apertures are f/5.6 and wider, such as f/4.0, f/3.2, f/2.8, f/2.0, f/1.4, and f/1.2. Narrow apertures begin at f/8 and continue through f/11, f/16, f/22, and f/32. Different lenses have different ranges of apertures.

Lenses with a wide maximum aperture such as f/2.8 are referred to as fast lenses, and vice versa. In addition, some lenses have variable apertures, where the maximum aperture changes based on the zoom setting on the lens. For example, the Canon EF 28-300mm f/3.5-f/5.6L IS USM lens allows a maximum aperture of f/3.5 at the 28mm zoom setting and f/5.6 at the 300mm zoom setting.

For more information on lenses, see Chapter 8.

Time: The role of shutter speed

Shutter speed controls how long the shutter stays open to let light from the lens strike the image sensor. The longer the shutter, or curtains, stays open, the more light reaches the sensor (at the aperture and ISO that you've set). When you increase or decrease the shutter speed by one full setting, it doubles or halves the exposure. For example, twice as much light reaches the image sensor at 1/30 second as at 1/60 second.

In daily shooting, shutter speed is also related to the following:

 The ability to handhold the camera and get sharp images, particularly

6.6 A reasonably narrow f/8 aperture provides extensive depth of field. Exposure: ISO 100, f/8, 1/90 second.

in low light. The general rule for handholding a non-Image Stabilized lens is the reciprocal of the focal length. For example, if you're shooting at 200mm, then the slowest shutter speed at which you can handhold the lens and get a sharp image is 1/200 second.

The ability to freeze motion or show it as blurred in a picture. For example, you can set a fast shutter speed to show a basketball player's jump in midair with no blur. As a general rule, set the shutter speed to 1/250 second or faster to stop motion. Or set a slow shutter speed to show the motion of water cascading over a waterfall as a silky blur. To show motion as a blur, try 1/30 second or slower and use a tripod.

You can control the shutter speed in Shutter-priority AE (Tv) or Manual (M) mode. In Shutter-priority AE (Tv) mode, you set the shutter speed, and the camera automatically sets the correct aperture. In Manual (M) mode, you set both the shutter speed and the aperture based on the reading from the camera's light meter and the ISO. The light meter is displayed in the viewfinder as a scale — the exposure level index — and it shows overexposure, underexposure, and correct exposure based on the shutter speed, aperture, and ISO.

Equivalent Exposures

Cameras require a specific amount of light to make a good exposure. As you have seen, after the camera meters the light and factors in the selected ISO, two remaining factors determine the exposure — the aperture and the shutter speed.

Many combinations of aperture (f-stop) and shutter speed produce exactly the same exposure at the same ISO setting. For example, f/22 at 1/4 second is equivalent to f/16 at 1/8 second, as is f/11 at 1/15 second, f/8 at 1/30 second, and so on. And this is based on the doubling and halving effect discussed earlier. For example, if you are shooting at f/8 and 1/30 second, and you change the aperture (f-stop) to f/5.6, then you have doubled the amount of light reaching the image sensor, so the time that the shutter stays open must be halved to 1/60 second.

While these exposures are equivalent, the rendering of the image and your shooting options sometimes change significantly. An exposure of f/22 at 1/4 second produces extensive depth of field in the image, but the shutter speed is slow, so your ability to

6.7 A fast shutter speed freezes subject motion as seen in this image, while a slow shutter speed shows subject motion. Exposure: ISO 100, f/5.6, 1/160 second.

handhold the camera and get a sharp image is dubious. But if you switch to an equivalent exposure of f/5.6 at 1/60 second, you are more likely to be able to handhold the camera, but the depth of field will be shallow. As with all aspects of photography, you have to evaluate the tradeoffs as you make changes to the exposure. Your creative options for exposure are most often determined by the amount of light in the scene.

Putting It All Together

ISO, aperture, shutter speed, and the amount of light in a scene are the essential elements of photographic exposure. On a bright, sunny day, you can select from many differ-

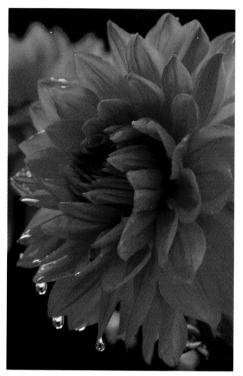

6.8 Practicing with aperture, shutter speed, and ISO combinations is the best way to learn how they work together to create the effect that you want. Exposure: ISO 100, f/8, 1/2 second.

ent f-stops and still get fast shutter speeds to prevent image blur. You have little need to switch to a high ISO for fast shutter speeds at small apertures.

As it begins to get dark, your choice of f-stops becomes limited at ISO 100 or 200. You need to use wide apertures, such as f/4 or wider, to get a fast shutter speed. Otherwise, your images will show some blur from camera shake or subject movement. Switch to ISO 400 or 800, however, and your options increase and you can select narrow apertures, such as f/8 or f/11, for greater depth of field. The higher ISO allows you to shoot at faster shutter speeds to

reduce the risk of blurred images, but it also increases the chances of digital noise.

Let There Be Light

The one characteristic that will set your images apart from all others is the use of light — looking and waiting for or setting up magical light makes all the difference. In addition, the common thread in getting good detail and accurate color is light — its direction, quality, intensity, and color.

You can use the qualities of light to set the mood; control the viewer's emotional response to the subject; reveal or subdue the subject's shape, form, texture, and detail; and render scene colors as vibrant or subdued. To get stunningly lit images, it's important to understand the basic characteristics of light and how you can use it to your advantage. This section provides a basic foundation for exploring and using the characteristics of light.

Understanding color temperature

Few people think of light as having color until the color becomes obvious, such as at sunrise and sunset when the sun's low angle causes light to pass through more of the earth's atmosphere, creating visible and often dramatic color. However, regardless of the time of day, natural light has a color temperature, and each color, or hue, of sunlight renders subjects differently. Likewise, household bulbs, candlelight, flashlights, and electronic flashes all have distinct color temperatures.

As humans, our eyes automatically adjust to the changing colors of light so that white appears white, regardless of the type of light in which we view it. Digital image sensors are not, however, as adaptable as the human eye. For example, when the Rebel XS/1000D is set to the Daylight white balance, it renders color in a scene most accurately in the light at noon on a sunny, cloudless day. But at the same setting, it does not render color as accurately at sunset or in a living room because the temperature of the light is different.

For details on setting color temperature using white balance settings, see Chapter 3.

Color temperature is important to understand because different times of day and different light sources have different color temperatures, and to get accurate color in images, the camera must be set to match the temperature of the light in the scene.

Color temperature is measured on the Kelvin temperature scale and is expressed in Kelvin units, which are abbreviated simply as K. For the camera to render color accurately, the white balance setting must match the specific light in the scene. For example, sunlight on a clear day is considered to be between 5200K and 5500K, so the Daylight white balance setting renders colors accurately in this light.

When learning about color temperatures, keep in mind this general principle: The higher the color temperature is, the cooler (or bluer) the light; the lower the color temperature is, the warmer (or yellower/redder) the light.

On the XS/1000D, setting the white balance tells the camera the general range of the light temperature so that it can render white as white, or neutral, in the final image. The more faithful you are in setting the correct White Balance setting or using a Custom White Balance, the less color correction you have to do on the computer later.

The colors of light

Like an artist's palette, the color temperature of natural light changes throughout the day. By knowing the predominant color temperature shifts throughout the day, you can adjust settings to ensure accurate color, to enhance the predominant color, and, of course, to use color creatively to make striking photos. Studio and flash light also have color and are used in similar ways to natural light.

Sunrise

In predawn hours, the cobalt and purple hues of the night sky dominate. But as the sun inches over the horizon, the landscape begins to reflect the warm gold and red hues of the low-angled sunlight. During this time of day, the green color of grass, tree leaves, and other foliage is enhanced, while earth tones take on a cool hue. Landscape, fashion, and portrait photographers often use the light available during and immediately after sunrise.

Although you can use the AWB (Automatic White Balance) setting, you get better color if you set a custom white balance, which is detailed in Chapter 3.

Note

If you are shooting RAW images, you can also adjust the color temperature precisely in Canon's Digital Photo Professional RAW conversion program.

Midday

During midday hours, the warm and cool hues of light equalize to create a light that the human eye sees as white or neutral. On a cloudless day, midday light often is considered too harsh and contrasty for many types of photography, such as portraiture. However, midday light is effective for photographing images of graphic shadow patterns, flower petals and plant leaves made

translucent against the sun, and images of natural and man-made structures.

For midday pictures, the Daylight White Balance setting on the XS/1000D is a reliable choice. If you take portraits during this time of day, use a silver reflector, or the built-in flash or an accessory flash to fill dark shadows. You can set flash exposure compensation in 1/3- or 1/2-stop increments to get just the right amount of fill light using either the built-in flash or an accessory Speedlite.

For more details on flash exposure compensation, see Chapter 7.

Sunset

During the time just before, during, and just after sunset, the warmest and most intense color hues of natural light occur. The predominantly red, yellow, and gold hues create vibrant colors, while the low angle of the sun creates soft contrasts that define and enhance textures and shapes. Sunset colors create rich landscape, cityscape, and wildlife photographs.

For sunset pictures, the Cloudy or AWB settings are good choices.

Diffused light

On overcast or foggy days, the light is diffused and tends toward cool color hues. Diffusion spreads light over a larger area, making it softer and usually reducing or eliminating shadows. Light can be diffused by clouds; an overcast sky; atmospheric conditions including fog, mist, dust, pollution, and haze; or objects such as awnings or shade from trees or vegetation.

Diffused light renders colors as rich and saturated, and it creates subdued highlights and soft-edged shadows.

6.9 At midday, the colors of the sky and wagon are rendered accurately using the Daylight White Balance setting that's calibrated for this type of light. This light creates deep, hard-edged shadows as are shown under the wagon. Exposure: ISO 100, f/2.8, 1/1000 second.

Because diffuse light is particularly flattering for portraits, you can create diffuse light even on a brightly lit day by using a scrim, a panel of cloth such as muslin or other fabric, stretched tightly across a frame. The scrim is held between the light source and the subject to diffuse the light.

Because overcast and cloudy conditions commonly are between 6000K and 8000K, the Cloudy White Balance setting on the XS/1000D works adequately for overcast and cloudy conditions.

Note

To learn more about light, visit Canon's Web site at www.canon. com/technology/s_labo/light/003/01.html.

Electronic flash

Most on-camera electronic flashes are balanced for the neutral color of midday light, or 5500K to 6000K. Because the light from an electronic flash is neutral, it reproduces colors accurately. Flash is useful in low-light situations, and it is also handy outdoors to fill or eliminate deep shadow areas caused by strong top lighting. You can also use it to provide detail in shadow areas for backlit subjects.

On the XS/1000D, the Flash White Balance setting is the best setting to use because it reproduces colors accurately.

Tungsten light

Tungsten is typically the light provided by household lights and lamps. This light has a warmer hue than daylight and produces a yellow/orange cast in photos. In moderation, the yellow hue is valued for the warm feeling it lends to images.

Setting the XS/1000D to the Tungsten White Balance setting retains a hint of the warm hue of tungsten light while rendering colors with reasonable accuracy. If you want neutral colors without the warm hue of tungsten, then set a Custom White Balance.

6.10 Sunset drama is typically most brilliant in the western sky. Here the silhouetted trees frame the sunset and provide foreground interest and context. Exposure: ISO 400, f/8, 1/125 second.

Fluorescent and other light

Commonly used in offices and public places, fluorescent light ranges from a yellow to a blue-green hue. Other types of lighting include mercury-vapor and sodium-vapor lights found in public arenas and auditoriums that have a green-yellow cast in unfiltered or uncorrected photos. You should set a Custom White Balance on the XS/1000D in this type of light or shoot a white or gray card so that you can balance to neutral during RAW-image conversion.

Note

You can learn more about setting custom white balance and using white or gray cards at www.cambridgeincolour.com/ tutorials/white-balance.htm.

6.11, Overcast light provided soft and subject-appropriate illumination for the poppy bud. Exposure: ISO 100, f/2.8, 1/45 second.

Light from fire and candles creates a redorange-yellow color hue. In most cases, the color hue is warm and inviting and you can modify it to suit your taste on the computer.

Metering light

Light is the key ingredient for exposure, and to make a proper exposure, the camera must measure the amount of light in a scene accurately. Measuring or "metering" light is done by using the XS/1000D's onboard light meter, and it is measured at the active AF point when you half-press the Shutter button to establish focus. To understand exposure and light, it's important to understand how the light meter measures light in a scene.

6.12 A touch of fill flash using the built-in flash brings the flower visually forward in the frame. Exposure: ISO 100, f/3.5, 1/200 second with Flash Exposure Compensation set to -2 EV (Exposure Value).

The XS/1000D's reflective light meter sees only gray, and the meter measures light that is reflected back to the camera from the subject. In any scene, the light meter sees tones ranging from black to white and all shades of gray in between. The meter measures how much light these shades of gray, plus black and white, reflect back to it. Objects that are neutral gray, or an even a mix of black and white, reflect 18 percent of the light falling on them and absorb the rest of the light. In the black-and-white world of a camera's light meter, objects that are white reflect 72 to 90 percent of the light and absorb the remainder. Objects that are black absorb virtually all of the light.

Because the camera's light meter sees only monotone, you may wonder how that translates to color. Simply stated, all of the colors that you see map to a percentage or shade of gray. In color scenes, the light and dark values of color correspond to the swatches of gray on the grayscale. A shade of red, for example, has a corresponding shade of gray on a grayscale. The lighter the color's shade, the more light it reflects. Predictably, intermediate percentages between black and white reflect and absorb different amounts of light.

Another important characteristic of the light meter is that it is calibrated for an "average" scene, one that contains a balance of dark and light tones that average out to 18 percent reflectance. The meter produces an accurate rendition of the scene as long as it has average reflectance.

However, in non-average scenes such as those with large expanses of snow or white sand, or scenes with large expanses of dark

6.13 A tungsten lamp provided the light for this antique china watering can. The warmth of the tungsten lighting is evident throughout the image. Exposure: ISO 400, f/2.8, 1/80 second.

tones, the camera continues to average the scene tones to 18 percent gray. As a result, the camera tends to make white snow or black graduation gowns gray instead of white and black respectively.

As detailed in Chapter 2, you can use exposure modifications in non-average scenes. For example, to render the snow as white, you set exposure compensation to a positive value, such as +1 or +2 Exposure Values (EVs), to increase the exposure and render the snow as white in the image. For scenes with large dark expanses, you use a negative exposure compensation to get true dark

tones in the image.

6.14 These flowers were lit by commercial fluorescent light in a grocery store. The Fluorescent white balance setting on the XS/1000D provides visually pleasing color rendition. Exposure: ISO 100, f/2.8, 1/100 second

Additional characteristics of light

Photographers often describe light as hard or soft. Hard light creates shadows with well-defined edges. Soft light creates shadows with soft edges. Understanding the effect of each type of light before you begin shooting is the key to using both types of light, and variations in between, effectively.

Hard light

Hard light is created when a distant light source produces a concentrated spotlight effect — such as light from the sun in a cloudless sky at midday, an electronic flash,

Dealing with Reflected Light

In addition to light reflected from the subject back to the camera, photographers must also take into account reflected light in a scene. Given that surfaces other than pure black are reflective, these surfaces reflect their color onto the subject. For example, if you photograph a person in a grassy area, some of the green color from the grass reflects onto the subject. The closer the subject is to the grass, the more green is reflected on the subject. Similarly, photographing a subject under an awning or near a colored wall also results in color from the surface reflecting onto the subject. The amount of reflectance depends on the proximity of the subject to the colored surface, the intensity of the color, and the reflectance of the surface.

Reflected color, of course, can make getting accurate color in the image difficult. To avoid or minimize corrections, you can move the subject away from the surface that is reflecting onto the subject. If you want neutral color in the image, set a Custom White Balance. Alternatively, if you're shooting RAW capture, you can shoot a gray or white card to make color correction easier during image conversion.

or a bare light bulb. Hard light creates dark, sharp-edged shadows as well as a loss of detail in highlights and shadows.

Portraits taken in hard overhead light create dark, unattractive shadows under the eyes, nose, and chin. This type of light is also called contrasty light. Contrast is measured by the difference in exposure readings (f-stops) between highlight and shadow areas: the greater the difference, the higher the contrast. Because hard light is contrasty, it produces well-defined textures and bright colors. Hard light is best suited for subjects with simple shapes and bold colors.

To soften hard light, you can add or modify light on the subject by using a fill flash or a reflector to bounce more light into shadow areas. In addition, you can move the subject to a shady area or place a scrim (diffusion panel) between the light and the subject. For landscape photos, you can use a graduated neutral density filter to help compensate for the difference in contrast between the darker foreground and brighter sky.

6.15 This rose was lit by midday sun that created deep, hard-edged shadows. Exposure: ISO 100, f/5.6, 1/500 second.

Soft light

Soft light is created when a light source is diffused. In the outdoors, clouds or other atmospheric conditions diffuse a light source, such as the sun, or you can diffuse bright light to soften it by using a scrim. Diffusion not only reduces the intensity (quantity) of light, but it also spreads the light over a larger area (quality). In soft light, shadow edges soften and transition gradually, texture definition is less distinct, colors are less vibrant than in hard light, detail is apparent in both highlights and shadow areas of the picture, and overall contrast is reduced.

When working in soft light, consider using a telephoto lens and/or a flash to help create separation between the subject and the background. Soft light is usually well suited for portraits and macro shots, but soft light from an overcast sky is less than ideal for travel and landscape photography. In these cases, look for strong details and bold colors, and avoid including an overcast sky in the photo.

Directional light

Whether natural or artificial, the direction of light can determine the shadows in the scene. You can use both the type and direction of light to reveal or hide detail, add or reduce texture and volume, and help create the mood of the image.

Front lighting. Front lighting is light that strikes the subject straight on at approximately the subject's eye level. This lighting approach produces a flat effect with little texture detail and with shadows behind the subject, as seen in many snapshots taken with an on-camera flash. Side lighting. Side lighting places the main light to the side of and at the same height as the subject. One side of the subject is brightly lit, and the other side is in medium or deep shadow, depending on the lighting setup. This technique is often effective for portraits of men, but it is usually considered unflattering for portraits of women.

However, a variation of side lighting is high-side lighting, a classic portrait lighting technique where a light is placed to the side of and higher than the subject.

- Top lighting. Top lighting, as the term implies, is light illuminating the subject from the top, such as you what find at midday on a sunny, cloudless day. This lighting produces strong, deep, hard-edged shadows. This lighting direction is suitable for some subjects, but it usually is not appropriate for portraits. However, for studio portraits, a variation on top lighting is butterfly or Paramount lighting, a technique popularized by classic Hollywood starlet portraits. Butterfly lighting places the main light high, in front of, and parallel to, the vertical line of the subject's nose to create a symmetrical, butterfly-like shadow under the nose.
- ◆ Backlighting. Backlighting is light that is positioned behind the subject. This technique creates a classic silhouette, and, depending on the angle, also can create a thin halo of light that outlines the subject's form. Although a silhouette can be dramatic, the contrast obliterates details in the subject. A fill flash can be used to show detail in the subject. In addition, backlighting often produces lens flare displayed as

6.16 The plastic covering of a greenhouse provided soft lighting for this flower. Exposure: ISO 100, f/2.8, 1/60 second.

bright, repeating spots or shapes in the image. Flare can also show up in the image as a dull haze or unwanted rainbow-like colors. To avoid lens flare, use a lens hood to help prevent stray light from striking the lens, or change your shooting position.

Although you may not be able to control the light, especially natural outdoor light, consider these alternatives, which may improve your shot:

- Move the subject.
- Change your position.
- Use a reflector or scrim.
- Wait for better light or a light color that enhances the subject or message of the picture.

Using Flash

ountless scenes open the door for using a flash — either the Rebel XS/1000D's onboard flash unit or one or more accessory Canon EX-series Speedlites. And on the creative front, a flash offers opportunities for capturing everything from portraits to a drip of water suspended in flight.

This chapter explores flash technology, details the use of the XS/1000D's onboard flash, and covers the menu options for the built-in flash and for accessory EX-series Speedlites. This chapter is not an exhaustive look at all the ways in which you can use the onboard or accessory flash units. Rather, the focus is on fundamental flash techniques and ideas for using flash for both practical situations and for creative effect.

Exploring Flash Technology

Both the onboard flash and Canon's EX-series Speedlites employ E-TTL II technology. E-TTL stands for Evaluative Through-the-Lens flash exposure control. E-TTL II is a flash technology that receives information from the camera, including the focal length of the lens, distance from the subject, exposure settings including aperture, and the camera's built-in evaluative metering system to balance subject exposure with the ambient light.

In more technical terms, with E-TTL II, the camera's meter reads through the lens, but not off the focal plane. After the Shutter button is fully pressed but before the reflex mirror goes up, the flash fires a preflash beam. Information from this preflash is combined with data from the evaluative metering system to analyze and compare ambient light exposure values with the amount of light needed to make a good exposure. Then the camera calculates and stores the flash output needed to illuminate the subject while maintaining a natural-looking balance with the ambient light in the scene.

In addition, the flash automatically figures in the angle of view for the XS/1000D given its cropped image sensor size. Thus,

In This Chapter Exploring flash technology Using the onboard flash Modifying flash exposure Using flash control options Using one or more accessory Speedlites

regardless of the focal length of the lens you're using, the built-in flash and EX-series Speedlites automatically adjust the flash zoom mechanism for the best flash angle and to illuminate only key areas of the scene, which conserves power. Altogether, this technology makes the flash very handy for a variety of subjects.

With the built-in flash, you can use it in all of the camera's Creative Zone modes and the Basic Zone modes except Landscape, Sports, and Flash Off modes, knowing that the exposure settings are taken into account during exposure, given the maximum sync speed for the flash.

In Basic Zone modes except Landscape, Sports, and Flash Off, the camera automatically fires the flash when it determines the light level is too low to produce a sharp handheld image. And in P mode, the camera automatically sets the shutter speed between 1/60 and 1/200 second to prevent blur from camera shake.

When shooting with accessory Speedlites, Canon's flash technology allows wireless, multiple flash photography where you can simulate studio lighting in both placement of lights and light ratios (the relative intensity of each flash unit).

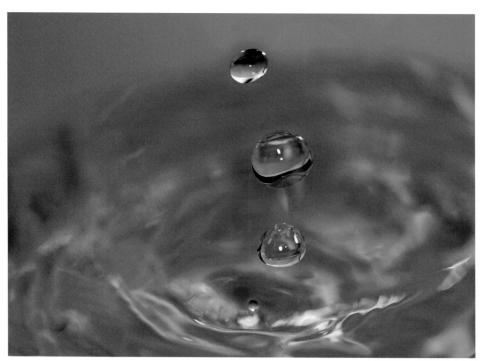

7.1 For this image, I used the built-in flash to capture water drops falling into a glass of water. Exposure: ISO 100, f/2.8, 1/200 second.

Why Flash Sync Speed Matters

Flash sync speed matters because if it isn't set correctly, only part of the image sensor has enough time to receive light while the shutter is open. The result is an unevenly exposed image. The XS/1000D doesn't allow you to set a shutter speed faster than 1/200 second, but you can set a slower flash sync speed, as shown in Table 7.1. With slower sync speeds, more of the ambient light in the scene contributes to the final exposure. Using Custom Function C.Fn-2, you can choose whether the XS/1000D sets the flash sync speed automatically (Option 0) or always uses 1/200 second (Option 1) when you shoot in Av mode. If you choose to always use 1/200 second, then the flash acts as the main light source.

Using the Onboard Flash

The onboard flash unit on the XS/1000D offers a handy complement to existing-light photography. The built-in flash offers coverage for lenses as wide as 17mm (equivalent to 27mm in full 35mm frame shooting). The flash recycles in approximately one to three seconds, depending on the number of firings, and the readiness is indicated by the Flash-ready light in the viewfinder.

The built-in flash offers good versatility and features overrides, including Flash Exposure Compensation (FEC) and Flash Exposure Lock (FE Lock), detailed later in this chapter. In addition, many flash options can be set on the camera's Flash Control menu when you shoot in Creative Zone modes.

Flash Control menu options include the ability to turn off firing of the built-in flash and an accessory flash, shutter sync with first or second curtain, and Evaluative or Average metering. The XS/1000D also allows you to set Custom Functions for an accessory EX-series Speedlite through the Set-up 2 (yellow) camera menu — a handy feature that allows you to use the camera's larger-size LCD to set up external flash functions. Control of Red-eye

reduction is also provided on the Shooting 1 (red) menu.

7.2 In this and other images in this chapter, I use the same subject to show the effect of different flash settings and techniques. The subject is lit by window light to the left and by the built-in flash with C.Fn-2 set to Option 1: Fixed meaning the flash provided the primary illumination. Dark shadows characteristic of flash are evident. Exposure: ISO 100, f/14, 1/200 second.

Using One or More Accessory Speedlites

With one or more accessory flash units, a new level of lighting options opens up, ranging from simple techniques such as bounce flash and fill flash to controlled lighting ratios with up to three groups of accessory flash units. With E-TTL II metering, you have the option of using one or more flash units as either the main or an auxiliary light source to balance ambient light with flash to provide even and natural illumination and balance among light sources.

The 580EX II, 580EX, and 430EX II are compatible with wireless multiple flash photography and can be set up in groups of multiple flash units with triggering from the master flash. A switch on the Speedlite allows you to designate master and slave units. In addition, you can use the Canon Speedlite Transmitter ST-E2 to set up lighting ratios to mimic studio lighting systems.

One or more Speedlites provide an excellent portable studio for portraits and still-life shooting. And you can add light stands and light modifiers such as umbrellas and/or

7.6 Here I used two EX-series Speedlites: a 580EX Speedlite mounted on the camera and bounced off a white reflector held above the flash, and a 550EX Speedlite to the right of the subject to light the background. The 550 was fired wirelessly from the 580. Exposure: ISO 100, f/2.8, 1/80 second.

softboxes, and use a variety of reflectors to produce images that either replicate studio lighting results or enhance existing light.

I encourage you to explore the options that multiple Speedlites offer. For detailed information on using Canon Speedlites, be sure to check out the Canon Speedlite System Digital Field Guide by J. Dennis Thomas (Wiley, 2007).

Table 7.2

XS/1000D Built-in Flash Range with the EF-S 18-55mm f/3.5-5.6 IS II Lens

ISO	18mm	55mm	
100	1 to 3.7m (3.3 to 12.1 ft.)	1 to 2.3m (3.3 to 7.5 ft.)	
200	1 to 5.3m (3.3 to 17.4 ft.)	1 to 3.3m (3.3 to 10.8 ft.)	
400/Auto	1 to 7.4m (3.3 to 24.3 ft.)	1 to 4.6m (3.3 to 15.1 ft.)	
800	1 to 10.5m (3.3 to 34.4 ft.)	1 to 6.6m (3.3 to 21.7 ft.)	
1600	1 to 14.9m (3.3 to 48.9 ft.)	1 to 9.3m (3.3 to 30.5 ft.)	

Using the flash's autofocus-assist beam without the flash

In some low-light scenes, you may want to shoot using ambient, or existing, light without using the flash. However, the camera may have trouble establishing good focus due to the low light. In these situations, you can have the camera use only the autofocus-assist (AF-assist) beam from the flash to help the camera establish focus quickly.

To use the flash's AF-assist beam to assist in focusing without firing the flash, follow these steps.

- Press the Menu button, and then press the right cross key until the Set-up 2 (yellow) menu is displayed.
- Press the down cross key to highlight Flash control, and then press the Set button. The Flash control screen appears.
- Press the up or down cross key to highlight Flash firing, and then press the Set button. Two options appear.
- 4. Press a cross key to select either Enable or Disable, and then press the Set button. If you choose

Using Guide Numbers

A guide number indicates the amount of light that the flash emits — the power of the flash — so that you can determine the best aperture to use at a particular distance and at a given ISO, usually ISO 100. The built-in flash guide number is 13, or 43 (feet)/13 (meters) at ISO 100. The relationship between the aperture and the flash-to-subject distance is Guide Number \div Aperture = Distance for optimal exposure, and Guide Number \div Distance = Aperture for optimal exposure. For example, with a guide number of 43, and shooting 8 feet from the subject, the optimal aperture is determined thusly: 43 \div 8 feet is 5.375, or rounded up to f/5.6. You can do some quick math to get an idea of the effective range of the built-in flash and the exposures needed at the maximum distance. For example, at ISO 100 and f/2.8, the maximum range of the flash is 15 feet. If you need more extensive depth of field, the guide number calculations let you know that at that distance you'd need to increase the ISO to 400 to move to f/5.6.

Disable, neither the built-in flash nor an accessory Speedlite will fire. However, the camera will use the flash's AF-assist beam to establish focus in low-light scenes.

5. Pop up the built-in flash by pressing the Flash button on the front of the camera, or mount an accessory EX-series Speedlite, press the Shutter button halfway to focus, and then press the Shutter button completely to make the picture. When you press the Shutter button halfway, the flash's AF-assist beam fires to help the camera establish focus. If the scene has low light, be sure to use a tripod or stabilize the camera on a solid surface.

Also, with Custom Function C.Fn-6, you can choose whether the AF-assist beam is fired by the camera's built-in flash or by an accessory Speedlite. If this function is set to 1: Disable, the AF-assist beam is not used. If you've set the Custom Function on the Speedlite for AF-assist beam firing to Disable, the AF-assist beam is not used, regardless of what option you choose on the camera for C.Fn-6. You can also select Option 2: Only external flash emits so that only the Speedlite's AF-assist beam is fired and the built-in flash AF-assist beam does not fire.

For details on Custom Functions, see Chapter 5.

Red-eye reduction

A disadvantage of flash exposure in people and pet portraits is unattractive red color in the subject's eyes. There is no sure way to prevent red eye, but a few steps help reduce it. First, be sure to turn on Red-Eye Reduction on the XS/1000D. This option is set to Off by default. Then, before making the picture, have the subject look at the Red-Eye

Reduction lamp on the front of the camera when it fires at the beginning of a flash exposure. Also ensure that the room well lit.

Before you begin, ensure that the Flash Firing is set to Enable on the Set-up 2 (yellow menu). Then, to turn on Red-Eye Reduction, follow these steps.

- Press the Menu button, and then press the left cross key to select the Shooting 1 (red) menu if it isn't already displayed.
- Press the down cross key to highlight Red-eye On/Off, and then press the Set button. Two options are displayed.
- Press the down cross key to highlight On, and then press the Set button. The setting you choose applies to both Basic and Creative Zone modes.
- 4. If you're shooting in P, Tv, Av, M, or A-DEP, press the Flash button on the front of the camera to pop up the built-in flash. In Basic-Zone modes such as Full Auto, Portrait, Close-up and so on, the XS/1000D pops up and fires the flash automatically, depending on the amount of light in the scene. If you're shooting a portrait, also alert the subject to look at the camera's red-eye reduction lamp when it fires.
- 5. Focus on the subject by pressing the Shutter button halfway, and then watch the timer display at the bottom center of the viewfinder. When the timer display in the viewfinder disappears, press the Shutter button completely to make the picture. When you press the Shutter button halfway, the redeye reduction lamp illuminates briefly to contract the subject's

irises provided that the subject is looking at the lamp.

Modifying Flash Exposure

There are doubtless times when the output of the flash will not produce the picture that you envisioned. Most often, the output is stronger than desired, creating an unnaturally bright illumination on the subject, hot spots on the subject's skin, and dark shadows behind the subject. The XS/1000D offers two options for modifying the flash output that can help reduce these problems: Flash Exposure Compensation (FEC) and Flash Exposure Lock (FE Lock) for both the and one or more accessory built-in Speedlites. These flash modification techniques can be used only in P, Tv, Av, and A-DEP modes.

Flash Exposure Lock

One way to modify flash output is by using FE Lock. Much like Auto Exposure Lock (AE Lock), FE Lock allows you to meter and set the flash output on any part of the scene.

With FE Lock, you lock the flash exposure on a midtone area in the scene. The camera calculates a suitable flash output, locks the exposure, and then you recompose the image, focus, and make the picture.

FE Lock is also effective when there are reflective surfaces such as a mirror, chrome, or glass in the scene. Without using FE Lock, the camera takes the reflective surface into account and reduces the flash, causing underexposure. Instead, set FE Lock for a midtone area in the scene that does not include the reflective surface, and then make the exposure.

To set FE Lock, follow these steps:

- Set the camera to P, Tv, Av, M, or A-DEP, and then press the Flash button to raise the built-in flash or mount the accessory Speedlite. The flash icon appears in the viewfinder.
- 2. Point the lens at the midtone area of the subject or scene where you want to lock the flash exposure, press the Shutter button halfway, and then press the AE/FE Lock button on the back right side of the camera. This button has an asterisk above it. The flash exposure is set at the currently selected AF point. The camera fires a preflash. FEL is displayed momentarily in the viewfinder, and the flash icon in the viewfinder displays an asterisk beside it to indicate that flash exposure is locked. The camera retains the flash output in memory.

Note

If the flash icon in the viewfinder blinks, you are too far from the subject for the flash range. Move closer to the subject and repeat Step 2.

 Move the camera to compose the image, press the Shutter button halfway to focus on the subject, wait for the flash timer display in the viewfinder to disappear, and then completely press the Shutter button to make the image.

Note

You can take additional pictures at this flash output as long as the asterisk is displayed in the viewfinder.

FE Lock is a practical technique to use when shooting individual images. But if you're shooting a series of images under unchanging light, then FEC is more efficient and practical.

7.3 To prevent highlight blowout on the wine bottle, I used FE Lock to set the flash exposure on the highlight at the center of the bottle. Exposure: ISO 100, f/2.8, 1/200 second using the Canon Speedlite 580EX.

Flash Exposure Compensation

Flash Exposure Compensation (FEC) is much like Auto Exposure Compensation in that you can increase or decrease flash exposure up to plus or minus two stops in 1/3-stop increments. A positive compensation increases the flash output and a negative compensation decreases the flash output. The compensation is applied to all flash exposures until you reset the compensation back to zero.

As with non-flash exposure, the camera is calibrated for an "average" scene of 18 percent gray, and flash exposures can be thrown off by very light and very dark subjects or

scenes. As a result, very light subjects may need increased flash exposure and darktoned subjects may need a reduced flash exposure. Some experimentation is required because subjects and scenes vary.

If you use flash compensation to create a more natural-looking portrait in daylight, try setting negative compensation between -1 and -2 stops. Also be aware that in bright light, the camera assumes that you're using fill flash to reduce dark shadows and automatically provides flash reduction. Experiment with the Rebel XS/1000D in a variety of lighting scenes to know what to expect from the flash.

It's important to note that if you use FEC, you may not see much, if any, difference in images because the XS/1000D has Auto Lighting Optimizer turned on by default for all JPEG images except when you're shooting RAW+JPEG images. This feature automatically corrects images that are underexposed or have low contrast. So if you set FEC to a negative setting to reduce flash output, the camera may detect the image as being underexposed (too dark) and automatically brighten the picture.

If you're using FEC, it's best to turn off Auto Lighting Optimizer. Just press the Menu button, highlight the Set-up 3 (yellow) menu, and then press the down cross key to select Custom Functions (C.Fn). Press the Set button. Press the right or left cross key until the C.Fn II: Image, Auto Lighting Optimizer screen appears and the number 5 is displayed in the box at the top right of the screen. Press the Set button to activate the option controls. Press the down cross key to select Option 1: Disable, and then press the Set button. The Auto Lighting Optimizer remains disabled for Creative Shooting modes only until you enable it again.

7.4 In this image, the Custom Function 2 (C. Fn-2) was set to Auto so that window light from the left factored more into the exposure. The shadows are softened significantly as compared to figure 7.2. Exposure: ISO 100, f/14, 1/4 second.

Note Auto Lighting Optimizer is used in Basic Zone shooting modes such as Portrait, Landscape, and so on, and you cannot change it.

If you use an accessory Speedlite, you can set FEC either on the camera or on the Speedlite. However, the compensation that you set on the Speedlite overrides any compensation that you set on the XS/1000D's Set-up 2 (yellow) camera menu. If you set compensation on both the Speedlite and the camera, the Speedlite setting overrides what you set on the camera. So set compensation either on the Speedlite or on the camera, but not both.

FEC can be combined with Exposure Compensation. If you're shooting a scene where one part of the scene is brightly lit and another part of the scene is much darker — for example, an interior room with a view to the outdoors — then you can set Exposure Compensation to -1 and set the FEC to -1 to make the transition between the two differently lit areas more natural.

To set FEC for the built-in flash, follow these steps:

- Set the camera to P, Tv, Av, M, or A-DEP.
- 2. Press the Menu button, and turn the Main dial to select the Shooting 2 (red) menu.
- Press the down cross key to select Flash exp comp, and then press the Set button. The Exposure Level indicator meter is activated.
- 4. Press the left cross key to set negative compensation (lower flash output to darken the image) or the right cross key to set positive flash output (increased flash output to lighten the image). As you make changes, a tick mark under the Exposure Level meter moves to indicate the amount of FEC in 1/3-stop increments. The FEC is displayed in the viewfinder when you press the Shutter button halfway. The FEC you set on the camera remains in effect until you change it.

To remove FEC, repeat these steps, but in Step 4, press the left or right cross key to move the tick mark on the Exposure Level meter back to the center point.

7.5 In this image, I used the Canon EX-580 Speedlite with Custom Function 2 (C.Fn-2) set to Auto. I pointed the flash head straight up and bounced the flash off a small silver reflector. Exposure: ISO 100, f/14, 1/4 second.

Using Flash Control Options

With the XS/1000D, many of the onboard and accessory flash settings are available on the camera menus. The Set-up 2 (yellow) menu offers onboard flash settings, including the first- or second-curtain shutter sync, Flash Exposure Compensation, and the option to choose E-TTL II or Average exposure metering.

When an accessory Speedlite is mounted, you can use the Set-up 2 (yellow) menu to set FEC and to set Evaluative or Average

flash metering. In addition, you can change or clear the Custom Function (C.Fn) settings for compatible Speedlites such as the 580 EX II. If the Speedlite functions cannot be set with the camera, these options display a message notifying you that the flash is incompatible with this option. In that case, set the options you want on the Speedlite itself.

To change settings for the onboard or compatible accessory EX-series Speedlites, follow these steps:

- 1. Set the camera to P, Tv, Av, M, or A-DEP. If you're using an accessory Speedlite, mount it on the camera and turn on the power.

 The XS/1000D is compatible with the Canon 580EX II, 430EX, 220EX, Macro Ring Lite MR-14X, and Macro Twin Lite MT-24EX, although available options for each Speedlite may vary on the External flash func. setting screen menu that's accessed from the Flash Control screen.
- Press the Menu button, and then press the right cross key until the Set-up 2 (yellow) menu is displayed.
- Press the down cross key to highlight Flash Control, and then press the Set button. The Flash Control screen appears with options for the built-in and external flash.
- 4. Press a cross key to highlight the option you want, and then press the Set button. Choose a control option from the Flash Control menu and press the Set button. Table 7.3 lists the menu settings, options, and suboptions that you can choose from to control the flash.

	Table 7.3			
Flash	Control	Menu	0	ptions

Setting	Option(s)	Suboptions/Notes
Built-in flash func. setting	Flash mode	Cannot be changed from E-TTL II
	Shutter Sync	1st curtain: Flash fires right after the exposure begins.
		2nd curtain: Flash fires just before the exposure ends. Can be used with slow-sync speed to create light trails behind the subject.
	Flash exp. Comp	You can set positive or negative compensation up to +/-2 EV.
	E-TTL II	Evaluative (default) option sets the flash exposure based on an evaluation of the entire scene. Average option flash exposure is metered and averaged for the entire scene. Results in brighter output on the subject and less balancing of ambient light in the scene.
External flash	Flash mode	E-TTL II
func. setting	Shutter sync	You can choose either:
(You must have an exter- nal flash		1st curtain: Flash fires immediately after the exposure begins. Or,
mounted on the hot shoe to see these		2nd curtain: Flash fires just before the exposure ends. Can be used with slow-sync speed to create light trails behind the subject.
options.)	FEB (Flash Exposure Bracketing)	You can set the FEB amount.
	Flash exp. comp.	You can set positive or negative Flash Exposure Compensation.
	E-TTL II	You can choose either Evaluative or Average metering.
External flash C.Fn setting	(The available options depend on the Speedlite's Custom Functions.)	You can select the C.Fn settings that you want to set for the Speedlite you're using.
Clear ext. flash C.Fn set.	Clears C.Fn settings for the Speedlite you're using	

Using One or More Accessory Speedlites

With one or more accessory flash units, a new level of lighting options opens up, ranging from simple techniques such as bounce flash and fill flash to controlled lighting ratios with up to three groups of accessory flash units. With E-TTL II metering, you have the option of using one or more flash units as either the main or an auxiliary light source to balance ambient light with flash to provide even and natural illumination and balance among light sources.

The 580EX II, 580EX, and 430EX II are compatible with wireless multiple flash photography and can be set up in groups of multiple flash units with triggering from the master flash. A switch on the Speedlite allows you to designate master and slave units. In addition, you can use the Canon Speedlite Transmitter ST-E2 to set up lighting ratios to mimic studio lighting systems.

One or more Speedlites provide an excellent portable studio for portraits and still-life shooting. And you can add light stands and light modifiers such as umbrellas and/or

7.6 Here I used two EX-series Speedlites: a 580EX Speedlite mounted on the camera and bounced off a white reflector held above the flash, and a 550EX Speedlite to the right of the subject to light the background. The 550 was fired wirelessly from the 580. Exposure: ISO 100, f/2.8, 1/80 second.

softboxes, and use a variety of reflectors to produce images that either replicate studio lighting results or enhance existing light.

I encourage you to explore the options that multiple Speedlites offer. For detailed information on using Canon Speedlites, be sure to check out the Canon Speedlite System Digital Field Guide by J. Dennis Thomas (Wiley, 2007).

Creative Accessories and More

P A R T

In This Part

Chapter 8Exploring Canon Lenses

Chapter 9
In the Field with the EOS Rebel XS/1000D

Appendix ADownloading Images
and Updating Firmware

Appendix BExploring RAW
Capture

Glossary

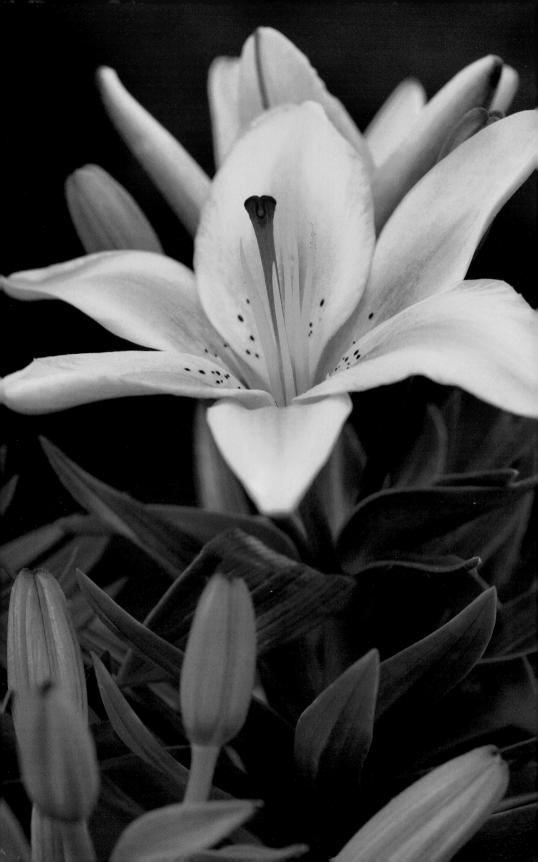

Exploring Canon Lenses

uch of the creative freedom that your Rebel XS/1000D offers comes with the ability to use a wide range of different lenses. Whether you love shooting macro shots or shooting wildlife, there are lenses that suit every shooting need.

Because the lens is the eye of the camera, the importance of quality lenses can't be overstated. High-quality lenses produce pictures with stunning detail, high resolution, and snappy contrast. Conversely, low-quality optics can produce images with less-than-crisp details, soft edges, and flat contrast. Over time your investment in lenses will far exceed the money that you invested in the camera body. And the lenses you buy will still be in your camera bag long after you've moved to one or more different Canon camera bodies. For these reasons, making studied decisions on lens purchases pays off for years to come in getting great image sharpness and quality and in building a solid photography system.

This chapter looks at the lenses that are available, to help you make decisions about lenses you can add to your system, and to enhance the type of photography you most enjoy.

Understanding the Focal Length Multiplication Factor

One of the first things to understand about lenses and the Rebel XS/1000D is that the Rebel's image sensor is smaller than a traditional 35mm film frame. And the 35mm film frame is the industry standard for manufacturing lenses. This affects the angle of view of the lenses you use. A lens's angle of view is how much of the scene, from side to side and top to bottom, the lens includes in the image. For example, a 15mm

In This Chapter

Understanding the focal length multiplication factor

Lens choices

Zoom versus prime lenses

Canon lens terminology

Using wide-angle lenses

Using telephoto lenses

Using normal lenses

Using macro lenses

Using tilt-and-shift lenses

Using image-stabilized lenses

Exploring lens accessories

fisheye lens has a 180-degree angle of view. By contrast, a 200mm lens has a scant 12-degree angle of view. But with a smaller sensor size, those angles of view change.

Specifically, the EOS Rebel XS/1000D image sensor is 1.6 times smaller than a traditional 35mm film frame. This means that the angle of view for all lenses you use on the XS/1000D is reduced by a factor of 1.6 times at any given focal length, producing an image that is equal to that of a lens with 1.6 times the focal length. For example, a 100mm lens on a 35mm film camera becomes the equivalent of a 160mm lens on the XS/1000D. Likewise, a 50mm "normal" lens becomes the equivalent to a short telephoto lens on a full-35mm-frame size.

The Canon EF-S lenses are usable only on the cropped-frame cameras, including the XS/1000D, due to a redesigned rear element that protrudes back into the camera body.

The multiplication factor has at least two implications for your shooting and choice of lenses. First, the focal length multiplication factor works to your advantage with a telephoto lens because it effectively increases the lens's focal length (although technically the focal length doesn't change). And because telephoto lenses tend to be more expensive than other lenses, you can buy a shorter and less expensive telephoto lens and get 1.6 times more magnification at no extra cost.

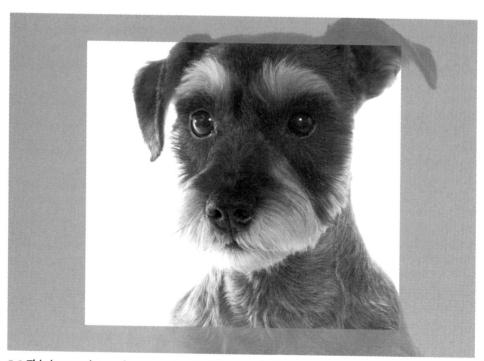

8.1 This image shows the approximate difference in image size between a 35mm film frame and the XS/1000D. The smaller image size represents the XS/1000D's image size.

However, the focal length multiplication factor works to your disadvantage with a wideangle lens because the sensor sees less of the scene when the focal length is magnified by 1.6x. But, because wide-angle lenses tend to be less expensive than telephoto lenses, you can buy an ultrawide 14mm lens to get the equivalent of an angle of view of 22mm.

Telephoto lenses provide a shallow depth of field, so it seems reasonable to assume that the conversion factor would produce the same depth-of-field results on the XS/1000D that a longer lens gives. That isn't the case, however. Although an 85mm lens on a full 35mm-frame camera is equivalent to a 136mm lens on the XS/1000D, the depth of field on the XS/1000D matches the 85mm lens, not the 136mm lens.

This depth-of-field principle holds true for enlargements. The depth of field in the print is shallower for the longer lens on a fullframe camera than it is for the XS/1000D.

Lens Choices

Lenses range in focal lengths (the amount of the scene included in the frame) from fisheye to super-telephoto and are generally grouped into three main categories: wide angle, normal, and telephoto. There are also macro lenses that serve double-duty as either normal or telephoto lenses and offer macro capability. The following sections provide an overview of each category of lenses.

8.2 As a result of the focal length multiplication factor on the XS/1000D, less of the scene is included than would be on a full-frame camera. Exposure: ISO 400, f/11, 1/320 second using a Canon EF 24-70mm f/2.8L USM lens.

Wide angle

Wide-angle lenses offer a wide view of a scene. This category traditionally ranges from 15mm, or fisheye, to 35mm, with an angle of view ranging from 180 degrees to 63 degrees. Simply stated, lenses shorter than 50mm are considered wide angle on full-frame 35mm image sensors. On the Rebel XS/1000D with the focal length multiplication factor, lenses shorter than 35mm are wide angle. A wide-angle lens offers sharp detail from foreground to background, especially at narrow apertures such as f/22. The amount of reasonably sharp focus from front to back in an image is referred to as depth of field.

8.3 The Canon EF 70-200mm f/2.8L IS USM telephoto zoom lens zoomed to 145mm (equivalent to 232mm with the 1.6x focal length multiplication factor) enables a close-up view of this vocalist during a concert. Exposure: ISO 400, f/2.8, 1/60 second.

Depth of field is discussed in detail in Chapter 7.

Normal

Normal lenses offer an angle of view and perspective very much as your eyes see the scene. On full 35mm-frame cameras, 50-55mm lenses are considered normal lenses. However, with the focal length conversion factor of 1.6x on the XS/1000D, a 35mm lens is closer to the "normal" focal length. Normal lenses provide extensive depth of field (particularly at narrow apertures) and are compact in size and versatile.

Telephoto

Telephoto lenses offer a narrow angle of view, enabling close-ups of distant scenes. On full 35mm-frame cameras, lenses with focal lengths longer than 50mm are considered telephoto lenses. On the Rebel XS/1000D with the focal length multiplication factor, a 50mm lens is equivalent to 80mm and thus falls in the telephoto category. Telephoto lenses traditionally begin with the 60mm lens and go through to the super-telephoto 800mm lens. Telephoto lenses offer shallow depth of field, providing a softly blurred background, particularly at wide apertures. And, of course, they offer a closer view of distant scenes and subjects.

Macro

Macro lenses are designed to provide a closer lens-to-subject focusing distance than non-macro lenses. Depending on the lens, the magnification ranges from half-life size (0.5x) to 5x magnification. Thus, objects as small as a penny or a postage stamp can fill

8.4 The Canon EF 100mm f/2.8 USM lens is one the best lenses in my camera bag, and it provided this intimate look at a vellow lily petal. Exposure: ISO 100, f/18, 1/160 second.

the frame, while nature macro shots can reveal breathtaking details that are commonly overlooked or are not visible to the human eye. By contrast, non-macro lenses typically allow maximum magnifications of about one-tenth life size (0.1x). Macro lenses are single focal-length lenses that come in normal and telephoto focal lengths.

Zoom versus Prime Lenses

Within the basic focal-length lens categories, you can choose between zoom and prime (also called single focal-length) lenses. The most basic difference between zoom and prime lenses is that zoom lenses offer a range of focal lengths in a single lens while prime lenses offer a fixed, or single, focal length. There are additional distinctions that come into play as you evaluate which type of lens is best for your shooting needs.

About zoom lenses

Zoom lenses, with their variable focal length, are versatile because they offer multiple and variable focal lengths in a single lens. Available in wide-angle and telephoto ranges, zoom lenses can maintain focus during zooming. To keep the lens size compact, and to compensate for aberrations with fewer lens elements, most zoom lenses use a multigroup zoom with three or more movable lens groups.

Some zoom lenses are slower than single focal-length lenses, and getting a fast zoom lens usually comes at a higher price. In addition, some zoom lenses have a variable aperture, which means that the minimum aperture changes at different zoom settings (discussed in the following sections).

Zoom lens advantages

The obvious advantage of a zoom lens is the ability to quickly change focal lengths and image composition without changing lenses. In addition, only two or three zoom lenses are needed to encompass the focal range you use most often for everyday shooting. For example, carrying a Canon EF-S 17-55mm IS USM lens and a Canon EF 55-200mm f/4.5-5.6 II USM lens, or a similar combination, provides the focal range needed for everything from landscape to portrait and nature photography.

A zoom lens also offers the creative freedom of changing image composition with the turn of the zoom ring — all without changing your shooting position or changing lenses. Most mid-priced and more expensive zoom lenses offer high-quality optics that produce sharp images with excellent contrast. As with all Canon lenses, full-time manual focusing is available by switching the button on the side of the lens to MF (Manual Focus).

Zoom lens disadvantages

Although zoom lenses allow you to carry around fewer lenses, they tend to be heavier than their single focal-length counterparts. Mid-priced, fixed-aperture zoom lenses also tend to be slow, meaning that with maximum apertures of only f/4.5 or f/5.6, they call for slower shutter speeds that, in turn, limit your ability to get sharp images when handholding the camera, provided that the lens does not have Image Stabilization (IS), a technology that is detailed later in this chapter.

Some zoom lenses have variable apertures. A variable-aperture lens of f/4.5 to f/5.6 means that at the widest focal length, the maximum aperture is f/4.5 and at the telephoto end of the focal range, the maximum aperture is f/5.6. In practical terms, this limits the versatility of the lens at the longest focal length for shooting in all but bright light unless you set a high ISO. And unless

you use a tripod and your subject is stone still, your ability to get a crisp picture in lower light at f/5.6 will be questionable.

For a complete discussion on aperture, see Chapter 6.

8.5 Wide-angle zoom lenses such as the Canon EF 16-35mm f/2.8L USM lens are ideal for the smaller sensor size of the XS/1000D.

About prime lenses

Long the mainstay of photographers, prime, or single focal-length, lenses offer a fixed focal length — in other words, no zoom capability. Prime lenses such as Canon's venerable EF 50mm f/1.4 USM lens and EF 100mm f/2.8 Macro USM lens are only two of a full lineup of Canon prime lenses. Because you cannot zoom the lens, you must move closer to or farther from your subject, or change lenses to change image

composition. Single focal-length lenses generally have a brighter maximum aperture than zoom lenses, and so they offer a broader range of creative expressiveness. Prime lenses produce excellent sharpness and contrast.

Prime lens advantages

Unlike zoom lenses, prime lenses tend to be fast with maximum apertures of f/2.8 or wider on non-telephoto lenses and on some telephoto lenses. Wide apertures allow fast shutter speeds, and that combination allows you to handhold the camera in lower light and still get a sharp image. Compared to zoom lenses, single focal-length lenses are lighter and smaller.

In addition, many photographers believe that single focal-length lenses are sharper and provide better image quality overall than zoom lenses.

8.6 Although zoom lenses are versatile, single focal-length lenses are often smaller and lighter. The Canon EF 50mm f/1.4 lens is one of the lightest and most versatile lenses in Canon's lineup.

Prime lens disadvantages

Most prime lenses are lightweight, but you need more of them to have lenses that run the full focal-length range. Prime lenses also limit the options for some on-the-fly composition changes that are possible with zoom lenses.

Canon Lens Terminology

Before you get into using each type of lens, it's helpful to become familiar with Canon designations and lens construction technologies. Here is an overview of the terms and technologies that will help you understand common lens designations.

EF or EF-S lens mount. The designations EF and EF-S identify the type of mount that the lens has. Both mounts provide not only quick mounting and removal of lenses, but they also provide the communication channel between the lens and the camera body. The EF and EF-S mounts are fully electronic and resist abrasion, shock, and play, and need no lubrication like other lens mounts. The EF and EF-S system does a self-test using a built-in microcomputer so that you're alerted to possible malfunctions of the lens through the camera's LCD display. In addition, if you use lens extenders, the exposure compensation is automatically calculated. The EF-S lens mount is designed specifically for croppedimage sensor cameras such as the XS/1000D. These lenses tend to be more affordable than some EF lenses and have good optical resolution. Because EF-S lenses have a

- shorter back focus than EF lenses, the EF-S lenses won't be compatible should you eventually buy a full-frame Canon EOS camera.
- ◆ USM. When you see USM, it indicates that the lens features a built-in ultrasonic motor with a very quiet focusing mechanism. The motor is powered by the camera; however, because the lens has its own focusing motor, you get exceptionally fast focus. USM lenses use electronic vibrations created by piezoelectric ceramic elements to provide quick and quiet focusing action with near instantaneous starts and stops.

In addition, lenses with a ring-type ultrasonic motor offer full-time manual focusing without the need to first switch the lens to manual focus. This design is offered in the large-aperture and super-telephoto lenses. A second design, the microultrasonic motor, provides the advantages of this technology in the less expensive EF lenses.

- L-series lenses. Canon's L-series lenses feature a distinctive red ring on the outer barrel, or in the case of telephoto and super-telephoto lenses, are distinguished by Canon's well-known white barrel. The distinguishing characteristics of L-series lenses, in addition to their sobering price tags, are a combination of technologies that provide outstanding optical performance. L-series lenses include one or more of the following technologies and features:
 - UD/Fluorite elements. Ultralow Dispersion (UD) glass elements help minimize color fringing or chromatic aberration. This glass

- also provides improved contrast and sharpness. UD elements are used, for example, in the EF 70-200mm f/2.8L IS USM and EF 300mm f/4L IS USM lenses. On the other hand, Fluorite elements, which are used in supertelephoto L-series lenses, reduce chromatic aberration. Lenses with UD or Fluorite elements are designated as CaF2, UD, and/or S-UD.
- Aspherical elements. This technology is designed to help counteract blurred images that happen as a result of spherical aberration. Spherical aberration happens when wide-angle and fast normal lenses cannot resolve light rays coming into the lens from the center with light rays coming into the lens from the edge into a sharp point of focus. An aspherical element uses a varying curved surface to ensure that the entire image plane appears focused. These types of optics help correct distortion in ultra-wideangle lenses as well. Lenses with aspherical elements are designated as AL.
- Dust-, water-resistant construction. For any photographer who shoots in inclement weather, having a lens with adequate weather sealing is critical. The L-series EF telephoto lenses stand up well to inclement weather and heavy use. L-series lenses have rubber seals at the switch panels, exterior seams, drop-in filter compartments, and lens mounts to make them both dust- and water-resistant. Moving parts,

- including the focusing ring and switches, are also designed to keep out environmental contaminants.
- Image Stabilization. Lenses labeled as IS lenses offer image stabilization, which is detailed later in this chapter. IS lenses allow you to handhold the camera at light levels that normally require a tripod. The amount of handholding latitude varies by lens and the photographer's ability to hold the lens steady, but you can generally count on one to four more f-stops of stability with an IS lens than with a non-IS lens.
- Macro. Macro lenses, which are covered in detail later in this chapter, enable close-up focusing with subject magnification of one-half to life-size and a maximum aperture of f/25.
- Full-time manual focusing. An advantage of Canon lenses is the ability to use autofocus, and then tweak focus manually using the lens's focusing ring without switching out of autofocus mode or changing the switch on the lens from the AF (Autofocus) to MF setting. Full-time manual focusing comes in very handy, for example, with macro shots and when using extension tubes.
- Inner and rear focusing. Lenses' focusing groups can be located in front of or behind the lens diaphragm, both of which allow for compact optical systems with fast AF. Lenses with rear optical focusing, such as the EF 85mm f/1.8 USM, focus faster than lenses that move their entire optical system, such as the EF 85mm f/1.2L II USM.

- Floating system. Canon lenses use a floating system that dynamically varies the gap between key lens elements based on the focusing distance. As a result, optical aberrations are reduced or suppressed through the entire focusing range. In comparison, optical aberrations in non-floating system lenses are corrected only at commonly used focusing distances. At other focusing distances, particularly at close focusing distances, the aberrations appear and reduce image quality.
- AF Stop. The AF Stop button, offered on several EF IS super-telephoto lenses, allows you to temporarily suspend autofocusing of the lens. For example, if the lens is focusing and an obstruction comes between the lens and the subject. you can press the AF Stop button to stop focusing to prevent the focusing from being thrown off. Once the obstruction passes by the subject, the focus remains on the subject, provided that the subject hasn't moved, so that you can resume shooting.
- **Diffractive optics.** Diffractive optics (DO) bonds diffractive coatings to the surfaces of two or more lens elements. The elements are then combined to form a single multilayer DO element designed to cancel chromatic aberrations at various wavelengths when combined with conventional glass optics. Diffractive optics result in smaller and shorter telephoto lenses without compromising image quality. For example, the EF 70-300mm f/4.5-5.6 DO IS USM lens is 28 percent shorter than the EF 70-300mm f/4.5-5.6 IS USM lens.

With a background on categories of lenses, as well as the terms and technologies, we'll talk about the characteristics of different types of lenses.

Using Wide-Angle Lenses

A wide-angle lens is a versatile lens for capturing subjects such as large groups of people, sweeping landscapes, travel, and architectural interiors and exteriors, as well as for taking pictures where space is cramped. The distinguishing characteristic of wide-angle lenses is the range of the angle of view. Within the Canon lens line-up, you can choose angles of view from the 15mm fisheye lens, which offers a 180-degree angle of view, to the 35mm, which offers a 63-degree angle of view, not counting the 1.6x focal length multiplication factor.

When you shoot with a wide-angle lens, keep these lens characteristics in mind:

- Extensive depth of field. Particularly at small apertures from f/11 to f/32, the entire scene, front to back, will be in acceptably sharp focus. In addition, wide-angle lenses give you slightly more latitude for less-than-perfectly focused pictures.
- Narrow, fast apertures. Wideangle lenses tend to be faster (meaning they have wider maximum apertures) than telephoto lenses. As a result, these lenses are good choices for shooting scenes where the lighting conditions are not optimal.

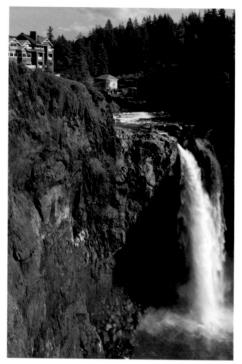

- 8.7 Despite the focal length multiplication factor, the Canon EF 24-70mm f/2.8L USM lens set to 24mm was wide enough to capture the lodge and the full length of Snoqualmie Falls. Exposure: ISO 100, f/22, 1/25 second.
 - Distortion. Wide-angle lenses can distort lines and objects in a scene, especially if you tilt the camera up or down when shooting. For example, if you tilt the camera up to photograph skyscrapers with a wide-angle lens mounted, the lines of the buildings tend to converge toward the center of the frame and the buildings appear to lean backward (also called keystoning). Occasionally you can use this wide-angle lens characteristic to creatively enhance a composition, or you can move back from the subject and keep the camera parallel to the main subject to help avoid the distortion.

Perspective. Wide-angle lenses make objects close to the camera appear disproportionately large. You can use this characteristic to move the closest object visually forward in the image, or you can move back from the closest object to reduce the effect. Moderate wide-angle lenses are popular for portraits, but if you use a wideangle lens for close-up portraiture, keep in mind that the lens exaggerates the size of facial features closest to the lens

If you're shopping for a wide-Tip angle lens, look for aspherical lenses. These lenses include a nonspherical element that helps reduce or eliminate optical flaws to produce better edge-to-edge sharpness and reduce distortions.

Using Telephoto Lenses

Choose a telephoto lens to take portraits and to capture distant subjects such as birds, buildings, wildlife, and landscapes. Short telephoto lenses such as 85mm and 100mm are ideal for portraits, while long lenses (200mm to 800mm) allow you to photograph distant birds, wildlife, and athletes. When photographing wildlife, long lenses also allow you to keep a safe distance from the subject.

When you shoot with a telephoto lens, keep these lens characteristics in mind:

8.8 Telephoto lenses are larger and heavier than wide-angle and normal lenses, but having a sharp and versatile telephoto zoom lens is indispensable. This 70-200mm lens also features Image Stabilization, which helps you counteract camera shake when handholding the camera.

- ♦ Shallow depth of field. Telephoto lenses magnify subjects and provide a limited range of acceptably sharp focus. At wide apertures, such as f/4, you can reduce the background to a soft blur. Because of the shallow depth of field, there is no latitude for anything except tack-sharp focus. All Canon lenses include full-time manual focusing that you can use to fine-tune the camera's autofocus.
- Narrow coverage of a scene. Because the angle of view is narrow with a telephoto lens, much less of the scene is included in the image. You can use this characteristic to exclude distracting scene elements from the image.
- ◆ Slow speed. Mid-priced telephoto lenses tend to be slow; the widest aperture is often f/4.5 or f/5.6, which limits the ability to get sharp images without a tripod in all but bright light unless the lens has Image Stabilization. And because of the magnification, even the slight movement when handholding the camera and lens or in subject movement is exaggerated.
- Perspective. Telephoto lenses tend to compress perspective, making objects in the scene appear close together.

If you're shopping for a telephoto lens, look for those with UD glass or Fluorite elements that improve contrast and sharpness. Image Stabilization counteracts blur caused by handholding the camera.

Evaluating Bokeh Characteristics

The quality of the out-of-focus area in a wide-aperture image is called *bokeh*, originally from the Japanese word *boke*, pronounced bo-keh, which means fuzzy. In photography, bokeh reflects the shape and number of diaphragm blades in the lens, and that determines, in part, the way that out-of-focus points of light are rendered in the image. Bokeh is also a result of spherical aberration that affects how the light is collected.

Although it is subject to controversy, photographers often judge bokeh as being either good or bad. Good bokeh renders the out-of-focus areas as smooth, uniform, and generally circular shapes with nicely blurred edges. Bad bokeh, on the other hand, renders out-of-focus areas with polygonal shapes, hard edges, and with illumination that creates a brighter area at the outside of the disc shape. Also, if the disc has sharper edges, then either points of light or lines in the background become more distinct when, in fact, they are better rendered blurred. Bokeh is also affected by the number of blades used in the lens's diaphragm. Generally lens diaphragms are comprised of five, eight, or nine blades. A five-blade design renders the point of light as a pentagon, while an eight-blade diaphragm renders it as an octagon. You can check the specifications for the lens you're considering to find out how many blades are used, but generally, the more blades, the more visually appealing the bokeh.

Ken Rockwell provides an article on bokeh with excellent examples at www.ken rockwell.com/tech/bokeh.htm.

Using Normal Lenses

A normal, or 50-55mm, lens is perhaps the most-often overlooked lens. This lens, which Canon categorizes as a "standard" lens, was long the primary or only lens that photographers of past decades used, and it remains a classic that provides outstanding sharpness and contrast. On a 35mm film camera. a normal lens is 50mm, but on the XS/1000D, a 35mm lens is closer to normal considering the focal-length conversion factor. Normal lenses are small, light, and often affordably priced, and offer fast and superfast apertures such as f/1.4 and faster.

When you shoot with a normal lens, keep these lens characteristics in mind:

- Natural angle of view. A 50mm lens closely replicates the sense of distance and perspective of the human eye. This means that the final image will look much as you remember seeing it when you made the picture.
- Little distortion. Given the natural angle of view, the 50mm lens retains a normal sense of distance, especially when you balance the subject distance, perspective, and aperture.
- Creative expression. With planning and a good understanding of the 50mm lens, you can use it to simulate both wide-angle and medium telephoto lens effects. For example, by shooting at a narrow aperture and at a low- or high-angle shooting position, you can create the dynamic feeling of a wide-angle lens but without the distortion. On the other hand, a large aperture

and a conventional shooting angle create results similar to that of a medium-telephoto lens.

8.9 A normal focal length, used for this image, provides an angle of view similar to that of the human eye. Exposure: ISO 100, f/1.8, 1/60 second, Canon EF 50mm, f/1.4 USM lens.

Using Macro Lenses

Macro lenses open a new world of photographic possibilities by offering extreme levels of magnification. In addition, the reduced focusing distance allows beautiful, moderate close-ups as well as extreme close-ups of flowers and plants, animals, raindrops, and everyday objects. The closest focusing distance can be further reduced by using extension tubes.

The 60mm and two Canon telephoto lenses offer macro capability. Because these lenses can be used both at their normal focal length and for macro photography, they do double-duty. Macro lenses offer one-half or life-size magnification.

8.10 Canon offers several macro lenses, including the EF 180mm f/3.5L Macro USM (left), which offers 1x (life-size) magnification and a minimum focusing distance of 0.48m/1.6 ft. Also shown here is the Canon EF 100mm f/2.8 Macro USM lens.

Based on focal length and magnification, choose the lens that best suits the kinds of subjects you want to photograph. I often use the 100mm, f/2.8 Macro USM lens as a walk-around lens because much of my work lends itself to a short telephoto focal length or macro work. Other photographers would never think of using a prime lens as a walk-around lens, but for me, the 100mm is often ideal.

8.11 The EF 100mm is one of my favorite lenses, and I used it to capture this image. Exposure: ISO 100, f/29, 1/30 second.

Referred to as TS-E, tilt-and-shift lenses allow you to alter the angle of the plane of focus between the lens and sensor plane to provide a broad depth of field, even at wide apertures, and to correct or alter perspective at almost any angle. In short, TS-E lenses allow you to correct perspective distortion and control focusing range.

Tilt movements allow you to bring an entire scene into focus, even at maximum apertures. By tilting the lens barrel, you can adjust the lens so that the plane of focus is uniform on the focal plane, thus changing the normally perpendicular relationship between the lens's optical axis and the camera's focal plane. Alternately, reversing the tilt has the opposite effect of greatly reducing the range of focusing.

Shift movements avoid the trapezoidal effect that results from using wide-angle lenses pointed up to take a picture of a building, for example. Keeping the camera so that the focal plane is parallel to the surface of a wall and then shifting the TS-E lens to raise the lens results in an image with the perpendicular lines of the structure being rendered perpendicular and with the structure being rendered with a rectangular appearance.

All of Canon's TS-E lenses are manual focus only. These lenses, depending on the focal length, are excellent for architectural, interior, merchandise, nature, and food photography.

Using Image-Stabilized Lenses

Image Stabilization (IS) is a technology that counteracts motion blur from handholding the camera. Whether IS belongs in the lens or in the camera is a matter of debate. But for Canon, the argument is that stabilization belongs in the lens because different lenses have different stabilization needs. If you've shopped for lenses lately, you know that IS comes at a premium price, but IS is often worth the extra money because, in practice, you gain from one to four f-stops of stability - and that means that you may be able to leave the tripod at home.

Not taking IS into account, the rule of thumb for handholding the camera is 1/[focal length]. For example, the slowest shutter speed at which you can handhold a 200mm lens and avoid motion blur is 1/200 second. If the handholding limit is pushed, then shake from handholding the camera bends light rays coming from the subject into the lens relative to the optical axis, and the result is a blurry image.

With an IS lens, miniature sensors and a high-speed microcomputer built into the lens analyze vibrations and apply correction through a stabilizing lens group that shifts the image parallel to the focal plane to reduce the effect of camera shake. The lens detects camera motion using two gyro sensors - one for yaw and one for pitch. The sensors detect the angle and speed of shake. Then the lens shifts the IS lens group to suit the degree of shake to steady the light rays reaching the focal plane.

154 Part III ★ Creative Accessories and More

Stabilization is particularly important with long lenses, where the effect of shake increases as the focal length increases. As a result, the correction needed to cancel camera shake increases proportionately.

But what about when you want to pan or move the camera with the motion of a subject? Predictably, IS detects panning as camera shake and the stabilization then interferes with framing the subject. To correct this, Canon offers two modes on IS lenses. Mode 1 is designed for stationary subjects. Mode 2 shuts off IS in the direction

of movement when the lens detects large movements for a preset amount of time. So when panning horizontally, horizontal IS stops but vertical IS continues to correct any vertical shake during the panning movement.

IS lenses come at a higher price, but they are very effective for low-light scenes and telephoto shooting.

Tables 8.1 and 8.2 show the Canon lenses that are available at this writing.

8.12 IS provided a level of insurance for sharpness in this scene where I handheld an EF 70-200mm f/2.8L IS USM lens zoomed to 130mm. Exposure: ISO 100, f/11, 1/100 second.

Table 8.1

Canon EF Wide, Standard, and Medium Telephoto Lenses

Ultrawide Zoom	Wide-Angle	Standard Zoom	Telephoto Zoom	Standard and Medium Telephoto
EF16-35mm f/2.8L II USM	EF 14mm f/2.8L II USM	EF-S 17-55mm f/2.8 IS USM	EF 55-200mm f/4.5-5.6 II USM	EF 50mm f/1.2L USM
EF-S 10-22mm f/3.5-4.5 USM	EF 14mm f/2.8L USM	EF-S 17-85mm f/4-5.6 IS USM	EF-S 55-250mm f/4.5.6 IS	EF 50mm f/1.4 USM
EF 17-40mm f/4L USM	EF 15mm f/2.8 Fisheye	EF-S 18-55mm f/3.5-5.6 IS	EF 70-200mm f/2.8L IS USM	EF 50mm f/1.8 II
	EF 20mm f/2.8 USM	EF-S 18-55mm f/3.5-5.6 IS	EF 70-200mm f/2.8L USM	EF 85mm f/1.2L II USM
	EF 24mm f/1.4L USM	EF 24-70mm f/2.8L USM	EF 70-200mm f/4L IS USM	EF 85mm f/1.8 USM
	EF 24mm f/2.8	EF 24-85mm f/3.5-4.5 USM	EF 70-200mm f/4L USM	EF 100mm f/2 USM
	EF 28mm f/2.8	EF 28-105mm f/3.5-4.5 II USM	EF 70-300mm f/4-5.6 IS USM	
	EF 35mm f/1.4L USM	EF 28-105mm f/4 IS USM	EF 70-300mm f/4.5-5.6 DO IS USM	
	EF 35mm f/2	EF 24-105mm f/4L IS USM	EF 80-200mm f/4.5-5.6 II	
	EF 28mm f/1.8 USM	EF 28-135mm f/3.5-5.6 IS USM	EF 75-300mm f/4-5.6 III USM	
		EF 28-200mm f/3.5-5.6 USM	EF 75-300mm f/4-5.6 III	
		EF 28-300mm f/3.5-5.6L IS USM	EF100-300mm f/4.5-5.6 USM	
		EF 28-80mm f/3.5-5.6 II	EF 100-400mm f/4.5-5.6L IS USM	
		EF 28-90mm f/4-5.6 III	EF-S 55-250mm f/4.5-05.6 IS USM	
		EF-S 18-200mm f/3.5-5.6 IS		

Table 8.2	
Canon EF Telephoto, Super-Telephoto, Macro, and TS-E Lenses	

Telephoto	Super-Telephoto	Macro	Tilt-Shift
EF 135mm f/2L USM	EF 300mm f/2.8L IS USM	EF 50mm f/2.5 Compact Macro – Life-Size Converter EF	TS-E 24mm f/3.5L
EF 135mm f/2.8 with Softfocus	EF 400mm f/2.8L IS USM	EF-S 60mm f/2.8 Macro USM	TS-E 45mm f/2.8
EF 200mm f/2.8L II USM	EF 400mm f/4 DO IS USM	MP-E 65mm f/2.8 1-5x Macro Photo	TS-E 90mm f/2.8
EF 300mm f/4L IS USM	EF 400mm f/5.6L USM	EF 100mm f/2.8 Macro USM	
EF 200mm f/2L IS USM	EF 500mm f/4L IS USM	EF 180mm f/3.5L Macro USM	
	EF 600mm f/4L IS USM	(Life-Size Converter EF for use with the EF 50mm f/2.5 Compact Macro lens)	
	EF 800mm f/5.6L IS USM		

Exploring Lens Accessories

There are a variety of ways to increase the focal range and decrease the focusing distance to provide flexibility for the lenses you already own. These accessories are not only economical, but they also extend the range and creative options of existing and new lenses. Lens accessories can be as simple as using a lens hood to avoid flare; adding a tripod mount to quickly change between vertical and horizontal positions without changing the optical axis or the geometrical center of the lens; or adding a drop-in or adapter-type gelatin filter holder. Other options include using lens extenders, extension tubes, and close-up lenses.

Lens extenders

For relatively little cost, you can increase the focal length of any lens by using an extender. An extender is a lens set in a small ring mounted between the camera body and a regular lens. Canon offers two extenders, a 1.4x and 2x, that are compatible only with L-series Canon lenses. Extenders can also be combined to get even greater magnification.

For example, using the Canon EF 2x II extender with a 200mm lens doubles the lens's focal length to 400mm, and then you can apply the 1.6x focal length conversion factor to get the equivalent of a 640mm lens. Using the Canon EF 1.4x II extender increases a 200mm lens to 280mm or 448mm with the 1.6x conversion factor.

Extenders generally do not change camera operation, but they do reduce the amount of light reaching the sensor. The EF 1.4x II extender decreases the light by one f-stop, and the EF 2x II extender decreases the light by two f-stops. In addition to being fairly lightweight, the obvious advantage of extenders is that they can reduce the number of telephoto lenses you carry.

The 1.4x extender can be used with fixed focal-length lenses 135mm and longer (except the 135mm f/2.8 Softfocus lens). The 1.4x extender can be used with any lens that has an f/4 or faster maximum aperture. With the EF 2x II. the extender can be used with any lens that has an f/2.8 or faster maximum aperture. Autofocus is possible if the lens has an f/2.8 or faster maximum aperture and compatible Image Stabilization lenses continue to provide stabilization. The extenders offer weather-resistant construction and antireflective surfaces in the barrel of the extender.

Extension tubes and close-up lenses

Extension tubes are close-up accessories that provide magnification from approximately 0.3 to 0.7 and can be used on many EF lenses, though there are exceptions. Extension tubes are placed between the camera body and lens and connect to the camera through eight electronic contact points. The function of the camera and lens is unchanged, and you can combine extension tubes for greater magnification.

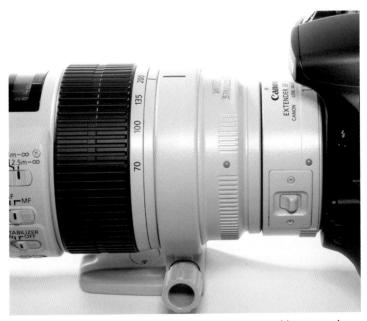

8.13 Extenders, such as this Canon EF 1.4x II mounted between the camera body and the lens, extend the range of L-series lenses. They increase the focal length by a factor of 1.4x, in addition to the 1.6x focal-length conversion factor inherent in the camera.

158 Part III ◆ Creative Accessories and More

Canon offers two extension tubes, the EF 12 II and the EF 25 II. Magnification differs by lens, but with the EF12 II and standard zoom lenses, it is approximately 0.3 to 0.5. With the EF 25 II, magnification is 0.7. When combining tubes, you may need to focus manually.

Extension tube EF 25 II is not compatible with the EF 15mm f/2.8 fisheye, EF 14mm f/2.8L USM, EF 20mm f/2.8 USM, EF 24mm f/1.4L USM, EF 20-35mm f/3.5-4.5 USM, EF 24-70mm f/2.8L USM, MP-E 65mm f/2.8

1-5x Macro Photo, TS-E 45mm f/2.8, and EF-S 18-55mm f/3.5-5.6 (at wide angles).

Additionally, you can use screw-in close-up lenses. Canon offers three lenses that provide enhanced close-up photography. The 250D/500D series uses a double-element design for enhanced optical performance. The 500D series features single-element construction for economy. The working distance from the end of the lens is 25cm for the 250D, and 50cm for the 500D.

In the Field with the EOS Rebel XS/1000D

his chapter begins with a brief overview of commonly used approaches to photographic composition. If you are new to photography, working on good composition is one of the fastest ways to make significant improvements to your images. If you're familiar with composition techniques, then skip to the second part of the chapter, which covers a wide variety of photography subjects that you can explore with your EOS Rebel XS/1000D. In addition to the examples, there are ideas for thinking about photographing these subjects. Whether you shoot all or only some of the subjects in this chapter, I think you'll gain a full appreciation of the image quality and versatility that the XS/1000D provides.

Approaches to Composition

Until now, the technical aspects of photography have been the primary concentration of this book. But to make memorable images, you must combine technical competence with artful, creative composition and compelling content. The content of images is up to you and your imagination, but it's worthwhile to discuss some time-honored approaches to composition.

While composition guidelines will help you design an image, the challenge and the joy of photography is combining your visual, intellectual, and emotional perceptions of a scene from the objective point of view of the camera. And, while composition guidelines are helpful, at the end of the day, your personal aesthetic is the final judge.

In This Chapter

Approaches to composition

Action and sports photography

Animal and wildlife photography

Architectural and interior photography

Child photography

Macro photography

Nature and landscape photography

Night and low-light photography

Portrait photography

Still-life photography

Stock photography

Travel photography

Subdividing the photographic frame

The first step in composition is deciding how to divide the photographic frame. Since antiquity, this decision has occupied the thinking of artists, builders, and engineers who looked to nature and mathematics to find ways to portion spaces to create a harmonious balance of the parts to the whole space.

Tip

As you think about composition, remember that if you're in doubt about how to compose an image, keep it as simple as possible. Simple compositions clearly and unambiguously identify the subject, and they are easy for the viewer to "read" visually.

From the fifth century BCE, builders, sculptors, and mathematicians applied what is now known as the Divine Proportion. Euclid, the Greek mathematician, was the first to express the Divine Proportion in mathematical language. The Divine Proportion is expressed as the Greek symbol Phi where Phi is equal to 1/2(1 + square root of 5) =1.618033989. This proportion divides a line in such a way that the ratio of the whole to the larger part of the line is the same as the larger part is to the smaller part. This proportion produced such pleasing balance and symmetry that it was applied in building the pyramids of Egypt; the Parthenon in Athens, Greece; and Europe's Gothic cathedrals. The proportion also made its way into art. For example, some believe that the Divine Proportion provides the underlying structure for Leonardo da Vinci's The Last Supper and Mona Lisa paintings.

Over time, harmonious balance was expressed as the Golden Section, or the Golden Rectangle. The 35mm photographic frame, although being slightly deeper and

having a ratio of 3:2, is very similar to the Golden Rectangle. The Golden Rectangle provided a map for artists to balance color, movement, and content within the confines of a canvas.

However, unlike painters, photographers don't begin with a blank canvas but with a scene that often presents itself ready-made. Even with a ready-made scene, photographers have a variety of creative guidelines at their disposal to structure the photographic frame. A popular device is the rule of thirds. This "rule" divides the photographic frame into thirds much like superimposing a tic-tac-toe grid on the frame. To create visually dynamic compositions, place the subject or the point of interest on one of the points of intersection, or along one of the lines on the grid.

The rule is, of course, approximate because not all scenes conform to the grid placement. But the rule of thirds provides a good starting point for subdividing the frame and for placing the subject within the subdivisions. For example, if you're taking a portrait, you might place a subject's eyes at the upper-left intersection point of the grid. In a landscape scene, you can place the horizon along the top or bottom line of the grid, depending on what you want to emphasize.

Balance and symmetry

Balance is a sense of "rightness" or harmony in a photo. A balanced photo appears to be neither too heavy (lopsided) nor too off-center. To create balance in a scene, evaluate the visual "weight" of colors and tones (dark is heavier than light), the shape of objects (larger objects appear heavier than smaller objects), and their placement (objects placed toward an edge appear heavier than objects placed at the center of the frame).

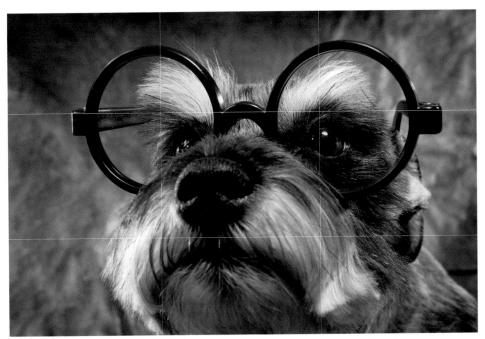

9.1 This image, with a rule-of-thirds grid superimposed, places the dog's right eye approximately at the top-right point of intersection. Exposure: ISO 100, f/11, 1/125 second using an EF 24-70mm, f/2.8L USM lens.

The eye seeks balance in an image. Whether it is in tones, colors, or objects, the human eye seeks equal parts, equal weight, and resolved tension. Static balance begins with a single subject in the center of the frame, with other elements emanating from the center point to create equal visual weight. Variations on this balance include two identical subjects at equal distances from each other, or several subjects arranged at the center of the frame.

Conversely, dynamic balance is created when tones, colors, or weights are asymmetrical, or unequally balanced, creating visual tension.

9.2 Symmetry is the hallmark of nature, as illustrated in the symmetrical arrangement of petals around this flower bud. Exposure: ISO 100, f/2.8, 1/125 second using an EF 100mm, f/2.8 USM lens.

Just because the human eye seeks balance and symmetry, does it mean that compositions should be perfectly balanced? Perfectly symmetrical compositions create a sense of balance and stability. And while symmetry is a defining characteristic in nature, if all images were perfectly balanced and symmetrical, they would tend to become boring. While the human eye seeks symmetry and balance, once it finds it, the interest in the image quickly diminishes.

In real-world shooting, the choice of creating perfect balance or leaving tension in the composition is your choice. If you choose perfect symmetry, then it must be perfect, for the eye will immediately scan the image

and light on any deviation in symmetry. In dynamic balance, the viewer must work to find balance, and that work can be part of the satisfaction in viewing the image.

Tone and color

At the most fundamental level, contrast is the difference between light and dark tones in an image. But in a larger context, contrast includes differences in colors, forms, and shapes, and it is at the heart of composition. In photography, contrast not only defines the subject, but it also renders the shape, depth, and form of the subject and establishes the mood and the subject's relationship to other elements in the image.

9.3 In this image, the subject is comprised of the harmonizing colors of yellow and green with the complementary color of red in the background. Exposure: ISO 100, f/13, 1/30 second, with a negative half-stop exposure compensation using an EF 100mm, f/2.8 USM lens.

Related to tones are colors used in composition. Depending on how colors are used in a photo, they can create a sense of harmony, or visual contrasts. In very basic terms, colors are either complementary or harmonizing. Complementary colors are opposite each other on a color wheel — for example, green and red, and blue and orange. Harmonizing colors are adjacent to each other on the color wheel, such as green and yellow, yellow and orange, and so on, and offer no visual conflict or tension.

If you want a picture with strong visual punch, use complementary colors of approximately equal intensity in the composition. If you want a picture that conveys peace and tranquility, use harmonizing colors.

The more that the color of an object contrasts with its surroundings, the more likely it is that the object will become the main point of interest. Conversely, the more uniform the overall color of the image, the more likely that the color will dictate the overall mood of the image.

The type and intensity of light also strongly affect the intensity of colors, and, consequently, the composition. Overcast weather conditions, such as haze, mist, and fog, reduce the vibrancy of colors. These conditions are ideal for creating pictures with harmonizing, subtle colors. Conversely, on a bright, sunny day, color is intensified and is ideal for composing pictures with bold, strong color statements.

While a full discussion of tone and color is beyond the scope of this book, knowing some characteristics of tone and color will help you make decisions about photographic compositions.

- The viewer's eye is drawn to the lightest part of an image. If highlights in an image fall somewhere other than on the subject, the highlights will draw the viewer's eye away from the subject.
- Overall image brightness sets the mood of the image. In addition, the predominance of tones determines the "key." Images with primarily bright tones are said to be "high key," while images with predominantly dark tones are "low key."
- Colors, like tones, advance and recede; they have symbolic, cultural meanings; and they elicit emotional responses from viewers. For example, red advances and is associated with energy, vitality, and strength, as well as with passion and danger. Conversely, blue recedes and tends to be dark. It is widely associated with nature and water.

Note

When speaking of color and when working with images in editing programs, keep these definitions in mind. Hue is the color—or the name of the color. For example, blue is a hue. Saturation is the intensity or purity of a hue. Brightness determines if the hue is light or dark.

Lines and direction

Because lines have symbolic significance, you can use them to bolster communication, to direct focus, and to organize visual elements. For example, you can place a subject's arms in ways that direct attention to the face. In an outdoor scene, you can use a gently winding river to guide the viewer's eye through the scene. You can use a strong diagonal beam in an architecture shot to bolster the sense of the building's strength.

164 Part III ◆ Creative Accessories and More

When planning the composition, keep in mind that images have both real and implied lines. Examples of implied lines include the bend of a leaf or a person's hand. Ideally, lines will also lead the viewer's eye toward the subject, rather than away from it or out of the frame.

Leaving space in the frame can reinforce a sense of direction. For example, leaving space in the direction that the subject is looking or moving provides visual space to look or move into.

Lines traditionally convey these meanings:

- Horizontal lines imply stability and peacefulness.
- Diagonal lines create strength and dynamic tension.
- Vertical lines imply motion and strength.
- Curved lines symbolize grace.
- Zigzag lines convey a sense of action.
- Wavy lines indicate peaceful movement.
- Jagged lines create tension.

9.4 In this image, the reflection of the clouds and fading light on the water form strong lines that are intersected by the silhouetted line of trees and the pier. Exposure: ISO 100, f/7, 1/50 second using an EF 24-70mm, f/2.8L USM lens.

Fill the frame

Just as an artist would not leave part of a canvas blank or fill it with extraneous details, you should try to fill the full image frame with the subject and elements that support the subject and the message of the image. Try to include elements that reveal more about the subject.

9.5 Moving in close to the planters and baskets allowed me to not only fill the frame, but also to eliminate nearby cars and benches that would have been distracting from a more distant shooting position. Exposure: ISO 100, f/5.6, 1/200 second using an EF 24-70mm, f/2.8L USM lens.

Check the background

In any picture, the elements behind and around the subject become as much a part of the photograph as the subject, and occasionally more so because the lens tends to compress visual elements. As you compose the picture, check all areas in the viewfinder or LCD for background and surrounding objects that will, in the final image, seem to merge with the subject, or that compete with or distract from the subject.

A classic example of failing to use this technique is the picture of a person who appears to have a telephone pole or tree growing out of the back of his or her head. To avoid this type of background distraction, you can change your shooting position or, in some cases, move the subject.

Frame the subject

Photographers often borrow techniques from painters — and putting a subject within a naturally occurring frame, such as a window or an archway, is one of the borrowed techniques. The frame may or may not be in focus, but to be most effective, it should add context and visual interest to the image.

Control the focus and depth of field

Sharp focus establishes the relative importance of the elements within the image. And because the human eye is drawn first to the sharpest point in the photo, be sure that the point of sharpest focus is on the part of the subject that you want to emphasize; for example, in a portrait, the point of sharpest focus should be on the subject's eyes.

Differential focusing controls the depth of field, or the zone (or area) of the image that is acceptably sharp. In a nutshell, differential focusing works like this: the longer the focal length (in other words, a telephoto lens or zoom setting) and the wider the aperture (the smaller the f-stop number), the shallower the depth of field is (or the softer the background). Conversely, the shorter the focal length and the narrower the aperture, the greater the depth of field.

You can use this principle to control what the viewer focuses on in a picture. For example, in a picture with a shallow depth of field, the subject stands in sharp focus against a blurred background. The viewer's eyes take in the blurred background, but they return quickly to the much sharper area of the subject.

To control depth of field, you can use the following techniques in Table 9.1 separately or in combination with each other.

Tip

For portraits, experiment with different viewpoints. For example, if you photograph a subject from a position that is lower than eye level, the subject seems powerful, while a position that is higher than eye level creates the opposite effect.

9.6 In this scene, I wanted to let the foreground graffiti serve as context for the artist and yet keep it from becoming too distracting. To accomplish that, I chose a wide aperture of f/5.6. Exposure: ISO 100, f/5.6, 1/100 second using an EF 70-200mm, f/2.8L IS USM lens.

Table 9.1 Depth of Field

To Decrease the Depth of Field (Soften the Background Details)

Choose a telephoto lens or zoom setting Choose a wide aperture from f/1.4 to f/5.6 Move closer to the subject

To Increase the Depth of Field (Sharpen the Background Details)

Choose a wide-angle lens or zoom setting Choose a narrow aperture from f/8 to f/22 Move farther away from the subject

Defining space and perspective

Some ways to control the perception of space in pictures include changing the distance from the camera to the subject, selecting a telephoto or wide-angle lens or zoom setting, changing the position of the light in a studio or changing the subject position in an outdoor setting, and changing the camera position.

For example, camera-to-subject distance creates a sense of perspective and dimension so that when the camera is close to a foreground object, background elements in the image appear smaller and farther apart.

A wide-angle lens also makes foreground objects seem proportionally larger than midground and background objects.

While knowing the rules provides a good grounding for well-composed pictures, Henri Cartier-Bresson summed it up best when he said, "Composition must be one of our constant preoccupations, but at the moment of shooting it can stem only from our intuition, for we are out to capture the fugitive moment, and all the interrelationships involved are on the move. In applying the Golden Rule, the only pair of compasses at the photographer's disposal is his own pair of eyes." (From The Mind's Eye: Writings on Photography and Photographers by Henri Cartier-Bresson [Aperture, 2005].)

Action and Sports Photography

Anyone who shoots action and sports events knows that a fast camera is essential for capturing the energy and critical moments of the action. With a burst rate of 3 frames per second (fps) sustainable up to the capacity of the media card of Large/Fine JPEG images and 5 RAW and 4 RAW+JPEG (Large/Fine) frames in Continuous Drive mode, the XS/1000D is fast enough to capture some action scenes. To get the best performance, evaluate which Custom Functions to disable when shooting action. For example, if you're shooting in relatively low light with a high ISO setting, then if you've enabled C.Fn-4, the burst rate can be slowed down noticeably. For action shooting, it also pays to have a speedy SD/SDHC card.

In regard to lenses, the focal length multiplication factor of 1.6x brings the action in close with telephoto lenses. For example, using the Canon EF 70-200mm f/2.8L IS USM lens effectively provides a 112-320mm equivalent focal length.

And with shutter speeds ranging from 1/4000 to 30 seconds, the camera offers ample opportunity to freeze action or show motion blur, and to create panned action shots. In addition, you can choose among three Autofocus modes. Al Servo AF mode is designed specifically for action shooting, and tracks subject motion automatically. Depending on the action, you might alternately find that Al Focus AF is equally handy. In this mode, for example, you can focus on one of many runners at the start line using One-Shot AF mode. Then when the runner begins moving, the camera detects motion

and automatically switches to AI Servo AF and tracks subject motion until you press the Shutter button

When you shoot action and sports scenes, the best images are those that capture the moment of peak action. That moment may be a runner crossing the finish line, a pole-vaulter at the height of a vault, or a race car getting the checkered flag. But other moments are equally compelling, such as when an athlete takes a spill, the look of disappointment when an athlete comes in second, third, or last in a race — in short, moments of high emotion. As much as any other area of photography, sports and action photography offers you the opportunity to tell the rich and compelling story of the person and event.

Because the XS/1000D isn't the fastest camera, capturing the peak action requires that you anticipation the action to ensure that you begin shooting just as it approaches its climax. Otherwise, if you begin shooting earlier, you may get a "busy" message on the camera from the last burst, and that will prevent you from capturing the peak action.

How fast a shutter speed is fast enough to freeze subject motion? The answer is that it depends on the direction of the subject's motion. Here are some general guidelines to follow in setting shutter speed. Depending on the light, you may need to adjust the ISO higher to get the requisite shutter speed, but to ensure good image quality, set the ISO only as high as necessary to get the shutter speed you need. Also, the best way to control the shutter speed is to use Tv shooting mode.

9.7 The 1.6x focal length multiplication factor on the Rebel XS/1000D worked in my favor for this shot at a skate park. Using an EF 100-400mm f/4.5-5.6L IS USM lens zoomed to 190mm gave an effective focal length of 304mm. Exposure: ISO 100, f/5, 1/400 second.

- If the subject is moving toward you, set the shutter speed to 1/250 second.
- If the subject is moving side to side or up and down, set the shutter speed to 1/500 to 1/2000 second.

Chapter 5 details setting Custom Functions.

Inspiration

As you take sports and action photos, use the techniques of freezing and showing motion as a blur to capture the emotion and give the sense of being in the moment and of the entire event. You can also create sequences of images that tell the story of a part or all of an event, or the story of a single athlete during the event.

Action photography techniques are by no means limited to sports. Any event that has energy and motion is an opportunity to apply sports and action shooting techniques, whether it's a baby taking his or her first steps or pets playing in the park, a top spinning, or water dripping from a faucet.

For ongoing inspiration in shooting action photos, I recommend MSNBC's The Week in Sports Pictures at www.msnbc.msn.com/ id/3784577.

9.8 Part of telling the story of the game or event involves capturing the details, particularly if you're capturing your kid's activities. This soccer ball is a well-used favorite of a young player who was attending a summer soccer camp. Exposure: ISO 100, f/5.6, 1/250 second.

Taking action and sports photographs

9.9 In this image, I wanted to capture the skateboarder on the rail with a sense of visual tension as he was about to exit the ramp.

Table 9.2

Action and Sports Photography

Setup

In the Field: The image in Figure 9.9 is one of a series at a skate park. The XS/1000D's fast and accurate autofocus helps to capture this type of action.

Additional Considerations: At sports events, find a good shooting position with a colorful, non-distracting background. If you're shooting JPEG capture and the light is bright, setting a negative exposure compensation of up to –1 Exposure Value (EV) can help avoid getting blown highlights, or highlights that go completely white with no detail in them. If you shoot in RAW capture mode, you can recover some highlight detail during image conversion, but I still recommend watching exposures carefully and setting negative exposure compensation if necessary to avoid blown highlights.

Lighting

In the Field: Shooting action images at sunset is an iffy proposition. While I wanted the warmth of the sunset light, the light fades quickly, making it difficult to maintain suitably fast shutter speeds.

Additional Considerations: Moderate and overcast light is ideal for showing motion blur, although motion blur can be shown in brightly lit scenes as well.

Lens

In the Field: Canon EF 100-4000mm, f/4.5-5.6L IS USM lens zoomed to 400mm, or 640mm equivalent with the focal length conversion factor.

Additional Considerations: The lens you choose depends, of course, on the subject you're shooting and your distance from the action. A zoom lens is especially useful as subjects move across the playing field or arena, because you can zoom the lens as the action advances toward you and recedes from you. A telephoto lens also offers the advantage of blurring distracting backgrounds often found at sports events, and increases the background blur if you're panning with subject motion.

Camera Settings

In the Field: RAW capture, Aperture-priority AE (Av) mode with the White Balance set to Daylight, Evaluative metering mode, Continuous drive mode, and Autofocus mode set to AI Focus AF, modified Neutral Picture Style.

Additional Considerations: AI Servo AF mode is often used for action shooting. In this mode, the camera automatically chooses the point of sharpest focus and tracks subject motion maintaining focus. But the point of sharpest focus may not be where you want. In best-case scenarios, the sharpest focus will be on the player's face. In worst-case scenarios, the sharpest focus will be on the athlete's clothing or on another athlete, or on the background. If you prefer to control the point of sharpest focus, consider using AI Focus AF, described earlier in this section. In mixed-light situations, a Custom white balance will deliver the most accurate color. If you're shooting RAW capture, you can take a picture of a gray or white card in the venue light, and then balance the entire image series from the gray card during RAW image conversion.

Exposure

In the Field: ISO 100, f/5.6, 1/320 second, Shutter-priority AE mode (Tv). The light was bright enough that I could keep the ISO at 100 to maintain the highest image quality. Only a few minutes later, however, the light faded enough that I had to increase the ISO to 400 to get a action-stopping shutter speed. Be sure to monitor the shutter speed in the viewfinder, especially in late-afternoon games, and adjust the ISO as necessary to ensure fast shutter speeds.

Additional Considerations: For indoor sports events, you'll need to increase ISO — a little or a lot — to get a fast enough shutter speed to freeze subject action. It's also important that the shutter speed is fast enough to prevent camera shake from handholding the camera and lens. The rule for handholding lenses is 1/[focal length]. So if you're shooting with a 200mm lens, the slowest shutter speed you can use and not get blur from handholding the camera is 1/200 second if you are using a non-Image Stabilized (IS) lens. If you're shooting late afternoon events, as the light level decreases, you'll need to increase the ISO setting. Set the ISO only as high as necessary to get a fast enough shutter speed to freeze subject motion.

Accessories

At slower shutter speeds and when using a telephoto lens or zoom setting, use a tripod or monopod to ensure sharp focus. With Canon L-series f/2.8 lenses, you can consider using a lens extender to extend the range of a telephoto lens. The lens extenders cost you 1 to 2 f-stops of light, so an extender is a good option in brightly lit scenes, but less handy in indoor stadiums where the light levels are lower.

Action and sports photography tips

- tings. To ensure speedy response from the XS/1000D, I recommend setting C.Fn-3 Long exposure noise reduction to Off, and setting C.Fn-4 High ISO speed noise reduction to Off. And if you're close enough to the action to use a flash, then set C.Fn-2 to Option 1: 1/200 sec. (fixed) to ensure a faster shutter speed than Option 0: Auto, which allows flash exposures at shutter speeds slower than 1/200 second.
- Set the autofocus mode before you begin shooting. If you're new to using different autofocus modes, then you can do a quick test of AI

- Servo AF mode by doing some test shooting in Sports mode. Then check the images to see if the camera chose the correct point of sharpest focus through the series of images. If it did not, then I recommend using AI Focus AF. In this mode, you focus on the subject first, and then when the subject begins moving, the camera switches to AI Servo AF to track the motion.
- Experiment with shutter speeds. To obtain a variety of action pictures, vary the shutter speed for different renderings. At slower shutter speeds, part of the subject will show motion, such as a player's arm swinging, while the rest of the subject's motion will be stopped.

- Find the best light and wait. If lighting varies across the sports field with areas of very low light, find the best-lit spot on the playing field or court, set the exposure for that lighting, and then wait for the action to move into that area. This technique works well in a low-lit indoor stadium as well. You can also prefocus on this spot and wait for the athlete or action to move into the area.
- Get a clean background. Many stadium walls are plastered with advertisements. Youth sports fields have concession stands and parking lots in the background — all of which become visual distractions.
- As you set the shutter speed, also monitor the aperture (f-stop) in the viewfinder. Ideally, at the given shutter speed, you need to freeze subject motion; you'll also get a wide aperture that helps blur background details. Regardless, try to find a shooting position that minimizes background distractions.
- Practice timing and composition. If you're new to shooting action photos, practice as often as you can to hone your reflexes, and then concentrate on refining image composition. With practice, both timing and composition come together to give you fine action shots.

Animal and Wildlife Photography

Next to photographing people, pet and wildlife images are some of the most interesting and compelling photographic subjects. With domesticated pets, it's possible to convey a sense of the animal's personality. In the wild, capturing animals interacting or in their environment going about their daily activities delivers a sense of their habits and personalities.

If you're photographing moving animals or birds, many of the suggestions for Rebel XS/1000D settings in the previous Action and Sports sections apply. And as with action shooting, telephoto zoom lenses are favored for their inherently shallow depth of field, and their ability to zoom as the subject moves closer or farther from you, and to

allow you to maintain a safe shooting distance from the animal. Canon has some fine, reasonably priced telephoto zoom lenses that provide greater reach when used on the XS/1000D, thanks to the 1.6x focal length multiplication factor. For example, the EF 70-300mm f/4.5-5.6 IS USM lens on the XS/1000D is equivalent to 112-480mm which is suitable for photographing birds, animals at a zoo, or wildlife in their natural settings. If you're shooting with an f/2.8L EF-series telephoto zoom lens, you can also use a lens extender for even greater reach.

Note

If you're photographing pets and domesticated animals, keep the welfare of the animal in mind. Never put the animal in danger or expect more of the animal than it is capable of or willing to give.

If you're photographing pets, young pets and animals provide strong visual appeal. Give the pet a large but confined play area,

and use props, toys, and rewards to entice the behavior you want. Set a fast shutter speed of 1/200-1/500 second to ensure that you don't get blur if the animal moves, and set the ISO only as high as necessary to attain that shutter speed range. You can shoot in either Tv or Av mode. If the animal is likely to move a little or a lot, use Tv mode and set a fast shutter speed. If the animal is less likely to move, and you want the ability to control the amount of distinct detail in the background — the depth of field — then choose Av mode and set a wide aperture (f-stop) to blur the background, or a narrow aperture to provide more background detail to keep the animal in the context of its surroundings.

Don't be surprised if pets you're photographing do not respond predictably to verbal commands. They can't see your face when you're behind the camera. Instead, establish eye contact with the pet as you set up the camera, and then talk to the animal as you shoot, and offer rewards and verbal encouragement.

In bright sun, be sure to play back images in the detailed shooting information display mode that includes not only the histogram, but also a blinking highlight overexposure display. In simple terms, any highlights that are blown out flash on the screen, alerting

9.10 This image of a miniature Schnauzer was taken with the dog on a folding table against a white seamless background. I used the continuous tungsten modeling lights on my studio strobes to light the scene and set a Custom White Balance using a modified Neutral Picture Style. During image editing, I lightened the background slightly. Exposure: ISO 100, f/5, 1/50 second using an EF-S 18-55mm f/3.5-5.6 IS USM lens.

you that you may need to use exposure modification such as AE Lock or Exposure Compensation, detailed in Chapter 2. My experience with the XS/1000D is that it tends toward slight overexposure, so check images as you shoot to know if you need to modify the exposure. To set the XS/1000D to detailed shooting information, just press

9.11 This tiger was enjoying the afternoon sun and was reluctant to move away from the plants near its face. I waited for other photographers to move so I could get a slightly better shooting position. Exposure: ISO 100, f/8, 1/200 second using an EF 180mm f/3.5L Macro USM lens.

the Playback button, and then press the Disp. button until the preview image is displayed along with one or more histograms.

Tip Nature treks provide excellent shooting opportunities. If you go to a preserve, call the facility first because they can give useful tips on the best times to capture the animals. For example, a northwest animal preserve recommends visiting during over-

> cast or rainy weather because the animals are out in the open more often than in sunny

Inspiration

weather.

Photo opportunities with domesticated pets include any new experiences for the animal. such as getting acquainted with another pet, sleeping in odd positions or curled up with other pets, watching out the window for kids to come home from school, racing after a ball or Frisbee, or performing in an arena. For wildlife and birds, check with local photo clubs and groups of photographers who often organize annual trips during the best times to capture wildlife and birds in your area. Check with a local camera store or on the Web to find upcoming treks and river trips. Also, providing plants, feeders, bird baths, and open areas in your yard can attract a variety of birds for ongoing photo ops.

Taking animal and wildlife photographs

9.12 You don't have to leave home to capture bird and wildlife images. In my area, bobcats, black bears, coyotes, deer, and rabbits make the year. I encourage bird activity by having multiple birdbaths.

Table 9.3 Animal and Wildlife Photography

Setup

In the Field: To avoid scaring off the wide variety of birds that frequent the birdbaths, I keep the screen off the windows and the windows open, and I have the camera and a long telephoto lens ready. Then I am ready to shoot when a beautiful bird drops by for a bath (figure 9.12).

Additional Considerations: For outdoor wildlife shots, find open areas where grass or natural foliage can be the background. Be patient, be alert, and be sure to focus on the animal's eyes.

continued

Table 9.3 (continued)

Lens

In the Field: Canon EF 100-400mm f/4.5-5.6L IS USM set to 400mm. Because I was shooting from the kitchen window, I stabilized my hands on a coffee canister, and I turned on IS. I was well beyond the lens handholding limits for this shot. Situations like this are where IS lenses pay their way.

Additional Considerations: Your lens choice makes a world of difference in being able to bring animals in close while keeping a safe distance. Even with the focal length conversion factor of 1.6x and a 70-200mm lens, the 200mm focal length often isn't long enough to get good shots. I recommend using at least a 400mm lens, equivalent to 640mm on the Rebel XS/1000D, for zoo and animal preserve photography coupled with a tripod or monopod. And for photographing animals in the wild, super-telephoto lenses are favored.

Camera Settings

In the Field: Aperture-priority AE (Av), RAW capture, using Daylight White Balance, Evaluative metering, One-shot AF mode with manual AF-point selection. AI Focus AF would also have been a good choice given that the subject could have started moving at any time. I also was using my modified version of the Neutral Picture Style that is my standard for virtually all of my shooting.

Additional Considerations: Av mode allows you to control the depth of field, but if you're in lower light and if the animal gets restless, Shutter-priority AE (Tv) mode is the best choice to ensure a shutter speed fast enough to prevent blur.

Exposure

In the Field: ISO 100, f/5.6, 1/160 second. The lower light of sunset compared to midday light made this exposure relatively straightforward with less concern about getting blown highlights. As a result, I opted to use Av mode to control the appearance of the background foliage. A relatively wide aperture of f/5.6 allowed me to blur most of the background tree details. And despite the shutter speed that was slower than the handholding limit at 400mm, I stabilized my hands and used IS on the lens to ensure sharp focus.

Additional Considerations: If you use Aperture-priority AE (Av) mode, watch the shutter speed in the viewfinder to ensure it isn't so slow that you will get motion blur if the animal moves. If you have to increase the ISO to the maximum setting and shoot with the aperture wide open to get the shot as I did here, an IS lens can mean the difference between getting a sharp image or not getting an image at all.

Accessories

If you're shooting with telephoto lenses, invest in a stable monopod or tripod, and then be sure to use it.

Animal and wildlife photography tips

- ♣ Buy camera and lens raincoats. The Rebel XS/1000D is a sturdy camera, but it lacks extensive weather sealing, and environmental elements such as rain, moisture, dust, and sand can damage it. Several companies, including Storm Jacket (www.stormjacket.com), offer a variety of camera and lens covers to protect both the camera and lens from the elements.
- ◆ Use an extender. If you don't have a super-telephoto lens, you can extend the range of your telephoto lens by adding an extender, as detailed in Chapter 8, to extend the focal length of certain Canon telephoto lenses by 1.4 or 2x.
- ◆ Do your research. If you're interested in photographing specific birds or wildlife, learn all you can about their habits and habitats, including feeding and mating behavior. For example, know what time of year the birds are in breeding plumes. The more you know, the better prepared you are to capture unique shots and to maintain your personal safety.
- Be patient and have the camera ready. Observe the habits of the indigenous wildlife. Once you know

- the path they regularly take, set up the camera so that you blend with the background, and with an eye toward how the lighting will fall on the animal. Then wait patiently for the animals to approach your area with the camera turned on and the exposure set. For example, I keep the camera turned on with a telephoto lens mounted and on a tripod near the back door. If I see a deer, bobcat, or bear coming through the back yard, I am ready to shoot from the deck, or depending on the animal, through an open window. I have set the camera to Av shooting mode, f/5.6, Evaluative metering, One-shot AF mode with manual AF-point selection, Continuous Drive mode, and modified Neutral Picture Style. If the light is bright, I may also quickly set Exposure Compensation at a 1 f-stop EV in both directions.
- ◆ Use Continuous Drive mode. Once you have the opportunity to photograph wildlife or pets, have the camera set to shoot in rapid-fire sequence to take advantage of the opportunity. To set the camera to Continuous Drive mode, press the Drive mode selection button (left cross key) on the back of the camera, press the left or right cross key to select Continuous shooting, and then press the Set button.

Architectural and Interior Photography

Whether you enjoy the variety and power of architectural styles or you're interested in shooting home exteriors and interiors for your business or to sell your own home, this photography specialty area is both fun and a great way to hone your composition and lighting techniques.

The challenge of exterior and interior photography with the XS/1000D is the cropped sensor size that requires wide and super-wide angle lenses to capture the sweep of the

Wide-Angle Distortion

Wide-angle lenses are a staple in architectural photography. When you use a wide-angle lens, and especially when the camera is tilted upward, the vertical lines of buildings converge toward the top of the frame. You can correct the distortion in an image-editing program, or you can use a tilt-and-shift lens, such as the Canon TS-E24mm f/3.5L, that corrects perspective distortion and controls focusing range. Shifting raises the lens parallel to its optical axis and can correct the wide-angle distortion that causes the converging lines. Tilting the lens allows greater depth of focus by changing the normally perpendicular relationship between the lens's optical axis and the camera's sensor.

To use a tilt-and-shift lens, set the camera so the focal plane is parallel to the surface of the building's wall. As the lens is shifted upward, it causes the image of the wall's surface to rise vertically, thus keeping the building's shape rectangular. For details on tilt-and-shift lenses, see Chapter 8.

structure or interior. A lineup of both EF and EF-S lenses, including the EF-S 10-22mm f/3.5-4.5 USM, provide the wide viewing angle needed for many types of architectural shooting. There is also the ultrawide EF 14mm f/2.8L USM lens, which gives the equivalent of approximately 22mm on the XS/1000D, and several tilt-and-shift lenses that help counteract wide-angle lens distortion.

Regardless of how much or how little you include in the frame, architectural photography is about capturing a sense of place and

space. Styles of architecture mirror the culture and sensibilities of each generation. New architecture reflects the hopeful aspirations of the times, while older structures reflect earlier cultural norms and sensibilities. For photographers, photographing both new and old architecture provides rich photo opportunities to document changes in culture and urban development locally or as part of traveling.

If you're new to architectural shooting, begin by choosing a building or interior space that interests you, and then study how light at

©Sandy Rippel

9.13 Focusing on specific architectural detail helps viewers to appreciate the intricate stonework and decorative elements in this image from India. Exposure: ISO 100, f/8, 1/200 second using an EF 24-105mm f/4L IS USM lens.

High Dynamic Range Images

The popularity of high dynamic range (HDR) images is growing, particularly for architecture and interior photography. In architectural photography, HDR gives a true "view" and sense of the interior or exterior by showing fine detail in bright window views to the outside — detail that would be sacrificed as very bright or blown highlights in single exposure. And the same is true for showing detail in deep shadows. Because HDR captures a full stop of information in every tonal range through multiple exposures, HDR delivers true-to-life and almost surreal renderings that are not possible with single image capture, or with double-processed RAW image composites.

Shooting HDR images involves shooting a series of three to seven images that are bracketed by shutter-speed. Then the images are merged in Photoshop, and contrast and tonal adjustments are made. If you are interested in learning more about HDR images, Pop Photo's Web site offers an online tutorial at www.popphoto.com/howto/3038/how-to-create-high-dynamic-range-images.html.

different times of the day transforms the sense and character of the building or space. Look for structural details and visual spaces that create interesting shadow patterns as they interact with light and surrounding spaces.

Most buildings are built for people, and people contribute to the character of the building. In a compositional sense, people provide a sense of scale in architectural photography, but more importantly, they give the building a sense of life, motion, energy, and emotion.

The umbrella of architectural photography includes interior photography of both commercial and private buildings and homes. With interior shooting, lighting plays a crucial role in communicating the style and ambience of the space. It's usually possible to get pleasing interior shots by using existing room lighting and window lighting, but you can also consider using portable strobes or multiple wireless flash units to add light and reveal details that might be lost using ambient-only light.

Inspiration

To get a true sense of the structure's character, explore both the exterior and interior of the building. Look for interior design elements that echo the exterior design. As you shoot, study how the building interacts with surrounding structures. See if you can use juxtapositions for visual comparisons and contrasts. Or find old and new buildings that were designed for the same purposes — courthouses, barns, cafes and restaurants, libraries, or train stations, for example. Create a photo series that shows how design and use have changed over time.

As you consider buildings and interiors, try to verbalize what makes the space distinctive. When you can talk about the space, you're often better able to translate your verbal description into visual terms. Many new structures include distinctive elements such as imported stone, crystal abstract displays, and so on that reflect the architect's vision for the structure. Be sure to play up the unique elements of exteriors and interiors. Very often, you can use these features as a theme that runs throughout a photo series.

9.14 I was drawn by the bright colors and visual energy of this Mexican restaurant. The early sunset light from a window to the left enhanced the warmth of the space. Exposure: ISO 800, f/2.8, 1/8 second using an EF 16-35mm f/2.8L USM lens.

Taking architectural and interior photographs

9.15 To exaggerate the high-rise aspect of this building, I took advantage of the wide-angle lens distortion that causes lines to converge at the top, and shot straight up toward the top of the building as I stood just outside the portico.

Table 9.4

Architectural and Interior Photography

Setup

In the Field: Normally, you want to avoid wide-angle lens distortion, but in some cases, you can use it to underscore a particular aspect of a building, as I did in Figure 9.15. This approach doesn't work for most architectural shooting because you want to retain the building's correct perspective with little or no distortion. It's important to plan the setup carefully and present a clean, appealing shot that captures the spirit of the space.

Additional Considerations: Study the building or space and look for the best details. Will details be best pictured straight on or from the side? If you're shooting interiors or exteriors, can you isolate repeating patterns that define the style? Also study whether you want to include ceiling details such as beams, chandeliers, skylights, or decorative elements.

Lighting

In the Field: The type of light that you choose sets the mood for the image. For a clean, straightforward presentation of the building, particularly modern skyscrapers, shoot against a sparkling blue sky with white clouds at mid-morning or late afternoon. For a richer and more evocative rendition, shoot at sunrise or sunset.

Additional Considerations: The golden late-afternoon light often enhances images of old structures, but with modern buildings, you can take advantage of sunny weather to show off the bold details and angular design. For mirrored buildings, reflections cast by nearby sculptures, passing clouds, and passing people can add interest.

Lens

In the Field: Canon EF 16-25mm f/2.8L USM lens set to 16mm.

Additional Considerations: Architectural and some landscape shooting are where the Rebel's 1.6x focal length conversion factor works against you. Having an ultra-wide lens such as the EF-S 10-22mm f/3.5-4.5 USM helps close the gap between the Rebel's cropped sensor and a full-frame sensor. You may also want to have a moderate telephoto lens in the bag and use it to isolate architectural details while excluding extraneous objects such as street signs.

Camera Settings

In the Field: Aperture-priority AE (Av) mode RAW capture, Evaluative metering, Single-shot drive mode, and One-shot AF mode with manual AF point selection using a modified Neutral Picture Style.

Additional Considerations: With mixed lighting indoors, setting a custom white balance is my preference because it makes color correction easier and faster.

continued

Table 9.3 (continued)

Exposure

In the Field: ISO 100, f/8, 1/50 second. Before shooting, I evaluated the building for any areas that could result in blown highlights. But only a few areas of highlights appeared on a few places in the lower part of the building, and I opted for the camera's suggested exposure with no exposure modifications.

Additional Considerations: In high-contrast scenes, you can use Exposure Bracketing to make multiple exposures, which helps to ensure that detail is maintained in the brightest highlights of at least one frame. Then you can composite the bracketed images in Photoshop or another image-editing program. Alternately, you can use Auto Exposure Lock and lock the exposure on or near the brightest highlights. Auto Exposure Lock is detailed in Chapter 2.

Accessories

A polarizing filter is an excellent way to reduce or eliminate glare from glass and mirrored building surfaces. In addition, it also enhances color contrast.

Architectural and interior photography tips

- Try A-DEP mode. If your photograph shows a succession of buildings from an angle that puts them in a stair-stepped arrangement, use A-DEP mode to get the optimal depth of field. You lose a bit of control with A-DEP mode because you can't choose the AF point manually. But watch in the viewfinder to ensure that the Rebel XS/1000D correctly sets the AF points. If it doesn't, then shift your shooting position slightly until the camera selects the correct AF points. Also watch the shutter speed display in the viewfinder to ensure that you remain within the handholding limits of the lens you're using, and if the shutter speed is slow, be sure to use a tripod.
- For low-light and night exterior and interior shots, turn on Longexposure noise reduction Custom Function using C.Fn-3.

Immediately after exposures of 1 second or longer, the camera creates a second "dark frame" image that it uses to reduce noise in the original image. The second exposure lasts as long as the first exposure, which slows down the shooting process, but it provides the best insurance against objectionable levels of digital noise in images.

Cross-Reference

For details on setting Custom Functions, see Chapter 5.

- ◆ Take advantage of High ISO noise reduction. If you're shooting exteriors or interiors in low light at a high ISO, then I recommend turning on noise reduction. You can set C.Fn-4 High ISO speed noise reduction to Option 1: On to have the XS/1000D perform the noise reduction automatically.
- Avoid wide-angle distortion. If you use a wide-angle lens and want to avoid distortion, keep the camera on a level plane with the

building and avoid tilting the camera up or down. This may mean shooting the building from a high position such as from a building across the street, or using a ladder.

Alternately, you can use a tilt-andshift lens, or you can correct lens distortion in Adobe Photoshop or Adobe Elements.

Child Photography

Perhaps no specialty area is simultaneously as satisfying and challenging as child photography. It is satisfying because it is a singular opportunity to capture the innocence, fun, and curiosity of unspoiled (so to speak) kids, and it is challenging because success depends on engaging the child so that you can reveal the child's sense of innocence, fun, and curiosity.

The EOS Rebel XS/1000D is well suited to kid photography, and it is small and light enough to pick up quickly to capture spur-of-the-moment images. While it's tempting to shoot in a Basic Zone mode such as Portrait, you'll get much more control over the final image by shooting in Av mode. In Av mode, you can control the point of sharpest focus by manually selecting the AF point that is over one of the child's eyes, and, of course, you can control the ISO, White Balance, Picture Style, and the use of the flash.

Tip Tired, hungry, bored, or out-ofsorts children will not put up with your attempts to direct and guide them for long, if at all, and a photo shoot can quickly degrade into a struggle of historic proportions. A better choice is to wait until the child is in good spirits.

The kit lens is handy for photographing kids because it has a good range that allows you to photograph groups of children in the 24-35mm range, and photograph one or two children at the 55mm focal length. But if children are a primary photography subject

for you, then I suggest adding a moderate telephoto zoom lens to your gear bag. Good choices include the EF 24-105mm f/4L IS USM, the EF 28-135mm, f/3.5-5.6 IS USM, or the EF 70-200mm, f/4L IS USM lens, which is more compact, lighter, and less expensive than its counterpart, the EF 70-200mm, f/2.8L IS USM lens.

As with most portraits, a wide aperture between f/5.6 and f/2.8 helps bring the subject visually forward in the frame while providing a shallow depth of field to help blur background distractions.

In all portraits, the subject eye that is closest to the lens should always be the point of sharpest focus. This means that you should manually select the AF point that is over the child's eye that is closest to the camera. If you need a refresher on how to manually choose an AF point, go back to Chapter 2. A good Autofocus mode is AI Focus AF. In this mode, you can focus on the child, but if the child begins to move, then the camera automatically switches to AI Servo AF mode, which tracks the child to maintain focus. It is also a good idea to set the Drive mode to Continuous so that you can shoot bursts of multiple images.

Tip Children catch onto photography quickly: By the end of their first year of life, most babies have perfected a cheesy "camera smile." This is definitely not the smile you want. The better you are able to connect with the child, the greater your chances are of capturing genuine expressions of happiness, interest, or concentration.

©Bryan and Corbin Lowrie

9.16 This portrait of a young girl from a mountain village in Honduras shows the girl's connection with the photographer. Exposure: ISO 100, f/5.6 at 1/100 second using an EF-S 18-55mm f/3.5-5.6 USM lens.

Inspiration

Child photography is one of the areas where you can often let the child inspire you. If you allow yourself to go with the flow of the child's activity, you can often get much better images than if you try to pose, direct, or control the child. In other words, let the child do what comes naturally as long as the child remains safe.

Not all child portraits have to show a sunny, smiling child, although many images should have a smile. But emotions can also make compelling images that parents can cherish for years to come.

9.17 As you make images of the children in your family, remember to capture images of the current hair and clothing styles. Exposure: ISO 200, f/2.8, 1/320 second using an EF 70-200mm f/2.8L IS USM lens.

Taking child photographs

9.18 It is hard to beat window light for portraits. In this image, the window light provided lovely highlights on one side of the boy's face.

Table 9.5 Child Photography

Setup

In the Field: The image in Figure 9.18 was taken during a large gathering. I persuaded the energetic boy to stop just long enough for me to take a few shots. While his smile has a "practiced camera smile" aspect to it, it's countered by the boy's mischievous and fun personality that's conveyed through his eyes.

Additional Considerations: Try to find an area where the background is free of distractions. This will not only net a better picture, but it will save you time editing the image on the computer. If you can't find a clean background, then use a wide aperture such as f/4 or f/2.8 to blur background detail. If you're using the built-in or an accessory flash, be sure to move the subject well away from the background to avoid shadows.

continued

Table 9.5 (continued)

Lighting

In the Field: This image was taken using only window light. The primary light was to the right of the subject from a southeast window. Light from the right side of the bay window filled the shadow side of the boy's face nicely. The photo was taken in late afternoon light.

Additional Considerations: The least flattering light is outdoors at midday on a sunny day. If you must shoot then, move the children to open shade and use fill flash to fill dark shadows on the face. You can use an inexpensive silver reflector to reflect light into the shadow side of the child's face.

Lens

In the Field: Canon EF 24-70mm f/2.8L IS USM lens set to 48mm, Evaluative metering, One-shot AF mode with manual AF-point selection.

Additional Considerations: A short or long telephoto lens and wide aperture provide the soft background that you want for portraits. A telephoto lens has an inherently shallow depth of field that, when combined with a wide aperture, helps keep background details from distracting from the subject.

Camera Settings

In the Field: RAW capture, Aperture-priority AE (Av) mode with the white balance set to AWB (Automatic White Balance). I used AWB because I knew that I could easily adjust the color during RAW image conversion for the color version of this image. Generally, AWB has a cool tint, so if you're shooting JPEG capture, be sure to set the white balance to match the light source. I also used modified Neutral Picture Style, although the Portrait Picture Style would be appropriate as well.

Additional Considerations: As the light fades, you can switch to Shutter-priority AE (Tv) mode to help ensure that subject movement or handholding the camera doesn't create blur. IS lenses give you one, two, or more additional stops of flexibility for handheld shooting than non-IS lenses.

Exposure

In the Field: ISO 200, f/2.8, 1/100 second. The subdued interior light made this exposure very easy to nail. Background highlights went reasonably light, but all of them held good detail.

Additional Considerations: As with all portraits, controlling the depth of field gives you control over the level of distinct detail in background elements in the scene. If the background is very busy, using lenses such as the EF 50mm f/1.4 USM is ideal because they offer super-wide apertures. At the same time, you must set the point of sharpest focus precisely on the child's eye, because the plane of sharp focus is extremely narrow at wide apertures such as f/1.4.

Child photography tips

Practice with manual AF-point selection. As I mentioned earlier, in all portraits, the child's eye that is closest to the lens should be the point of sharpest focus. And as children move around, you must be able to select different AF points manually with practiced ease and speed. As you practice setting the AF point manually, the process will become second nature, and you'll be able to change AF points quickly as the subject position changes. Once you set the focus by half-pressing the Shutter button, do not move the camera to recompose the image.

- ▼ Turn on High ISO noise reduction. If you're photographing children in low light scenes, chances are good that you'll also need to increase the ISO to get faster shutter speeds. To avoid the digital noise that is inherent in high-ISO shooting, set C.Fn-4 to Option 1: On. This way, the Rebel XS/1000D will automatically reduce digital noise in High ISO images before storing the images on the SD/SDHC card. Be aware that the noise reduction process will slow down the burst rate in Continuous drive mode.
- Have an assistant or baby/child wrangler. Any photographer who has shot child portrait sessions alone has likely had the sense that sessions often teeter just on the

- edge of chaos. Having an assistant to interact with the child and chat with the parents allows you more latitude in concentrating on lighting, composition, and changing camera position.
- Plan images beforehand. It's important to keep the child's size in perspective, so plan to have objects or props in the scene that will give a sense of scale. To draw the viewer into the child's world, shoot from the child's eye level and be sure to connect with the child by coming out from behind the camera periodically to interact with the child. When shooting portraits, try to compose the image so that the subject's head and eyes are in the top half or third of the frame.

Macro Photography

Many people think about shooting flowers when they think macro photography. Certainly, few photographers can resist the temptation to photograph flowers, exotic plants, and gardens. But macro photography applications are much broader than subjects offered in nature. With any of Canon's macro lenses, you have the opportunity to make stunning close-up images of everything from stamps and water drops to jewelry and the weathered hands of an elder. At its best, macro photography is a journey in discovering worlds of subjects that are overlooked or invisible in non-macro photography. The enticements of macro subject composition include colors, the allure of symmetry and textures, intricate design variations, and descriptive details found in objects and the human form.

To explore these small worlds, a fine lineup of Canon macro lenses offers one-half to life-size magnifications. Each lens offers a different working distance from the subject, and with a good set of extension tubes, you can reduce the focusing distance of any lens to create dynamic close-up images. In addition, the Canon's Macro Twin Lite MT-24EX and the Macro Ring Lite MR-14EX provide versatile lighting options for small subjects.

Chapter 8 details Canon's macro lens line-up as well as extension tubes.

Regardless of the subject, focus is critical in macro work. And at 1:1 magnification, the depth of field is very narrow. For much of my nature macro work, I maximize depth of field by using a narrow aperture between f/11 and f/16, and, of course, a tripod. The choice of aperture depends, of course, on the subject and what I want to convey in the image. When I use narrow apertures, I also use the 2-second Self-timer mode to avoid camera shake from the motion of pressing the Shutter button with my finger. To ensure rock-solid stability, I use Mirror Lockup,

9.19 At wide apertures, macro images clearly illustrate the extremely shallow plane of acceptably sharp focus. I chose a shallow depth of field to highlight a specific verse in this antique German/English Bible. Exposure: ISO 100, f/2.8, 1/60 second using the 2-second Self-timer mode to trip the shutter. I used the EF 24-70mm, f/2.8L Macro USM lens.

which flips up the reflex mirror and keeps it up so that the slap of the mirror doesn't cause blur in combination with the Selftimer mode. In outdoor shooting, light can vary from bright to very low. This is where either of the Canon macro Speedlights is handy for adding a pop of light.

For how to set the Mirror Lockup function, see Chapter 5.

Inspiration

The beauty of macro photography is showing details that most people commonly overlook. Use your macro lens as a microscope to find the most unique and compelling structures in

the subject you're shooting. Reveal to the viewers what they haven't seen before. Combine depth of field with subject position for creative effect. For example, a picture of an insect coming straight at the lens at eye-level foreshortens the body and blurs the back of the body, creating a sense of power that is disproportionate to the creature's size.

Macro lenses reveal the hidden structures and beauty of everything from flowers and insects to the wrinkles on a farmer's weathered face or hands. A single drop of water bouncing up from a pool, or the reflections of a garden in a water droplet on a flower petal, provide endless creative opportunities for macro images.

9.20 For this image, I used the EF 100mm f/2.8 Macro USM lens and a narrow aperture to provide as much sharpness throughout the frame as possible. The stamps are lit by window light. I used a tripod and the 2-second Self-timer mode. Exposure: ISO 100, f/14, 1.3 seconds.

Taking macro photographs

9.21 Flowers provide an endless source of macro shooting opportunities, and because of their inherent beauty and grace, it's hard to take a bad flower shot.

Table 9.6

Macro Photography

Setup

In the Field: For Figure 9.21, I wanted to emphasize the graceful lines of the rose. I set the flower on a table with a black foldout poster board background. Because the sides of the poster board fold out to create a stand for the board, they also add deep contrast to the edges of the rose.

Additional Considerations: Flowers, plants, insects, and other natural subjects in outdoor light usually offer ready-made setup. If you don't have a garden, local nurseries and greenhouses offer plentiful subjects.

Lighting

In the Field: The rose is lit by one tungsten light above and over the camera, and another tungsten light at a 45-degree angle to camera left. I placed the lights to highlight the center and left side of the rose while letting the right side go into moderate shadow. This type of contrast adds a good sense of depth to the blossom.

Additional Considerations: Outdoor light ranging from overcast conditions to bright sunshine is suitable for macro shooting. For outdoor flower shots, try taking a low shooting position, and then shoot upward to use the blue sky as a backdrop. For indoor shooting, window light to one side of the subject offers a beautiful light quality, and it is often bright enough for shooting on a tripod. Try using reflectors to direct light toward a small group or blossom. Macro Speedlites are a good option as well.

In the Field: Canon EF 100mm f/2.8 Macro USM lens.

Additional Considerations: As detailed in Chapter 8, Canon offers excellent macro lenses, including the EF 180mm f/3.5L Macro USM. the EF-S 60mm f/2.8 Macro USM, as well as the venerable EF 100mm f/2.8 Macro USM. The 180mm offers a longer working distance for subjects you can't or don't want to approach from a close shooting distance.

Camera Settings

In the Field: Aperture-priority AE (Av), RAW capture using a Custom White Balance, Evaluative metering, One-shot AF mode with manual AF-point selection, Self-timer Drive mode, and a modified Neutral Picture Style. I also had C.Fn-3 Long exposure noise reduction set to Option 2: On to apply noise reduction to the image, which was exposed for 3.2 seconds.

Additional Considerations: Decide on the depth of field that you want for the subject that you're shooting, and then use aperture selection, camera-to-subject distance, and the lens choice to get the effect you envision. If there are bright highlights on the subject, you can ensure that the highlights retain detail, particularly with JPEG capture, by using AE Lock, a technique described in Chapter 2.

Lens

Exposure

In the Field: ISO 100, f/22, 3.2 seconds. For this image, I wanted extensive depth of field for a maximum level of acceptable sharpness throughout the frame. If you recall from Chapter 6, depth of field is affected by the aperture choice, lens, and shooting distance. Choosing a narrow aperture helped counteract the use of a telephoto lens and the close camera-to-subject shooting distance, both of which decrease depth of field.

Additional Considerations: Unless you want to use selective focusing, where a very small part of the subject is in sharp focus, set a narrow aperture such as f/11 to f/22 to maximize the depth of field, which is by virtue of the close focusing distance very shallow. Also use a tripod, beanbag, or mini-pod to stabilize the camera, and Self-timer mode to fire the shutter. This is also a good time to use Mirror Lockup (detailed earlier) to ensure tack-sharp focus.

Accessories

A tripod is always a good precaution when you're taking macro shots and when using a telephoto lens. You can also buy plant holders to hold plants steady. These holders do not damage the plant and are inexpensive.

Macro photography tips

- Ensure tack-sharp focus. The Rebel offers several Self-timer modes that you can combine with Mirror Lockup, described previously, and a solid tripod for tacksharp focus. Before you begin shooting, ensure that there is no "drift" of the camera as it is mounted on the tripod head, such as when the camera is pointed down or in a vertical shooting position. If you detect any drift, tighten the fitting of the camera on the tripod head quick-release plate or the fitting that attaches the camera to the tripod.
- Make the most of lighting. If you want to emphasize depth in textured subjects, use strong side light that rakes across the subject. Or if you want controlled, focused light, you can fashion a modifier to reduce the breadth of light from a Speedlite. For example, one photographer fashioned a narrow "snoot" by using black electrical

- tape on a Speedlite to concentrate the flash output into a narrow beam for tiny subjects.
- Maximize the depth of field. To get the maximum acceptable sharpness throughout the frame, especially for small objects, shoot on a plane that is parallel with the subject, and use a narrow aperture such as f/11 or narrower in Av shooting mode. Any tilt of the lens will quickly create blur.
- Watch the background. The viewer's eye is drawn to the brightest area in the image, so it's important to avoid bright background highlights that distract from the subject. You can move your shooting position or the position of the subject to avoid background highlights.
- ★ Take advantage of backlighting. Many flower petals and plant leaves are transparent, and with backlighting, the delicate veins are visible. You can use backlighting to create compelling and very graphic images of flowers and plants.

Nature and Landscape Photography

With breathtaking vistas of forests, mountains, and expanse of sky, God's handiwork remains an awesome wealth of photographic material for photographers. From dawn to dusk and sometimes beyond, nature provides an endless source of inspiration for stunning images. Seasonal changes to flora and fauna, passing wildlife, rain, sunshine, fog, and snow all contribute to nature's ever-changing canvas. And with the creative control that the EOS Rebel XS/1000D offers, you have full control over the exposures to maximize the scene in a variety of lighting conditions.

The image histogram is your best tool for evaluating whether the exposure captured detail in both light and dark areas. If the histogram shows pixels crowded against the left, right, or both sides of the histogram, the camera wasn't able to maintain detail in one or both areas. Filters, such as a graduated neutral-density (NDGrad) filter, can help balance the exposure for bright sky areas and darker foreground areas, allowing the sensor to hold detail in both areas.

Nature and landscape scenes also often require exposure modification to ensure that you capture detail in the highlights without blocking up the shadows. Blocked shadows are those that go to pure black very quickly instead of transitioning gradually to reveal detail in the shadow areas. Favored exposure

©Sandy Rippel

9.22 This scene in Hyderabad, India takes full advantage of showing the ruins of Golconda Fort in the foreground and the current city in the background, providing a unique sense of cultural heritage. Exposure: ISO 100, f/8, 1/200 second, using an EF 24-105mm f/4L IS USM lens.

modification techniques are Auto Exposure Lock, Exposure Bracketing, and Exposure Compensation. Each technique is suited for different shooting situations.

- Use Auto Exposure Lock in almost any scene to decouple the Rebel's autofocus and light metering systems. Using AE Lock, you lock the exposure on a bright highlight to ensure that detail in the highlights is retained, and then you recompose the shot and focus on the appropriate area within the scene.
- Exposure Bracketing takes three separate images: one at the camera's suggested exposure, one with more exposure, and one with less exposure. From these three images, you will get one that is correct for the scene. And, if you want, you can composite separate images in an image-editing program to get the best of all three exposures.
- Exposure Compensation is the standard to use in scenes that are "non-average," or those that have a preponderance of very light areas such as snow, or very dark areas such as a large body of water. For example, in a snow scene, setting a negative 1 or 2 EV exposure compensation renders snow as white instead of gray. Setting a positive 1 or 2 EV exposure compensation renders dark expanses of water as dark rather than as gray.

While nature and landscape images are frequently good candidates for using exposure modification, be aware that the effects of bracketing and compensation may not be visible in your images because the XS/1000D has Auto Lighting Optimizer turned on by default for images that you capture in JPEG format. Auto Lighting Optimizer detects images that are too dark or that lack contrast,

and automatically adjusts them. If you prefer not to have the camera make automatic adjustments, then turn off Auto Lighting Optimizer.

To turn off Auto Lighting Optimizer, press the Menu button, and then turn the Main dial to select the Set-up 3 menu. Select Custom Functions (C.Fn), and then press the Set button. Press the right (or left) cross key until the number 5 is displayed in the box at the top right of the screen. Press the Set button. Press the down cross key to select 1: Disable, and then press the Set button. Auto Lighting Optimizer remains turned off until you change it by repeating these steps.

For details on using and modifying Picture Styles, see Chapter 3.

For landscapes, you may want to try the Landscape Picture Style, which delivers vivid blues and greens and boosts image contrast and sharpness. If you're shooting JPEG images, the Picture Style is applied in the camera, but you can adjust the sharpness, contrast, color saturation, and color tone as detailed in Chapter 3. If you're shooting RAW, you can apply the Picture Style when you convert the image in Canon's Digital Photo Professional program. A word of caution is in order, however: Many photographers find that the Landscape Picture Style color, contrast, and saturation are too intense and vivid.

Inspiration

Choose a place that gives you a unique visual or emotional sense. For example, if you find a scene that exudes tranquility, try different positions, focal lengths, and foreground elements to help convey the sense of peace. As you take pictures, look both at the overall scene and the components that

make it compelling. Isolate subscenes that make independent compositions or can be used as a center of interest for the overall scene.

As you look around, ask whether including more or less of the sky will enhance the scene and the composition. Generally, a gray, cloudless sky adds no visual value to the image. Stormy skies, on the other hand, can add drama as well as beautiful color to outdoor images.

9.23 This cluster of roses and buds caught my eye for the sense of rising hopefulness they convey. Exposure: ISO 100, f/5.6, 1/250 second using a Canon EF 100mm f/2.8 Macro USM lens.

Taking nature and landscape photographs

9.24 Snoqualmie Falls is a popular natural attraction in Washington, especially during times when the mountain snow melts and increases the volume of water going over the falls.

Table 9.7

Nature and Landscape Photography

Setup

In the Field: In Figure 9.24, I shot from a viewing platform that juts out over the surrounding cliffs. The challenge was to jockey for a good shooting position and hold the camera steady among the adults and children crowded around me on the platform.

Additional Considerations: Because such a wide variety of scenes is possible with landscapes and nature, the best advice is to trust your eye to find compelling images. Try to exclude distracting utility wires, road signs, and other distractions from the scene. Shoot from a variety of low, high, and eye-level positions. For sweeping scenes, include a foreground object such as a person, a rock, or a fence to provide a sense of scale. Also look for lines and shapes that you can use to direct the viewer's eye through the picture.

Lighting

In the Field: The falls are a classic high-dynamic range scene where the difference between the highlights and shadows, as measured in f-stops, is wide and can exceed the camera's ability to hold detail in both areas. I chose to shoot in late afternoon when the sun intensity subsided. I knew that the shadows would go very dark, and that I'd have to work with the final image in Photoshop to bring up the detail in the shadows.

Additional Considerations: A variety of lighting conditions are inherent in landscape and nature photography. Inevitably, the best light is during and just after or before sunrise and dawn, when the low angle of the sun creates long shadows and enhances the colors of flora and fauna.

In the Field: Canon EF 24-70mm f/2.8L USM lens set to 32mm.

Additional Considerations: Both wide-angle and telephoto zoom lenses are good choices for landscape and nature photography. For distant scenes, a wide-angle lens may render some elements, such as distant mountains, too small in the frame. Use a telephoto lens to bring them closer.

Camera Settings

In the Field: Aperture-priority AE (Av) mode with white balance set to Daylight, and then adjusted during RAW conversion, Evaluative metering, One-shot AF mode with manual AF-point selection, and a modified Neutral Picture Style. I used AE Lock in this image to set the exposure on the water highlights to retain detail in them. Exposing for the highlights darkened the rest of the scene, and I subsequently lightened the midtones and shadows in Photoshop.

Additional Considerations: Because some landscape images look better with deeper color, you can set Exposure Compensation to -1/2 or -1/3 stop if you're shooting JPEGs, and this also helps to retain detail in bright highlights. Just hold down the AV button at the top-right side of the LCD as you turn the Main dial to set the amount of compensation you want. Be sure to check the image histogram after capture to ensure proper exposure. Also remember to remove the compensation when you're finished shooting.

Lens

Table 9.7 (continued)

Exposure

In the Field: ISO 100, f/8, 1/160 second using AE Lock on the water highlights.

Additional Considerations: Use the lowest ISO possible to avoid digital noise and to ensure the highest overall image quality. In most landscape and nature photos, extensive depth of field is the best choice, so choose a narrow aperture.

Nature and landscape photography tips

- Switch to Tv mode and use a slow shutter speed to show falling water as a silky blur. To show the motion of a waterfall as a silky blur, use Tv mode and set the shutter speed to 1/2 to 1 second or longer. You can also use a polarizing filter to reduce the glare of surrounding wet surfaces such as rocks. It goes without saying that you also need to use a tripod for long exposures such as this.
- Set a narrow aperture. To show extensive detail throughout the frame in landscape images, choose a narrow aperture between f/11 and f/22. If the narrow aperture results in a slow shutter speed, then use a tri-

- pod. Also, with a slow shutter speed, any motion of trees and grass blowing in the wind will show up as blur. You may have to adjust the aperture, depending on the shutter speed and the amount of wind.
- Look for details that underscore the sense of the place, history, or culture. A dilapidated fence or a rusted watering trough in a peaceful shot of a prairie helps convey how the land was used
- ♦ Shoot at low ISO settings. As detailed in Chapter 2, the lower the ISO setting, the better the overall image quality in terms of the absence of excessive digital noise, as well as improved color and detail. If you have to shoot at a high ISO, then I recommend setting C.Fn-4 to Option 1: On.

Night and Low-Light Photography

If you're ready to challenge your photography skills, shooting low-light and nighttime images is a great way to do it. Night and low-light images not only challenge your exposure skills, but they also open a new world of creative challenge, enjoyment, and the potential for stunning images. Because many family events and school performances are in low light, it's important to

have a good understanding of how to get high-quality results without getting excessive digital noise.

Tip

For outdoor images, sunset and twilight are magical photography times for shooting city skylines, harbors, and downtown buildings. During twilight, the artificial lights in the landscape, such as street and office lights, and the light from the sky reach approximately the same intensity. This crossover lighting time offers a unique opportunity.

9.25 For this shot of a widely known diner in Oklahoma, I sat the camera on the hood of a car and set the Drive mode to the 2-second Self-timer to ensure a sharp image. I also increased the ISO sensitivity, but only as far as necessary to get a reasonably fast shutter speed. Exposure: ISO 400, f/2.8, 1/40 second using an EF 24-70mm f/2.8L USM lens.

For night and low-light shooting, I recommend taking advantage of the XS/1000D's two Custom Functions that reduce noise from long exposures and from shooting at high ISO sensitivity settings. Setting C.Fn-3 to Option 2: On reduces noise in exposures of 1 second and longer, and setting C.Fn-4 to Option 1: On reduces digital noise in high ISO exposures. The downside of turning on

these Custom Functions is that the burst rate is reduced, but the image quality is much better.

For details on setting Custom Functions, see Chapter 5.

Low-light and night photos also offer a great opportunity to use Manual mode on the XS/1000D. Sample starting exposure recommendations are provided in Table 9.8.

		Table 9.8					
Ideal Night and Low-Light Exposures							
Subject	ISO	Aperture	Shutter Speed				
City skylines (shortly after sunset)	100 to 400	f/4 to f/8	1/30 second				
Full moon	100	f/11	1/125 second				
Campfires	100	f/2.8	1/15 to 1/30 second				
Fairs, amuse- ment parks	100 to 400	f/2.8	1/8 to 1/60 second				

continued

Table 9.8 (continued)						
Subject	ISO	Aperture	Shutter Speed			
Lightning	100	f/5.6 to f/8	Bulb; keep shutter open for several lightning flashes			
Night sports games	400 to 800	f/2.8 1/250 second				
Candlelit scenes	100 to 200	f/2.8 to f/4	1/4 second			
Neon signs	100 to 200	f/5.6	1/15 to 1/30 second			
Freeway lights	100	f/16	1/40 second			

Inspiration

Try shooting city skyline shots in stormy weather at dusk when enough light remains to capture compelling colors and the fear-some look of the sky. Busy downtown streets as people walk to restaurants, cafés,

and diners; gasoline stations; widely spaced lights on a lonely stretch of an evening highway; the light of a ship coming into a harbor; or an outdoor fountain or waterfall that is lit by nearby streetlights are all potential subjects for dramatic pictures, as are indoor events such as concerts and recitals.

9.26 If you watch the local weather or check an almanac, you can capture various weather and moon events such as I did with this Solstice moon shot. I had to wait about an hour for the heavy cloud cover to dissipate. Exposure: ISO 200, f/11, 1/6 second using a Canon EF 100-400mm, f/5.6L IS USM lens.

Taking night and low-light photographs

9.27 Low-light scenes such as sports events, interiors, and music concerts offer wonderful photo opportunities, but they are challenging in terms of exposure, timing for capturing the action, and composition.

Table 9.9

Night and Low-Light Photography

Setup

In the Field: The primary setup for Figure 9.27 was to find a good shooting position and use the exposure that I had previously tested for this particular stage lighting.

Additional Considerations: If you are photographing outdoor night and low-light images, ensure that your composition has a clear subject and isn't visually confusing by including too much in the frame. Outdoors, be aware that passing cars and nearby lights can influence the camera's meter reading. You may need to wait for cars to pass.

continued

Table 9.9 (continued)

Lighting

In the Field: Stage lights from the top and sides, and gelled floor lights comprised the lighting for this scene. The circular lights in the background are multiple strands of twinkle lights. The key was to expose for the highlights on the vocalist's face from spotlights.

Additional Considerations: If you're shooting scenes with floodlit buildings, bridges, or other night scenes, begin shooting just after sunset so the buildings stand out from the surroundings. And whether you're shooting indoors or outdoors, check the histogram on the LCD to ensure that highlights are not being blown out. Shadows will block up quickly in low light, but if you're shooting RAW capture, you can open the shadows some and apply noise reduction if necessary during image conversion.

Lens

In the Field: Canon EF 85mm f/1.2L USM lens.

Additional Considerations: The lens you use, of course, depends on the subject or scene. A wide-angle zoom lens set to 16mm or 24mm allows you to get a broad expanse of night and evening scenes. Telephoto lenses, of course, are great for bringing distant scenes closer. Regardless of the lens you use, mount the camera or lens on a tripod to ensure tack-sharp focus.

Camera Settings

In the Field: Aperture-priority AE (Av), RAW capture with White Balance set to auto (AWB) and adjusted during RAW conversion, Evaluative metering, One-shot AF mode with manual AF-point selection using a modified Neutral Picture Style.

Additional Considerations: Aperture-priority AE (Av) mode gives you control over the depth of field. If you have to handhold the camera, you may want to use Tv mode and set a shutter speed that's appropriate for handholding the lens that you're using, and then make adjustments to the ISO as necessary. Low-light scenes are also a good time to use the Self-timer mode to trip the shutter, and to use Mirror Lockup, which you can enable using C.Fn-8.

Exposure

In the Field: ISO 400, f/1.8, 1/125 second. I applied some noise reduction to the image during RAW image conversion. Before the event began, I made some test shots to ensure that the facial highlights would retain good detail at these exposure settings.

Additional Considerations: Light changes quickly in late-day out-door scenes. This is a good time to consider using Auto ISO, where the Rebel automatically sets the ISO between 100 and 800 based on the available light. Just past sunset, you can usually rely on the meter to give a good exposure, but you may choose to bracket exposures at 1/3 or 1/2-stop intervals, as the camera can tend toward a bit of overexposure. However, if bright lights surround the scene, the meter can be thrown off. Check the histogram often, and use a lens hood to avoid having stray light come into the lens.

Accessories

Using a tripod or setting the camera on a solid surface is essential in low-light scenes.

Night and low-light photography tips

- Be safe and use common sense. Night shooting presents its own set of photography challenges, including maintaining your personal safety. Always follow safety precautions when shooting wear reflective tape or clothing, carry a flashlight, and carry a charged cell phone with you.
- Use a level when using a tripod. A small bubble level designed to fit on the hot shoe mount helps to avoid tilted horizon shots. Some tripod heads also have built-in levels.
- Try the Self-timer mode. You can, of course, negate the advantage of using a tripod by pressing the Shutter button with your finger, causing camera shake and a noticeable loss of sharpness. A better solution is to use one of the Self-timer modes and Mirror Lockup.

Portrait Photography

Portraiture is likely the most popular of photographic specialties and provides a continuing challenge and opportunity for photographers. Making a portrait is a process of discovering the spirit and spark of people and conveying it in images — certainly a compelling and challenging endeavor. Despite the challenges, portrait photography is ultimately very satisfying and rewarding.

The following sections detail some of many considerations involved in portraiture.

Lens choices

For head and head-and-shoulders portraits, normal to medium telephoto lenses ranging from 35mm to 100mm are excellent choices. With an inherently shallow depth of field, telephoto lenses provide a lovely background blur that brings the subject visually forward in the image. For full-length and environmental portraits, a moderate wide-angle lens is a good choice. For environmental portraits such as Figure 9.30, a wide-angle lens like the EF 24-70mm allows you to include some or a lot of the context of the environment.

9.28 Setups for portraits do not have to be elaborate. Here a neutral color wall and light from a door in front of the subject create a nice exposure, complete with good catchlights in Ev's eyes. In this portrait, the OU (University of Oklahoma) hat held special significance for the subject. Exposure: ISO 100, f/2.8, 1/40 second using an EF 24-70mm f/2.8L USM lens.

Backgrounds and props

In all portraits, the subject is the center of attention, and that's why choosing a non-distracting or softly blurred background is important. Even if you have trouble finding a good background, you can de-emphasize the background by using a wide aperture such as f/4 or f/2.8 and moving the subject well away from the background. Conversely, some portraits benefit by having more background context. For example, when taking high school senior portraits, backgrounds and props that help show the student's areas of interest are popular. More extensive depth of field is the ticket for showing a star football player in the context of a football field.

Formal portraiture often incorporates more elaborate backgrounds and props, particularly in studio settings. However, if you are just starting out, a simple background and few or no props create fine portraits as well. Just remember the image is not about the background or the props. The image is first and always about the subject.

Lighting

Lighting differs for portraits of men and women. For men and boys, strong, directional daylight can be used to emphasize strong masculine facial features. For women and girls, soft, diffuse light from a nearby window or the light on an overcast day is flattering. To control light, you can use a variety of accessories, including reflectors to bounce light into shadow areas and diffusion panels to reduce the intensity of bright sunlight. These accessories are equally handy when using the built-in or an accessory flash for portraits. To determine exposure, take a meter reading from the highlight area of the subject's face, use Auto Exposure Lock, and then recompose, focus, and take the picture.

Tip

The Rebel XS/1000D doesn't have a PC terminal to connect a studio strobe system directly to the camera, but several companies make affordable hot-shoe adapters for this purpose. Adapters come with either male or female connectors, and they attach to the hot shoe on the Rebel. Ensure that the voltage of the strobe system is safe to use with the XS/1000D. Consider Safe-Sync adapters that regulate and reduce flash sync voltage to protect camera circuitry.

Accessory flash

You often have more flexibility with lighting when you use an accessory flash. With accessory flash units, you can soften the light by bouncing it off a nearby wall or ceiling. You can also mount one or more accessory flash units on light stands and point the flash into an umbrella to create studio-like lighting results on location. Inexpensive flash attachments such as diffusers and softbox attachments are also a great option for creating nice portrait lighting.

See Chapter 7 for details on using accessory flash units and accessories.

Regardless of the light source, be sure that the subject's eyes have catchlights, or small, white reflections of the main light source — a 2 o'clock or 10 o'clock catchlight position is classic. Light also affects the size of the subject's pupils — the brighter the light, the smaller the pupil size. A smaller pupil size is preferable because it emphasizes the subject's irises (the color part of the eye), making the eyes more attractive.

Posing

Entire books are written on posing techniques for portraits. But you won't go wrong with one essential guideline - the best pose is the one that makes the subject look comfortable, relaxed, and natural. In practice, this doesn't mean that the subject slouches on a chair; it means letting the subject find a comfortable position, and then tweaking it to ensure that the subject lines and appearance are crisp and attractive. Key lines are the structural lines that form the portrait. You can also use diagonal and triangular lines formed by the legs, arms, and shoulders to create more dynamic portraits. And placing the subject's body at an angle to the camera is more flattering and dynamic than a static pose with the head and shoulders squared off to the camera.

Rapport

Even if you light and pose the subject perfectly, a portrait will fail if you haven't connected with the subject. Your connection with the subject is mirrored in the subject's eyes. Every minute that you spend building a good relationship with the subject pays big dividends in the final images. In short, building a relationship with the subject is the single most important step in creating meaningful portraits.

Direction

Portrait subjects are most often self-conscious in front of a camera. Even the most sparking personalities can freeze up when the lens is pointed in their direction. To ease their anxiety, you have to be a consummate director, calming the subject, gently guiding him or her into the spirit of the session, and providing encouraging feedback. Very often,

instead of describing how I want a person to sit or stand, I demonstrate what I have in mind. Most subjects catch on immediately and add their own interpretations.

Inspiration

Before you begin, talk to the subject about his or her interests. Then see if you can create setups or poses that play off of what you learn. Consider having a prop that the subject can use for inspiration and improvisation. Alternately, play off the subject's characteristics. For example, with a very masculine subject, use angular props or a rocky natural setting that reflects masculinity.

9.29 Open shade on a cloudy afternoon provided the light for the portrait of Zach. The shallow depth of field blurs the background trees while maintaining the outdoor context. Exposure: ISO 200, f/4.5, 1/160 second using an EF 24-70mm f/2.8L USM lens.

Taking portrait photographs

9.30 Outdoor light, particularly when it is diffused and directional, is excellent for portraits because it doesn't create dark shadows under the eyes, nose, and chin, while the directional quality provides good definition and depth of the subject's features.

Table 9.10 Portrait Photography

Setup

In the Field: For Figure 9.30, the setup for this portrait is exceptionally simple — a front yard with a lot of bushes in the background. I moved Greg several feet in front of the foliage so that it would blur more.

Additional Considerations: Uncluttered and simple backgrounds are effective for making the subject stand out from the background. If you don't have white paper, use a plain, neutral-color wall, and move the subject four to six feet or further from the background. If you're using an accessory Speedlite, moving the subject away from the background also helps reduce or eliminate background shadows. Keep poses simple and straightforward; allow the subject to assume a natural position, and then tweak the pose for the best effect.

Lighting

In the Field: I waited until late afternoon so that the low angle of the light would cover the right side of Greg's face, and the shadow of the nearby house would provide a slight shadow on the left side of his face. Natural lighting such as this is flattering for all types of subjects, from babies to elders.

Additional Considerations: In addition to natural outdoor or window light, you can use multiple accessory flash units and a wireless transmitter to simulate studio lighting. I recommend the Canon ST-E2 wireless Speedlite Transmitter for multiple Speedlite setups. Window light supplemented by silver or white reflectors is the most beautiful portrait lighting. Use a silver reflector on the opposite side of the window to fill shadows, and another reflector at the subject's waist level to fill shadows under the chin.

Lens

In the Field: Canon EF 70-200mm f/2.8L IS USM lens.

Additional Considerations: Most photographers prefer a focal length of 85mm to 105mm for portraits. Canon offers a variety of zoom lenses that offer a short telephoto focal length, such as the EF 24-105mm f/4L IS USM and the EF 70-200mm f/2.8L IS USM lenses. Another lens to consider for excellent contrast in portraits is the venerable Canon EF 50mm f/1.4 USM lens (equivalent to 80mm on the EOS XS/1000D).

Camera Settings

In the Field: Av shooting mode with a custom White Balance, Evaluative metering, One-shot AF drive mode with manual AF point selection, and using a modified Neutral Picture Style.

Additional Considerations: In most cases, you want to control depth of field for portraits, and Aperture-priority AE (Av) mode gives you that control. For focusing, manually select the AF point that is over the subject's eye that is closest to the lens, and focus on the eyes. From my experience, tack-sharp focus isn't maintained if you lock focus, and then move the camera to recompose the image. So set the focus by pressing the Shutter button halfway, and then don't move the camera to recompose the shot.

Exposure

In the Field: ISO 100, f/2.8, 1/400 second.

Additional Considerations: To avoid digital noise in shadow areas, set the lowest ISO possible. To ensure features that are reasonably sharp throughout the face, set the aperture to f/5.6 or f/8, depending on your distance from the subject, the subject's distance from the background, and the amount of available light. Alternately, if you want to make the subject's eyes stand out, choose a wide aperture of f/2.8 or wider and ensure that you have tack-sharp focus on the subject's eyes.

Accessories

A tripod ensures tack-sharp focus on the subject's eyes, but it limits your ability to move around the subject quickly to get different angles. If the light permits, shooting off the tripod frees you to try more creative angles and shooting positions.

Portrait photography tips

- Use the Portrait Picture Style. I find that Portrait provides the classic skin tone rendition, with subdued contrast that makes lovely prints. You can also change the settings of the Portrait Picture Style if you want a bit more contrast or a different rendition of skin tones. See Chapter 3 for details on modifying Picture Styles. I alternate between Portrait and Neutral Picture Styles for my work.
- Focus on the eyes. Without question, the most common problem that I see with photography students' portraits is not focusing on the subject's eye that is closest to the lens. Review the technique for manually selecting a single AF point that is detailed in Chapter 2, and then manually select the AF point that is over the subject's eye for your portraits.
- Flatter older subjects. For older adults, ask the subject to lift his or her head and move it forward slightly to reduce the appearance of lines and wrinkles. Watch the change to see if the wrinkles are minimized. If not, adjust the pose further.
- Narrow the aperture when shooting groups. As the number of people in the portrait increases, so should the aperture to keep faces that are on different planes as sharp as possible. For groups of two to three people, I use f/8 and a wider focal length than I use for a single subject. For a large family of

- six to ten people, I use f/11, and I ensure that they are a good distance in front of the background to blur background details. Also, if you have three rows of people, ask the back row of people to lean forward just slightly, and ask the front row to lean back slightly toward the middle row. This technique helps to put the subjects more on the same plane to give better sharpness for all subjects.
- Pay attention to hands. If the shot includes the subject's hands, you can minimize the appearance of veins by asking the subject to hold the hands with the fingers pointed up for a few minutes before you begin shooting.
- Framing the subject. As a general rule, keep the subject's head in the upper one-third of the frame. If you're not using a flash and if the subject is in shade, then use a silver or white reflector to add catchlights to the subject's eyes.
- Always be ready to take a shot. When a good rapport is established between you and the subject, be ready to shoot spontaneously even if the setup isn't perfect. A natural, spontaneous expression from the subject is much more important than futzing to get a perfect setup.
- Shoot and keep shooting. It's possible and probable that something will be amiss with "the perfect" pictures that you think you've captured even after you examine them on the LCD. So keep shooting, especially when the session is going well.

Still-Life Photography

Arrangements of food, pottery, fruit, found objects, rocks, and plants that are reminiscent of classic and modern paintings jump to mind first when many people think of still-life photography. As with painters, photographic still-life images are typically characterized by striking lighting that defines the subject form. But still-life arrangements also can be found in existing scenes in old homes and buildings, along sidewalks, and in stores. Closely related to still-life images are product images. So whether you bought the XS/1000D for personal shooting or to photograph products for your business, the camera performs well in both photographic categories.

With the XS/1000D, you can have control over the creative expression of your still-life images through the shooting mode you choose, the metering mode, and the Picture Style to name a few. In addition, if you want maximum sharpness throughout the scene, try using A-DEP shooting mode and be sure to use a tripod if the camera sets a slow shutter speed in this mode.

In this area of photography, you can incorporate techniques that you use in macro, portrait, and nature shooting. Still-life photography subjects invite you to experiment with dramatic lighting to define subject form and substance and to set the mood of the image. For example, if the subject or scene is backlit, then switch to Partial Metering to

9.31 You can buy a Safe Sync flash adapter so that you can use the XS/1000D with a studio lighting system. Four Photogenic strobes and a large silver reflector lit this still-life image of cell phones. I lightened the background to pure white in Photoshop. Exposure: ISO 100, f/22, 1/125 second using an EF 24-70mm, f/2.8L USM lens.

ensure exact exposure on critical areas within the scene. Partial Metering mode evaluates the light from 10-percent at the center of the viewfinder.

Depending on the subject, this is also a good time to try the Sepia and Monochrome Picture Styles.

Tip

Some photographers shy away from still-life photography because of its slower pace. But the exacting lighting and demanding subject setups necessary for still-life shooting offer photographers a chance to expand their creative skills. And still-life shooting offers ample opportunity to try varied techniques both in the camera and on the computer.

Inspiration

Traditional still-life subjects are a great way to start learning the art of still-life photography. Almost anything that catches your eye for its beautiful form, texture, shape, and design is a good candidate for a still-life photo. Because the success of the image often depends on the setup and arrangement, study art and design books; magazines and advertisements can also help spark ideas for creating your own setups.

9.32 The subjects that qualify as still life include natural subjects such as this detail shot of magnolia petals. Exposure: ISO 200, f/22, 1/125 second using an EF 180mm f/3.5L Macro USM lens.

Taking still-life photographs

9.33 This was a "found" still-life scene. When I saw the rows of apples, I immediately decided to focus on the green apple and let a shallow depth of field blur the surrounding apples.

Table 9.11

Still-Life Photography

Setup

In the Field: Figure 9.33 was shot at a grocery store, and there was no setup involved. I only had to determine how I wanted to render the rows of apples.

Additional Considerations: You can find many existing still-life images around your home or outside the home. Just watch carefully for small, discrete settings that form independent compositions.

Lighting

In the Field: The apples were lit by overhead commercial fluorescent lights. There were highlights on the apples that became distracting, so I cloned out many of them during image editing.

Additional Considerations: For small still-life and product shots that you set up on your own, the diffuse light from a nearby window is often the most attractive light for subjects such as flowers, baskets, and pottery. Alternately, you can use bright light to create deep, sharp-edged shadows.

continued

Table 9.11 (continued)

Lens

In the Field: Canon EF 100mm f/2.8 Macro USM lens.

Additional Considerations: Your lens choice depends on the scene you're shooting and your vision for the image. Use a telephoto zoom lens to visually compress the space among elements in the scene, or use a wide-angle lens to visually separate elements.

Camera Settings

In the Field: Aperture-priority AE (Av) mode, RAW capture using the Fluorescent White Balance, Evaluative metering, One-shot AF mode with manual AF-point selection, and using a modified Neutral Picture Style.

Additional Considerations: To control the depth of field, choose Aperture-priority AE (Av) mode and set the white balance to the type of light in the scene. If the light is low and you are handholding the camera, you can switch to Shutter-priority AE (Tv) mode and set a shutter speed appropriate for the lens you're using to avoid camera shake, or use a tripod.

Exposure

In the Field: ISO 100, f/4.0, 1/100 second. The wide aperture, the moderate telephoto lens, and a close shooting distance worked together to create the extremely shallow depth of field that I envisioned for this shot. An alternate rendering of this subject would be to use a wide-angle lens, a narrow aperture of f/8 or f/11, and to move my shooting position back a bit. This approach would provide an extensive depth of field to make this subject a "pattern" shot of apples in rows.

Additional Considerations: If you want background objects to appear as a soft blur, choose a wide aperture such as f/5.6 or wider. This brings the focus to the main object in the scene.

Accessories

Silver reflectors and diffusion panels are handy accessories for still-life and product photography.

Still-life photography tips

- Choose items with the most aesthetic appeal for still-life arrangements. If you're photographing fruit or food, spend time looking for the freshest and most attractive pieces of fruit, or the freshest plate of food. With other subjects, be sure that you clean, polish, or otherwise ensure that the subject is as clean and attractive as possible.
- Try out the Rebel XS/1000D's Picture Style options. If you've set up a subject and you want a soft and subdued look, try the Portrait or Sepia styles.
- Experiment with different backgrounds. A draped sheer curtain, a black poster board, or a rough adobe wall can make interesting backdrops.

Stock Photography

At some point, almost everyone who has more than a passing interest in photography contemplates the idea of making money from his or her images. And for those who do, their short list of ideas includes stock photography near the top. Stock photos fill the pages of popular newsstand magazines and brochures, and grace posters in public places and bill-boards along the highways. Stock photography refers to existing images available for licensing by clients, including advertising agencies, corporations, magazines, book publishers, and others. Stock images can be marketed by individual photographers, photographer cooperatives, or by stock photo agencies.

With more than 1,000 stock photography agencies and organizations to choose from — ranging from the leaders such as Getty and Corbis to micro-stock companies — there is a good chance that you can make your way into stock photography.

Stock agencies market the work of many photographers. Agencies negotiate with and finalize licensing rights with clients, collect payment, and subsequently pay the photographer a percentage of the licensing price. The percentage split between the photographer and the agency varies, but a common split is 50/50: 50 percent to the photographer and 50 percent for the agency. In turn, the agency takes over marketing and licensing tasks, which gives photographers more time to make pictures. And with the potential to license a single image multiple times, a photo marketed by an agency or cooperative can provide a continuing source of income for months or even years.

9.34 The range of images needed by stock agencies ranges from children and lifestyle images to technology and locations. This image of a young boy throwing rocks into the lake would be a candidate for stock submission. Exposure: ISO 100, f/10, 1/400 second using an EF 70-200mm f/2.8L USM lens.

Check stock agency Web sites to learn the hottest trends in stock photography, which range from lifestyle images to outdoor activities and sports.

Note

Many agencies have a minimum resolution for stock images. If you're new to stock shooting, be sure to check the agency requirements for resolution.

Inspiration

Over the years, major stock agencies have acquired thousands of images, so they now have need for more specific subjects. For photographers shooting on assignment or for pleasure, it pays to consider potential stock use as you make images. For example, if you're shooting landscape images, you may veer off the road to shoot highways leading up to the area because advertising agencies often look for stock images of scenic roads into which they can drop the car of their client later.

Conceptual shooting is also a good area to consider. Themes such as single, breaking up, and the tranquility of a spa are examples of recent stock requests.

9.35 Conceptual images are also fodder for stock. This image could illustrate the rising cost of prescription medications. Exposure: ISO 100, f/10, 1/400 second using an EF 24-70mm f/2.8L USM lens.

Taking stock photographs

9.36 Some stock agencies specialize in food photography, and a subject such as these coffee beans would be a potential submission.

Table 9.12

Stock Photography

Setup

In the Field: For the image in Figure 9.36, I wanted the coffee beans to have a warm glow that suggests the feeling of sipping warm coffee on a cold day. I used a warm tinted paper for the background that also reflected onto the beans. I also raked my fingers through the beans to create rows of beans.

Additional Considerations: For stock shots, white backgrounds are useful because clients often need to replace the background with a color or other background that fits their needs. Leaving space within the image for buyers to insert text and other graphics is also a good practice.

Lighting

In the Field: This image was taken using several tungsten lights with one light over the beans in front of the cup. A large silver reflector was to the right of the beans to fill shadows.

Additional Considerations: Bright, clean images are preferred by buyers, although stylistic variations can set your images apart from the multitudes of stock images.

Lens

In the Field: Canon EF 24-70mm f/2.8 Macro USM lens.

Additional Considerations: Your lens choice depends on the scene you're shooting and your distance from it. Use a telephoto zoom lens to bring distant scenes closer and a wide-angle lens to capture breathtaking sweeps of landscape.

Camera Settings

In the Field: Aperture Priority AE (Av) mode, RAW capture mode using a Custom White Balance with slight color correction during RAW image conversion, Evaluative metering, One-shot AF mode with manual AF-point selection, and using a modified Neutral Picture Style.

Additional Considerations: You can most easily control the depth of field by using Aperture-priority AE (Av) mode. If the light is low, switch to Shutter-priority AE (Tv) mode and choose a shutter speed that allows handholding based on the lens you're using if you aren't shooting with a tripod.

Exposure

In the Field: ISO 100, f/3.2, 1/25 second. To direct the viewer's eye, I wanted only the beans coming out of the cup to be in sharp focus, and using a wide aperture accomplished that goal.

Additional Considerations: Shoot many variations of stock images, including some with extensive depth of field and some with shallow depth of field.

Stock photography tips

- Study existing styles. The quality of stock imagery is some of the best available on the market. Minimum expectations are excellent exposure, composition, and subject matter. Agencies look for a personal style that sets imagery apart from the mass of images they have on hand. Study the images offered by top stock agencies, and then determine how well you can match and do better than what's currently being offered.
- Captions and keywords. Photographers are responsible for providing clear and accurate captions. In fact, some buyers and photo researchers make go and no-go decisions based on caption accuracy and completeness. Be

- sure to research how the agency wants keywords and captions added, and follow those guidelines.
- Build a sizeable portfolio. Most stock photo agencies expect potential photographers to have a substantial body of work — images numbering in the hundreds if not thousands.
- ♣ Image content and marketability. Agencies look for a creative edge, if not creative genius, that makes images stand out. The standout quality is, of course, judged through the dispassionate eye of a photo editor — someone who reviews hundreds of images from polished photographers every day and can quickly cull pedestrian images from star performers. Make your images stand out technically and creatively.

Travel Photography

The XS/1000D is lightweight, small, fast, and extremely versatile, making it ideal to use when traveling. With a set of compact zoom lenses and plenty of SD/SDHC cards, you'll have everything you need to take high-quality shots to document your travels.

Before you begin traveling, spend a few minutes checking the Custom Function settings on the XS/1000D. The Custom Function options that you need for traveling may not be the options that you set for day-to-day shooting. Consider what you will likely be shooting during the trip. For example, the lure of nighttime shooting is hard to resist when you're traveling, so setting C.Fn-3 Long-exposure noise reduction to Option 1: Auto and C.Fn-4 High ISO speed noise reduction to Option 1: On are two options you can set in advance. You can consider setting C.Fn-6 AF-assist beam firing to Option 0: Enable so

that whether on not you use the flash, the camera can use the autofocus assist beam to help establish focus in low-light scenes.

Before you begin a trip, clean your lenses and ensure the camera is in good working condition. Have spare batteries and SD/SDHC cards. If you're traveling by air, check the carry-on guidelines on the airline's Web site and determine whether you can carry the camera separately or as part of your carry-on allowance.

Tip

Be sure to check the latest Transportation Security Administration (TSA) regulations on how many spare camera batteries you're allowed to carry. The regulations recently changed for lithium batteries. Spare batteries must be placed in seethrough, sealable bags, and carried in carry-on luggage. For more information, check the TSA Web site at www.tsa.gov/trave lers/airtravel/assistant/batter ies.shtm.

9.37 Airports and planes provide ample opportunity for travel images. This plane wing was shot through the plane window, which reduced the overall contrast and sharpness of this image. I increased both the contrast and sharpness during image editing. Exposure: ISO 100, f/7, 1/500 second, using an EF 24-70mm f/2.8L USM lens.

Another pre-trip task is to research the destination by studying brochures and books to find not only the typical tourist sites, but also favorite spots of local residents. When you arrive, you can also ask the hotel concierge for directions to popular local spots. The off-the-beaten-path locations will likely be where you get some of your best pictures.

As you travel to different areas, be sure to take pictures of signs that identify cathedrals, towns, restaurants, and attractions. Having the picture is far easier than writing down the names of the sites that you photograph.

Here are some additional tips for getting great travel pictures:

 Research existing photos of the area. At your destination, check out the postcard racks to see what the often-photographed sites are.

Determine how you can take shots that offer a different or unique look at the site.

- Include people in your pictures.

 To gain cooperation of people, always be considerate, establish a friendly rapport, and show respect for individuals and their culture. If you do not speak the language, you can often use hand gestures to indicate that you'd like to take a person's picture, and then wait for their positive or negative response.
- Waiting for the best light pays big dividends. Sometimes this means you must return to a location several times until the weather or the light is just right. Once the light is right, take many photos from various positions and angles.

Inspiration

If the area turns out to have a distinctive color in the scenery or architecture, try using the color as a thematic element that unifies the images you take in that area. For example, the deep burnt-orange colors of the Southwest can make a strong, unifying color for vacation images.

Watch for details and juxtapositions of people, bicycles, and objects with backgrounds such as murals and billboards. Also watch for comical or light-hearted encounters that are effective in showing the spirit of a place.

9.38 This image shows a temple carved out of a rock in Golconda Fort in Hyderabad, India. Exposure: ISO 100, f/8, 1/250 second using an EF 24-105mm f/4.0L IS USM lens.

©Sandy Rippel

Taking travel photographs

©Sandy Rippel

9.39 This street scene captured in Hyderabad, India combines everyday activity against the backdrop of the Charminar Palace grounds.

Table 9.13

Travel Photography

Setup

In the Field: For the picture shown in Figure 9.39, Sandy wanted to include the context of the street activity against the Charminar Palace grounds.

Additional Considerations: In many cases, you want to choose locations that are iconic, or classic, and try different positions, angles, or framing to show the location to give a fresh perspective on a well-photographed area. Include people in your images to provide an essence of the location. Narrow the scope of your image so that you present a clear story or message. Always ask permission to photograph local people.

Lighting

In the Field: Sandy made this image at mid-afternoon.

Additional Considerations: The type and quality of light for travel photos runs the full range. The trick is to know when to shoot and when not to shoot. Ask yourself if the existing light is suited for the subject. If it isn't, wait for the light to change or come back at a different time of day when the light is more appealing.

Lens

In the Field: Canon EF 24-105mm f/4L IS USM lens.

Additional Considerations: Your lens choice depends on the scene you're shooting and your distance from it. Use a telephoto zoom lens to bring distant scenes closer, and a wide-angle lens to capture large scenes such as festivals and fairs or to include environmental context for people shots.

Camera Settings

In the Field: Aperture-priority AE (Av) mode, Daylight White Balance, Evaluative metering, One-shot AF mode with manual AF-point selection, using the Standard Picture Style.

Additional Considerations: To control the depth of field, choose Aperture-priority AE (Av) mode and set the White Balance to the type of light in the scene.

Exposure

In the Field: ISO 100, f/8, 1/125 second.

Additional Considerations: Set the ISO as low as possible given the existing light. If you're photographing people of the area and they are the subject of the image, then use a wide aperture such as f/5.6 to blur the background without making it unreadable. Watch the shutter speed in the viewfinder to make sure it isn't so slow that subject or hand motion spoils the picture.

Travel photography tips

- Control the depth of field. In general, choose a narrow aperture such as f/8 to f/16 when you want show the scene in acceptably sharp focus from front to back. This is ideal for landscapes, cityscapes, architectural details, and some street scenes. When you're photographing people, choose a wide aperture between f/5.6 and f/2.8 to blur background detail so that it doesn't draw the viewer's eye away from the subject. The best way to control aperture is by using Av shooting mode. However, also check the shutter speed in the viewfinder. If the shutter speed is 1/30 second, adjust the aperture to a wider setting that will give you a faster shutter speed. Alternately, you can increase that ISO setting.
- Guard your equipment. Digital cameras are a target for thieves. Be sure to keep the camera strap around your neck or shoulder, and never set it down and step away. This sounds like common sense, but you can quickly get caught up in activities and forget to keep an eye on the camera.
- Use reflectors. Small, collapsible reflectors come in white, silver, and gold, and they are convenient for modifying the color of the light. They take little space and are lightweight, and can be used for portraits or still-life subjects.
- Carry only the equipment you need. You want to ensure you have the gear you need and still have your camera bag-pass airline requirements for carry-on luggage. A good multipurpose lens, such as the EF 28-300mm f/3.5-5.6L IS USM lens or the EF 100-400mm f/4.5-5.6L IS USM, is ideal for travel.

Downloading Images and Updating Firmware

ou can download digital images from the EOS Rebel XS/1000D using the USB cable that is supplied with your camera, or by using an accessory card reader. And once you download the images to the computer, you can use the programs that Canon provides with the camera to view, sort, and edit the images.

One of the advantages of digital photography is that manufacturers periodically offer updates to the internal instructions that improve aspects of the camera or resolve minor problems. These internal instructions are called firmware. Canon offers not only firmware updates for the Rebel XS/1000D, but it also offers updates to the software programs, such as Digital Photo Professional, that come with the camera.

In this appendix, you learn how to download images to your computer and how to update the Rebel firmware when updates are available.

Downloading with a USB Cable

Downloading images using the USB cable supplied with the camera is as simple as connecting the camera and the computer using a USB cable. Because you must turn the camera on during download, you must ensure that the battery charge is sufficient to complete the download without interruption.

In This Appendix

Downloading with a USB cable

Downloading with a card reader

Updating the XS/1000D firmware

Canon provides programs for downloading and organizing images. Other programs are available for these tasks, but for this appendix, I use the Canon programs in the examples.

Cross-Reference

For details on choosing JPEG or RAW capture options, see Chapter 2.

Before you begin downloading images, be sure that your camera battery has a full charge and that you've installed the programs on the EOS Digital Solution Disk

Follow these steps to download pictures to your computer:

- Turn off the camera, and then insert the USB cable into the digital terminal located on the side of the camera under the rubber cover. Be sure that the symbol on the top of the cable plug faces the front of the camera.
- Insert the other end of the USB cable into an available USB slot on your computer.
- Turn the camera power switch On.
 The device driver software installs, and then a program selection

- screen appears. If Windows XP displays a Found New Hardware Wizard dialog box, click Cancel. An AutoPlay window appears.
- 4. Select Canon EOS Utility in the program selection screen. If Windows asks you to select a program to launch the action, click EOS Utility, click Always use this program for this action in Windows XP, or click Always do this for this device in Windows Vista, and then click OK, if necessary. The EOS Utility window appears on the computer screen, and the Direct Transfer screen appears on the camera's LCD monitor. On the camera's LCD, the All images option is selected.
- 5. Press the Set button to transfer all images to the computer. Alternately, you can press the down cross key to select one of the following options:
 - New images. The camera automatically chooses and transfers images that haven't already been transferred to the computer and asks you to confirm

Organize and Back Up Images

One of the most important steps in digital photography is establishing a coherent folder system for organizing images on your computer. With digital photography, your collection of images will grow quickly, and a well-planned filing structure helps to ensure that you can find specific images months or even years from now.

Another good practice is to add keywords to image files. Some programs allow you to display and search for images by keyword — a feature that can save you a lot of time as you acquire more and more images.

The most important step is to back up images on a CD or DVD regularly. Many photographers make it a habit to burn a backup disc right after downloading pictures to the computer. Also, as with images on the computer, it's a good idea to have a filing system for your backup discs as well.

the transfer. Press the right cross key to select OK, and then press the Set button.

- Transfer order images. To use this option, select the Playback menu on the camera. Select Transfer order, and then press the Set button. The Transfer order screen appears. Select Sel. Image, and then press Set. An image appears. Press the left or right cross key to select an image, and then press the up or down cross key to place a check mark in the upper-left area of the image. Repeat this process for all of the images that you want to transfer. Press the Menu button twice to save your image selections to the Secure Digital (SD) card. The Menu screen displays.
- Select and transfer. Press the left or right cross key to select individual images, and then press the Set button.
- Wallpaper. Select if you want to use one of the images on the media card as the wallpaper for your computer screen.
- 6. To transfer images, press the Print/Share button on the back of the camera or press the Starts to download images option in the EOS Utility screen on your computer. The Print/Share button, located to the right of the LCD panel, has a printer icon with a wavy arrow under it and is litin blue. The blue Print/Share light blinks as the images transfer to your computer. The All images transfer screen appears as the images are downloaded to the computer. Then a Transferred

- screen appears. On the computer, transferred images are displayed in a Quick Preview window, and Digital Photo Professional opens to display all images.
- 7. Press the Set button to select OK on the Transferred screen on the camera. The Direct transfer screen reappears on the camera. The Digital Photo Professional screen appears on the computer and displays all of the transferred images.
- Turn off the camera, and then disconnect the cable from the camera and the computer.

After the images are downloaded to the computer, you can choose the task that you want to do next from the panel or toolbar in the Digital Photo Professional window.

Downloading with a Card Reader

The easiest way to download images from the camera to the computer is by using a card reader. A card reader is a small device that plugs into the computer with its own USB cable. When you're ready to download images, you insert the media card into the card-reader slot, and then go to the card reader, which displays as a drive on the personal computer.

You can leave the card reader plugged into the computer indefinitely, making it a handy way to download images. Also, with a card reader, you don't have to use the camera battery while you download images.

Card readers come in single and multiple card styles. Multiple-card-style readers accept SD, SDHC (Secure Digital High Capacity), and other media card types. Card readers are inexpensive and have a small footprint on the desktop. All in all, they are a bargain for the convenience that they offer.

Install the card reader according to manufacturer recommendations, and then follow these steps to download images:

Note

The steps may vary slightly depending on your card reader and computer's preferences.

- Remove the media card from the camera, and insert it into the card reader. A window opens, displaying the media card folder.
- Double-click the folder to display the images, select all of the images, and drag them to the folder where you want to store them on your computer.

Updating the XS/1000D Firmware

One of the greatest advantages of owning a digital camera such as the XS/1000D is that Canon often posts updates to the firmware (the internal instructions) for the camera to its Web site. New firmware releases can add improved functionality to existing features and, in some cases, fix reported problems with the camera.

New firmware, along with ever-improving software, keeps your camera and your ability to process images current as technology improves. To determine if you need to update firmware, you can compare the firmware version number installed on your XS/1000D to the latest release from Canon on their Web site.

To check the current firmware version installed on your camera, follow these steps:

- 1. Press the Menu button.
- 2. Press the right cross key to access the Set-up 3 menu (yellow). The Firmware Ver. menu item displays the currently installed version of the firmware. Note the firmware version number. If the firmware installed on your camera is older than the firmware offered on the Web site, then your camera needs updating.

To download the latest version of firmware, go to the Canon Web site at www.usa. canon.com/consumer/controller?act=Mode IInfoAct&fcategoryid=139&modelid=17316 #DownloadDetailAct.

Tip

You can also use this link to download the latest versions of Canon's Digital Photo Professional, Image Browser, PhotoStitch, and other programs that are provided on the EOS Digital Solution Disk. This Web page also has links where you can download online versions of the printed manuals that come with the XS/1000D.

Before installing firmware updates, be sure that the camera battery has a full charge, or use the AC Adapter Kit ACK-E5 to power the camera. You don't want the camera to lose power during the firmware update because the camera can become inoperable.

Also have a freshly formatted SD/SDHC card available on which to copy the firmware update. You can connect the camera to your computer with a USB cable, and then copy the firmware file onto the media card in the camera.

To download firmware updates and install them on the EOS XS/1000D, follow these steps:

- Insert the media card into a card reader attached to your computer, and then go to the Canon Web site. Alternately, you can attach the camera with an SD/ SDHC card inserted in the computer, and download the firmware to the card located in the camera.
- On the Canon Web site (the address noted above), click Drivers & Downloads, and then click the down arrow next to Select OS and select your computer's operating system.
- Scroll down the page to the Firmware section, and then click the firmware link.
- 4. Scroll down on the Canon Web page to the License Agreement, and click I Agree Begin Download. A new window opens with details on the firmware updates and installation instructions.

- Follow the installation instructions provided on the Web site to copy the firmware update to the SD/SDHC card.
- 6. Insert the media card into the camera. The firmware update program starts and displays an upgrade screen. Press the right cross key to select OK, and then press the Set button. The camera checks the firmware versions and displays a replacement screen.
- 7. Press the right cross key to select OK, and then press the Set button. The camera displays the progress of the update and notifies you when the firmware is successfully updated. As the update progresses, do not press any buttons on the camera, open the media card door, or turn off the camera.
- 8. Press the Set button to complete the firmware update.

Exploring RAW Capture

ou may have heard about RAW capture, but you may not understand what the advantages and disadvantages of RAW shooting are. This appendix provides an overview of RAW capture, as well as a brief walk-through on converting RAW image data into a final image.

RAW capture provides significant advantages, including the ability to get the best-quality images from the Rebel XS/1000D. But RAW capture isn't for everyone. If you prefer images that are ready to print straight out of the camera, then JPEG capture is the best option. However, if you enjoy working with images on the computer and having creative control over the quality and appearance of the image, then RAW is the option to explore.

Learning about RAW Capture

When you shoot JPEG images, the camera "edits" or processes the images before storing them on the SD/SDHC card. This processing includes converting images from 12-bit files to 8-bit, setting the color rendering and contrast, and generally giving you a file that is finished. Very often, the results are ready to print. But in other cases, you may encounter images where you wish you had more control over how the image is rendered — perhaps to recover blown highlights that have no detail, to tone down very high-contrast images, or to correct the color of an image where you forgot to set the white balance for the light in the scene. Of course, you can edit JPEG images in an editing program, but the amount of latitude for editing can be limited.

By contrast, RAW capture allows you to work with the data that comes off the image sensor with virtually no internal camera processing. The only camera settings that the camera applies to a RAW image are ISO, shutter speed, and aperture.

In This Appendix

Learning about RAW capture

Canon's RAW conversion program

Sample RAW image conversion

Creating an efficient workflow

And because many of the key camera settings have been noted but not applied in the camera, you have the opportunity to make changes to settings, including image brightness, white balance, contrast, and saturation, when you convert the RAW image data into a final image using a conversion program such as Canon's Digital Photo Professional, Adobe Camera Raw, Adobe Lightroom, or Apple Aperture.

Note

In addition to the RAW image data, the RAW file also includes information, called metadata, about how the image was shot, the camera and lens used, and other description fields.

An important characteristic of RAW capture is that it offers more latitude and stability in editing converted RAW files than JPEG files offer. With JPEG images, large amounts of image data are discarded when the images are converted to 8-bit mode in the camera. and then the image data is further reduced when JPEG algorithms compress image files to reduce the size. As a result, the image leaves little, if any, wiggle room to correct tonal range, white balance, contrast, and saturation during image editing. Ultimately, this means that if the highlights in an image are overexposed or, blown, then they're blown for good. If the shadows are blocked up (meaning they lack detail), then they will likely stay blocked up. It may be possible to make improvements in Photoshop, but the edits make the final image susceptible to posterization, or banding that occurs when the tonal range is stretched and gaps appear between tonal levels. This stretching makes the tonal range on the histogram look like a comb.

Cross-Reference

See Chapter 2 for a more detailed explanation of bit depth.

On the other hand, RAW images have rich data depth and provide significantly more image data to work with during conversion and subsequent image editing. In addition, RAW files are more forgiving if you need to recover overexposed highlight detail during conversion of the RAW file.

Table B.1 illustrates the general differences in file richness between a RAW image and a JPEG image. Note that the table data assumes a 5-stop dynamic range, the difference between the lightest and darkest values in an image, for an exposure.

Note

With digital cameras, dynamic range depends on the sensor. The brightest f-stop is a function of the brightest highlight in the scene that the sensor can capture, or the point at which the sensor element is saturated with photons. The darkest tone is determined by the point at which the noise in the system is greater than the comparatively weak signal generated by the photons hitting the sensor element.

These differences in data richness translate directly to editing leeway. And maximum editing leeway is important because after the image is converted, all of the edits you make in an editing program, such as Adobe Elements, are destructive.

Proper exposure is important with any image, and it is no less so with RAW images. With RAW images, proper exposure provides a file that captures rich tonal data that withstands conversion and editing well. For example, during conversion, image brightness levels must be mapped so that the levels look more like what we see with our eyes — a process called gamma encoding. In addition, you will also likely adjust the contrast and midtones and move the endpoints on the histogram. For an image to withstand

these conversions and changes, a correctly exposed and data-rich file is critical.

RAW exposure is also critical, considering that digital capture devotes the lion's share of tonal levels to highlights while devoting far fewer levels to shadows, as shown in Table B.1. In fact, half of all the tonal levels in the image are assigned to the first f-stop of brightness. Half of the rest of the tonal levels account for the second f-stop, and half into the next f-stop, and so on.

Clearly, capturing the first f-stop of image data is critical because fully half of the image data is devoted to that f-stop. If an image is underexposed, not only is important image data sacrificed, but the file is also more likely to have digital noise in the shadow areas.

Underexposure also means that during image conversion, the fewer captured levels must be stretched across the entire tonal range. Stretching tonal levels creates gaps between levels that reduce the continuous gradation between levels.

The general guideline when shooting RAW capture is to "expose to the right" so that the highlight pixels just touch the right side of the histogram. Thus, when tonal mapping is applied during conversion, the file has significantly more bits that can be redistributed to the midtones and darker tones where the human eye is most sensitive to changes.

If you've always shot JPEG capture, the exposing-to-the-right approach may just seem wrong. When shooting JPEG images, the guideline is to expose so that the highlights are not blown out because if detail is not captured in the highlights, it's gone for good. This guideline is good for JPEG images where the tonal levels are encoded and the image is essentially pre-edited inside the camera. However, with RAW capture, gamma encoding and other contrast adjustments are made during conversion with a good bit of latitude. And if highlights are overexposed, conversion programs such as Adobe Camera Raw can recover varying amounts of highlight detail.

			Tab	ole B.1	
C	om	parison	of	Brightness	Levels

F-stop	Brightness Levels Available		
-	12-bit RAW file	8-bit JPEG file	
First f-stop (brightest tones)	2048	69	
Second f-stop (bright tones)	1024	50	
Third f-stop (midtones)	512	37	
Fourth f-stop (dark tones)	256	27	
Fifth f-stop (darkest tones)	128	20	

In summary, RAW capture produces files with the most image data that the camera can deliver, and you get a great deal of creative control over how the RAW data is converted into a final image. Most

important, you get strong, data- and colorrich files that withstand image editing and create lovely prints. However, if you decide to shoot RAW images, you also sign on for another step in the process from capturing images to getting finished images, and that step is RAW conversion. With RAW capture, the overall workflow is to capture the images, convert the RAW data in a RAW-conversion program, edit images in an image-editing program, and then print them. You may decide that you want to shoot in RAW+JPEG so that you have JPEGs that require no conversion, but you have the option to convert exceptional or problem images from the RAW files with more creative control and latitude.

Canon's RAW Conversion Program

If you're new to RAW conversion, it is worth noting differences between JPEG and RAW images. With JPEG images, the camera automatically processes the image data coming off the sensor, converts the images from 12-to 8-bit files, and compresses them in the JPEG file format. JPEG is a familiar file format that allows images to be viewed on any computer and to be opened in any image-editing program.

By contrast, RAW images are stored in proprietary format, and they cannot be viewed on some computers or opened in some image-editing programs without first converting the files to a more universal file format such as TIFF, PSD, or JPEG. Canon includes a free program, Digital Professional Pro, on the EOS Digital Solution Disk. You can use this program to convert XS/1000D RAW files, and then save them as TIFF files.

Images captured in RAW mode include unique filename extensions, such as .CR2 for Canon XS/1000D RAW files.

Tip

Digital Photo Professional (DPP) is noticeably different from traditional image-editing programs. It focuses on image conversion tasks, including correcting, tweaking, or adjusting white balance, brightness, shadow areas, contrast, saturation, sharpness, noise reduction, and so on. It doesn't include some familiar image-editing tools, such as healing or history brushes, nor does it offer the ability to work with layers.

Note

Canon also includes a Picture Style Editor on the disk that comes with the camera. This program is a great way to set up a Picture Style that works well for RAW capture. For details on the Picture Style Editor, see Chapter 3.

Whatever conversion program you choose, be sure to explore the full capabilities of the program. One of the advantages of RAW conversion is that as conversion programs improve, you can go back to older RAW image files and convert them again using the improved features and capabilities of the conversion program.

Sample RAW Image Conversion

Although RAW image conversion adds a step to image processing, this important step is well worth the time. To illustrate the overall process, here is a high-level task-flow for converting an XS/1000D RAW image using Canon's DPP.

Be sure to install the Digital Photo Professional application provided on the EOS Digital Solution Disk before following this task sequence.

- B.1 This figure shows Canon's Digital Photo Professional's main window with the toolbar for quick access to commonly accessed tasks.
 - Start Digital Photo Professional (DPP). The program opens. If no images are displayed, you can select a directory and folder from the Folder panel. RAW images are displayed with a camera icon and the word RAW in the lower-left corner of the thumbnail, and the file extension is .CR2.
 - 2. Double-click the image you want to process. The RAW image tool palette opens next to an image preview with the RAW tab selected. In this mode, you can:
 - Drag the Brightness adjustment slider to the left to darken the image or to the right to lighten it. To quickly return to the original brightness setting, click the curved arrow above and to the left of the slider.
- Use the white balance adjustment controls to adjust color. You can click the Eyedropper button, and then click an area that is white in the image to quickly set white balance, choose one of the preset white balance settings from the Shot Setting drop-down menu, or click the Tune button to adjust the white balance using a color wheel. Once you have the color corrected, you can click Register to save the setting, and then use it to correct other images.
- Change the Picture Style by clicking the down arrow next to the currently listed Picture Style and selecting a different Picture Style from the list. The Picture Styles offered in DPP are

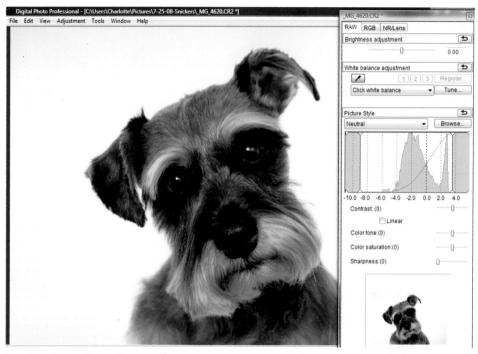

B.2 This figure shows the RAW image adjustment controls in Canon's Digital Photo Professional.

the same as those offered on the menu on the XS/1000D. When you change the Picture Style in DPP, the image preview updates to show the change. You can adjust the curve, color tone, saturation, and sharpness. If you don't like the results, you can click the curved arrow to the right of Picture Style to change back to the original Picture Style.

- Adjust the black and white points on the image histogram by dragging the bars at the far left and right of the histogram toward the center. By dragging the slider under the histogram, you can adjust the tonal curve.
- Adjust the Color tone, Color saturation, and Sharpness by dragging the sliders. Dragging

the Color tone slider to the right increases the green tone, and dragging it to the left increases the magenta tone. Dragging the Color saturation to the right increases the saturation, and vice versa. Dragging the Sharpness slider to the right increases the sharpness, and vice versa.

- 3. Click the RGB image adjustment tab. Here you can apply an RGB curve, and also apply separate curves in each of the three color channels: Red, Green, and Blue. You can also adjust the following:
 - Click one of the tonal curve options to the right of Tone curve assist to set a classic "S" curve that lightens the

Which Conversion Program is Best?

Choosing a RAW conversion program is a matter of personal preference in many cases. Canon's Digital Photo Professional is included with the XS/1000D, and program updates are offered free. Third-party programs, however, often have a lag time between when the camera is available for sale and when the program supports the new camera.

Arguments can be made for using either the manufacturer's or a third-party program. The most-often cited argument for using Canon's program is that because Canon knows the image data best, it is most likely to provide the highest quality RAW conversion. On the other hand, many photographers have tested the conversion results from Canon's program and Adobe's Camera Raw plug-in, and they report little or no difference in conversion quality.

Assuming there is parity in image-conversion quality, the choice of conversion programs boils down to which program offers the ease of use and features that you want and need. Certainly Adobe has years of experience building feature-rich programs for photographers within an interface that is familiar and relatively easy to use. Canon, on the other hand, has less experience in designing software features and user interfaces, but Canon's program has made significant strides in recent releases.

Because both programs are free (provided you have Photoshop in the case of Adobe Camera Raw), you should try both programs and other RAW conversion programs that offer free trials. Then decide which one best suits your needs. I often switch between using Canon's DPP program and Adobe Camera Raw. When I want to apply a Picture Style to a RAW image, I use DPP. For most everyday processing, however, I use Adobe Camera Raw as a matter of personal preference.

Another consideration when you are choosing a program is which program offers the most efficient processing. For example, Canon's DPP allows you to apply conversion settings from one photo to others in the folder, as does Adobe Camera Raw.

midtones in the image without changing the black and white points. If you want to increase the curve, click the Tone curve assist button marked with a plus (+) sign one or more times to increase the curve. Alternately, you can click the linear line on the histogram, and then drag the line to set a custom tonal adjustment curve. If you want to undo the curve changes, click the curved arrow to the right of Tone curve adjustment, or the curved arrow to the right of Tone curve assist.

- Click the R, G, or B buttons next to RGB to make changes to a single color channel.
 Working with an individual color channel is helpful when you need to reduce an overall color cast in an image.
- Drag the Brightness slider to the left to darken the image or to the right to brighten the image. The changes you make are shown on the RGB histogram as you make them.

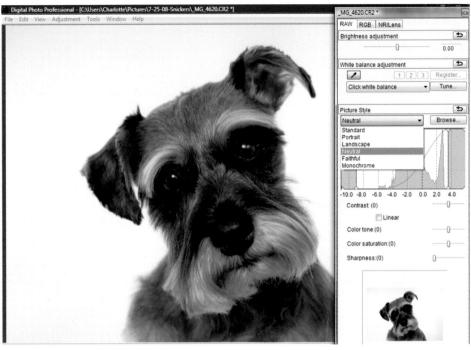

B.3 This figure shows the Picture Style option in DPP.

- Drag the Contrast slider to the left to decrease contrast or to the right to increase contrast.
- Drag the Color tone, Color saturation, and Sharpness sliders to make the appropriate adjustments.
- 4. In the image preview window, choose File Convert and Save. The Convert and save dialog box appears. In the dialog box, you can specify the file type and bit depth at which you want to save the image. Just click the down arrow next to Save as type and choose one of the options, such as TIFF 16-bit. Then you can set the Quality setting if you are saving in JPEG or TIFF plus JPEG format, set the Output resolution, choose to embed the color profile, or resize the image.
- Tip The Edit menu also enables you to save the current image's conversion settings as a recipe. Then you can apply the recipe to other images in the folder.
- 5. Click Save. DPP displays the Digital Photo Professional dialog box until the file is converted. DPP saves the image in the location and format that you choose.

Creating an Efficient Workflow

Workflow is the process of converting and editing images in a logical and consistent manner. The overall concept of workflow begins with image capture by setting image quality, the color space, and type of capture.

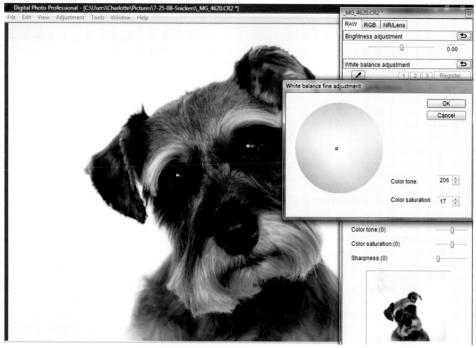

B.4 This figure shows the White Balance fine adjustment in Canon's DPP RAW conversion window.

Then it continues with RAW image conversion, ensuring that the image quality settings and color space remain consistent in the conversion program, editing the image in image-editing software, and, finally, printing the image.

While workflow varies depending on your needs, here are some general steps to consider as you create your workflow strategy.

- Back up files. The first workflow step is backing up original images to a standalone hard drive or to a DVD. Whether you do this step now or later, it's a critical aspect of any workflow.
- Batch rename files. Batch file renaming allows you to identify groups of images by subject, location, date, or all of these elements.

Programs such as DPP and Adobe Elements offer tools for batch renaming that save time in the workflow.

- Use a standard template. Create a standard template that has your name, address, phone number, and other important information about the image that you appended to the image metadata.
- Select images. Regardless of whether you're shooting RAW or JPEG images, programs such as Adobe Bridge and DPP provide tools to rate images and then sort them to display top-rated images to process.
- Consider processing RAW files as a group. If you're processing RAW images, you can open the selected

images individually or in groups, depending on the RAW-conversion program you're using. Then you can save the images or open them in Elements or another image-editing program for additional editing.

- ★ Take advantage of actions. If you create JPEG versions of the images for your Web site and if you use Elements or Photoshop, you can use an action to make and automatically size images for the Web and save the images in a separate subfolder.
- Save JPEGs in your image database. If you maintain a database of your images, this is a good time to add JPEG versions of the images to the database.
- Consider copyrighting your images. You may want to register

- images with the Copyright Office to protect the copyright to your images. The copyright gives you the right to control use of your images for your lifetime plus 70 years. The annual fee for bulk image registration is provided on the Copyright Web site at www.copyright.gov/register/visual.html. For additional information on registering copyrights, visit www.editorialphoto.com/copyright/.
- Finalize images. With the final selections made, you can do the final image editing in Photoshop.
- Archive images for safe keeping. When the final images are ready, you can add the edited images to the standalone hard dive or burn a DVD. Consider storing the backup files in a fire-safe and flood-safe location.

B.5 This is the final image after conversion and editing in Photoshop. Exposure: ISO 100, f/5, 1/50 second.

Glossary

A-DEP (Automatic depth of field AE) The camera mode that automatically calculates sufficient depth of field for near and far subjects within the coverage of the seven AF focusing points, such as when several people are sitting at various distances from the camera.

AE Automatic exposure.

AE Lock (Automatic exposure Lock) A camera control that lets the photographer lock the exposure from a meter reading. After the exposure is locked, you can then move the camera to recompose the image and set focus.

ambient light The natural or artificial light within a scene. Also called available light.

angle of view The amount or area seen by a lens or view-finder, measured in degrees. Shorter or wide-angle lenses and zoom settings have a greater angle of view. Longer or telephoto lenses and zoom settings have a narrower angle of view.

aperture The lens opening through which light passes. Aperture size is adjusted by opening or closing the diaphragm. Aperture is expressed in f-numbers such as f/8, f/5.6, and so on. See also f-number.

aperture priority (Av Aperture-priority AE) A semiautomatic camera mode in which the photographer sets the aperture (f-stop), and the camera automatically sets the shutter speed for correct exposure. See also AV.

autofocus A function where the camera automatically focuses on the subject using the autofocus point or points shown in the viewfinder, or tracks a subject in motion and creates a picture with the subject in sharp focus. Pressing the Shutter button halfway down activates autofocus at the selected AF point.

Av Used to indicate the Aperture-Priority shooting mode on the Mode dial. See also aperture priority.

AWB (Automatic White Balance) A white balance setting where the camera determines the color temperature of the light source automatically.

barrel distortion A lens aberration resulting in a bowing of straight lines outward from the center.

bit depth The number of bits (the smallest unit of information used by computers) used to represent each pixel in an image that determines the image's color and tonal range.

blocked up Describes areas of an image lacking detail due to excess contrast.

bracket To make multiple exposures, some above and some below the average exposure, calculated by the light meter for the scene. Some digital cameras can also bracket white balance to produce variations from the average white balance calculated by the camera.

brightness The perception of the light reflected or emitted by a source. The lightness of an object or image. See also lightness and luminance.

buffer Temporary storage for data in a camera or computer.

bulb A shutter speed setting that keeps the shutter open as long as the Shutter button is fully depressed.

color balance The color reproduction fidelity of a digital camera's image sensor and of the lens. In a digital camera, color balance is achieved by setting the white balance to match the scene's primary light source.

color/light temperature A numerical description of the color of light measured on the Kelvin scale. Warm, late-day light has a lower color temperature. Cool, early-day light has a higher color temperature. Midday light is often considered to be white light (5000K). Flash units are often calibrated to 5000K.

color space In the spectrum of colors, a subset of colors included in the chosen color space. Different color spaces include more or fewer colors.

compression A means of reducing file size. Lossy compression permanently discards information from the original file. Lossless compression does not discard information from the original file and allows you to recreate an exact copy of the original file without any data loss. See also lossless and lossy.

contrast The range of tones from light to dark in an image or scene.

depth of field The zone of acceptable sharpness in a photo extending in front of and behind the primary plane of focus.

diaphragm Adjustable blades inside the lens that determine the aperture, or the size of the lens opening.

dynamic range The difference between the lightest and darkest values in an image. A camera that can hold detail in both highlight and shadow areas over a broad range of values is said to have a high dynamic range.

exposure The amount of light reaching the light-sensitive medium — the film or an image sensor. It is the result of the intensity of light multiplied by the length of time the light strikes the medium.

exposure compensation An exposure modification control that allows the photographer to overexpose (plus setting) or underexpose (minus setting) images by a specified amount from the metered exposure.

exposure meter A built-in light meter that measures the amount of light on the subject. EOS cameras use reflective meters. The exposure meter indicator is shown in the viewfinder and on the LCD panel as a scale with a tick mark under the scale that indicates ideal exposure, as well as overexposure, and underexposure.

extender An attachment that fits between the camera body and the lens to increase the focal distance of the lens.

extension tube A hollow ring attached between the camera lens mount and the lens that increases the distance between the optical center of the lens and the sensor, and decreases the minimum focusing distance.

filter A piece of glass or plastic that is usually attached to the front of the lens to alter the color, intensity, or quality of the light. Filters also are used to alter the rendition of tones, reduce haze and glare, and create special effects such as soft focus and star effects.

fisheye lens A lens with a 180-degree angle of view.

flare Unwanted light reflecting and scattering inside the lens causing a loss of contrast and sharpness and/or artifacts in the image.

fluorite A lens material with an extremely low index of refraction and dispersion when compared to optical glass. Fluorite features special partial dispersion characteristics that allow almost ideal correction of chromatic aberrations when combined with optical glass.

f-number A number representing the maximum light-gathering ability of a lens or the aperture setting at which a photo is taken. It is calculated by dividing the focal length of the lens by its diameter. Wide apertures are designated with small numbers, such as f/2.8. Narrow apertures are designated with large numbers, such as f/22. See also aperture.

focal length The distance from the optical center of the lens to the focal plane when the lens is focused on infinity. The longer the focal length is, the greater the magnification.

focal point The point on a focused image where rays of light intersect after reflecting from a single point on a subject.

focus The point at which light rays from the lens converge to form a sharp image. Also the sharpest point in an image achieved by adjusting the distance between the lens and image.

f-stop See also f-number and aperture.

grain See noise.

gray card A card that reflects a known percentage of the light that falls on it. Typical grayscale cards reflect 18 percent of the light. Gray cards are standard for taking accurate exposure-meter readings and for providing a consistent target for color balancing during the color-correction process using an image-editing program.

highlight A term describing a light or bright area in a scene, or the lightest area in a scene.

histogram A graph that shows the distribution of tones or colors in an image.

hot shoe A camera mount that accommodates a separate external flash unit. Inside the mount are contacts that transmit information between the camera and the flash unit and that trigger the flash when the Shutter button is pressed.

hue The color of a pixel defined by the measure of degrees on the color wheel, starting at 0 for red depending on the color system and controls.

image stabilization A technology that counteracts unintentional camera movement when the photographer handholding the camera at slow shutter speeds or uses long lenses.

infinity The farthest position on the distance scale of a lens (approximately 50 feet and beyond).

ISO (International Organization for Standardization) A rating that describes the sensitivity to light of film or an image sensor. ISO in digital cameras refers to the amplification of the signal at the photosites. Also commonly referred to as film speed. ISO is expressed in numbers such as ISO 125. The ISO rating doubles as the sensitivity to light doubles. ISO 200 is twice as sensitive to light as ISO 100.

JPEG (Joint Photographic Experts Group) A lossy file format that compresses data by discarding information from the original file.

Kelvin A scale for measuring temperature based around absolute zero. The scale is used in photography to quantify the color temperature of light.

lightness A measure of the amount of light reflected or emitted. See also brightness and luminance.

linear A relationship where doubling the intensity of light produces double the response, as in digital images. The human eye does not respond to light in a linear fashion. See also nonlinear.

lossless A term that refers to image file compression that discards no image data. TIFF is a lossless file format. See also compression and lossy,

lossy A term that refers to compression algorithms that discard image data in the process of compressing image data to a smaller size. The higher the compression rate, the more data that's discarded and the lower the image quality. JPEG is a lossy file format. See also compression and lossless.

luminance The light reflected or produced by an area of the subject in a specific direction and measurable by a reflected light meter. See also brightness and lightness.

Manual mode A camera mode in which you set the aperture and the shutter speed, and the ISO. Commonly used in low-light and night scenes and when you want to vary the exposure over or under the camera's ideal exposure.

megapixel A measure of the capacity of a digital image sensor. One million pixels.

metadata Data about data, or more specifically, information about a file. Data embedded in image files by the camera includes aperture, shutter speed, ISO, focal length, date of capture, and other technical information. Photographers can add additional metadata in image-editing programs, including name, address, copyright, and so on.

midtone An area of medium brightness; a medium gray tone in a photographic print. A midtone is neither a dark shadow nor a bright highlight.

neutral density filter A filter attached to the lens or light source to reduce the required exposure.

noise Extraneous visible artifacts that degrade digital image quality. In digital images, noise appears as multicolored flecks and as grain that is similar to grain seen in film. Both types of noise are most visible in high-speed digital images captured at high ISO settings.

nonlinear A relationship where a change in stimulus does not always produce a corresponding change in response. For example, if the light in a room is doubled, the room is not perceived as being twice as bright. See also linear.

open up The switch to a wider f-stop, which increases the size of the lens diaphragm opening.

panning A technique of moving the camera horizontally to follow a moving subject, which keeps the subject sharp but blurs background details.

photosite The place on the image sensor that captures and stores the brightness value for one pixel in the image.

pincushion distortion A lens aberration causing straight lines to bow inward toward the center of the image.

pixel The smallest unit of information in a digital image. Pixels contain tone and color that can be modified. The human eye merges very small pixels so they appear as continuous tones.

plane of critical focus The most sharply focused part of a scene. Also referred to as the point of sharpest focus.

polarizing filter A filter that reduces glare from reflective surfaces such as glass or water at certain angles.

ppi (pixels per inch) The number of pixels per linear inch on a monitor or image file. Used to describe overall display quality or resolution.

RAM (Random Access Memory) The memory in a computer that temporarily stores information for rapid access.

RAW A proprietary file format that has little or no in-camera processing. Processing RAW files requires special image-conversion software such as Canon Digital Photo Professional or Adobe Camera Raw. Because image data has not been processed, you can change key camera settings, including exposure and white balance, in the conversion program after the picture is taken.

reflected light meter A built-in device that measures light emitted by a photographic subject. Exposure is then calculated based on the light meter reading.

reflector A surface, such as white cardboard, used to redirect light into shadow areas of a scene or subject.

resolution The number of pixels in a linear inch. Resolution is the amount of data in a digital image that represents detail. Also, the resolution of a lens that indicates the capacity of reproduction of a subject point of the lens. Lens resolution is expressed as a numerical value such as 50 or 100 lines, which indicates the number of lines per millimeter of the smallest black and white line pattern that can be clearly recorded.

RGB (**Red**, **Green**, **Blue**) A color model based on additive primary colors of red, green, and blue. This model is used to represent colors based on how much light of each color is required to produce a given color.

saturation As it pertains to color, a strong, pure hue undiluted by the presence of white, black, or other colors. The higher the color purity is, the more vibrant the color.

shutter A mechanism that regulates the amount of time during which light is let into the camera to make an exposure. Shutter time or shutter speed is expressed in seconds and fractions of seconds such as 1/30 second.

shutter priority (Shutter-priority AE) A semiautomatic camera mode designated as Tv on the mode dial that allows the photographer to set the shutter speed and the camera to automatically set the aperture (f-number) for correct exposure.

slave A flash unit that is synchronized to and controlled by another flash unit.

sRGB A relatively small color space or gamut that encompasses a typical computer monitor.

stop See aperture.

stop down To switch to a narrower f-stop, thereby reducing the size of the diaphragm opening.

telephoto A lens or zoom setting with a focal length longer than 50 to 60mm in 35mm format.

TIFF (Tagged Image File Format) A universal file format that most operating systems and image-editing applications can read. Commonly used for images, TIFF supports 16.8 million colors and offers lossless compression to preserve all the original file information.

tonal range The range from the lightest to the darkest tones in an image.

TTL (Through-the-Lens) A system that reads the light passing through a lens that will expose film or strike an image sensor.

UD (Ultralow Dispersion) A lens made of special optical glass with processing optical characteristics similar to fluorite. UD lenses are effective in correcting chromatic aberrations in super-telephoto lenses.

white balance The relative intensity of red, green, and blue in a light source. On a digital camera, white balance compensates for light that is different from daylight to create correct color balance.

wide angle Describes a lens or zoom setting with a focal length shorter than 50 to 60mm in full-frame 35mm format.

Index

A	top camera controls, 4–6
accessories	viewfinder display, 9-10
action/sports photography, 171	angle of view, 151, 235
animal/wildlife photography, 176	animal/wildlife photography
architectural/interior photography, 170	inspiration, 174
close-up lenses, 157–158	overview, 172–174
extension tubes, 157–158	shooting, 175–176
lens extenders, 156–157	tips, 177
macro photography, 191	aperture. See also ISO (International
night/low-light photography, 200	Organization for Standardization); shutter
portrait photography, 202, 205	speed
still-life photography, 210	choosing, 110–111
	defined, 235
action/sports photography inspiration, 169	narrow, 110
overview, 167–168	nature/landscape photography, 196
	portrait photography, 206
shooting, 169–171	setting, 21
tips, 171–172	wide, 109–110
A-DEP (Automatic Depth of Field) mode	wide-angle lenses, 148
architectural/interior photography, 182	Aperture-priority AE (Av) mode, 31-32, 235
built-in flash, 128	architectural/interior photography
overview, 33–34, 235 relationship with Quick mode, 85	inspiration, 179–180
AE (Automatic Exposure) Lock, 40–42, 193, 235	overview, 177–179
	shooting, 180–182
AEB (Auto Exposure Bracketing), 39–40 AF-assist beam (autofocus-assist beam),	tips, 182–183
129–130	aspherical elements, 146
AF (Autofocus)	Auto Exposure (AE) Lock, 40-42, 193, 235
action/sports photography, 171	Auto Exposure Bracketing (AEB), 39–40
defined, 235	Auto Lighting Optimizer
improving performance, 47–48	disabling, 83
lens control, 10	overview, 36–38
modes, 7, 8, 46–48	relationship with exposure, 81
relationship with Drive mode, 48	relationship with Flash Exposure
	Compensation, 132–133
selecting points, 49–50 tips, 47–48	Auto play, 53
AF Point Selection	auto reset file numbering, 18
button, 7, 9	Autofocus. See AF (Autofocus)
child photography, 186	autofocus-assist beam (AF-assist beam),
	129-130
tips, 48 AF Stop, 147	Autofocus/Drive Custom Functions, 93, 96–97
Al Focus/Al Servo AF mode, 47	Automatic Depth of Field mode. See A-DEP
ambient light, 235	(Automatic Depth of Field) mode
anatomy	automatic modes. See Basic Zone modes
camera terminals, 9	Automatic White Balance (AWB), 236
front camera controls, 4	Av (Aperture-priority AE)
LCD, 9	button, 7
lens control, 10–11	defined, 236
overview, 3	mode, 31–32, 128
rear camera controls, 6–9	AWB (Automatic White Balance), 236
rear camera controls, 0-3	

В	Canon
back-focusing, 49	RAW conversion program, 228
background	Web site, 78, 117, 222
action/sports photography, 172	card readers, 221–222
checking, 165	Center-weighted Average metering, 37
macro photography, 191	C.Fn. See Custom Functions (C.Fn)
night/low-light photography, 202	changing. See modifying
portrait photography, 202	child photography
still-life photography, 210	inspiration, 184
backing up images, 220	overview, 183–184
backlighting, 122–123	shooting, 185–186
balance, 160–162	tips, 186–187
barrel distortion, 236	choosing. See selecting
Basic Zone modes	close-up lenses, 157–158
automatic settings, 22	Close-up mode, 25
Close-up, 25	color
flash, 126	balance, 236
Flash-off, 27	compensation, 69
Full Auto, 22–23	of light, 116–118
Landscape, 24–25	overview, 162–163
metering modes, 35	RAW images, 65
Night Portrait, 26–27	spaces, 59–62, 236
overview, 19, 21–22	temperature, 70, 115, 236
Portrait, 23–24	composition
Sports, 25–26	action/sports photography, 167–172, 172
battery life, 80	animal/wildlife photography, 172–177
bit depth, 236	architectural/interior photography, 177–183
blocked up, 236	background, 165
bokeh characteristics, 150	balance and symmetry, 160–162
bracket, 236	child photography, 183–187
brightness, 42–43, 227, 236	depth of field, 165–166
buffer, 236	focus, 165–166
built-in flash	frame, 160, 165
autofocus-assist beam without flash, 129–130	lines and direction, 163–164
Creative Zone modes, 128	macro photography, 187–191
guide numbers, 129	nature/landscape photography, 192–196
overview, 4, 5, 127–128	night/low-light photography, 196–201 overview, 159
ranges, 129	portrait photography, 201–206
bulb, 236	space and perspective, 167
burst rate, 68	still-life photography, 207–210
	stock photography, 211–214
C	tone and color, 162–163
camera	travel photography, 214–218
raincoats, 177	compression
shake, 30	defined, 236
terminals, 9	ratios, 15–16
camera controls, 4, 6–11	Continuous drive mode, 50–51, 177
camera settings	continuous file numbering, 17–18
action/sports photography, 170	Continuous shooting mode, 48
animal/wildlife photography, 176	contrast, 162–163, 236
architectural/interior photography, 181	creating efficient workflows, 232–234
child photography, 186	Creative Zone modes
macro photography, 190	A-DEP, 33–34
nature/landscape photography, 195	Av (Aperture-priority AE), 31–32
night/low-light photography, 200	built-in flash, 128
portrait photography, 205	M (Manual), 32–33
still-life photography, 210	overview, 19, 28
stock photography, 213	P (Program AE), 28–29
travel photography, 217	setting color space, 61–62
	Tv (Shutter-priority AE), 29-31

Custom Functions (C.Fn) accessing, 92 action/sports photography, 171 C.Fn-1 Exposure-level increments, 93 C.Fn-2 Flash synchronization speed in Av (Aperture-priority AE) mode, 93, 94	Drive modes changing, 51 relationship with Autofocus, 48 selecting, 7, 8, 50–51 Dust Delete Data, 13, 55–56 dust-resistant construction, 146–147 dynamic range, 236
C.Fn-3 Long-exposure noise reduction, 93, 94–95, 182	dynamic range, 200
C.Fn-4 High ISO speed noise reduction, 93, 95	E
C.Fn-5 Auto Lighting Optimizer, 93, 95–96	E-TTL (Evaluative Through-the-Lens) II
C.Fn-6 AF-assist beam firing, 93, 96, 130 C.Fn-7 AF during Live View shooting, 93, 97	technology, 125
C.Fn-8 Mirror Lockup, 92, 93, 97	editing JPEG images, 15
C.Fn-9 Shutter button/AE Lock button, 93, 98-99	EF/EF-S lens mount, 4, 145–146 EF Extenders, 48
C.Fn-10 Set button when shooting, 93, 99	EF telephoto lenses, 156
C.Fn-11 LCD display when power On, 93, 99–100	electronic flash color, 117
C.Fn-12 Add original decision data, 93, 100	EOS Integrated Cleaning System
changing screen color, 103 customizing My Menu, 101–103	automatic sensor cleaning, 55
groupings, 92	Dust Delete Data, 55–56
Live View, 82–83	overview, 54–55
overview, 91–92	Erase button, 7, 8 evaluating
restoring, 101	bokeh characteristics, 150
setting, 100–101	exposure, 42–44
specifics, 92	Evaluative metering, 35–36
types, 91–100 customizing	Evaluative Through-the-Lens (E-TTL) II
My Menu, 101–103	technology, 125
Picture Style, 70–75	ExpoDisc cards, 65
• *	expoimaging Web site, 65 exposure. See also aperture; ISO (International
D	Organization for Standardization); shutter
date, setting, 13–14	speed
default settings, 12	action/sports photography, 171
deleting	animal/wildlife photography, 176
images, 53–54	architectural/interior photography, 182
My Menu items, 102	Auto Exposure Lock 40, 42
depth of field control, 165–166	Auto Exposure Lock, 40–42 Auto Lighting Optimization, 37–38
Depth of Field Preview button, 4, 5	bracketing, 193
macro photography, 191	Brightness histogram, 42–43
overview, 111–112, 236	child photography, 186
previewing, 31	Custom Functions, 92–94
with telephoto lenses, 150	elements, 20–21
travel photography, 218	equivalent, 113–114
with wide angle lenses, 148 diaphragm, 236	evaluating, 42–44 Exposure Compensation, 38–39
Diffractive optics (DO), 147–148	JPEG compared with RAW images, 45
diffused light, 116–117	macro photography, 191
digital noise, 109	meter, 237
Digital terminal, 9	modifying flash, 131–134
direction, 163–164, 203	nature/landscape photography, 196
directional light, 122–124	night/low-light photography, 197–198, 200
Display (Disp.) button, 6–7, 53 displaying	overview, 114–115, 236 portrait photography, 205
My Menu, 102–103	RAW images compared with JPEG images,
RGB histogram, 43–44	226–227
distance scale, 11	relationship with shooting modes, 20-21
distortion, 148, 151	RGB histogram, 43–44
DO (Diffractive optics), 147–148	simulation and metering, 81
downloading images, 219–222	Continued

Index **←** E—I

exposure (continued)	defined, 237
still-life photography, 210	full-time manual, 147
stock photography, 213	inner, 147
travel photography, 217	Live mode, 85–86
Exposure Compensation, 38–39, 193, 237	Live View, 80–81
exposure elements	macro photography, 191
intensity, 106, 109–112	minimum distance for lenses, 25
light, 106–107	modes, 46–47
overview, 105–106	point, 23
sensitivity, 106, 107–109	portrait photography, 206
time, 106, 112–113	Quick mode, 84–85
extenders, 177, 237	rear, 147
extension tubes, 157–158, 237	ring, 11
	verifying sharp, 50
E .	formatting SD/SDHC cards, 12–13
F	frames
f-number, 237	filling, 165
f-stop, 237	framing subjects, 165
FE Lock, 131	portrait photography, 206
FEC (Flash Exposure Compensation), 132–133	subdividing, 160
file format	front camera controls, 5
JPEG quality options, 14	front lighting, 122
PF2, 76–78	Full Auto mode, 22–23, 28
RAW quality options, 15	full-time manual focusing, 147
file numbering, 117–118	ran time mandar rocusing, 147
filter	6
defined, 237	G
neutral density, 239	grain. See noise
polarizing, 239	gray cards, 65, 237
firmware, 222–223	guide numbers, 129
fisheye lens, 237	
flare, 237	H
flash	hard light, 120–121
accessory Speedlites, 136	HDR (high dynamic range) images, 179
built-in, 4, 5, 127–130	High ISO noise reduction, 182, 187
control options, 134–135	highlight, 238
FE Lock, 131	histograms
Flash Control Menu options, 135	Brightness, 42–43
Flash Exposure Compensation (FEC), 132–133	color spaces, 60–61
Live View shooting, 81	defined, 238
modifying exposure, 131–134	RGB, 43-44
night/low-light photography, 202	hot shoe, 238
red-eye reduction, 130–131	hue, 238
relationship with Live View, 80	
sync speed, 127	1
technology overview, 125–126	1.40
Flash Control Menu options, 135	image sensor, 140
Flash Exposure Compensation (FEC), 132–133	Image Stabilization (IS)
Flash-off mode, 27	defined, 238
Flash Pop-up button, 4, 5	image-stabilized lenses, 147, 153–154
floating system, 147	Image Stabilizer switch, 10–11
Flourite elements, 146, 237	images
fluorescent light color, 118	avoiding loss of, 15
focal length	backing up, 220
defined, 237	Custom Functions, 93, 94–96
multiplication factor, 139–141	downloading, 219–222
tips, 48	editing JPEG, 15
focal point, 237	erasing, 53–54
focus-lock and recompose, 49	exposure differences in JPEG and RAW
focusing	images, 45
back-, 49	organizing, 220
control 165-166	protecting, 54

quality, 17	Lens Release button, 4, 5
viewing, 52–53	lenses
improving Autofocus performance, 47–48	accessories, 156–158
Index Display, 52–53	action/sports photography, 170
infinity	animal/wildlife photography, 176
compensation mark, 11	architectural/interior photography, 181
defined, 238	bokeh characteristics, 150
inner focusing, 147	child photography, 186
inspiration	choices, 141–143
action/sports photography, 169	control, 10–11
animal/wildlife photography, 174	focal length multiplication factor, 139–141
architectural/interior photography, 179-180	image-stabilized, 153-154
child photography, 184	lens extenders, 156–157
macro photography, 188–189	lens hood, 128
nature/landscape photography, 193–194	lens raincoats, 172
night/low-light photography, 198, 203	macro lenses, 151–152, 156
still-life photography, 208	macro photography, 190
stock photography, 212	minimum focusing distance, 25
travel photography, 216	nature/landscape photography, 195
installing custom Picture Styles, 78	night/low-light photography, 200, 201
intensity exposure element	portrait photography, 201, 205
choosing aperture, 110–111	standard, 151, 155
depth of field, 111–112	still-life photography, 210
narrow aperture, 110	stock photography, 213
overview, 109	telephoto, 149-150, 155, 156
wide aperture, 109–110	terminology, 145–148
interior photography. See architectural/interior	tilt-and-shift, 153
photography	travel photography, 217
International Organization for Standardization. See	TS-E, 156
ISO (International Organization for	wide-angle, 148–149, 155
Standardization)	zoom compared with prime, 143-145
IS. See Image Stabilization (IS)	level, 201
ISO (International Organization for	lighting
Standardization). See also aperture; shutter	action/sports photography, 172, 270
speed	ambient, 235
nature/landscape photography, 196	architectural/interior photography, 181
overview, 21, 238	child photography, 186
setting sensitivity, 44–46	color temperature, 115
Speed button, 4–5, 6	colors of light, 116–118
, and the second	directional light, 122
1	exposure element, 106–107
IDEC (Link District and his Formerts Cream)	hard light, 120–121
JPEG (Joint Photographic Experts Group)	macro photography, 190, 191
compared with RAW images, 226	metering, 118–120
editing images, 15	nature/landscape photography, 195
image exposure compared with RAW images, 45	night/low-light photography, 200, 202
overview, 15–16, 238	portrait photography, 202, 205
relationship with speed, 12	reflected light, 121
jump bar, 53	soft light, 122
	still-life photography, 209
K	stock photography, 213
Kelvin	temperature, 236
defined, 238	tips, 47–48
scale, 64	travel photography, 217
	linear, 238
L	lines, 163–164
	Live mode focusing option, 80, 85-86
L-series lenses, 146	Live View
Landscape mode, 24–25 landscape photography. <i>See</i> nature/landscape	features and functions, 80–81
photography	focusing, 80–81
LCD, 9, 10	Co
LOD, 0, 10	

246 Index + L—P

Live View (continued)	N
overview, 79–80	
setting up for, 81–84	nature/landscape photography
shooting in, 84–90	inspiration, 193–194
tethered shooting, 87–90	overview, 192–193
lossless, 238	shooting, 194–196
lossy, 238	tips, 196 neutral density filter, 239
low-light photography. See night/low-light	
photography	night/low-light photography inspiration, 198
luminance, 238	overview, 196–198
	shooting, 199–200
M	tips, 201
M (Manual) mode, 32–33, 128	Night Portrait mode, 26–27
macro lenses	noise, 109, 239
choices, 156	nonlinear, 239
overview, 142–143, 147	normal lenses, 142, 151
using, 151–152	,,
macro photography	0
inspiration, 188–189	One-shot AF mode, 46–47
overview, 187–188	
shooting, 189–191	open up, 239 operation Custom Functions, 93, 97–100
tips, 191	organizing images, 220
Main dial, 5, 6	organizing images, 220
manual focusing option, 80, 86–87	p
Manual (M) mode, 32–33, 238	
manual reset file numbering, 18	P (Program AE) mode, 28–29, 128
measuring	panning, 239
color compensation, 69	Partial metering, 36
color temperature, 115	perspective
media cards, 12–13	defining, 167
medium lenses, 155	with telephoto lenses, 150
megapixel, 238	with wide-angle lenses, 149
Menu button, 6, 7 metadata, 13, 238	PF2 files, 76–78
metering	photography genres. <i>See specific genres</i> photosite, 239
Center-weighted Average mode, 37	Picture Styles
Evaluative mode, 35–36	button, 7, 8
exposure, 81	customizing, 70–75
light, 118–120	Editor, 76–78, 77, 228
Partial mode, 36	installing custom, 78
midday light, 116	modifying, 74
midtone, 239	Monochrome Filter, 75
Mode dial, 4, 6	options for still-life photography, 210
modes. See also Basic Zone modes; Creative Zone	overview, 70–72, 73
modes	saving custom, 78
AF (Autofocus), 7, 8, 46–48	Toning Effects, 75
focusing, 46–47	pincushion distortion, 239
Metering, 7, 8, 34–37	pixel, 239
modifying	plane of critical focus, 239
AF modes, 47	Playback button, 7, 8, 52–53
Drive mode, 51	polarizing filter, 239
exposure, 37–42	Portrait mode, 23–24
file numbering, 17–118	portrait photography
ISO sensitivity setting, 46	accessory flash, 202
Picture Styles, 74	backgrounds and props, 202
screen color, 103	direction, 203
Speedlite settings, 134	inspiration, 203
Monochrome Filter effects, 75	lens choices, 201
Monochrome Picture Style, 72	lighting, 202
My Menu, 101–103	overview, 201
	posing, 203

rapport, 203 shooting, 204–205 tips, 206 posing, 203 ppi (pixels per inch), 239 preset white balance settings, 64–65 previewing depth of field, 31 prime lenses, 143–145 Print Share/WB (White Balance) button, 7–8 Program AE (P) mode, 28–29 props, 202 protecting images, 54	screen color, 103 SD/SDHC media cards, 12–13 Secure Digital High Capacity media cards, 12–13 selecting AF modes, 46–48 aperture, 110–111 Autofocus (AF) points, 49–50 color spaces, 61–62 Drive modes, 50–51 file format and quality, 14–17 metering modes, 34–37 Picture Style, 70–75 RAW conversion programs, 231 shooting modes, 20–28
quality	white balance options, 62–70
relationship with file format, 14–15	Self-timer lamp, 4, 5
setting image, 17	Self-timer modes, 51, 201
Quick mode focusing option, 80, 84–85	sensitivity exposure element, 107–108 sensor cleaning, 55
	Set button, 9
R	setting
RAM (Random Access Memory), 239	Auto Exposure (AE) Lock, 41
range, built-in flash, 129	Auto Exposure Bracketing (AEB), 40
rapport, 203	Basic Zone modes, 22
RAW Capture	color spaces, 61–62
brightness level comparisons, 227	custom white balance, 65-67
Canon's RAW conversion program, 228	date and time, 13–14
choosing RAW conversion programs, 231	Exposure Compensation, 39
overview, 225–228	FE Lock, 131
sample RAW image conversion, 228–232	FEC, 133
workflows, 232–234	image protection, 54
RAW conversion programs, 228, 231	image quality, 17
RAW images	ISO sensitivity, 44–46, 46
compared with JPEG images, 45, 226	Live View Custom Functions (C.Fn), 82–83
overview, 16–17, 239 relationship with color, 65, 116	Live View preferences, 83–84
relationship with speed, 12	resetting default, 12
RawWorkflow.com Web site, 65	White Balance Auto Bracketing, 68 White Balance Correction, 69–70
rear camera controls, 6–9	White Balance Shift, 68–70
rear focusing, 147	setup
recompose, 49	action/sports photography, 170
Red-eye reduction, 4, 5, 130–131	animal/wildlife photography, 175
reflected light, 121, 239	architectural/interior photography, 181
reflectors, 218, 239	changing file numbering, 17–18
registering User Defined Picture Style, 75–76	child photography, 185
Remote Control terminal, 9	choosing file format and quality, 14-17
removing. See deleting	formatting SD/SDHC cards, 12–13
resetting	Live View, 81–84
Custom Functions, 100	loss of images, avoiding, 15
default settings, 12	macro photography, 190
resolution, 211, 239	nature/landscape photography, 195
restoring Custom Functions, 101	night/low-light photography, 199
RGB (Red, Green, Blue), 43–44, 59–60, 240	overview, 11–12
Rockwell, Ken, on bokeh, 150	portrait photography, 204
	resetting to default settings, 12
S	setting date and time, 13–14
Safe Sync flash adapter, 207	still-life photography, 209
saturation, 240	stock photography, 213 travel photography, 217
saving custom Picture Styles, 78	traver photography, 217
scene coverage, 150	

Index + S—T

shooting	sunrise light, 116
action/sports photography, 169–171	sunset color, 116
animal/wildlife photography, 175–176	super-telephoto lenses, 156
architectural/interior photography, 180-182	symmetry, 160–162
child photography, 185–186	sync speed, 127
in Live View, 84–90	
macro photography, 189–191	T
nature/landscape photography, 194–196	
night/low-light photography, 199-200, 204-205	Tagged Image File Format (TIFF), 240
still-life photography, 209–210	telephoto, 240
stock photography, 212–213	telephoto lenses, 142
tethered, 87–90	choices, 155
travel photography, 216–217	shopping for, 150
shooting modes, 20–21. See also specific shooting	using, 149–150
modes	temperature
shopping	color, 115
for telephoto lenses, 150	white balance ranges, 62
for wide-angle lenses, 149	10-second self-timer mode, 51
shutter	10-second self-timer plus continuous shots mode, 51
button, 4, 5–6	terminals, 9
defined, 240	tethered shooting, 87–90
priority, 240	Through-the-Lens (TTL), 240
Shutter-priority AE (Tv) mode. See Tv (Shutter-	TIFF (Tagged Image File Format), 240
priority AE) mode	tilt-and-shift lenses, 153
shutter speed. See also aperture; ISO (International	time exposure element, 112–113
Organization for Standardization)	time, setting, 13–14
action/sports photography, 171	timing, 172
nature/landscape photography, 196	tips
relationship with camera shake, 31	action/sports photography, 171–172
setting, 21	animal/wildlife photography, 177
side lighting, 122	architectural/interior photography, 182–183
simulation, 81	Autofocus, 47–48
Single-image playback, 52	child photography, 186–187
Single-shot mode, 48, 50	macro photography, 191
slave, 240	nature/landscape photography, 196
soft light, 122	night/low-light photography, 201, 206
space, 167	still-life photography, 210
Speedlites, 133, 136	stock photography, 214
Sports mode, 25–26	travel photography, 218
sports mode, 23–20 sports photography. See action/sports	tonal range, 240
photography	tone, 162–163
sRGB, 59–60, 240	Toning Effects, 75
Stabilizer mode switch, 11	top camera controls, 4–6
standard lenses, 155	top lighting, 122
starting Picture Style Editor, 77	Transportation Security Administration (TSA)
still-life photography	regulations, 214
inspiration, 208	travel photography
overview, 207–208	inspiration, 216
shooting, 209–210	overview, 214–215
	shooting, 216–217
tips, 210 stock photography	tips, 218
inspiration, 211	tripod level, 201
overview, 211	TS-E lenses, 156
shooting, 212–213	TTL (Through-the-Lens), 240
0.	Tungsten light color, 117
tips, 214	Tv (Shutter-priority AE) mode
stop. See aperture stop down, 240	built-in flash, 128
	nature/landscape photography, 196
Storm Jacket Web site, 177 subjects. <i>See also</i> portrait photography	overview, 29–31
contrast, 48	twilight. See night/low-light photography
framing, 165	2-second self-timer mode, 51
naming, 100	

U	white balance
UD (Ultralow Dispersion), 146, 240	accurate color with RAW images, 65
ultrasonic motor (USM), 146	choosing, 62–70
updating firmware, 222–223	overview, 62–64, 240
USB cables, 87–90, 219–221	preset settings, 64–65
User Defined Picture Style, 75–76	setting custom, 65–66, 66–67
USM (ultrasonic motor), 146	temperature ranges, 62, 70
	White Balance Bracketing, 67–68
V	White Balance Shift, 68–70
Video Out terminal, 9	wide-angle
viewfinder display, 9–10	defined, 240
viewing images, 52–53	distortion, 178, 182–183
viewing images, 52–55	wide-angle lenses
VA/	choices, 155
W	overview, 142
water-resistant construction, 146–147	shopping for, 149 using, 148–149
Web sites	wide-angle distortion, 178, 182–183
Canon, 78, 117, 222	wildlife photography. See animal/wildlife
expoimaging, 65	photography
Ken Rockwell, 150	workflows, 232–234
MSNBC's The Week in Sports Pictures, 169	WOI KIIOWS, 232–234
RawWorkflow.com, 65	7
Storm Jacket, 177	Z
Transportation Security Administration	zoom lenses, 143–145
(TSA), 214	zoom ring, 11
white/gray cards, 118	
WhiBal cards, 65	

Guides to go.

Colorful, portable Digital Field Guides are packed with essential tips and techniques about your camera equipment, iPod, or notebook. They go where you go; more than books—they're *gear*. Each \$19.99.

978-0-470-16853-0

978-0-470-12656-1

978-0-470-04528-2

978-0-470-12051-4

978-0-470-11007-2

978-0-7645-9679-7

Also available

Canon EOS 30D Digital Field Guide • 978-0-470-05340-9 Digital Travel Photography Digital Field Guide • 978-0-471-79834-7 Nikon D200 Digital Field Guide • 978-0-470-03748-5 Nikon D50 Digital Field Guide • 978-0-471-78746-4 PowerBook and iBook Digital Field Guide • 978-0-7645-9680-3

Available wherever books are sold